My Commedia dell'Arte
Jacqueline Burckhardt

for Dino

I had you in mind when I wrote this

Gu

Jacqueline

11. 6. 2024

To my dear friend and mentor

Kurt W. Forster

1935–2024

My Commedia dell'Arte

Jacqueline Burckhardt

Edited by
Theres Abbt and Mirjam Fischer

Edition Patrick Frey

Contents

7 Preface
Theres Abbt and Mirjam Fischer
11 Acknowledgements
Jacqueline Burckhardt

I
NOT A BIOGRAPHY
BUT A CONVERSATION
Juri Steiner and Jacqueline Burckhardt

16 Restoration, "Dual Historical Nature," St. Francis' Left Ear and an Alien Angel
26 Giulio Romano, *Sprezzatura* and the *Bee Opera* on the Novartis Campus
62 Göreme, Living it up in Zurich, *Parkett*, *Una discussione*, Polke's Agates and Nonno's Flies
112 In the Grove of Academe, Expo.02 and the Turf Brick, Federal Art Commission, Frissons and Sincerity
148 Limbo, Spaghetti al Sugo, Tipp-Ex and Octopus, *My Commedia dell'Arte*

INTERMEZZO

207 Pipilotti Rist
212 Kurt W. Forster
218 Catherine & Tarcisius Schelbert
221 Ernst H. Gombrich
223 Kurt W. Forster
232 Laurie Anderson
242 Herbert Lachmayer
246 Katharina Fritsch

II
TEXTS
Jacqueline Burckhardt

- 252 O like Oppenheim or "x = hare"
 Meret Oppenheim
- 274 Rocaille Rock Eye
 Pipilotti Rist
- 278 Sip My Ocean
 Pipilotti Rist
- 284 In the Nerve Stream
 Laurie Anderson
- 296 Apocalypse and Silver Lining
 Mona Hatoum
- 306 The Weight of a Grain of Dust
 Robert Wilson and *Le Martyre de Saint Sébastien*
- 316 Dance About Dance About Me About Us
 The Dance Performer Dana Reitz
- 322 Studio Visit
 Alex Katz
- 328 Bio-Graphy
 Jean-Luc Mylayne
- 340 The Octopus's Strategy
 Katharina Fritsch
- 358 *Smearings* in the Ernst & Young Building
 Alexej Koschkarow
- 366 Wall Sculpture *Tismemskiblo*
 El Anatsui
- 374 Grossmünster Windows
 Sigmar Polke

- 393 Contributors
- 396 Bibliography
- 406 Index

Preface

We have the pleasure of presenting Jacqueline Burckhardt's *My Commedia dell'Arte* in English, two years after issuing the first edition in German.

Jacqueline Burckhardt has shown us time and again that she makes no distinction between life and art, that art for her is a wellspring of creative energy and helps us to understand the world.

Her training at the Istituto Centrale del Restauro in Rome laid the foundations for an attitude that has played an enduring role in her life and work ever since. While there, she learned that past and present cannot be separated, that they influence each other and that the perception of art and culture is subject to ongoing modification.

In numerous conversations with her, we learned how much she cherishes networked thinking, historical knowledge and interdisciplinary work. Theory and practice fuse into a single whole. Jacqueline approaches art from many different angles but with an underlying attitude that encompasses everything she does. Whether she is acting as restorer, art historian, initiator of performance programs at Kunsthaus Zürich, curator of site-specific art at Novartis Campus, director of the Sommerakademie im Zentrum Paul Klee in Bern or as a lecturer at the Accademia di architettura in Mendrisio—her approach remains the same. She was closely involved in cultural policy making for nine years while serving as president of the Federal Art Commission.

My Commedia dell'Arte offers an insight into the many roles Jacqueline has played throughout the various stages of her career.

The first half of the publication consists of an extended conversation that reveals her interest, or rather "inter-esse" in the Latin sense of the word, which means being in between and in the midst of the vast field of art. We had the privilege of securing

curator and art historian Juri Steiner as an ideal partner in conversation. He and Jacqueline spoke at length over the course of many months, meandering effortlessly and yet profoundly through a diversity of subjects, the whole yielding a fascinating image of the way Jacqueline works and thinks. Their conversation is like a rhizome, branching off into all the fields that have been part of her life, beginning with the "dual historical nature" of a work of art as a crucial factor in restoration and the virtuoso implementation of that concept by Giulio Romano, High Renaissance artist and architect, who is the subject of her dissertation, titled *Regisseur einer verlebendigten Antike* (Director of a Revivified Antiquity).

Her understanding of art as an all-embracing medium is particularly outspoken when she curates site-specific work, as in her collaboration with artists and experts at the Novartis Campus in Basel. We also learn how Robert Wilson wanted to incorporate her art historical expertise into his plans to produce Claudio Monteverdi's madrigals in Mantua or how she assisted Sigmar Polke in preparing his project for the windows of the Grossmünster Cathedral in Zurich, later actually standing by and helping him in their execution.

Her pioneering achievement when she was working as a restorer at Kunsthaus Zürich is exceptional. Over 40 years ago she brought Performance Art to Switzerland for the first time by inviting artists like Laurie Anderson, Dana Reitz and the Japanese Sankai Yuku group to perform at Kunsthaus Zürich. As cofounder and editor of the international art journal *Parkett*, she contributed for decades to a stimulating, visionary platform which brought together artists and writers from all over the world, and which issued over 270 special editions by artists in every conceivable medium and technique.

She has been blessed by Kairos, her favorite god of Greek antiquity, who must be seized with eyes and mind wide open to capture the right moment. Italy is her dearly beloved second home, and no wonder, considering that she found a number of

role models there around 1970, such as the feminists and writers Sibilla Aleramo and Dacia Maraini, and the actresses Sophia Loren and Anna Magnani.

The Intermezzo of artistic and literary contributions in the middle of the book were created especially for this publication by five people of special significance for Jacqueline: Laurie Anderson, Kurt W. Forster, Katharina Fritsch, Herbert Lachmayer and Pipilotti Rist. In addition, a letter to Jacqueline from Ernst H. Gombrich, one of the most important art historians of the 20th century, has resurfaced, in which he expresses his appreciation of her trailblazing discoveries and reinterpretation of Mannerist Giulio Romano's work on the Palazzo Ducale in Mantua. The genesis of the exchange between Gombrich and Jacqueline is described by Catherine and Tarcisius Schelbert.

We have selected 13 texts from Jacqueline's substantial body of writings, which testify to her affinity with art and reveal how profoundly it touches her. In her own words: "Art is my oxygen. It is also an inexhaustible horn of plenty, across the ages and disciplines."

We thank Catherine Schelbert, Jacqueline's congenial translator for 35 years, for her work on this substantial publication and the stimulating exchange in preparing the English version. We cordially thank our publisher Patrick Frey and his team for their unstinting, generous support. We also thank Martina Brassel, who has found the right form for such a diversity of content with great sensitivity and an unerring eye for fitting design as well as Marjeta Morinc for her careful image processing. We are indebted to Kai Damian Matthiesen for the idea underlying Herbert Lachmayer's design of the cover. We are more than happy that in 2022 the German edition of this book received the "50 Books/50 Covers" award from the prestigious American Institute of Graphic Arts (AIGA).

We extend our very special gratitude to Juri Steiner, who has given the conversation wings with his committed nonchalance or rather *sprezzatura*, to use a term that he and Jacqueline analyze with delightful consequences.

Heartfelt thanks go to Laurie Anderson, Kurt W. Forster, Katharina Fritsch, Herbert Lachmayer and Pipilotti Rist. In particular, we have been much moved by our encounters with Kurt W. Forster, who drew our attention to the immeasurable vistas of humanist thought.

This book is more than a portrait of an award-winning Swiss art historian and an exceptional individual: it is an inspiring handbook that demonstrates a discerning appreciation of art in a spirit of attentive commitment and dispassionate open-mindedness; it bears witness to the ability to sustain a virgin gaze.

Dear Jacqueline, we thank you with all our heart for an incredibly inspiring journey, which now continues with the English version of your publication.

Theres Abbt and Mirjam Fischer

Acknowledgements

It all started with Theres Abbt and Mirjam Fischer, who originally approached me with the idea of doing a publication. The two editors flushed me out of hiding and encouraged me not to shelve everything I've done in various roles and places in the course of my professional life, but rather to think and talk and write about it. They tackled the project with committed, infectious energy, collecting my texts, trawling through my archives, raising funds and organizing a publisher. The moment I hesitated, plagued by uncertainty, they instantly dispelled my doubts. They secured Juri Steiner, a passionate, exceptionally knowledgeable curator and art historian, to conduct a conversation with me. It proved to be a lengthy exchange over a period of several months during Covid and now fills almost half the book. Juri kept me on a long leash, nimbly and skillfully guiding me through a labyrinth of memories, perceptions and analyses. Together, we arranged the elements of our exchange but without making any major modifications.

I will never stop revering those who have inspired me, helped me and given me direction. Some I know personally, others I don't; some are still alive, others were active centuries ago. This book is dedicated to all of them.

Some of those people—Laurie Anderson, Kurt W. Forster, Katharina Fritsch, Herbert Lachmayer, Pipilotti Rist, Catherine and Tarcisius Schelbert—have gifted contributions to the Intermezzo in the middle of the book. This touches me deeply. Most of them are pictured on the cover conceived and designed by Herbert Lachmayer and Kai Damian Matthiesen. The cover draws inspiration from Lachmayer's so-called *Hermeneutic Wallpapers*, which he produces as a curator, often depicting the protagonists of his exhibitions. Not only do those who contributed to the Intermezzo grace the cover but also my favorite animal, an octopus, my favorite god, Kairos, along with Giulio Romano, Isabella d'Este and a multifunctional tool that symbolizes my love of handcrafted work.

I was delighted when our publisher Patrick Frey, who is well aware of my passion for *italianità*, suggested an Italian title for this book. The minute he said that I thought of "commedia dell'arte," and later, Laurie Anderson cleverly proposed personalizing it: *My Commedia dell'Arte*. Of course, I don't come from theater but the rapport between the fine arts and commedia dell'arte is both appealing and stimulating.

Many are the fruitful hours I spent with the graphic designer Martina Brassel. Witnessing the intelligence, precise vision and skill with which she handles text and pictures at the computer, the care which she responded to my wishes or elegantly surprised me with better solutions, reinforced my belief in the success of our project. Working for almost 40 years with the translator Catherine Schelbert has been an enriching experience. I also had the privilege of enjoying the steady, unconditional support and advice of Bice Curiger, Renata Burckhardt and Nicole Stotzer, and was most fortunate in having Hanna Williamson and Simone Eggstein, the two graphic designers of the art journal *Parkett*, supply me with illustrations from the magazine.

In closing, very special thanks go to all those whose generosity has made the English version of this book possible.

Jacqueline Burckhardt

FIG. 1 On the special course for wall painting at ICCROM (International Center for Conservation Rome), 1972.

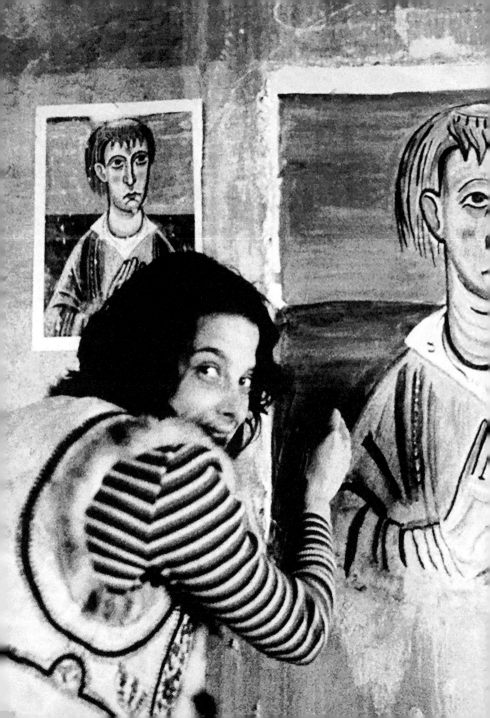

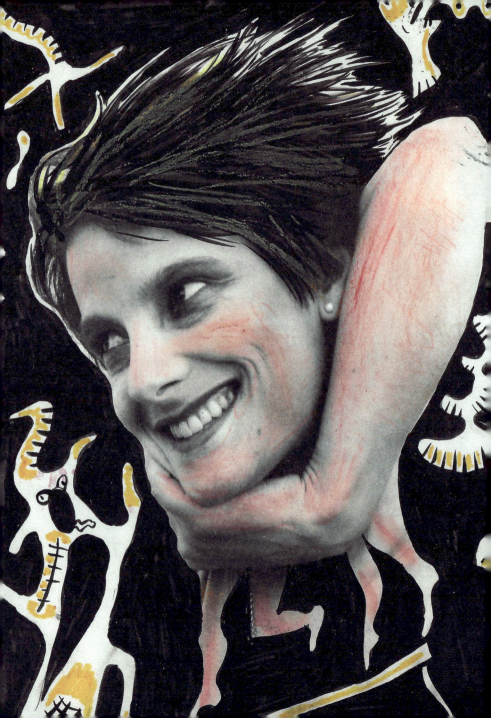

I
Not a Biography But a Conversation

Juri Steiner and Jacqueline Burckhardt

FIG. 2 Andreas Züst, overpainted photo of me, 1980.

1

Restoration, "Dual Historical Nature,"

St. Francis' Left Ear

and an Alien Angel

JURI STEINER There are key motifs in every biography, where personal and professional life overlap, where past, present and future intersect. Jacqueline, you once told me that, in spite of pursuing so many different activities and interests, in your thoughts and at heart you're a restorer...

> JACQUELINE BURCKHARDT ...and specifically a restorer of the Cesare Brandi school.

JS Who was he and what does he mean to you?

JB Cesare Brandi (1906–1988) was an art historian, university professor, artist, philosopher, writer and journalist. He was also founding director of the Istituto Centrale del Restauro (ICR) in Rome, where I studied for four years. He and the art historian Giulio Carlo Argan (1909–1992) defined the concept and the structure of the institution in 1938, in Fascist Italy, at the same time that a new Italian law had been passed to protect all registered immovable and movable cultural heritage. Ever since then, authorities have to be notified before anything can be done to a registered item of cultural heritage. After the war, the ICR became the center of expertise for conservation and restoration. They do excellent work and they're also active in research and education. Specialized restorers, archaeologists, skilled craftspeople, art historians, photographers, microbiologists, chemists, physicists and lawyers are all involved in interdisciplinary exchange under the same roof. Theory and practice are never separated because Cesare Brandi defines restoration primarily as a critical activity on which practical activity depends. His *Theory of Restoration* (1963; Eng. 2005) is the most compelling treatise that has been written to date and it includes instructions for putting his theory into practice.

JS *Theory of Restoration*: I'm at a loss. Maybe a brief introduction?

JB Restoration always involves two, sometimes conflicting, basic concerns: the interests of history, on one hand, and the interests of aesthetics, on the other. Brandi gave priority to the latter. In addition, he wrote about the "dual historical nature" of a work of art, meaning that we have to take into account both the work's origin and its ongoing history once it leaves the artist's hands. It is subject to continuous change: its reception changes over time, the materials may

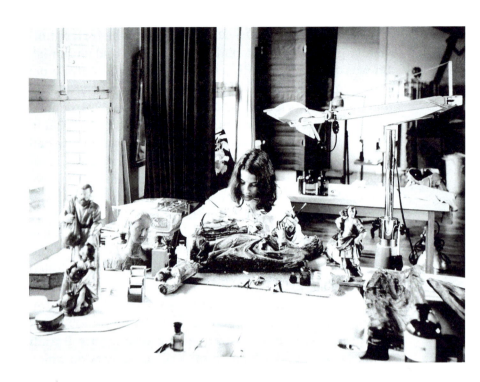

FIG. 3 Internship in the restoration studio of the National Museum Zurich, 1968.

FIG. 4 *Firenze restaura*, 1972. Catalog of the first major exhibition about restoration following the catastrophic flooding in Florence on November 4, 1966.

be damaged, it is subject to the natural process of aging, and it may be more or less skillfully restored. But its original state can never be recovered.

That's why the physical and aesthetic condition of the work and its significance in the history of reception has to be critically assessed before taking any action. That usually means having various experts evaluate and examine the work.

JS What are the most exciting aspects of restoration?

JB Cleaning a surface is the most exciting and also the most challenging. You want to remove the dirt, the awful varnishes that were added later or inept overpaint, but you don't want to lose the patina, the delicate washes or the subtle play of the colors. So you have to analyze the materials, be extremely skilled, have a sense of aesthetics, and never lose sight of the overall picture.

JS What do you do when the original has been overpainted?

JB Works of art and architecture often have multiple layers or added parts. They are like palimpsests. For example, if a beautiful Baroque facade has been applied to a Romanesque church, you don't just dismantle it to reveal the original underneath; instead, you take a very gentle approach to the building's "dual historical nature." You do research and document as much of the original state as possible, but you leave the Baroque facade. On the other hand, if the modifications are poor and insignificant, you remove them. As mentioned, aesthetic concerns take precedence over historical ones. And if something has been overpainted, you also consider the quality of that intervention and you have to be careful not to remove the pentimenti, that is, the artist's own authentic overpaint.

I can tell you about something pretty surprising that happened when I was still a student. In 1971 we were working on the ornamental paintings on the ceiling of the lower church of San Francesco in Assisi while the chief restorer of the ICR, Laura Mora, was working on Cimabue's *Maestà*. There, an ascetic, full-length figure is standing to the right of the throne with a crooked nose and conspicuously protruding ears: St. Francis. You'd think that it's a real-life portrait but it's not, because Cimabue wasn't born until 1240, 14 years after Francis died. So he must have based his portrait on descriptions of the saint. In any case, the size of his ears was reduced in an overpaint in a later century, and Laura Mora was in the process of removing that layer when there was an outcry from the Vatican to stop immediately. The reason: copies and reproductions of this famous painting always show a beautified Francis, and this is the saint that Catholics venerate all over the world. So he should stay that way. They were probably afraid that he would look ridiculous with his Dumbo ears. Laura Mora did as she was told; after all, she was an Italian civil servant and the Basilica di San Francesco d'Assisi belongs to the Vatican mini state, which is governed by its own laws.

Today, Francis's left ear shows part of the old overpaint and a piece of the unveiled original, which was finally accepted by the Vatican, and which respects the "dual historical nature" of the fresco.

JS The ear as the restorer's *pièce de resistance*. Are there any binding rules for dealing with missing parts?

JB Brandi defined two basic forms of treatment: if you know what the original looked like, you complete the picture with the so-called "tratteggio" technique, that is, filling the lacuna with delicate vertical, divisionist brushstrokes in watercolor, so that the intervention is easily reversible, and the original

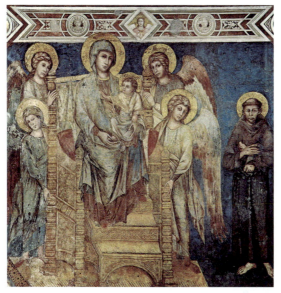

FIG. 5 Cimabue, *Maestà*, ca. 1285, fresco, Basilica di San Francesco d'Assisi.
FIGS. 6+7 Detail of the *Maestà* before and after Laura Mora's restoration in 1971. One notes the difference of Francis' left ear in the right-hand image.

can be distinguished at close range from the restored parts. On the other hand, if you can't reconstruct the original and you don't want to fake it, you paint or rather dye the lacuna with great restraint. In this case the goal is to restore the aesthetic harmony of the original painting by making the missing part recede into the background both in form and in color.

JS What is the significance of Brandi today?

> JB Brandi's theory applies primarily to historical art. Artists now work with entirely different materials and techniques, which require new methods of restoration. Ephemeral or non-objective art, performances or self-destructive works only survive through their documentation, such as Tinguely's machine *Homage to New York* of 1960 in the garden of MOMA or works by Gustav Metzger, who coined the term "auto-destructive art."
> However, Brandi's theory is still seminal and continues to provide guidelines for understanding art, not only for restorers or others who deal with art. Basically, anyone involved with culture will agree with Brandi's categorical imperative that artworks of quality are worth protecting because of their "dual historical nature," which gives them a timeless impact. Think of the works that have accumulated in museum storage that crop up out of oblivion at some point and, being recontextualized, inspire renewed critical reflection. Museum depots are reservoirs for the future and certainly not just archives of past achievements. Restorers who physically work on paintings and sculptures as well as curators and theorists, who place them in exhibitions or discuss them, contribute to their reception history and thus to the double historicity inherent in them. So do artists.

JS For example?

> JB Take what Walter Benjamin wrote about Klee's *Angelus Novus*, a painting he owned and bequeathed to Gershom Scholem because of their deep friendship and shared metaphysical Jewish mindset. Paul Klee painted the work after his hellish experiences as a soldier in the First World War and Benjamin described the figure as an "angel of history," staring at the debris and helplessly swept backwards

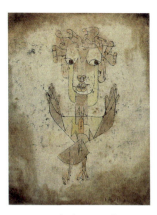

FIG. 8 Paul Klee, *Angelus Novus*, 1920, oil and watercolor on paper, 31.8 × 24 cm (12 ½ × 9 ½ in), Israel Museum, Jerusalem, formerly owned by Walter Benjamin.

by the storm from paradise into the future. And he interpreted the storm as a metaphor for progress.

Benjamin's fatalistic interpretation gave the painting a unique status in art history, especially among artists. He overturned conventional notions of past and future. We usually say that the future lies ahead of us, but according to Benjamin, it's the past that lies before us, because it's the only thing that we can overlook. In contrast, the storm is driving the angel back into the future. It lies behind us and we can't see it.

That makes sense and matches representations of the dance of death, where Death, the ultimate future, usually surprises his victims from behind. Besides, we also talk about those who come before and those who come after us. Benjamin's interpretation of Klee's *Angelus Novus* has inspired artists, like Laurie Anderson, who dedicated a song to him, "The Dream Before," released in 1989 on her CD *Strange Angels*. This is an example that shows the impact and reception of a work of art that persists over time in all kinds of media, changing its aura and thus contributing to its "dual historical nature."

Actually, you mounted an impressive exhibition centered on this picture when you were the director of the Zentrum Paul Klee.

JS I have long been fascinated by the question of why the angel's wide-open button eyes see the catastrophe without mirroring it. The *Angelus Novus* came to visit from the Israeli Museum in Jerusalem for just one week during the exhibition *Lost Paradise* (2008). We tried to reconstruct his view with a panorama of artifacts from the 20th and 21st centuries: we showed the storm and the desolate lives of people straying about in a world of total destruction. The Peace Memorial in Hiroshima lent us clothes and objects for the exhibition. And in the completely darkened gallery, you could see the flickering shadows of Alain Resnais' *Hiroshima, mon amour* (1959). There's a disturbing sentence in the film that keeps ringing in my ears: "Tu n'as rien vu à Hiroshima." (You haven't seen anything in Hiroshima). You hear a man with a strong Japanese accent saying that off-screen. Against the maimed backdrop of the devastated city, the film's traumatized protagonists seek a future beyond the debris of the past, like Adam and Eve after the Fall. It's as if the end of history is being celebrated in an eternal night. Even culture is nothing but a graveyard in silence after the onslaught of fate.

JB Another example: When you and Stefan Zweifel curated the exhibition *The Exhausted Man* (2020) at the National Museum in Zurich, you placed two plaster casts at the beginning and end of the tour: Laocoön and the Sleeping Hermaphrodite. The two figures from antiquity play an enormous role in the history of art. Hermaphrodite has become an icon of the transgender debate, while the discovery of Laocoön in Rome in 1506 was a cultural event of monumental significance. Michelangelo and Antonio da Sangallo were

there when it was excavated, and they instantly realized that it must be the very sculpture that Pliny the Elder considered the most beautiful in Emperor Titus' collection. In Rome, I didn't live far from where it was found and Mario, the chef of my regular restaurant in the Via dei Serpenti, used to tell every new customer that the name of the street was indebted to Laocoön's snakes and that the ancient sculpture had been discovered exactly under his kitchen: "se non è vero è ben trovato" (true or not, it's a great story).

Missing parts were added to the sculpture after it was found, which meant that it was in a state of non-authentic completeness, when such great thinkers as Winckelmann, Lessing, Herder and Goethe wrote about it. The removal of these modifications in 1958 and the addition of the original right arm, already found in 1903, dramatically changed Laocoön's posture and paved the way for new interpretations, most recently including yours, Juri.

JS We were utterly intrigued by the fact that Laocoön was the first man in antiquity to be depicted not as a roaring victor but as a groaning loser. And like Lautréamont, we dreamed our way out of our own existence with the Sleeping Hermaphrodite.

11

Giulio Romano, *Sprezzatura* and the Bee Opera on the Novartis Campus

JS Speaking of the imagination sparked by ancient sculptures, one cannot help but think of Giulio Romano (about 1499–1546) a key figure, if not *the* key figure in your art universe. He also had ancient sculptures restored for the Duke of Mantua so that they looked as if they had just been created yesterday with all signs of restoration concealed.

> JB You're right. My studies on this universalist, Raphael's favorite pupil, colleague, successor and heir, were seminal for my mindset. Much of what I have done since is in some way influenced by him. I always think about how he

managed to weave everything that he touched into surprising contexts.

JS He is the subject of your dissertation: *Giulio Romano, Regisseur einer verlebendigten Antike* (Director of a Revivified Antiquity). What is it about?

JB It's about the Loggia dei Marmi, a relatively small but unique Gesamtkunstwerk in Mantua, located in the piano nobile of an annex to the medieval complex of the Palazzo Ducale. Duke Federico II Gonzaga commissioned Giulio to build it around 1538. It is from this loggia that Federico and his entourage watched the tournaments and festivities of the Cortile della Cavallerizza. The finely chiseled interior is full of allusions to the temples and triumphal arches of Roman architecture. Above all, it was custom-built to accommodate a collection of ancient sculptures to which Giulio added reliefs of his own and other contemporaries. He combined the sculptures with the architecture and the murals so cleverly and skillfully that it looks as if the whole had been created all at once by a single hand.

JS So, did Giulio devise a new overall iconography for the jumble of sculptures from various periods?

JB Exactly. He was a superb director. Among the ancient and contemporary sculptures at his disposal, he selected those that represented Federico's aesthetic, political and cultural ideals. Women are the protagonists in the ensemble, like two antique Venus figures, a *Venus pudica* and a *Venus genetrix*. In this context, the latter embodies Federico's *divine progenitrix*. He pays tribute not just to her but also to his biological mother, the marvelous Isabella d'Este, through the Roman bust of Giulia, daughter of Emperor Titus, whose hairstyle Isabella imitated. The bust was placed in a round

niche above the sopraporte, in which was inserted the relief of a Roman sarcophagus with the scene of the battle of the Amazons against the Greeks. There's so much to say about how Giulio staged all the figures but that would go too far here. I wrote about that in my dissertation.

JS Is the Loggia still in its original condition?

 JB No, it was doubled in length in the 1570s. And then with the dramatic collapse of the Gonzaga dynasty in the 17th century, everything in their rich collection that wasn't nailed down ended up scattered all over the world, sold or stolen. Some artworks fell victim to vandalism and fires in England and Spain.

 Luckily, inventories and historical documents have survived, such as drawings by the Mantuan artist Ippolito Andreasi from 1567/68, including five that meticulously record the original state of the Loggia dei Marmi including the mise-en-scène of the sculpture in the architecture. When I started writing about the Loggia, there had not yet been any art-historical study of these drawings. So they became the basis of the dissertation, which is, incidentally, an extension of my master's thesis. With the Andreasi drawings in hand, I set out to find the sculptures and actually did find some of them again. My most valuable find was the Hellenistic *Venus genetrix*, now at the Kunsthistorisches Museum in Vienna, an extremely important figure for Raphael and Giulio Romano. They both represented her several times in their work. For the major Giulio Romano exhibition of 1989 in Mantua, I was able to have a plaster cast of this Venus, as well as some original sculptures and other casts, reinserted in the niches where Giulio had originally placed them. So, as a restorer, I had the opportunity to fill the gaps—some with original material.

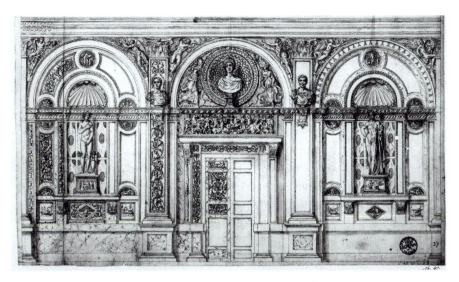

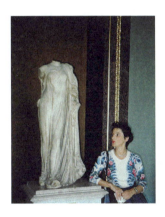

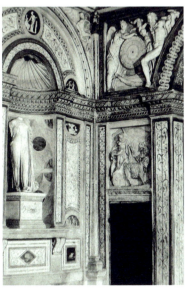

FIG. 9 Ippolito Andreasi, elevation of the north wall of Giulio Romano's Loggia dei Marmi, Palazzo Ducale, Mantua, ca.1568, pen and brown ink, gray wash on paper, 32.5 × 57.5 cm (12 ¾ × 22 ⅝ in), Print Collection of the Kunstmuseum Düsseldorf. The marble sculpture of *Venus genetrix* stands in the right-hand niche.

FIG. 10 I discovered the ancient *Venus genetrix* from the loggia in the Kunsthistorisches Museum in Vienna in 1977. It probably once formed part of Raphael's collection.

FIG. 11 I was able to provide an alternative to the original by incorporating a plaster cast of *Venus genetrix* into its position in Giulio's loggia.

JS Do you remember how you discovered Giulio Romano?

JB I'll never forget it. When I started looking for a subject for my master's thesis at the University of Zurich in the late 1970s, I first wanted to write about something related to my experiences as a restorer: distorting interventions, overpaintings, additions or restoration of great masters' works, because I had come across another fascinating case when I was still a student at the ICR. Laura Mora—we talked about her in connection with St. Francis's ear—had also restored Raphael's *Entombment* in the Villa Borghese, part of which meant removing overpaint from the 17th century.

Raphael's lines and shapes were obviously considered too daring and mannered for the classicist taste of the time, so they were "improved." Raphael was tamed with pedantic corrections that banalized parts of his painting. This criticism of Raphael directly affected his original, and the art historians who wrote about the *Entombment* didn't know about it—until Laura Mora uncovered the original again. As a record she left a piece of overpaint on the back of the man on the right carrying Christ. I wanted to analyze such cases in my thesis.

To prepare it, I went to Rome to meet with Kurt Forster, who was already one of my cultural heroes. He was then a professor of art history at Stanford University and also the director of the Istituto Svizzero in Rome. I told him about my plan with great enthusiasm and, luckily, he immediately advised me against it; the subject matter was far too complex for a master's thesis. Instead he suggested that I concentrate on Giulio Romano, an artist deeply admired by such people as Sebastiano Serlio, Giorgio Vasari, Torquato Tasso, Rubens, or Shakespeare. He had long been overshadowed in the history of art by the protagonists of the Cinquecento.

Ernst Gombrich was one of the first to take a renewed interest in Giulio; in the 1930s he devoted his dissertation to the "virtuoso inventor," as he called him.

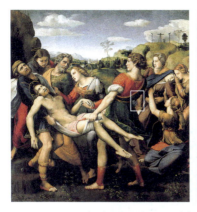

FIGS. 12+13 Raphael, *Entombment*, 1507, oil on wood, 178.5 × 174.5 cm (70 ⅜ × 68 ¾ in), Villa Borghese, Rome. Right: detailed view showing an example of the overpainting on the back of the right-hand bearer.

In the 1970s, Forster and a few other historians began studying Giulio's architecture in Mantua. Forster was as meticulous as Sherlock Holmes, in his investigations of Giulio's masterpiece, the Palazzo Te. With his brilliant mind and insatiable curiosity, he belongs to that rare breed of art historian who is also interested in such concrete things as techniques and craftsmanship. That's what makes him so credible. He crawled all around the attic of the palazzo, examining every nook and cranny looking for traces of the preceding building mentioned by Vasari. He even made a little hole in the facade and discovered the original masonry. The hole is still there. SEE INTERMEZZO P. 212

He told me all about his investigations in Rome and I was captivated. He took me along to Mantua, where Giulio moved in 1524 as court artist of Federico II Gonzaga and showed me Giulio's modifications of the labyrinthine Palazzo Ducale, which also houses the Appartamento di Troia with the Loggia dei Marmi. In fact, it was Forster who drew my attention to the five unpublished drawings of the Loggia in its original state by Ippolito Andreasi.

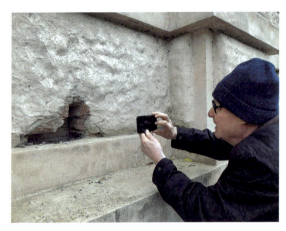

FIG. 14 In 2019, Kurt W. Forster photographs the exploratory hole that he had cut into the north facade of the Palazzo Te in 1971 and with which he had demonstrated that Giulio had covered an earlier building in this position.

JS In short: Kurt Forster treated you to an art historical delicacy.

> JB He certainly did! The more I studied Giulio's work, the more exciting it became—his ideas and inventions, so bold and versatile and as sensuous as they were profound. I also realized how much Federico influenced him, how closely he collaborated with his patron; he was supposedly just one year older than Federico, who was born in 1500, and they really inspired each other.

JS They were both so young when they met. You usually think of patrons as being older and more mature.

> JB Although only 24 years old, Federico was well prepared for his role as a patron when he summoned Giulio to Mantua. As a teenager, he had spent three years in the Vatican as a much-coddled hostage of Pope Julius II because his father Francesco II Gonzaga was allied with the French, which conflicted with the Pope's interests and the broader

geopolitical situation. By offering his son Federico as a hostage, Francesco sought to show his loyalty and willingness to cooperate with the Pope's objectives.

Cultural life in Rome at that time had burst into full flower. Federico saw Michelangelo painting the ceiling of the Sistine Chapel and Raphael the Vatican Stanze. He may well have encountered young Giulio, Raphael's most brilliant pupil. His mother Isabella d'Este was the most cultivated and passionate patron of the arts in the Renaissance and already known as the "primadonna del mondo" in her lifetime. Today she is still touted as the most significant woman of the Renaissance, as an impassioned, insatiable collector of art and other valuables, who cultivated the company of the most gifted intellectuals, scholars and musicians of her day. Not only that, her corpulence is legendary as well, although Titian painted her looking as young and beautiful as he possibly could. He also painted Federico as an exalted beau, with his right hand casually resting on his little devoted dog. The gesture symbolizes loyalty, though probably not marital loyalty but loyalty to political, cultural and equestrian concerns.

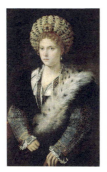 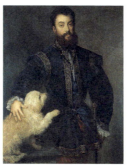 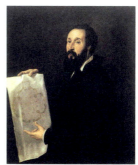

FIG. 15 Titian, *Isabella d'Este*, ca. 1536, oil on canvas, 102 × 64 cm (40 ¼ × 25 ¼ in), Kunsthistorisches Museum Vienna.
FIG. 16 Titian, *Federico II. Gonzaga*, ca. 1529, oil on canvas, 125 × 99 cm (49 ¼ × 40 in), Prado, Madrid.
FIG. 17 Titian, *Giulio Romano*, ca. 1536, oil on canvas, 101 × 85 cm (39 ¾ × 33 ½ in), Palazzo Te, Mantua.

The Gonzagas, like most noble families, adopted the French custom of devising personal philosophical and poetic *imprese*, heraldic emblems or symbols with mottos. Federico invented one for himself in allusion to his character: a lizard with an inscription that reads "Quod huic deest me torquet" (What it lacks, torments me). He considered himself the victim of his ardent passions in contrast to the cold-blooded lizard. SEE INTERMEZZO P. 217

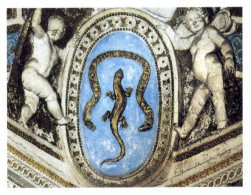

FIG. 18 The emblem of Federico Gonzaga on a ceiling in the Palazzo Te, lizard with banner carrying the motto "Quod huic deest me torquet" (What it lacks, torments me).

JS So, he always had grand ambitions?

> JB The first thing he did was to commission Giulio to convert the Palazzo Te from a stud farm into a palace of pleasure with stables. He wanted to offer his lover Isabella Boschetti the most beautiful and exciting surroundings imaginable.

JS And was Giulio "mature" enough to rise to the occasion and respond to these exacting ambitions?

> JB As Raphael's successor upon his death, he was eminently well prepared for his tasks in Mantua, and he was also the only Renaissance artist of any stature to be born in Rome.

That's why he had the surname Romano; he was Giulio Pippi by birth. He grew up near the Forum Romanum in the midst of the ruins. His art was based on them although he gave free rein to his imagination and did not bow to any rules. Pietro Aretino, a great man of letters in the 16th century, pinpointed Giulio's art: "concetti modernamente antichi e anticamente moderni" (ancient concepts with a modern touch and modern ones with an ancient touch).

JS Giulio actually ended up in Mantua because of a pornographic affair...

JB Yes, I'm sure the invitation in 1524 was most welcome because a scandal had just erupted, caused by a series of copper engravings based on 16 drawings by Giulio depicting sexual positions. This Kama Sutra alla romana was titled *I Modi*. Marcantonio Raimondi, Rome's most renowned copper engraver at the time, had printed and published them. The Pope was horrified. He sent Raimondi to prison and decreed the destruction of the drawings and death penalty for any owner of the engravings. However, Pietro Aretino, a friend of artists, courtesans and popes not only managed to have Raimondi released from prison, but also penned his raunchy *Sonetti lussuriosi* (Lewd Sonnets) to the *Modi*. I had heard a lot about the *Modi* through Bette Talvacchia, an American scholar who was doing research on Giulio at the same time that I was, and who later, as a professor at the University of Connecticut, published studies on eroticism in Renaissance culture.

JS So Federico Gonzaga did not take the matter quite as seriously as the Pope?

JB Quite so. He had no problems with it. In fact, Giulio and Federico were kindred souls. They both cherished the idea

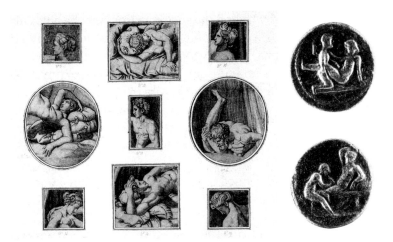

FIG. 19 Marcantonio Raimondi and others, nine fragments of the first etchings based on Giulio's drawings for *I Modi*, ca.1524, British Museum, London.
FIG. 20 Spintriae, ancient Roman tokens, with which services in brothels were paid for in order to avoid troubling the Emperor, whose face was found on coins. These were the inspiration for Giulio's *Modi*.

of transforming the highly cultured but rather gloomy city of Mantua in the swamps of the Po Plain into a small, sensual Rome, a "Rometta."

JS Giulio and Federico were in their twenties when they joined forces. How old were you when you immersed yourself in the story of these two soulmates? I wonder because I can imagine that a similarity in age might have bridged the gap of 500 years between you and them: young people are by nature more interested in young people.

> JB I've never thought about that. But it's true: I was also in my twenties when I started working on my master's. I finished it in 1978 and expanded it into a dissertation that was published in 1994.

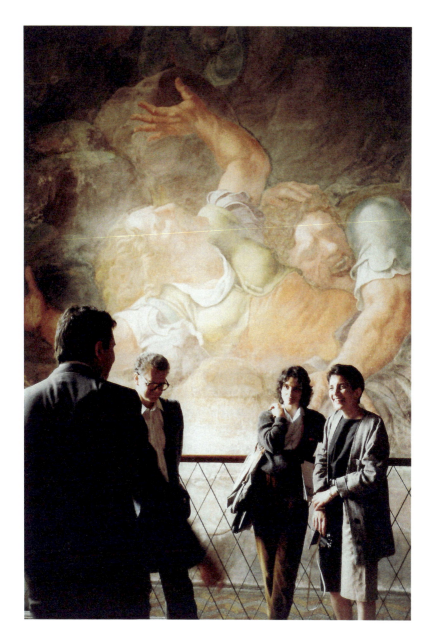

FIG. 21 With Bette Talvacchia, a specialist in the area of Giulio and his *Modi*, in the Sala dei Giganti, Palazzo Te, Mantua.

JS That's a long time—almost a phase of your life.

> JB True, but I was already active professionally. From 1979 to 1982, while working as a restorer at Kunsthaus Zürich, I started taking an intense interest in contemporary art, especially Performance Art. In Rome I had already been fascinated by the performance program organized by Palma Bucarelli, the director of the Galleria Nazionale d'Arte Moderna. Later I saw trailblazing performances organized by Jean-Christophe Ammann at Kunsthalle Basel and by Adelina von Fürstenberg at the Centre d'art contemporain in Geneva. I wanted to do something like that, too. Even though still working as a restorer at Kunsthaus Zürich, I asked the director Felix Baumann whether I could mount a performance program, and he agreed. SEE TEXTS PP. 284 + 316 That started it, and contemporary art quickly became increasingly important to me.
>
> In 1983, I co-founded and co-edited the art magazine *Parkett* based in Zurich and New York and had accepted several other mandates as well. I was juggling multiple tasks back and forth like Goldoni's *Servant of Two Masters*.
>
> A few years after completing my master's, I heard about plans for a major Giulio Romano exhibition in Mantua under the auspices of prestigious art historians: Ernst Gombrich as honorary president, Amedeo Belluzzi, Howard Burns, Silvia Ferino Pagden, Kurt Forster, Christoph Frommel, Konrad Oberhuber and Manfredo Tafuri. Forster was the founding director of the Getty Center for the History of Art and the Humanities; now it's called the Getty Research Institute. He invited me to come to Los Angeles in 1987 and gave me the opportunity to do research on Giulio in the Center's excellently stocked library and to write my contributions for the exhibition catalog. The softcover version ended up being a weighty 3.5 kg. The research motivated my dissertation.

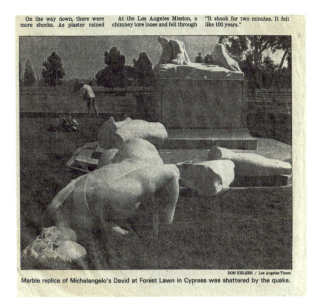

On the way down, there were more shocks. As plaster rained At the Los Angeles Mission, a chimney tore loose and fell through "It shook for two minutes. It felt like 100 years."

DON KELSEN / Los Angeles Times

Marble replica of Michelangelo's David at Forest Lawn in Cypress was shattered by the quake.

FIG. 22 On October 1, 1987, as I sat in the Getty Center writing my texts for the catalog of the Giulio Romano exhibition, a powerful earthquake caused a full-sized replica of Michelangelo's *David* to fall from its base at a cemetery in Los Angeles. Intrigued, I travelled there immediately in order to have a close look at the fragments and the details of the figure.

FIG. 23 Ernst H. Gombrich at the opening of the Giulio Romano exhibition in Mantua, 1989.

JS Getting a doctorate is an extremely complex form of scholarship. You put in a mammoth effort for very little return and minimal resonance. You also run the risk of getting lost in the thicket of your subject matter. Besides, a dissertation can be a substitute for psychoanalysis because you are thrown back on yourself and basically confronted with yourself and yourself alone. What did *you* find out about yourself?

> JB I realized that I always choose mentors and role models to hold me to a high standard, whether they are fictional, historical or living people. I have a great affinity for Giulio, and there's nothing he can do about it.
>
> I was so enthralled by the cultural context of Rome and Mantua in those days that I never thought about a return on the energy I was investing in the dissertation.
>
> And I loved every minute of it, every experience that I had in the process: those weeks in the fall of 1977 in the dense fog of Mantua, which at night created enchanting conical shapes of light floating down from the streetlamps on Piazza Erbe. Today that makes me think of Anthony McCall's room-filling light works. Or days spent in the spectral atmosphere of the Archivio di Stato, when I physically held autographs of Leon Battista Alberti, Isabella d'Este or Giulio in my hands—and discovered unpublished material. Unforgettable are the moments when Professore Rodolfo Signorini arrived unexpectedly, and words would come pouring out of him the minute you made the least little inquiry about the Renaissance in Mantua. Or roaming around in innumerable rooms and godforsaken cellars of the Palazzo Ducale in search of the sculptures that once were in the Loggia. Later, my residence at the sumptuous Getty Center in Los Angeles, where I met the writer Marina Warner, the art critic Leo Steinberg and the photographer Gisèle Freund. Or the days I spent at the Bibliotheca Hertziana in Rome, where director

Christoph Frommel strode through the room with his underlings, his hair brushed straight up like antenna to receive spiritual messages, and there was no mistaking the rule in the reading room that the volume of a voice corresponded to the speaker's rank. I didn't even dare to whisper.

JS What a setting! And you never had any crises?

JB Of course I did. Desperately trying to find the right words for something or having the feeling of the finish constantly receding into the distance. I had to think of targeted strategies to discipline myself. I holed up in my apartment in Zurich, tried to stop procrastinating, and I promised myself that once a week I would deliver a bundle of pages to my friend the philosopher Ursula Pia Jauch for her critical reading. And to keep myself from surrendering to the sirens calling from the TV, I deposited the TV cable in my office at *Parkett*.

JS After we talked about your life in an earlier conversation, I reread the foreword of your dissertation, looking for biographical triggers and found at least 20 relevant passages. You quote the architect and scholar Manfredo Tafuri, who said that if you want to study 16th century art, you should take a new look at it, pursue your own thoughts and not let yourself be blinded by the writings of previous authorities. Here's my interpretation of how this quote applies to you: between 1977, the beginning of your career, and 1989 when you were working on your doctorate, there were many dynamic changes in your life and things became more concrete as well. This could well be related to a fundamentally new way of looking at things, not only in reference to Giulio Romano but also to art and culture in general and maybe even to your life and the people around you.

IL DESPOTA E I RIBELLI

Senza il consenso dell'architetto arredatore essi hanno osato esporre quella statuetta.

FIG. 24 Working on my dissertation, Zurich, 1990.

FIG. 25 Giuseppe Novello, "The Despot and the Rebels ('You have dared to position this statuette without the agreement of the interior designer')" in: *Dunque dicevamo*, 1950, p. 43.

JB When I started studying Giulio towards the end of the 1970s, I hadn't been living in Zurich for very long yet, but the overbearing dominance of Zurich concrete artists was inescapable, especially the male representatives: Max Bill, Richard Paul Lohse, Gottfried Honegger. They thought they had all the answers. It was the era of Minimal and Conceptual Art and one of the most influential art critics in the United States, Clement Greenberg, proclaimed that formal, abstract content has priority over anything narrative, illusionistic or emotional.

For me, Giulio Romano was a comforting embodiment of the exact opposite. Immersing myself in his universe gave me a lot of energy in what seemed to me the oppressive atmosphere of Zurich. Giulio pulled out so many stylistic stops; he was such an appealing storyteller and skillfully intertwined Greco-Roman mythology allegorically with allusions to Federico's life and the political situation in upper Italy under Emperor Charles V.

JS He was postmodern avant la lettre?

JB Absolutely. That personal quest for freedom that artists and architects felt after the rigors of Modernism, Minimal and Conceptual Art can be projected into his work. Even painting, supposed to be dead, came back to life with an astonishing vibrancy echoing the unfettered spirit of Giulio. So, it's not surprising that the contemporary art world showed so much interest in him at the time. Over 250,000 people descended on remote Mantua in 1989 to see the first large-scale monographic Giulio Romano exhibition. It was reviewed all over the world, significantly by magazines specializing in art, architecture and design: *Domus, Ottagono, Artforum, Art in America*. When I wrote about him in *Parkett* prior to the exhibition, he was a new discovery for lots of people and even sedate, tight-lipped

professionals had begun to appreciate the audacious freedom of this Mannerist artist.

JS What do you mean by freedom?

JB Giulio had a playful way of revealing truth through deception, for instance, on the facades in the courtyard of the Palazzo Te. The triglyphs sliding down through cuts in the architrave make it look as if the building could come tumbling down in the next gust of wind. By blatantly ignoring the order of columns as defined by Vitruvius, he also reveals that the building is made of brick, and that the classical elements of architecture are neither loadbearing nor themselves loads that require support but purely a masquerade—brick-and-mortar reliefs attached to the wall. This play, this acting-as-if, gives the Palazzo Te a theatrical touch. The architecture is playing commedia dell'arte. The Palazzo was originally much more whimsical than it is today because at the end of the 18th century, the top floor of the dilapidated building was removed and a tympanum added to the garden facade. This made the building more ordinary; the once urban palazzo had become a villa suburbana. So, we're lucky to have drawings by Ippolito Andreasi that also document the original state of the Palazzo Te. The most exciting publication about this building, which analyzes its original condition in great detail, is aptly titled *Palazzo dei lucidi inganni* (Palace of Enlightened Deceits).

JS You said that Giulio was a catalyst but that he couldn't defend himself or have a conversation with you—a rather one-sided relationship. Later you selected artists who could do just that. But for you, Giulio is a benchmark of what it takes to be an artist—this universal being between two eras, who charted an unorthodox path of his own in Mannerism.

FIGS. 26+27 Giulio Romano, courtyard facade and Sala dei Giganti, Palazzo Te.

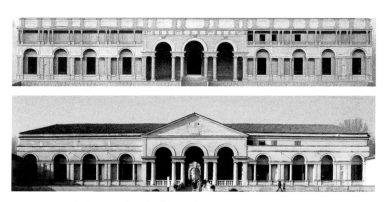

FIG. 28 Model of the east facade of the Palazzo Te in its original form.
FIG. 29 East facade of the Palazzo Te today, following the removal of the balustrade of columns at the upper level and the addition of the tympanum in the 18th century.

Is he your standard in reading art and artists, for understanding and engaging with them?

> JB Immersing myself in Giulio's universe taught me much that has served me in my professional life. For example, I learned to appreciate the term *sprezzatura* which describes the ability to make hard work look effortless. The term was coined by the Mantuan writer and diplomat Baldassare Castiglione (1476–1529) in *Il libro del cortegiano* (The Book of the Courtier), a bestseller in the Renaissance written in 1528 as a conversation about ideals, virtues and qualities that the gentiluomo and the gentildonna should acquire and cultivate. When Castiglione was the Mantuan ambassador to the court of Pope Leo X, he became friends with Raphael, who painted a marvelous portrait of him. At that time Giulio's bravura caught his eye, and he was so fascinated by the young artist that he recommended that Federico Gonzaga summon him to Mantua as his court artist. By the way, Castiglione was also the uncle of Federico's lover Isabella Boschetti.

JS *Sprezzatura* has been revived by the sociologist Richard Sennett in the sense of having a nonchalant, relaxed attitude towards oneself. Is it still relevant today?

> JB The term is actually very cutting edge. It circumscribes a great deal more than just court etiquette. Today people, things or situations are sometimes called cool. For someone like Castiglione, an indifferent, imploding coolness with neither oomph nor brains would be utterly uncool. *Sprezzatura* refers to a committed nonchalance, a serenity that does not exclude passion. It's about being thoroughly cultivated, which includes being open to others and to otherness. For Sennett, *sprezzatura* is a "craft." It has to be learned, reflected upon and trained in order to respond to the challenges of contemporary society.

JS If you had to name a present-day Giulio Romano or a Giulia Romana, who would it be?

> JB Do you mean a humanist, an artista universale (woman or man), who would be all in one: urbanist, painter, sculptor, architect, engineer, restorer, designer, archaeologist, collector and impresario, capable of designing everything from a salt vat, a dog's tombstone, irrigation systems, or a fish market to immense cycles of frescoes, palaces and cathedrals? An artista universale with a client who would also be an ideal patron and friend who would ensure that the artist has so much power that no one would dare build a wall in the city without his or her okay? If that's what you mean, then no. There are no such people anymore. Cultural, political, social and financial systems and circumstances are radically different today. There are institutions and specialists for every métier, which actually leads to the fact that creativity is endangered by so many professional constraints that

creativity is curtailed. But obviously there are artists of the same caliber or with the same potential as Giulio, and there always will be.

JS Have you come across a comparable intensity among contemporary artists?

JB Yes, of course—Laurie Anderson, Katharina Fritsch, Sigmar Polke, Pipilotti Rist, Robert Wilson—to name just a few that I've worked with and with great intensity. What they do is also incredibly diverse and rooted in vast dimensions of space and time.

JS A concrete example?

JB Yes, there is one that became a continuation of my stay in Mantua. In 1988, Robert Wilson was one of the "collaboration artists" for our magazine *Parkett*. At the same time he was at the Paris Opera Ballet, rehearsing *Le Martyre de Saint Sébastien*, a so-called mystery play and a collaboration of 1911 between Gabriele D'Annunzio and Claude Debussy. At the time the Catholic Church was scandalized because of its eroticism and because a woman, the famous dancer Ida Rubinstein, played the leading role of Saint Sébastien. Wilson gave this role to Sylvie Guillem, the star of the ballet ensemble under Rudolf Nureyev. Bice Curiger, editor-in-chief of *Parkett*, and I attended a few rehearsals and noticed that Wilson always had a reproduction of Andrea Mantegna's *San Sebastiano* from the Louvre on his director's desk.
SEE TEXT P. 306 We asked him what the picture meant to him.

JS What did he say?

JB I don't remember the details, but he was fascinated by the beauty of Mantegna's Sebastiano and above all by his

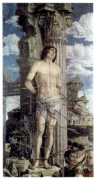

FIG. 30 Cover of *Parkett* no. 14, 1988, Sylvie Guillem in Debussy's *Saint Sébastien*, directed by Robert Wilson.
FIG. 31 Andrea Mantegna, *San Sebastiano*, ca. 1480, tempera on canvas, 257 × 142 cm (101 × 55 ¹⁵⁄₁₆ in), Musée du Louvre, Paris.

serenity—a special form of *sprezzatura* in the sense of self-control that a saint can achieve only through unshakable faith despite excruciating physical agony and inconceivable psychological stress. Wilson was also attracted by the lighting in the painting and the figure's mise-en-scène, placed in front of an imposing fluted column in the sharply delineated landscape of ancient ruins that heighten the motif of laceration even more.

In 1992 La Scala in Milan commissioned Wilson to stage the madrigals by Claudio Monteverdi (1567–1643) for the 350th anniversary of his birth in Mantua. Wilson invited me to advise him on art historical matters. He wanted to know about Mantua, where Monteverdi had served for 22 years as court musician to Federico's grandson, Vincenzo I Gonzaga. I showed him Pisanello's frescoes, Mantegna's Camera degli Sposi, Alberti's Sant'Andrea and, of course, Giulio's works. I told him about the fascinating universe of symbols and emblems of the Gonzagas, such as Federico's passionate one with the lizard and Isabella d'Este's stoic one: "*Nec spe nec metu*" (neither hope nor fear). Wilson was particularly taken with an emblem on the ceiling of Isabella's grotto in the

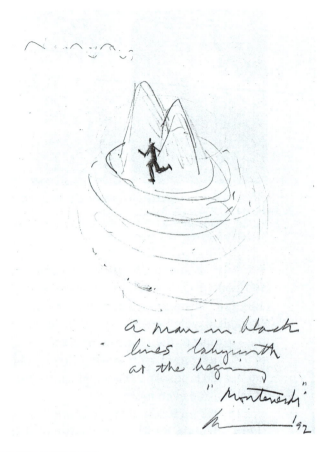

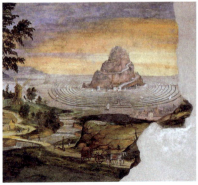

FIG. 32 Robert Wilson, sketch for Monteverdi's *Lamento di Arianna*, 1992.

FIG. 33 Fresco showing Mount Olympus at the center of a water labyrinth, ascribed to Lorenzo Leonbruno, ca. 1510, Palazzo Ducale, Mantua. The inspiration for Robert Wilson's stage design for Monteverdi's *Lamento di Arianna*.

FIG. 34 Robert Wilson, model with the Minotaur for the stage design for Monteverdi's *Lamento di Arianna* in the courtyard of Casa Mantegna in Mantua, 1992.

FIG. 35 Robert Wilson rehearses Monteverdi's madrigals in the Cortile della Cavallerizza in front of Giulio's Loggia dei Marmi in the Palazzo Ducale in Mantua, 1992.

Palazzo Ducale. I couldn't really decode it, but I knew that it was about musical pauses, about stillness, silence, although not dead silence but rather a vibrant, composed, rhythmic and modulated silence. The emblem also includes the lyrics of a song by Isabella's court composer and lute teacher Marchetto Cara: *"Forse che sì forse che no, el tacer nocer non pò"* (Maybe yes, maybe no, silence can't hurt). Gabriele D'Annunzio quotes this saying in the title of a novella and reproduces the emblem in it. Robert Wilson instantly sensed what it was about. And John Cage, who composed *4'33"*, 4 minutes 33 seconds of silence for piano in three movements, would certainly have liked it. SEE FIG. PP. 230/31

One day I asked Wilson if he could think of a device or motto that I could take to heart in my everyday life. His reply: "Go with your faults and charm the cat!" I love it.

Sadly, La Scala canceled the Monteverdi project in the middle of rehearsals because they didn't have enough funding.

JS Professor Forster really started something when he introduced you to Giulio Romano.

> JB I feel that Forster and Giulio are kindred spirits. Forster sensed that this universal artist would appeal to me.

JS I didn't realize that Giulio Romano's enormous range of activity and his universal spirit played such a seminal role for you. This artist literally cast your interests out into the great wide world, extending all the way to contemporary art.

> JB Absolutely. It was so exciting for me to be able to step into entire universes, into spaces where everything is engaged in conversation. That's what I felt about Giulio, but you can find that today as well. Now and throughout the summer of

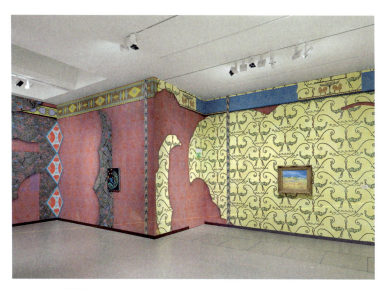

FIG. 36 Exhibition view, *Laura Owens & Vincent van Gogh*, Fondation Vincent van Gogh Arles, Arles, June 19 to October 31, 2021.

2021, an exhibition by Laura Owens is on view at the Fondation Vincent van Gogh in Arles, and it's just plain stunning. Owens conceived her work in response to seven paintings by Van Gogh. She came from Los Angeles to Arles for over a year, studied the works and designed a book, a one-of-a-kind book, for each of the paintings. They're lying on tables that Owens designed especially for them, accessible for visitors to leaf through if they want to. Her wallpaper installation that forms the backdrop to Van Gogh's and her paintings is unique as well. She found the motifs in an old sample book about 100 years old by a certain Winifred How. She playfully transformed and combined them in a diversity of printing techniques in up to 50 layers. I just love the way Owens engages in a duet with Van Gogh, with so much respect and yet self-confidence as well.

Being immersed in Giulio's world really helped me as a curator of site-specific art at the Novartis Campus in Basel.

JS Tell me about the Novartis Campus.

> JB Novartis was founded in 1996 as a fusion of Ciba-Geigy and Sandoz. The next step was the transformation of the Sandoz factory site from a place of production on the Rhine into the Novartis Campus, a place of research and knowledge, of administration and encounter. That required new buildings, landscape architecture and art. In my position, I often had to think of Giulio—how skillfully he was able to blend his interventions with existing elements, always with a vision of the whole, and also how obstacles actually inspired him to come up with ingenious solutions. He incorporated everything, from disparate elements down to the tiniest details, into a vibrant dialogue full of exhilarating contrasts. That was more important to him than blending everything into a harmonious whole. I often thought of how he got along with his patron, how he not only fulfilled Federico's wishes but even exceeded them without being obsequious.

JS Powerful, highly cultivated patrons obsessed with art and culture, like Isabella d'Este and Federico, were as rare then as they are now, weren't they?

> JB They certainly are, but there are always exceptions, like Francesca Thyssen-Bornemisza with her foundation TBA21. And there are a few outstanding, extremely knowledgeable Swiss patrons whose exceptional achievements have made an international impact. Think of Maja Hoffmann with her LUMA Foundation in Arles and Zurich, Maja Oeri with the Schaulager in Basel, or Uli Sigg with the donation of his collection of contemporary Chinese art to the Hong Kong M+ museum.
>
> As a curator at the Novartis Campus, I was lucky to work with Daniel Vasella, the CEO of Novartis and president of the board. He was a man of vision and committed to

redesigning the area. Conversations with him were a pleasure and sophisticated.

But I also really appreciated Helmut Maucher, the CEO of Nestlé in the 1990s, although he was quite the opposite. When I was president of the Fondation Nestlé pour l'art, he warned me against making any attempt to explain contemporary art to him but said I could call on him any time I wanted, and he would always support me. And he did. Thanks to Maucher, I came up with my stratus-cloud theory, according to which you should always reach for the sun, the top management, because you get stuck in stratus clouds. On the other hand, those who are underneath them have a larger view and a broader field of action. I experienced the same thing when, on the recommendation of the architect Mike Guyer, I was asked to curate the art in the Zurich headquarters of Ernst & Young and successfully negotiated with the top brass, CEO Bruno Chiomento, to engage, among others, the cultural philosopher Herbert Lachmayer to create a *Hermeneutic Wallpaper* referring to Ernst & Young.

JS But your biggest project in terms of site-specific art is still the Novartis campus. How did Daniel Vasella approach the redesign of the area?

JB To implement his vision, he brought in the Italian master planner, urbanist and architect Vittorio Magnago Lampugnani, two landscape architects Peter Walker from the US and Günther Vogt from Liechtenstein, design specialist Alan Fletcher from England. He engaged Harald Szeemann to curate the art, and after Szeemann passed away he contacted me on Lampugnani's recommendation. Vasella organized workshops where we had intense discussions about each step in the project. With Lampugnani, he selected the architects for the new administrative and laboratory buildings, among them several winners of the Pritzker Prize.

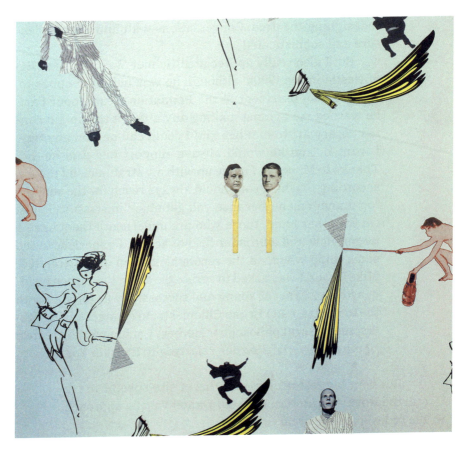

FIG. 37 Herbert Lachmayer, *Hermeneutic Wallpaper* for the main building of Ernst & Young (now EY) in Zurich, 2013.

FIG. 38 Herbert Lachmayer presents his design for the wallpaper. From left: the architect Mike Guyer, Bruno Chiomento, CEO of Ernst & Young, imitating the surfer on the wallpaper, and Herbert Lachmayer.

JS When and how did art come into the play of the architecture?

JB Once the architects had been selected, I proposed artists that I thought were suitable to being "coupled" with the type of architecture, its specific location and its function: El Anatsui, Laurie Anderson, Silvia Bächli, Katharina Fritsch, Olafur Eliasson, Dan Graham, Katharina Grosse, Alexej Koschkarow, Michael von Ofen, Sigmar Polke, Lutz & Guggisberg, Markus Raetz, Peter Regli, Pipilotti Rist, Kerim Seiler, Corinne Wasmuth and Cerith Wyn Evans. We didn't just bring together art and buildings, but most importantly, people and "cultures." For example, the Indian architect Rahul Mehrotra wanted to visit Pipilotti Rist in her studio and read as much as he could about her art. And this brought about the kind of collaboration that I like.

JS Are there any traces reminiscent of Giulio Romano on the campus?

JB Indeed. For example, the interplay of Dan Graham's bewildering *Pavilion* in front of the SANAA building in the park designed by Günther Vogt. The sculpture consists of two-way mirrored, semitransparent glass set in a steel frame. Its ground plan is shaped like an X, with one of the lines forming a slightly concave curve. Graham positioned it with meticulous precision, so that, when seen through the glass, SANAA's rigorously minimalist building acquires a playful Baroque touch, distorted, multiplied and melting into the park. Although of the same material as the SANAA building, Graham's *Pavilion* looks even more immaterial, almost like a fata morgana. He is basically playing with enlightened deception, like Giulio in the Palazzo Te.

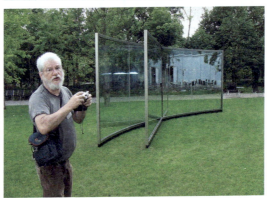

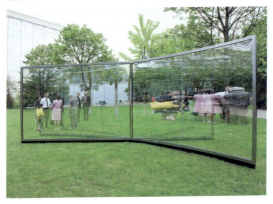

FIG. 39 Dan Graham determines, together with Günther Vogt and Albert Buchmüller, the exact position of his *Pavilion* in front of the SANAA building, Novartis Campus, Basel, 2007.

FIGS. 40+41 Dan Graham and his *Pavilion*, 2007, stainless steel, two-way reflective glass, 600 × 230 × 495 cm (236 × 90 ⅝ × 195 in).

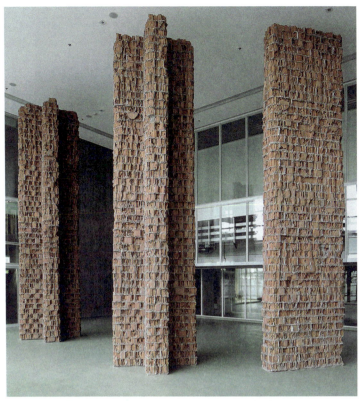

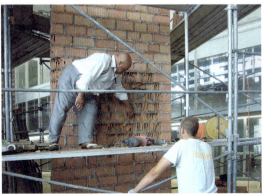

FIG. 42 Pedro Cabrita Reis, *The Basel Columns* in the laboratory building by the architect Eduardo Souto de Moura, 2011.

FIG. 43 Pedro Cabrita Reis works on his brick columns, Novartis Campus, Basel, 2011.

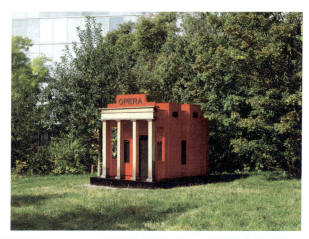

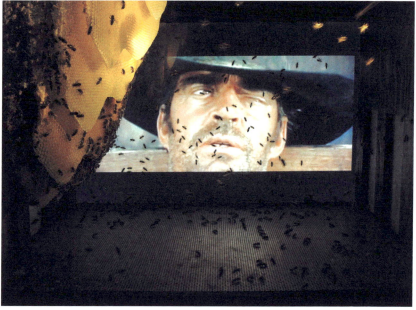

FIG. 44 Peter Regli, *Bee Opera*, 2012, painted wood, Novartis Campus, Basel.

FIG. 45 Interior view of the *Bee Opera* with Sergio Leone's spaghetti western *C'era una volta il west* (1964) as the stage design.

JS How do the artists on the Campus refer to the history of the location?

> JB I can give you two examples. The artist Pedro Cabrita Reis put up three slender brick columns in the lobby of Eduardo Souto de Moura's laboratory building and then scraped the surface of the bricks to reveal their hollow interior. *The Basel Columns*, as the work is called, look a little bit like ruins, recalling the red brick of the factory buildings that once occupied the site. Obviously, the stelae evoke a host of other associations as well. The architecture and the artwork by the two befriended Portuguese enter into a richly contrasting dialogue, their expressive impact mutually heightened by the encounter.
>
> Another example is Peter Regli's *Bee Opera*, a wooden cabin in Western-style, where the bees "enter" through the front door while the audience uses the backstage entrance. Once inside, you face a display case in which the bees are like actors on stage. Their honeycombs are the stage curtain, and the stage set consists of a flat screen showing famous scenes from Italo-Westerns, Pavarotti's opera performances, or cartoons.

JS Site-specificity is an important aspect of your projects at Novartis. But what do bees have to do with it or with the history of the pharmaceutical company?

> JB A lot. In earlier centuries, the textile trade played a dominant role in Basel, which included the work of dye makers. They used mostly plant juices and since bees pollinate the plants, they were crucial to the process. Similarly, medicinal plants are crucial in the history of medicine and therefore of Novartis, so bees have been influential players in Basel's economic success story. This opera pays tribute to them.

...
111

Göreme,

 Living it up in Zurich,

 Parkett,

 Una discussione,

 Polke's Agates

 and

 Nonno's Flies

JS Let's take a big leap back from the eccentric, whimsical Basel *Bee Opera* to Zurich of the 1970s. As you said, when you chose around 1977 to study a great Italian artist of the Cinquecento, concrete artists were the cutting-edge players in the current scene. Zurich vs. Mantua: Zurich hadn't made way for the Mediterranean yet, which would later be the mantra of the youth movement and the city wasn't burning yet either. Revolutionary advances were only felt in brief "underground explosions" of limited impact. What did the grandeur and generosity of the *italianità* mean?

JB Zurich seemed gray and oppressive until the late 1970s. Then things started changing in art and subculture and I felt a sense of relief. I was born with *italianità*. My mother's parents grew up in Milan as Swiss abroad so I have a little bit of Italian blood in my veins. Besides, I had already lived in Rome as a child and went to school there years before I worked at the ICR. Italy is just plain unique and phenomenal. The entire "boot" is filled with over 2500 years of advanced civilization in a state of constant renewal and deeply rooted in the intelligence and emotional capacity of the Italian people. I firmly believe in the enduring cultural vibrancy of Italy despite the economic, social and political downsides.

JS You never entertained the thought of emigrating to Italy or living in Rome or Milan?

JB Yes, I would have done that if I hadn't been laid low with a bad case of hepatitis during a 1974 restoration campaign in Göreme, Turkey. I had to go home to my parents in Zurich to recover—and ended up staying here.

JS Göreme?

JB Göreme was my greatest adventure in restoration. There were three of us, a Sudanese, a Frenchman and me. The International Center for Conservation (ICCROM) had sent us to Cappadocia to work with Turkish specialists on restoring the cave church Tokalı Kilise. The region is utterly surreal, stunningly beautiful, and consists entirely of tuff, the volcanic sandstone that has eroded into the weirdest formations, into mighty cones with gigantic hats that look like mushrooms.

People have been living there for 3000 years, especially persecuted Christians who carved monasteries and churches into the soft stone. Tokalı Kilise was the most

important church on the site. We worked on three layers of paintings dating from the 9th to the 11th centuries. I had dreamed of the region years before going there, having discovered it in Pasolini's film *Medea* (1969) that stars Maria Callas. Göreme is now a UNESCO world heritage site and has become a tourist destination. When I was there, it was still gloriously deserted. Occasionally, you would see herds of sheep guarded by Karabash, those frightening Anatolian shepherd dogs that wear wolf collars. And then I came down with a severe case of hepatitis, but I don't regret having been there for a single second.

JS Tell me more about the time before you moved to Zurich.

 JB Before going to Göreme, I had already participated in restoration campaigns while based in Rome, for example, in the Romanesque church San Pietro in Tuscany, which had been badly damaged in an earthquake, and in projects in Ireland, Romania, Spain and Venice. I would have loved to continue working for ICCROM and the UNESCO on world heritage sites, especially restoring murals because they are site-bound and I've always been interested in the actual context of art, the Gesamtkunstwerk. Mobile works of art are mostly wrenched from their surroundings or maybe hung to their disadvantage in museums and private collections.

 Because of my damaged liver, I couldn't work with chemicals for a whole year, which meant no more restoring. So I started studying again at the university in Zurich, which took me in unexpected directions.

JS Do you still sometimes dream of your days as a restorer?

 JB With pleasure. But I certainly don't regret what has happened to me in Zurich in the past four decades.

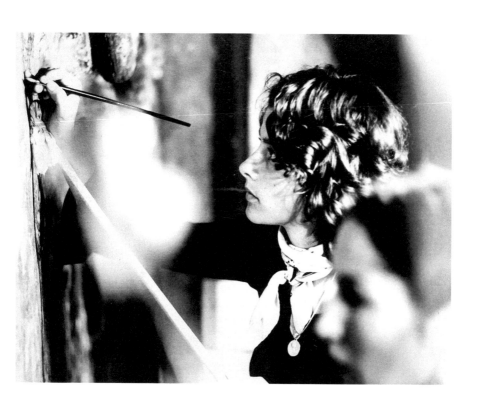

FIG. 46 With Carmen del Valle during the restoration of a wall painting in San Justo, Segovia, 1972.

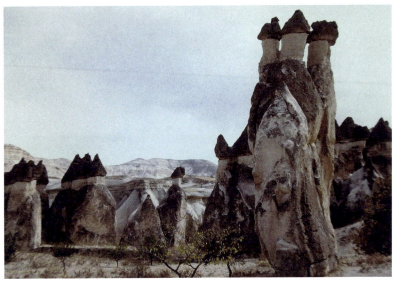

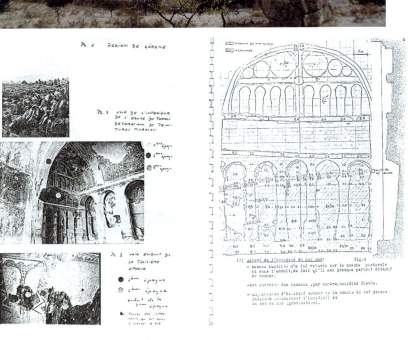

FIG. 47 Tuff formations in Göreme, Cappadocia.

FIGS. 48+49 Two pages from my restoration report from 1974. Right: investigation of the humidity in the layers of painted tuff in the Tokalı Kilise.

FIG. 50 Our daily lunch during the restoration campaign in the Tokalı church, Göreme, 1974.

FIG. 51 After work, I either gave German lessons in a carpet shop in Ürgüp or went to Avanos to visit Galip, who taught me how to make pottery. Galip was looking for a wife, so I painted him one on the wall, Avanos, 1974.

FIG. 52 We often dressed up and put on makeup during the restoration work. As here in San Justo, Segovia, 1972.

FIG. 53 The experienced team of restorers. From left, front: Maria Pia Gazzola, Antonio Sanchez-Barriga, Cinzia Conti; rear: Mollica Gaetani, me, Rita Cassano, Jeanne Amoore.

FIGS. 54 A+B Tuscania after the powerful earthquake of February 6, 1971. Despite the highly precarious conditions, we students of the Istituto Centrale del Restauro safeguarded the frescos in the Roman church of San Pietro.

FIG. 55 After spending five months restoring an altarpiece by Marco Basaiti in Venice in 1973, it was transported, completely unprotected, on a small boat to the church of San Pietro in Castello. Fortunately it arrived undamaged.

JS Since your rough landing in Zurich, puritan Zwingli society has become more and more Mediterranean.

JB Unmistakably so.

JS We were talking about *italianità*. What did that mean to you in the wake of the Schwarzenbach Initiative of 1970? The initiative wanted to throttle the presence of foreigners in Switzerland, specifically Italians.

JB In Rome at the time, I was ashamed to be Swiss and did everything to hide it. Even that Swiss women still couldn't vote at that time.

JS Would you say you were a driving force among the creative generation that propelled and established Italian *sprezzatura* in Zurich?

JB Maybe a tiny little stubborn catalyst, especially since 1984 as one of the founders of the art magazine *Parkett*. Bice Curiger's mother was from the Ticino, Walter Keller's mother was Italian, Dieter von Graffenried was cosmopolitan and Peter Blum had an extremely wide-ranging heritage. So we not only cultivated *italianità*; we were also international, which is related to *italianità* because Italians are highly cultivated, cosmopolitan people. *Parkett* wanted to build a transatlantic bridge for the exchange of art and ideas between Europe and the United States.

JS How would you describe your role at *Parkett*?

JB There were several. We never gave ourselves job specifications. You could call it a "family business" where everybody did everything, down to wrapping packages for the post office. Bice was our editor-in-chief with veto rights.

Walter Keller and Dieter von Graffenried were clearly in charge of finances and strategy. But we still discussed everything together. I was sparring partner, writer, editor, agent, ambassador, traveling companion and, as time passed, more and more frequently curator. I installed exhibitions of *Parkett* editions in Paris, Munich, Singapore and Taipei, and also in our *Parkett* space in Zurich.

JS There's a lot of leeway for *sprezzatura* in your profile and it has always been so important to you. You once told me about dancing all night in Rome, about movement and swing, about a very different body feeling.

JB I missed that in Zurich. I have just finished a few lines for the catalog of the exhibition *Ausbruch & Rausch: Frauen Kunst Punk 1975–1980* at the Strauhof in Zurich. I talk about the gloomy mood in mid-70s Zurich: strict closing hours, concubinage forbidden by law, poor manners, little charm and students drinking and hanging around for hours in smoke-filled dives. I simply didn't feel like doing that. Hardly anyone wanted to dance, least of all the buttoned-up men. The moles in the local government and "self-appointed sleuth" Ernst Cincera snooped around among the leftists and kept files on suspect individuals. Fritz Zorn's book *Mars* (1977) with a foreword by Adolf Muschg became a bestseller shortly after the young, depressed writer died of cancer. The scion of Zurich's affluent society blamed his cancer on the cold, inhibited nature of the people around him. I couldn't finish the book; it was too depressing, I desperately needed to get some fresh energy.

JS And where did it come from?

JB From the people I met through Bice. We became friends when we were both studying. It's through her that I met artists

like Martin Disler, Urs Lüthi, Peter Fischli & David Weiss, Olivia Etter, Klaudia Schifferle, Russia specialist and journalist Regula Heusser, Bice's closest friend Franz Staffelbach, owner of the fashion label Thema Selection Sissi Zöbeli, Patrick Frey, with whom I attended seminars about East Asian art, and Brida von Castelberg, who was studying medicine and later became the director of a Swiss hospital. We would get together on the Bachtel in the Zürcher Oberland where scientist, photographer and painter Andreas Züst lived.

I got to know the art dealer Thomas Ammann, who lived in the beautiful modern home from the thirties that Otto Salvisberg had built for himself on Zürichberg. There I met the international world of art, people like Cy Twombly, Francesco Clemente, Brice Marden and Andy Warhol. And This Brunner, Thomas's closest friend, introduced me to the film scene: John Waters, Daniel Schmid, Douglas Sirk, Werner Schröter, Magdalena Montezuma, Ulrike Ottinger, Ruth Waldburger.

That was also when Susan Wyss started her gallery. She had such a good nose and long antennae, and she had the support of Birgit Küng, who had a lot of gallery experience and a very good network in artistic circles. Susan showed artists like Meret Oppenheim, Martin Kippenberger, Albert Oehlen, Edward Ruscha, Vivian Suter, Alighiero e Boetti and Peter Fischli & David Weiss. *Parkett* worked with most of them.

JS What you say shows how Zurich really started living it up, a brewing excitement that spilled over into the youth movement of the 80s.

JB And how! All the old dust got blown away with a vengeance. But the air in Zurich was thick with tear gas because of the opera house riots. The situation exploded when the city wanted to spend 60 million on renovating the opera house and had refused to fund an autonomous youth center. Your

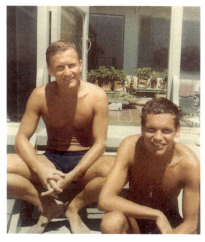

FIG. 56 From left, the gallerist Elisabeth Kaufmann, Martin Disler (seated), Urs Lüthi, and me in Disler's studio in the Rote Fabrik in Zurich, 1980.

FIG. 57 Susan Wyss presents Bice Curiger with a record case to mark the opening of the exhibition *Saus und Braus* in the Strauhof in Zurich, 1980.

FIG. 58 Thomas Ammann and This Brunner in Los Angeles, 1981.

FIG. 59 Andreas Züst, three painted portrait photos that he sent me as postcards. From left: me, Patrick Frey and Andreas Züst, self-portrait of Andreas Züst.

FIG. 60 The editors of *Parkett* in 1984. From left: me, Walter Keller, Bice Curiger, Peter Blum, Dieter von Graffenried.

FIG. 61 With Sigmar Polke on the occasion
of the launch of *Parkett* no. 1 in Platzspitz
in Zurich, April 14, 1984.

FIG. 62 With Bice Curiger after 49 editions of *Parkett*, Zurich, 1997.

comment on living it up alludes to *Saus und Braus* (Dizzy and Fizzy), the title of the exhibition Bice curated in 1980 at the Strauhof that so brilliantly captured the zeitgeist of the art and music scene in Zurich at the time, the vibrancy and energy of a flourishing subculture. It made such a splash that people still talk about it, even abroad. Peter Fischli & David Weiss showed their *Wurstserie* (Sausage Series), which was the first work they produced as a duo. Martin Disler, Olivia Etter, Klaudia Schifferle, Urs Lüthi, Anton Bruhin, Dieter Meier and many others participated. The only foreigner was Sigmar Polke. Bice quoted Adriano Celentano in the catalog: "Un po' artista un po' no" (a little bit of an artist, a little bit not), so people instantly knew who they were dealing with. She also invented enlightening subtitles for the catalog: "Stadtkunst" (City Art), "Statt Kunst," (Instead of Art), "Schall und Rauch" (Sound and Fury). Punk and New Wave bands, like Ladyshave, Mother's Ruin, Liliput, Hertz, Steffi Wittwer, Maloo Lala and others appeared in a so-called monster concert, and there was no shortage of weed.

Saus und Braus has made such an enduring impact that the original catalog was reprinted in the catalog of the exhibition *Ausbruch & Rausch* (2020) where Bice and Stefan Zweifel showed material they found in archives and original works from the "wildly rebellious show" *Frauen sehen Frauen*, presented in 1975 by a feminist collective.

JS Who else was working on contemporary art in Zurich in those days and in which institutions?

JB Erika Billeter and Ursula Perucchi were inspiring curators at the Kunsthaus. And there was the Halle für Internationale neue Kunst (InK) from 1978 to 1981, a cultural project of the Migros Genossenschaftsbund. Urs Raussmüller and Christel Sauer organized it. They showed mostly Arte povera as well as Minimal and Conceptual Art: Mario

Merz, Jannis Kounellis, Giuseppe Penone, Lawrence Weiner, Donald Judd, Robert Ryman, Joseph Beuys and Hanne Darboven. Some of these artists had already been on view at the Annemarie Verna Gallery. Bischofberger, Stähli and Ziegler were also important galleries along with others from abroad: Marlborough, Lelong, Facchetti, Gimpel & Hanover, Konrad Fischer. We founded *Parkett* in 1984, and Harald Szeemann added to the momentum when he became "permanent guest curator" at Kunsthaus Zürich in 1985, where he produced his auratic exhibitions. Kunsthalle Zürich was founded that same year, and a year later Haus Konstruktiv. Looking back, it's amazing what was happening in Zurich in the 1980s.

JS You often speak of heroes or heroines. Is there no actual center to the web of relationships that you've spun from Zurich?

JB To me, the center is where there are friends, art and a good atmosphere for me to work. My passport says that I come from Basel, but as the daughter of a diplomat I grew up in five different countries: the Czech Republic, Norway, Sweden, Italy and Switzerland. I was an adult when I first came to Zurich. And now I'm anchored here, on a long rope.

JS The second to last time we met, you went to Aarau afterwards to a reading by Paul Nizon. He embodies the postwar generation of Swiss art practitioners, who had to leave because it was impossible to reinvent a free life in Switzerland; there were just too many constraints. Artists in those days overcame the painful confines of Switzerland in Paris or elsewhere—if at all. But the next generation of artists after 1968 stopped suffering. They stayed put but became international. They turned the tables by capitalizing on the principle of exporting Swissness, and it worked. Just think

FIG. 63 Installation by Sylvie Fleury in the exhibition *Freie Sicht aufs Mittelmeer* in Kunsthaus Zürich in 1998, with three examples of both *First Spaceship on Venus* and *Gucci Satellite* in dialogue with works by Heinrich Füssli.

of Fischli & Weiss or Pipilotti Rist. I have the feeling that you are also among those who have had enough of suffering.

> JB The Swiss mentality has changed a lot in recent decades. When you worked with Bice on the exhibition *Freie Sicht aufs Mittelmeer* (Make Way for the Mediterranean) in 1998 at Kunsthaus Zürich, you used a title inspired by a slogan from the 1980 youth riots: "Down with the Alps, make way for the Mediterranean." But you deleted the first half because the horizon had expanded since then.

JS Bice was the great bridge builder between the protagonists of *Saus und Braus* and the younger generation of the late 1990s. She blithely ground down the Alps and flipped the Swiss perspective from vertical to horizontal. And she was right. The exhibition was exhilarating: 90 representatives of "young Swiss art" who quite literally exploded the boundaries, and a flashback to the 1980s in a mise-en-scène by John Armleder that looked as if the works had just left the studio. The accompanying program was sourced from the equally exhilarating, independent off-scene. It was almost like a spontaneous occupation of the venerable Kunsthaus: Sylvie Fleury's rockets in the Fuseli gallery, a gigantic cardboard

FIG. 64 I worked together with Bice Curiger and Dieter von Graffenried as editors of *Parkett* for 33 years.

FIG. 65 With Laurie Anderson and Lou Reed at the opening of the *Parkett* exhibition in MoMA, New York, April 2001.

video lounge by Costa Vece in the Department of Prints and Drawings. It was extremely dense but not the least bit crowded. I sensed such lightness in this breaker from the Mediterranean. And all through this long summer, Zurich seemed so perfect to me in a very imperfect way. There was no reason to leave the city.

JB Today artists are leaving Zurich because it's so expensive and so hard to find a studio. The cost of living has gone through the roof in Brooklyn and Berlin, too, so they go to Los Angeles, Brussels or Tbilisi. But one thing hasn't changed: in a country where prosperity breeds pragmatism, artistic expression and intellectual stimulation have no priority. It's getting harder to find attractive courses in the humanities or good articles in the arts section of a newspaper, because their efficiency is not quantifiable. And most people here have no interest in distinguishing between culture and cultural event.

JS But you can counter the indifference that you observe with a spirit of resistance. Have you experienced that feeling of joy when you realize that you were instinctively right and didn't buckle?

JB Oh yes. There were wet blankets who predicted the speedy demise of *Parkett* from the very beginning, but we refused to be intimidated. Over the years, *Parkett* became renowned as one of the world's best art journals. Lou Reed loved it. He wrote, "It is rare to see pure acts of love in print, but this is one of them. The world is a better place for *Parkett*." Prestigious institutions mounted exhibitions of *Parkett* and its special editions: Centre Pompidou, Kunsthaus Zürich, MOMA in New York, the Whitechapel Gallery in London, Museum Ludwig in Cologne as well as institutions in Beijing, Taipei and Japan.

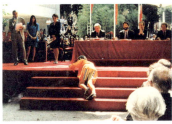

FIG. 66 Bice Curiger irons a tablecloth—the *Parkett* edition by Daniel Buren—in Franz Wassmer's Palazzo Remer in Venice in 2005 with the help of Dieter von Graffenried and me.

FIG. 67 Pipilotti Rist with Franz Wassmer on Wassmer's boat in Venice, 1997.

FIG. 68 Pipilotti Rist crawls up the steps to receive the "Premio 2000" for her installation *Ever is Over All* at the 1997 Biennale di Venezia.

FIG. 69 The collection of the *Parkett* editions in Franz Wassmer's Palazzo Remer in Venice.

It must be said, though, that the financial foundation was fragile from the start. We exploited ourselves and we managed to survive for 33 years. We owe this to art lovers and patrons who believed in us and generously supported us with no expectation of returns—people like Franz Wassmer, Maja Hoffmann, Cristina and Thomas Bechtler, George Reinhart, Annette Bühler, Patricia Kahane and Adrian Koerfer.

Franz Wassmer had the Palazzo Remer in Venice and a boat on the Grand Canal. He displayed all of the *Parkett* editions in the Palazzo for 10 years. We would go there twice a year to install the latest ones. When the Biennale opened, Franz would throw a party for *Parkett*, inviting anybody and everybody in the art world.

Maja Hoffmann has acquired the entire *Parkett* archives for her LUMA Foundation. They're especially valuable because they include a lot of analog material, handwritten letters or sketches for the editions, designs of covers, etc. At the opening of the LUMA Foundation in Arles in July 2021, we showed material from our archives on Sigmar Polke's collaboration with *Parkett* in Frank Gehry's building. It's an active, vibrant archive that will consolidate the enduring impact of *Parkett*.

FIG. 70 Fax from Maurizio Cattelan with the sketch for his *Parkett* edition, 2000.
FIG. 71 The first exhibition of the *Parkett* archive in the LUMA Foundation in Arles, with works by Sigmar Polke, 2021.

JS Apparently, cheerful self-exploitation and moments of glamour were closely related. The secret of *Parkett*'s success lies not least in a lighthearted ease and diligence combined with excellent contacts. But the founders of *Parkett* also suffered a terrible blow.

> JB We certainly did. Our dear friend and co-publisher Walter Keller was such an inspiring and inspired workaholic. He had initially founded a magazine about the sensation of the ordinary, *Der Alltag. Sensationsblatt des Gewöhnlichen*, with Nikolaus Wyss. Then he founded *Parkett* with us and later Scalo Publishers with a bookstore in Zurich and a gallery in New York. The existence of the Fotomuseum Winterthur is largely indebted to him as well. But he saw his hopes dashed with the death of his most important patrons, George Reinhart and Andreas Züst. Scalo went bankrupt and later—Walter was only 60—he died of a heart attack. He literally worked himself to death. It was such a terrible blow for us.

JS Walter Keller's death was a blow for me, too. It made me wonder why there wasn't something like an early warning system that would kick in with someone like Walter who was so hard on himself.

> JB He was such a restless person and we were always worried about his health. But it was useless to urge him to take care or to ease up on the constant pressure. He didn't want to or just simply couldn't. The setbacks that he suffered towards the end of his life had fatal consequences.

JS To me Walter was as much a part of Zurich as the Grossmünster Cathedral, and he wanted the city to grow culturally. When you launched *Parkett*, globalization as we know it today did not yet exist. Cities have since become increasingly isomorphic; the art world lives in bubbles.

FIG. 72 Walter Keller in the *Parkett* office, 1986.

JB A lot of artists are constantly on the move, so that it's hard to have regular or spontaneous encounters with them or really good, in-depth conversations.

JS But the need for that is greater than ever before, isn't it?

JB Absolutely. I hear that from artists themselves. Even the Swiss curator Hans Ulrich Obrist, who's constantly zipping nonstop all over the world, has publicly declared that he wants to settle down, especially after Corona, also arguing that his travels contribute to climate change.

JS I think there's a substantial difference between your relationship with Zurich and mine. I grew up in a Zurich where the art wonder of the 1990s was in full swing and its small-town character had already given way to a city on the move—with space to expand in Zurich-West and elsewhere. The tragedies of the '80s movement still lingered.

FIG. 73 With This Brunner and Bice Curiger in Crete, 2000.

The inferno of the Platzspitz with all the excruciating violence, self-destruction and impotence of the drug scene was unbearable. On the other hand, I felt a naïve, casual lightheartedness. The glass ceilings of society were relatively high in the art world. Anybody could talk to Harry Szeemann in the café of the Kunsthaus. That was when you and I met as well. There was no protocol for the boundaries between those who were important and those who weren't, between newcomers and those who had made it.

> JB You speak of the tragedies and stir some disturbing memories. The *Parkett* office is on Quellenstrasse in Kreis 5. In the mid-80s we had to pass the Platzspitz every day. The international media had dubbed it "Needle Park." Two young people died of an overdose on the street right next to our office. It was horrible. But shortly before that happened, there were lots of positive developments. And then years later, the air cleared as you've described it.

JS But the clear air and the freedom to explore possibilities was soon eclipsed by an increasingly professionalized, commercial art world. I was less thrilled by that.

> JB I can understand that only too well. The greedy ogling of prices, auction results and rankings that acquired traction at the time and still prevails—it's boring, and also extremely hard on artists.

JS You're going to the opening of Olafur Eliasson's show at Kunsthaus Zürich today. He has hundreds of assistants: a real industry.

> JB He has everything meticulously scheduled. It's a necessity when you work on many projects at once. There's nothing cozy and comfortable about him, but it's always been like that with artists in great demand. Think of Raphael. He had at least 50 people working for him. The pressure was immense, but they weren't constantly bugged by people from five continents or nonstop on the road, traveling all over the place. Sometimes I imagine Giulio at the Palazzo Te or the Palazzo Ducale, not 10 minutes away on foot from where he lived, meeting with Federico or Isabella d'Este and their entourage, including the world's elite, the literati, musicians, artists and astrologists. He also had access to most of the books that had been published by then. Luckily, I am not a pure art historian. I love to imagine, to elaborate on scenes like that.

JS Informality and intimacy were a springboard. To me, you have always seemed like a family or siblings: you, Bice and This Brunner, too. I think ultimately this sense of family has been a decisive factor in making whatever you envisioned really work. But the price that you've all paid for success is increasingly limited availability. A loss of intimacy?

JB True.

JS Or is it just a matter of preserving a clearly defined and protected private sphere?

JB That, too. As mentioned, spending time with people you really care about has become rare and precious. Which is why I just like to curl up with a small group of people, if possible.

JS *"Le rendez-vous des ami·e·s"*: could one describe the concept of *Parkett* as a rendezvous in magazine format? A meeting among friends even if you don't get together physically?

JB Yes, you could say that. But not all of them were our friends. *Parkett* was a podium for people important to us, people we wanted to spotlight. *Parkett* was a forum for the artists themselves; some also contributed as writers, like Robert Gober, Barbara Kruger, Nan Goldin, Mike Kelley and others. We wanted to publish texts that were not just informative or instructive but also inspiring. *Parkett* was actually a kind of salon or Kunsthalle on paper, and today you can still turn your apartment into a small, precious museum of contemporary art with editions from *Parkett*.

JS You once wrote that art criticism is primarily about exploring your own standpoint and thus ultimately about self-determination. For you as a critic, does that mean that art criticism is about defining your own place in the world?

JB Yes, that does apply to me. Artists teach me to see and to see differently. I don't feel like adding substantially to the great body of art history or burrowing my way through theories of art. It's more important to me to see if I can

understand how artists approach their work and find out what their work means to me emotionally and intellectually. Their unorthodox attitude toward norms and conventions influences the way I act and think.

JS I didn't pick up on what you said before: "Luckily, I am not a pure art historian." That was intentional, wasn't it?

> JB Of course. I was just being a bit flippant. What I mean is that, as an art historian or critic, I am not primarily committed to being objective, to appreciating art from a safe distance and keeping subjectivity at bay. I feel more affinity with what Proust wrote in *Remembrance of Things Past*: "In reality every reader, when he is reading, is the reader of his own self."

JS You say that a work of art, which does not speak to you verbally, allows exactly that kind of self-reflection. Actually, one could consider that a definition of art as such. So art criticism is primarily a means of addressing oneself.

> JB "Ogni pittore dipinge sé" (every painter paints himself) is another way of putting it. Those words are ascribed to Leonardo, but they don't just apply to artists; they apply to anyone who can and wants to seek fulfillment in whatever field. Because then you are what you do, what you eat, and your dog shares a lot with you as well. The reverse is also true. That reminds me of a delightful list that I read in Kurt Vonnegut's *Deadeye Dick*:
>
> > *To be is to do*—Socrates.
> > *To do is to be*—Jean-Paul Sartre.
> > *Do be do be do*—Frank Sinatra.
>
> You spoke about what Manfredo Tafuri said in the Giulio Romano catalog of 1989, namely, that one shouldn't follow in

the footsteps of others who wrote about Giulio, at least not mincing along on tiny feet in the large, trodden footsteps of others but rather writing from a contemporary point of view and from one's own perspective because that keeps art alive. That's essential for me.

JS Not succumbing to the fascination of earlier interpretations means reinterpreting things: the atmosphere at court in Mantua, the prevailing mentality, the religious convictions and the conventional mores of times gone by. A principle that could be applied to our own times?

JB Obviously. But the methods and observations of fascinating earlier interpreters are clearly stimulating. They reflect the zeitgeist of their own times. Reinterpretation means taking a new look at the impact of historical art or treating it like sleeping beauty and kissing it awake. To me, Kurt Foster is a model. The energy with which he explores everything, his passion and knowledge, asking unexpected questions, jettisoning all rigidity of discourse and not shying away from flights of fantasy.

JS Yes, certainly. But you are a medium between art and nonprofessionals. You're a missing link. Among art historians, you might say somewhat simplistically that there are two schools: those who are not the least bit interested in themselves but only in the subject of investigation, and those who are interested exclusively in themselves and in communicating how they see themselves mirrored in the work.

JB I belong to that category of art critics who are interested in art that strikes a chord in them. I'm not going to waste my energy on slamming art; that's no fun. I avoid theoretical jargon; it has to be right for me, simple and understandable. Which also makes more sense for nonprofessional readers.

I don't only inquire into what lies *behind* a work of art; I want to understand what happens *between* me and the work of art. But I don't think that art serves as a mirror. Everything is reversed and smaller in a mirror. It doesn't reflect vampires, those ghoulish living dead. Art doesn't think about life in reverse or diminished in size except when critical commentary strategically introduces distortion and contortion. Paul Klee says that "Art does not depict the visible; it makes things visible." Including vampires.

JS Vampires are creatures by artists with a tendency to take off on their own.

JB Artists give them visibility and viewers try to identify them in the artworks, bringing their own perception and intuition into play. So, art criticism inevitably says something about the writer. It is fruitful when it succeeds in raising new questions and stimulating thoughts and fancies. In contrast, I have trouble with ideologically motivated, brainy commentary that uses art to illustrate theory. And how anybody can refuse to meet artists for fear of losing their objectivity is beyond me. I prefer what Ernst Gombrich writes in his introduction to *The Story of Art* (1950): "There really is no such thing as Art. There are only artists." And Jean-Christophe Ammann always spoke about how important it was for him to be able to "look over the shoulder" of artists. He's the one who famously said, "Art doesn't come from artistry; it comes from the artist." And then there's the generalist Bazon Brock, who says, "There is no history of art, only a history of artists."

JS As a curator, you have joined artists in the process of making their works and have, on occasion, even influenced the outcome.

JB In that connection, Jean-Christophe Ammann gave me an incredibly exciting job in 1985 that kept me busy for almost a year. He was planning a group exhibition at Kunsthalle Basel with Joseph Beuys, Enzo Cucchi, Anselm Kiefer and Jannis Kounellis. He wanted them to relate to each other and create new works in the process. Inspired by Cucchi, he invited them to start by talking to each other for several days in the Kunsthalle library. Although of course familiar with the work of the others, they had never spoken. Cucchi and Kounellis spoke neither German nor English, and the German artists couldn't speak Italian. So Jean-Christophe took me on to translate and edit their conversations, which our *Parkett* press then published for the opening of the exhibition.

They talked about the cultural history of Europe, the decline of the Bildungsbürgertum (the educated bourgeoisie), the upheavals in new art of the 1980s and the role of the artist in society. They also addressed shortcomings and the need for role models. They often all spoke at once and sometimes in metaphors. For instance, Cucchi said that animals with tails have antennae to the universe—a statement that delighted Beuys, who had explained pictures to a dead hare in a performance piece. I noticed differences between the Nordic and Mediterranean mentality when I struggled to define the term "meritocracy" in Italian or when Beuys called the Greek artist Kounellis a man of antiquity who has to be credible before Agamemnon's grave while he, Beuys, had a kinship with the anthroposophists and wanted to persuade pansies of his decency. At lunch one day, Beuys remarked that Kounellis shouldn't use the term "ideology" anymore because of its negative connotations; he should talk about "connections between ideas." Kounellis retorted that he was using the term "ideology," as a Greek as a word from his mother tongue and if a German chose to misunderstand it, that that was his problem.

FIG. 74 Enzo Cucchi's drawing, which he made during the discussion between Cucchi, Joseph Beuys, Jannis Kounellis, and Anselm Kiefer in Basel in 1985, 15 × 23.5 cm (5 ¹⁵⁄₁₆ × 9 ⅜ in). During the discussion, Cucchi said: "We must find new formal codices, in order to hold back this barbarian weakness that is circling over Europe like a raven."
FIG. 75 Cover of the book *Ein Gespräch—Una discussione*, *Parkett*-Verlag 1986.

I had the chance to comb through my heavily edited transcriptions again with everyone except Beuys. He died shortly after we published the book. Luckily, he spoke with exceptional fluency; he had honed everything he said often enough in his actions. Talking was part of his art.

JS Ammann wanted the artists to refer to each other. They did that with great intensity, at least in talking, as your example demonstrates. Is authenticity, being genuine, a sacred cow in art?

JB A lot of things influence what is genuine in the creative process. You might speak of productive contamination or the drive to emulate or the delight in absorbing and even stealing the ideas of others in order to reconfigure them. That leads to new, genuine work. Heritage and genetic material are included in anything that might be identified as genuine. It makes personal things suprapersonal and it addresses collective perception.

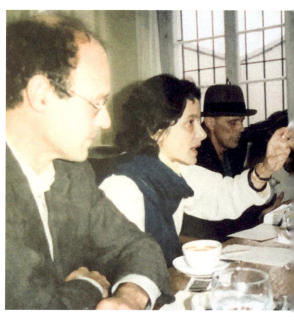

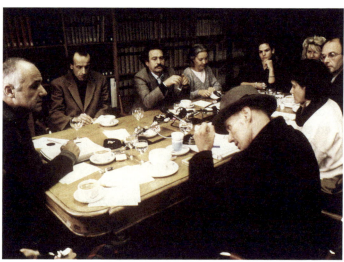

FIG. 76 From left: Anselm Kiefer, me, Joseph Beuys, Jean-Christophe Ammann, Bice Curiger, Enzo Cucchi (hidden), Jannis Kounellis.

FIG. 77 Clockwise, from left: Jean-Christophe Ammann, Enzo Cucchi, Jannis Kounellis, Michelle Coudray, Judith Ammann, Julia Kiefer, Anselm Kiefer, me, Joseph Beuys.

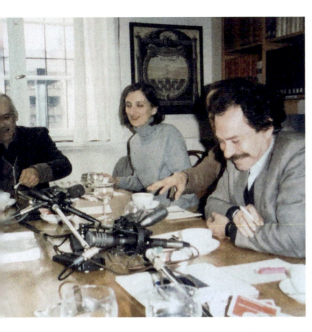

FIG. 78 Jean-Christophe Ammann and Joseph Beuys, who is kissing Enzo Cucchi, Basel, 1985.

To me, the experience of genuineness was the strongest when I was curating site-specific art, because I could follow the process of creation and felt literally interested in the sense of the Latin etymology, "inter-esse," being in between or in the middle. I can see firsthand what inspires artists and what their concerns are. And sometimes I'm a sounding board that enables someone else to "gradually give shape to thoughts while speaking" (Heinrich von Kleist, *Die allmählichen Verfertigung der Gedanken beim Reden*). I love being a helping hand in the process of making something, as I was for Sigmar Polke when he installed his relief of pyrite suns in a laboratory building of the Novartis Campus in Basel or composed his slices of agate for the windows in Zurich's Grossmünster Cathedral.

JS Polke—that's a chapter in itself. Working with him on the Grossmünster windows was another key experience for you. I realized when you showed a small group, including me, around the cathedral on a cold winter day, telling us about Polke's windows with such palpable, infectious enthusiasm.

JB Curating those 12 windows was a marvelous experience. It took five years from the time the parish announced the competition to the completion of the windows in 2009, a few months before Polke died. The windows were his last major project and he tackled them with such unstinting intensity that they might even be considered his legacy. The project embodies many of his lifelong preoccupations. SEE TEXT P. 374

But Zurich was important to Polke long before he won the competition. The year it was announced in 2005, Bice had curated his monographic exhibition at Kunsthaus Zürich, *Werke und Tage/Works and Days.* Perfect timing: it gave the jury the opportunity to study his work on site. In the final round, the jury had to judge five extremely

impressive projects by Silvie Defraoui, Olafur Eliasson, Katharina Grosse, Sigmar Polke and Christoph Rütimann. When Polke received the commission, Katharina Grosse told me with great elegance that the jury had made a good decision. She felt that he was the only right choice for this particular task.

JS How did Polke go about preparing for the competition?

 JB By doing a lot of research on the Grossmünster and on Huldrych Zwingli, the initiator of the Reformation in Switzerland. Around 1524 in the wake of drastic iconoclastic attacks, the altarpieces were removed and the stained glass—if it ever existed—was destroyed. They transformed the building into the barren Zwinglian "mother" church.
 In style, Polke wanted to stick to the most important building period around 1200 and he wanted his windows to look as if they had always been there. He wanted nothing to flaunt the contemporary here and now. He focused on the Old Testament, because to the east, Augusto Giacometti's choir windows of 1933 feature the birth of Christ and that's what the New Testament starts with.

JS Was Polke religious?

 JB Hardly. But he was interested in the spiritual, in Buddhism, Sufism, myths and rituals. He was extremely knowledgeable and explored possibilities with Käthi La Roche, the Grossmünster pastor, discussing which figure from the Old Testament he should feature in the windows and why. Only five of the windows are stained glass, the other seven consist of translucent slices of agate. Polke chose to use agate in reference to the creation of the world, to the eternally long time before the advent of humankind and therefore of glass. In the gemstones, we can read traces of the elements and

FIG. 79 Discussion with Sigmar Polke during the arrangement of the pyrite suns in the laboratory building of the architect Adolf Krischanitz on the Novartis Campus, Basel, 2008.

FIG. 80 Discussion with Sigmar Polke about his designs for the 12 windows in the Grossmünster, Zurich, 2006. From left: me, Sigmar Polke, Ulrich Gerster, Claude Lambert.

FIG. 81 Sigmar Polke during the assembly of his frieze *Wandverwandlung* with pyrite suns, Novartis Campus, Basel, 2008.

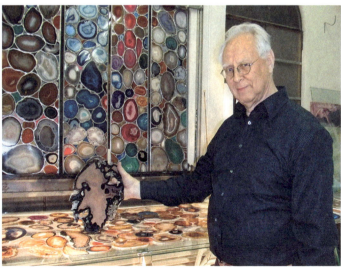

FIG. 82 Sigmar Polke during the arrangement of his agate discs for the windows in the Grossmünster, Zurich, 2007.

natural forces that formed the earth. The concentric layers hint at the time it took for the stone to acquire its provisional shape—provisional because the creation of the world will never be finished.

Polke found the perfect craftsman to execute his designs: Urs Rickenbach, the expert glass painter of the Zurich-based company, Glas Mäder. A stroke of luck because advancing cancer had made it increasingly difficult for Polke to do any hands-on work himself.

JS Do you often visit the Grossmünster?

> JB Yes, often with friends, and sometimes I give guided tours there.

JS How does it make you feel?

> JB It's like stepping into a world both familiar and mysterious. The play of light is so full of surprises, especially when it makes the crystal formations in the agate and tourmaline slices sparkle or when the colors streak across the window reveals. In a way, it's more of a natural phenomenon than when you study pictures in the unchanging artificial daylight of a museum.

JS Now it's clearer to me why for you, a restorer at heart, the work is not a mirror, as you say. It's a creature that fascinates you, that you make contact with, that you even want to dance with, as you did in Rome?

> JB That's beautifully said. That's why I like site-specific art or wall painting so much. It makes you move; you have to pace it off and look at it from different vantage points. Restorers are like doctors and not like pathologists who dissect corpses. They deal with physical aspects, of course, but

FIG. 83 With the fellows of the Sommerakademie im Zentrum Paul Klee in 2014 visiting Polke's windows in the Grossmünster in Zurich.

> they also want to reveal and release as best they can the energy and inexplicable flair of the artworks.

JS Yes. It's a good thing that art cannot be definitively defined. Otherwise it would be much too academic. But if you go to Olafur Eliasson's exhibition at the Kunsthaus or stand in front of Polke's windows in the Grossmünster, you face a completed process of creation. How does a work remain in process beyond that?

> JB The making of the work is complete. But every encounter with it reveals something different or new. The relationship has many layers; it's never final. It changes according to your mood or life situation, your particular interests at the moment, or who you're with when you look at it.

From the artist's point of view, finished work often contains something that wants to be pursued in what's to come, resulting in a process that runs through a whole group of works—a series that may, in turn, open up new territory.

JS Maybe it also depends on whether you can establish the intimacy that we were talking about before, whether the work responds to your state of mind and agrees to dance with you. The work exists. The artist exists. And the mutual entanglement exists. You can relate to both of them. And, of course, it's the most enjoyable when both succeed.

JB Especially if the artist is still alive. Although I could easily imagine going out for a pizza or dancing with Giulio Romano. Not so a rendezvous with the much greater and more spiritual master Michelangelo. That would be very intimidating. I would be hopelessly awestruck by someone of that caliber. Pope Julius II called him "il divino e il terribile." It takes a lot of courage to have a tryst with someone in whom both traits are united.

JS We've already unraveled several strands in your life: works of art, artists, heroes and heroines, past, present and the mix of all those things. We were like mediums, summoning Giulio Romano. It takes a specific kind of competence to make contact with people who no longer exist, not only with their works, writings or heritage, but with them as people. That brings another Jacqueline aspect into play: your family. A prominent representative is Jacob Burckhardt, whom you mention in your dissertation. Your relationship with him and, in fact, with many of your ancestors—grandparents, parents, uncles and aunts—is extremely vibrant and alive.

JB I've always enjoyed relating to older people. Maybe that's why I never really had the adolescent blues, except for

the consequences of changing hormones, the pimples and all that. Maybe because I had a relatively loose relationship with my parents as a child. They were extremely busy as diplomats, attending receptions and going out God knows where all the time. So my brother Muck (Michael) and I took advantage of the freedom and did our own thing. I had no trouble breaking loose. Besides, the mix of generations was perfectly natural as part of the *italianità*, while here generations tend to go separate ways. At any rate, here in Zurich the risk of running into your parents at a disco at 3 o'clock in the morning was pretty unlikely.

FIG. 84 My parents, Lucie and Jakob Karl Burckhardt, Stockholm, 1953.
FIG. 85 Walking with my brother Muck in Stocksund near Stockholm, 1953.

JS Several members of your family had somewhat eccentric leanings. A lot of colorful people who led exciting lives.

JB I was especially fond of my maternal grandparents. Nonno, as we called my grandfather August Gansser-Burckhardt (1876–1960), was a chemist and partner of

FIG. 86 Queen Noor al-Hussein of Jordan presents my parents with a medal marking the 200th anniversary of the birth of Johann Ludwig Burckhardt alias Sheik Ibrahim, Petra, 1984.

FIG. 87 My parents enjoyed dressing up. Here they are on the Via Appia Antica, Rome, 1955.

Ledoga, a factory in upper Italy that specialized in the processing of leathers with chestnut tannins. (The name is an acronym of Lepetit, Dollfuss and Gansser.) He had strange interests and wrote about things like the tanning of brains in the prehistoric Wildkirchli civilization. He set up his laboratory in the old stable next to his house in Basel, doing research and working there on his own, like the classical alchemist in an English picture book. He had a weatherman, a frog named Clara that lived there in a vivarium, and he experimented with unspeakable ingredients burbling and stinking in vats, trying to find out how to preserve the antique Roman leather he had found rummaging around in the piles of dirt from diggings in Roman Legion camps and settlements like Vindonissa and Augusta Raurica. Nonno actually constructed parts of the Roman uniforms of legionaries, for which he was decorated by Mussolini (don't tell anybody). He was also a passionate stamp collector and entomologist. His laboratory was stacked full of display cases in which he had pinned thousands of flies from Europe, North Africa and Mexico. As a leather fanatic, he discovered a species of botfly that causes damage by laying its eggs in the skin of ungulates. His efforts to find means of controlling them earned him an honorary doctorate from the University of Bern. Muck and I sometimes went with him to hunt flies, marching across meadows in the mountains, armed with a net and a collecting jar filled with vials of chloroform, test tubes, cotton, tweezers, etc. We had to look for cow pies and other dung because that was where you would find the most interesting insects. SEE INTERMEZZO P.237

Nonna—Lola Gansser-Burckhardt (1888–1973)—was born in Milan and came from a branch of the Basel Burckhardts who had emigrated to Italy in the 19th century. She was the exact opposite of Nonno: an elegant rococo lady who played bridge and used to take us to Confiserie Schiesser for proper tea or, all spruced up, to La Scala in Milan. The only room in

the house that suited both my grandparents was the veranda that was filled with plants and had a room-height aviary. You could hardly hear yourself think for all the chirping and warbling of the birds. That's where they were sitting—in the veranda—when Nonno died of a heart attack at the age of 84 while Nonna Lola was holding her lorgnette and reading the *Corriere della Sera* to him.

JS And then there was your famous uncle Augusto ...

JB ... the nephew and godchild of Nonno, also named Augusto Gansser (1910–2012). He was a geologist, explored Greenland and the Himalayas and died in Ticino at the age of 102. We used to go on spartan vacations in Sicily, with him, his wife Toti and their children. Uncle Augusto taught me how to snorkel and to love octopus. Once, in Lipari, we played with an octopus every day. Uncle Augusto would stroke him between the eyes with his index finger, which made him relax as if hypnotized. My friend Andreas Züst studied geology and glaciology with him at the ETH Zürich.

FIG. 88 My grandfather August Gansser-Burckhardt, alchemist and fly collector, clay figure modeled by my father Jakob Karl Burckhardt.
FIG. 89 My uncle Augusto Gansser, researcher and geologist, dressed as a Lama in the Himalayas, 1936.
FIG. 90 Johann Ludwig Burckhardt alias Sheik Ibrahim portrayed posthumously by Sebastian Gutzwiller, 1830, oil on canvas, 105 × 89 cm (41 ¾ × 35 in) (based on a drawing by Henry Salt, February 1817).

There are ancestors I feel particularly attracted to. Johann Ludwig Burckhardt (1784–1817) was a fascinating man. He called himself Sheik Ibrahim and, dressed accordingly, he traveled through the Near East and Egypt doing research for the "African Association for Promoting the Discovery of the Interior Parts of Africa." He rediscovered Petra and Abu Simbel and went on a pilgrimage to Mecca, risking his life as a fake Muslim. He had carefully prepared himself for these dangerous adventures in Cambridge, studying astronomy, medicine and local customs, rigorously getting himself into shape and learning Arabic. He translated *Robinson Crusoe* at the same time. He also honed his skills as a draftsman in order to illustrate his reports. Cameras had not yet been invented. He was 23 when he died of cholera in Cairo. I thought of him often when I was hiking with two ethnologists through the Tassili Mountains to study the prehistoric rock paintings.

You mentioned the art historian Jacob Burckhardt (1818–1897). He never got married and had no children. I am only very distantly related to him, but when people in Rome introduced me as his nipotina (granddaughter), I didn't deny it. They would've been too disappointed. His writings are superb, but I don't agree with his opinion of Giulio Romano. In *Cicerone* of 1855, he writes: "On the whole, Giulio's activity was extremely harmful. The utter indifference with which he exploited to superficial effect the formal idiom acquired from Raphael and even more perhaps from Michelangelo (largely in a number of frescoes) yielded the first notable example of soulless decorative painting." Giulio undoubtedly painted for the sake of effect, but he did so with the greatest skill; he was not a mere epigone but, as Gombrich puts it, a "virtuoso inventor."

Even so, on one of his trips to Mantua, Burckhardt sketched Giulio's Loggia dei Marmi with great interest and care.

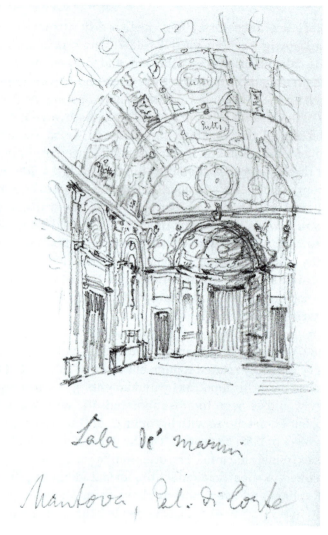

Sala de' marmi
Mantova, Pal. di Corte

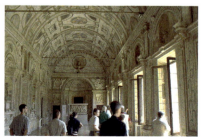

FIG. 91 Jacob Burckhardt, drawing of Giulio Romano's Loggia dei Marmi in a notebook, Mantua, August 8, 1878, full-size reproduction.

FIG. 92 The Loggia dei Marmi 141 years later photographed by me.

JS Could you imagine any of your ancestors considering themselves artists today?

JB That applies to my paternal grandmother. Elisabeth Burckhardt-Koechlin (1886–1963) studied painting in Paris. But her protestant upbringing in Basel was so ingrained that it prevented her from reaching out to Bohemians of the day or to Braque and Picasso. What appealed to her was the art of George Rouault, with its Christian leanings. Back in Basel, she had five children and had to look after the Gellert, as the family mansion with park was called. So she didn't have much time to spend at the easel—a typical woman's fate.

Many members of my family picked up pens and paintbrushes as amateurs. They were architects or humanists, pastors, politicians and diplomats, like my father Jakob Karl Burckhardt (1913–1996), until he moved from the Department of Foreign Affairs to the Department of the Interior to become President of the Board of the Swiss Federal Institute of Technology (ETH). He much enjoyed drawing and modeling. SEE FIG. 88, P.106

My mother Lucie Burckhardt-Gansser (1921–2003) was an outstanding athlete as a young woman and became president of the Swiss Society for Art History.

But there are a few fine artists or writers of significance. There is the sculptor Carl Burckhardt (1878–1923) and Carl Jacob Burckhardt (1891–1974), who was a historian, diplomat and president of the ICRC during the Second World War. He also wrote a four-volume biography of Richelieu and his correspondence with Hugo von Hofmannsthal has also been published.

Rudy Burckhardt (1914–1999) was an internationally renowned photographer and filmmaker but again only very distantly related. He left buttoned-up Basel for good in 1935 and settled down in pulsating New York City, where he made friends with people like Willem de Kooning, Paul Bowles

FIG. 93 The studio of my grandmother Elisabeth Burckhardt-Koechlin with her sister Valérie Koechlin as the model, Paris, ca. 1908.

FIG. 94 My mother Lucie (right) training for the international skiing championships. Cover of *Sie & Er*, no. 43, October 24, 1941.

and Alex Katz. Katz still has the cutout sculpture of Rudy with his best friend, the dancer, dance critic and poet Edwin Denby, in his studio. SEE FIG. 3, P. 323

Rudy didn't want to have anything to do with the Basel Burckhardts anymore but one day the performance dancer Dana Reitz took me along to see him in New York—unannounced. That broke the ice and I visited him again several times and once even with my father. Much to my surprise they had a great time exchanging nostalgic memories of their youth. Rudy did an insert for *Parkett* in 1996 where he presented a selection of his photographs from the 1930s to the 1990s.

Drawing, painting, modeling and writing to develop a feeling for art and literature is part of the family tradition. On the other hand, we don't instantly think that makes us artists. As a restorer, I learned how to deal with the materials and tools that artists use—that was good compensation. My brother Muck, who is more artistic than I am, became an architect.

iv

In the Grove of Academe,

Expo.02 and the Turf Brick,

Federal Art Commission,

Frissons

and

Sincerity

JS Let me return to something you said earlier, namely that "in a country where prosperity breeds pragmatism, artistic expression and intellectual stimulation have no priority." That's a broadside. But you've always tried to battle the lack of intellectual and emotional stimulation in artistic endeavor. And in very practical terms, when you were working on the Sommerakademie im Zentrum Paul Klee (SAK). What was the summer academy? And how did you give it shape with your aim of bringing together experts and artists, trained...

FIG. 95 With Tirdad Zolghadr (left) and Juri Steiner (right), Sommerakademie im Zentrum Paul Klee in Bern, 2009.

JB ... postgraduate artists, critics, curators and overlapping combinations ...

JS ... young talented people just starting out, all of them bunched together in an intense course that lasted 10 days?

JB From the beginning, there were fellows who went on to have outstanding careers, who were invited to the documenta in Kassel or the Biennale di Venezia and other international exhibitions: Thea Djordjadze, Cory Arcangel, Pamela Rosenkranz, Shirana Shahbazi, Mika Rottenberg, Crystal Z Campbell, Dineo Seshee Bopape, Kemang Wa Lehulere or Tris Vonna-Michell, who was nominated for the Turner Prize in 2014.

But it was not a course in the conventional sense of the term. I have to elaborate a little to explain the specific idea

behind the academy. It started in 2004 when the founders of the Zentrum Paul Klee (ZPK) got in touch with the Bern Kantonalbank to ask if they would support Renzo Piano's new building. The bank agreed but said they would not invest in glass, concrete and steel but specifically in a program of education for a period of 10 years. So, in 2005 the Stiftung Sommerakademie im Zentrum Paul Klee was founded with a capital of three million francs. The president of the foundation was the CEO of the bank, first Peter Kappeler and then Jean-Claude Nobili, both visionary and generous people. The director of the ZPK also sat on the board: Andreas Marti followed by you, Juri, then Peter Fischer and finally Nina Zimmer. The experts included Giovanni Carmine, Andreas Fiedler, Sabina Lang, Beate Söntgen, ex officio the respective head of the museum and me. Norberto Gramaccini, a professor at the University of Bern, headed the program for the first two years and I followed afterwards. Barbara Mosca took over the management.

Every August, the SAK invited an international group of 12 fellows up to the age of 35 for a period of 10 days with a new guest curator each year, who defined the theme and proposed suitable speakers.

We had speakers such as Candice Breitz, Tania Bruguera, Okwui Enwezor, Adrian Piper, Frances Stark and Marina Warner. People nominated from countries all over the world suggested possible candidates for the SAK, which was announced annually on our website—it's still online. Up to 170 candidates from 65 countries applied every year and we had to select twelve of them. All expenses were paid: travel, accommodation, food and a daily allowance. So much for the facts.

JS Was the term "academy" an issue for the artists?

JB Not at all. We wanted to run a summer academy that zeroes in on essentials, without any academic or dogmatic self-righteousness. We clearly indicated that the course did not offer any routine subject matter or career advice. What we envisioned was the ideal of the Socratic teaching style and the ancient gatherings in the Platonic Groves of Academe, where people in Athens would stroll about, talking to each other and engaging in exciting, challenging conversations. We wanted to create an atmosphere of stimulating, enlightening, bewildering and unforgettable situations and constellations, with none of the rules and regulations ordinarily imposed on publicly financed educational institutions. And we aimed to flatten the hierarchies as much as possible to give everyone room for development.

JS What about the subject matter?

JB It was always about essentials. Tirdad Zolghadr, our guest curator in 2009, selected Kandinsky's term "inner necessity" as his theme. Jan Verwoert and Pipilotti Rist wanted to explore the interaction between art and its recipients. Verwoert titled his SAK 2010 "When your Lips are my Ears, our Bodies become Radios" and the following year Pipilotti's was "Juicy Contaminated Circle—From Art to Life and Back." For the final edition in 2016, the artist Thomas Hirschhorn asked two existential questions: "Where do I stand? What do I want?"

During the day we were among ourselves, but in the evening the SAK was open to the public with lectures, film screenings, performances and drinks. And such things as discovering what a nimble ping pong player Okwui Enwezor was.

JS The SAK was situational, participatory and public. And took place in surprising locations.

JB I thought a lot about how to set up the SAK, because at the same time in the workshops at the Novartis Campus there was talk of finding strategies to change the company's work culture. With the aim of fostering the intrinsic motivation of the staff, they proposed making working hours and workplaces more flexible, encouraging people to work alone or together as a team in different and inspiring places on the campus, both inside the buildings and outside in the park.

We changed the location of the SAK every year and rarely stayed in the meeting rooms of the Zentrum Paul Klee because of the strict opening hours and safety regulations. We wanted the days to be open-ended. Besides, for us the title "Sommerakademie im Zentrum Paul Klee" didn't just refer to the institution; we were interested in the personality of the artist as such, and Paul Klee was an example of that. So we were practically always in other places that suited the respective guest curator's theme.

The guest curators Clémentine Deliss and Oscar Tuazon used a line from Elliott Smith's song *Fear City* as the title for their program in 2008: "Dragged down into lowercase." Tuazon outlined a hole and then had it dug out of a meadow in front of the ZPK, where the fellows installed their works out in the open in all wind and weather. The seminars took place in a barn next to the excavated structure with no electricity. In preparation for this edition of the SAK, everybody read Henry David Thoreau's *Walden* from 1854. Thoreau describes the two years he spent in the woods of Massachusetts, trying out an alternative way of life in complete isolation.

And in 2014, the Lithuanian guest curator Raimundas Malašauskas called his SAK "HR" as an acronym for Human Rights, and above all for Hermann Rorschach. The academy took place in Bern's Botanical Gardens, outdoors or in the succulent greenhouse, and sometimes in a fishing hut down by the Aare river.

FIG. 96 The hole designed by Oscar Tuazon for the Sommerakademie im Zentrum Paul Klee in Bern, 2008.

FIG. 97 The guest curator Clémentine Deliss stands before Charlie Tweed, who is emerging from a hole in his performance *The Man from Below*, 2008.

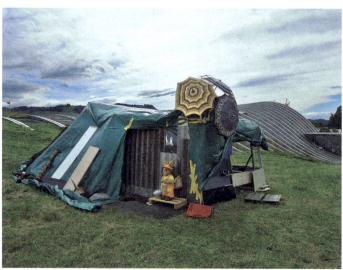

FIG. 98 The Sommerakademie im Zentrum Paul Klee in the Botanical Garden in Bern, 2014.

FIG. 99 The tent of the Austrian artist group Gelitin, Sommerakademie im Zentrum Paul Klee in Bern, 2007.

The Gardens with plants from all over the world became a metaphorical location for the fellows coming from a diversity of backgrounds. This was particularly noticeable when the botanist Beat Fischer gave a tour and introduced all the different species, explaining how sophisticated the arrangement of the plants and trees was on the small slope above the river. One evening they were talking about social anthropological issues and about how Hermann Rorschach once remarked that he no longer wanted to read only books; he wanted to read people, too. Some of the fellows jokingly tried to identify themselves with specific trees and plants and to analyze their relationships in psychodiagnostic terms.

JS During these long symposia, the participants really gave their all. And there were also physically demanding excursions on the weekends. It was a great challenge for many participants to step out of their own holes and to work in a group. That brings another Jacqueline keyword into play: teamwork. Kurt Forster writes that in addition to your professional competence, you are exceptionally capable of bringing people together. SEE INTERMEZZO P. 223

JB To do that you need a compelling, overarching idea that underlies all the elements and aspects of a project. That's why food played an important role for the SAK with its emphasis on essentials and on slowing down. We didn't want to make the fellows eat fast food and in 2012 we invited the cook and journalist David Höner as a speaker. He's the founder of "Cuisine sans frontières," an organization that sets up meeting places with kitchens under extremely precarious conditions in crisis and conflict hotspots in Africa and South America. He cooks on site together with the local people but it's not only about cooking; it's also about the value of ordinary activities that unite people and ultimately about the art of hospitality. That's what Höner writes about

in his book *Kochen ist Politik* (Cooking Is Politics, 2019). Some of the fellows went to the market with David to learn about our food and how it's prepared, and sometimes they cooked dishes from their own countries.

JS Putting together a summer academy is like a recipe. It takes a nose to find talented people, to bring out their potential and foster their development in specific contexts. The process applies not only to art but also to daily life and interpersonal communication. That worked surprisingly well at the summer academy. I remember an otherwise rather reticent artist and I was pretty sure she would want to book a single room in the hotel. I couldn't have been more off target.

JB The haphazard group of fellows, curators and speakers were usually put up in the same guesthouse. They liked staying together and when the course was over, they didn't want to lose sight of each other. The length of 10 days was short enough to sustain lively mutual interest without getting on each other's nerves.

They loved Bern, such a small city but with all the amenities of a big one. The Aare river played an important role in this respect. The idea of swimming to work with a waterproof garment bag was inconceivable to them. Is there any other capital where you can do that?

It was such an exciting experience when they all met again a year later at the SAK. They had been invited to present the publication they had worked on together throughout the year, not just as a postscript to their academy but also as a further development of what had happened during the course.

JS These summaries, a year later, were another collective endeavor that took another step beyond the group experience of the academy itself. And it didn't have to be a publication.

JB Not at all. For example, our guest curator in 2013, Sue Williamson from South Africa, chose the theme "You are HERE. Here is wherever I lay my head." She wanted to inquire into how nomadic artists behave in our globalized world. How do they deal with their own culture and identity when they're traveling from country to country? After Sue's academy was over and the fellows had all scattered to the winds, they each designed a table napkin, always of the same size and fabric. And at the SAK opening ceremony the following year, they personally presented the set of 12 napkins in an edition of 100. They made us think about the symbolism of a napkin: it starts out as a tidy, uniform item on a thoughtfully laid table that becomes an increasingly intimate object in the course of eating—stained, with traces of food and lipstick and usually ending up in a messy heap at the end of the meal. A brochure accompanied the edition with fictional conversations that the fellows had invented via the Internet in the course of the year after their SAK.

JS You mentioned that Tirdad's edition of the Sommerakademie was about inner necessity. Were the Swiss participants able to appreciate and learn from the fact that this inner necessity is entirely different for people from, say, Brazil or Russia?

JB That brings up the issue of prosperity again. It wasn't easy to select someone from Switzerland every year. Going through the submissions we realized that candidates from abroad were intellectually more committed as a rule—often out of necessity—more committed to social and political questions and therefore more prepared to resist or oppose. Fellows from Palestine or Colombia have to cope with things that we only hear about in the media. Generally speaking, we are less political and clearly more pampered materially. When we visited the Bern Academy of the Arts with

Thomas Hirschhorn, the fellows from abroad couldn't get over how comfortable and spacious the workshops were. And how little they were used. They also noticed that the students were relatively disinterested and didn't really seek opportunities to meet with their visitors. It was embarrassing for me.

JS Let's think about the SAK in terms of research: it wasn't a matter of making proper scholars out of the artists, but rather about other disciplines, about "taste intelligence." Herbert Lachmayer proposed that term for his Sommerakademie. SEE INTERMEZZO P. 244

JB He and his partner Brigitte Felderer curated the second edition of the SAK in 2007. Their theme: "Spectacle and Situation." As speakers they invited the artist Cerith Wyn Evans and the Austrian team of four (Ali Janka, Wolfgang Gantner, Tobias Urban, Florian Reithner), who call themselves Gelitin. Gelitin used thrift shop materials to build a tent behind the Zentrum Paul Klee, where they slept and welcomed fellows and guests. Brigitte joined the other fellows in the guest house and Herbert took up residence in the most elegant hotel in town, the Bellevue Palace. He had made a deal with the management: a beautiful room with a view of the river and the Alps in exchange for a public lecture on the history of the Grand Hotel since the early 19th century. He gave his lecture in an elegantly appointed room of the Bellevue, where he spoke about the Grand Hotel's cultural and productive function of offering a stage for individualism, where guests may be impostors like "Count" Wenzel Strapinski—actually a poor tailor's apprentice in Gottfried Keller's story *Kleider machen Leute* ("Clothes Make People")—provided they know the rules of the game and can play the role. According to Lachmayer, that has to do with "taste intelligence," a term he coined. It is different from conventional good taste since it

requires a sophisticated combination of intuition, creativity, knowledge and educated perception. It is also related to the ability to take a productive, impartial and, indeed, virgin approach to the quality of anything unusual, unsettling or unpleasant. So Lachmayer associates taste intelligence not only with art, design, fashion and an aesthetic sensibility in general, but also with everyday lifeArt (with a capital A). He vehemently rejects the term lifestyle. It is so easy to be cajoled into a lifestyle as if it were one's own. Not so lifeArt; we have to invent that ourselves. SEE INTERMEZZO P. 244

JS De gustibus non est disputandum. So you wouldn't subscribe to that?

JB It can certainly be fruitful and even fun to argue about taste, depending on who you're talking to, because it forces you to review and hone your ideas and refine your judgment. But not with people who have fixed ideas.

JS Ordinarily, you either have taste or you don't. You say that taste has a lot to do with culture, training, assimilation and education. But intelligence is more insidious because you can certainly train and assimilate it, but you can't buy it.

JB When people say, "I like it" or "I don't like it," it's usually a kind of habitual, gut reaction. But you can certainly acquire taste intelligence. It depends on the degree of curiosity. Art wants to move you, but it also wants to attack you. So it's perfectly normal to be repelled by the aesthetics, atmosphere or content of certain works and situations. In that case, you have to think about where your reaction comes from: is it related to the strangeness of the work or to a purely subjective aversion or to the failure to recognize its quality or maybe even because it has none?

JS Your role at the SAK was that of a coach for the highly gifted?

> JB There were highly gifted participants, but we liked the curious and alert fellows just as much. My role was more like that of a theater intendant who plans and implements ideas with the SAK team and then hands the reins over to the guest curators, fellows and speakers. As a rule, I only made an official appearance at the beginning and the end, but I took part in everything as much as possible as an onlooker to see how things were going, and I learned so much as well.
>
> While working on the SAK, I was also a lecturer at the Accademia di architettura in Mendrisio, where we had carte blanche. So in the lectures and seminars, I sometimes addressed issues we had discussed in the summer academies that seemed relevant for students of architecture as well.

JS You try to establish priorities and lure the participants out of their comfort zone. You want them to formulate their own inner necessity. In addition, they need to practice sharing. Because you aren't going to be compatible in a group if you can't argue or engage with others.

That's related to another of your activities as chairperson or member of many professional committees. Serving on juries means demonstrating your skill as a judge and asserting yourself. Kurt Foster mentions your persistence in this connection. When you argue and formulate your opinion as a juror, your goal is to select the best work or support the best artist. It has nothing to do with your own pleasure or ego.

> JB It's clearly about trying to select the most substantive and promising projects, the most suitable ones. It's such a delight when you find them.

JS And it's often about defining a work that doesn't exist yet or a biography that hasn't been lived yet. Sometimes you end up playing ahead of the music, doing some guesswork at a certain point, identifying potential that has not yet been tried and tested. Maybe you even envy the artists. You sense what they want to do or where they want to go.

JB I'm always thrilled, never envious, when I come across artists who have what it takes. They aren't competition; they're not taking anything away from me. They're enriching. But you have to be open-minded to recognize the potential of young artists without instantly starting to compare, which can undermine impartiality. It's not easy; it takes practice.

JS I'm being insistent: there's a kind of benchmark between the potential and its fulfillment. Being in situations of that kind is so interesting because you're like a hinge; you can open doors to something that would not happen without your involvement or influence. Or at least not as quickly.

JB You're talking about the Federal Art Commission (EKK) over which I presided for nine years from 1998 to 2006. I was happy to accept the mandate because it meant being able to support artists, architects, critics and curators and to award prizes. We decided who would be sent to the Biennials and had an influence on the system of artists' studios abroad and nonprofit spaces. We also made acquisitions for the Federal Art Collection. Artists are astonishingly well subsidized in our country by both public and private funding. There is money available for what you can see and touch. But investment in a vague, unquantifiable intellectual world is sometimes less forthcoming. That's why it was very important for the EKK to also consider critics, curators and even translators at the Swiss Art Awards. Launching

the Prix Meret Oppenheim in 2001 was especially dear to me because it honors the life work of cultural practitioners whose renown is a feather in Switzerland's cap. Besides, it's also a tribute to Meret Oppenheim, who already practiced crossover in the arts back in the 1930s, besides being active in fashion, design, literature, poetry and performance. She enjoyed a revival in the 1970s and became an international role model. Not only young artists are fascinated by her free spirit. She was witty, well-read, open-minded and communicative until the very end of her life in 1985. It made perfect sense to establish this prize in her name. SEE TEXT P. 252

JS Kurt Forster describes Harry Graf Kessler as a matchmaker. SEE INTERMEZZO P. 226 That applies to you as well. But one mustn't forget that you and Bice have often been involved in discovering artists before the match, instinctively and knowledgeably trying to foster talent when you see it.

JB Actually, *Parkett* never had the ambition to be the first to discover someone. Valuable pointers and impulses came from a variety of sources, from fellow artists, and sometimes we were just struck by someone's work in an exhibition. So we would contact artists directly, maybe publish an article about them or have them design a 16-page contribution, one of the so-called Inserts. Sometimes we would initiate a "Collaboration" right away with several texts and an edition that they would create exclusively for the publication.

JS "Collaboration" means having accomplices. But juries are not only about having inspiring contact with colleagues. Sometimes nothing takes off, there's no flow. There is no mutual inspiration.

JB That's why a fine-tuned jury is so important. Everything depends on the expertise and character of its members. I was spoiled in this respect because with few exceptions, I always had the privilege of working with congenial people. When I chaired the Federal Art Commission, Ruth Dreifuss was Secretary of the Interior and later Pascal Couchepin; David Streiff was the Director of the Federal Office of Culture and Urs Staub headed up the Department of Art, Design and Public Museums. I worked most closely with Andreas Münch of the arts section. It was a good combination and so was the composition of the Art Commission with people like John Armleder, Stefan Banz, Maria Pia Borgnini, Mendes Bürgi, Giovanni Carmine, Sylvie Defraoui, Alex Hanimann, Pierre Keller, Simon Lamunière, Claudio Moser, Chantal Prod'Hom, Hans Rudolf Reust, Philip Ursprung and Theodora Vischer. Isa Stürm was an important architectural consultant for us because the distinction between art and architecture was becoming increasingly blurred both in the submissions for the Swiss Art Awards and in our choice of who would represent Switzerland at the Biennale di Venezia. The point of making this list is to show that there were no "lame ducks." We certainly argued sometimes but that was because we were so committed; we always agreed on the basic issues.

JS You mentioned the decline of interest in the humanities because their effectiveness cannot be measured. But your Federal Art Commission introduced new criteria for the funding of programs, which are mostly geared toward efficiency or measurable success. What about cultural promotion? Do you think it is moving in the right direction?

JB I'm not in a position to judge that because I don't see behind the scenes anymore. But at the time I envisioned one single federal institution, a merger of Pro Helvetia and the Federal Office of Culture. This would give culture priority

over propaganda for our country. And in order to counteract bureaucracy or overzealous and even intrusive cultural management, highly qualified people would be recruited, who were closest to culture and reality. These experts and advisors would be employed on the basis of the militia system as is the case today with the Federal Art Commission. Pro Helvetia is an anachronistic, pre-war designation that was introduced to bolster the nation's self-confidence. Today we can afford to invest in "pro cultura" rather than "pro Helvetia."

JS So far we've been talking about professionals, about the summer academy and the Federal Art Commission. But the mission of cultural policy, namely promotion and mediation, which you have outlined, includes popular formats that are not only geared towards experts.

Now I want to talk about the third sphere, the popular formats, specifically the Swiss National Exhibition, Expo.02, this grand rendezvous of society, science, business, politics and culture. All of these factors join forces once every generation with an increasingly important role assigned to art. You contributed to one of the confederation's pavilions at the last Expo.

JB You did, too!

JS Yes, but not for the confederation or for a pavilion, but for the pirate ship of the people from the Canton of Jura. Popular appeal was a core requirement for all of us. How did that work for you?

JB Pipilotti Rist was still the artistic director when I first got involved, but a participatory campaign had already been launched before that, inviting anyone with an idea for a project to submit it for the Expo. Pipilotti had to take over this

grassroots democratic campaign and invited me to serve on the jury. 3000 projects had been submitted. And the result? Only 37 were carried out. Many were simply incredibly unimaginative or of extremely precarious interest or logistically and financially unfeasible. So the immense effort left behind 2963 dashed hopes and frustrated teams, all in the name of popular appeal. Popular appeal is all well and good; after all, culture has long engaged in the productive interplay of high and low and Beuys's idea of social sculpture. But the projects should have some substance and be intelligently presented.

JS I didn't have much to do with the campaign and then, only at the very end. Although frustration was a predictable result, I think active participation is key to making the idea of a national exhibition socially acceptable and it's based on a militia approach which is fundamental to the Swiss mentality. That would be a marvelous, tremendous practical example of the popularization of taste intelligence. But back to Pipilotti Rist, who asked you to work on the Expo. She was crucial to your work on the pavilion, wasn't she?

JB She was a source of inspiration for everyone who contributed to the Expo. She was deeply committed to the design of the entire Expo, and with great artistic intelligence. When she started working on it, it had already been decided that it would take place in the French-speaking part of Switzerland, spread out in four cities on three lakes, the so-called Arteplages. In addition, a theme consisting of antagonistic terms had already been determined for each site: "Moment and Eternity" for Murten, "Power and Freedom" for Biel, "Nature and Artificiality" for Neuchâtel and "The Universe and I" for Yverdon-les-Bains.

It was very important to Pipilotti to give each of the Arteplages an explicit, distinctive atmosphere to match

their respective theme. She designed models and prepared lists of related terms and keywords as a source of inspiration for the designers and architects. She made collages of images and filled suitcases with materials and objects, which evoked moods and associations through the variety of their textures, shapes and colors or through their symbolic significance. She included everything, sound and smell, even the food served in the restaurants. She wanted the Expo to affect both mind and body, to be an intense experience that would activate all the senses. And she wanted to be the catalyst, so she used playful, performative means to communicate her intentions to the media. She played various roles, such as an elevator operator, or showed up in a business suit or in folk costume.

I was pretty well informed about all this when I started working on my second, more exciting contribution to the Expo, the proposal for the federal pavilion in Yverdon-les-Bains.

JS How did that come about?

JB It was an emergency affair. The federal government had commissioned a pavilion with a specific team for each Arteplage. The theme for the Yverdon-les-Bains pavilion was "Who am I?" A first team had already worked on a preliminary project for two years, but it didn't meet with approval. So in November 2000, the architects Isa Stürm and Urs Wolf were commissioned as a second team to come up with a new proposal and they asked me to join them. I in turn asked Laurie Anderson if she'd like to design a ceiling projection for the pavilion and compose an ambient sound to go with it. She agreed and that really inspired us. Three months later we submitted our proposal and were commissioned to implement it.

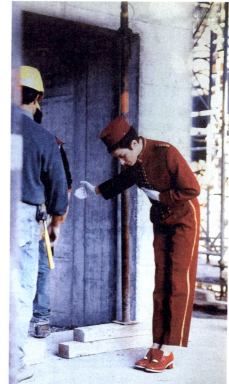

FIG. 100 In their laboratory of ideas, Pipilotti Rist and her team developed associative images and models for the four Arteplages of Expo, 1998. This collage is an associative image for the Arteplage Yverdon-les-Bains.

FIG. 101 Pipilotti Rist, artistic director of Expo.01 (which was pushed back a year to become Expo.02), presents herself to the press as a liftboy.

Martin Heller had already replaced Pipilotti as artistic director of the Expo by that time. But, as I said, we were influenced by the way she had approached the themes.

JS How did you make a virtue out of the government's tribulations?

JB We decided to respond to the question "Who am I?" in terms of the four basic elements: earth, water, fire and air. We had the square skeleton of the construction (floor area 32 square meters, height 16 meters) covered with sailcloth and then had it transformed into a gigantic, hand-painted turf brick, with roots, strata and grass on top. Isa had found a photograph at the ETH of a section through an ideal Swiss floodplain and had given it to two stage designers as a source image. The pavilion was supposed to look like a turf brick that had been cut out of the ground right there. When you walked into the pavilion, the bombastic scale of the brick made you feel like an insect. We wanted an Alice-in-Wonderland feeling. There were 12 entrances, and some of them led to a dead end—as in real life. We decided on the number 12 because of its symbolic significance in many cultures and religions and because it's the number of signs in the zodiac. And to be metaphorically consistent, we oriented the turf brick according to the four points of the compass, instead of the position defined in the master plan for the Arteplage.

The inside of the turf brick was filled with water about 20 cm high. Bridges led to a big platform in the center with six huge leaf-shaped beds with mattresses for 120 visitors. Laurie Anderson was responsible for the elements of fire and air. We assigned "fire" to her electronic projection of over 1000 square meters on the 16-meter-high ceiling. It was the largest overhead projection that had ever been made at the time, almost twice the size of Michelangelo's fresco on the ceiling of the Sistine Chapel. It was mirrored in the water,

FIGS. 102+103 Federal project. The pavilion *Wer bin ich?* (Who am I?), Expo.02, Arteplage Yverdon-les-Bains, 2002.

FIGS. 104+105 Interior view with the platform above water and the projections by Laurie Anderson.

making the platform feel like a spaceship. Laurie's ambient sound, symbolizing the element of air, ran non-stop for the entire five months of the Expo—a catchy tune that never became enervating.

JS It was an extremely physical experience; you would lie on this gigantic mat and watch the projection overhead. People often feel exhausted at these mega-events—too much sun, thirst or endlessly waiting in line. "Who am I?" responded to the physical need for relaxation; your hospitality and invitation to lie down was right on target.

JB The mattresses were made of viscoelastic polyurethane foam, which molds itself to the body. So you lie down in your predecessor's imprint and feel how the material gradually conforms to the shape of your body instead. Your body was photographed from the ceiling and then mapped into Laurie's projection. The mattresses were a poisonous green because they had to function as a blue screen to make the people on the ceiling appear detached. The attendants also wore the same green so that they wouldn't show up on the ceiling while disinfecting the mattresses or waking people who had fallen asleep.

JS What was that amusing story about their uniforms?

JB All four federal pavilions planned to use the same uniforms. But a uniform was the last thing we wanted, given the theme of "Who am I?" I consulted the fashion designer Sissi Zöbeli and she suggested we work with the students of fashion design at the Basel Academy of Art and Design. They created a kind of hoodie that you could drape around your body in different ways. It was streetwear typical of the digital age but rooted in primeval times. I guess people living in caves had fur hoodies; in the days of Wilhelm Tell in

FIGS. 106+107 The clothes of the supervisors, the so-called "Greenies," in the pavilion *Wer bin ich?* (Who am I?) were designed by fashion students of Basel Academy of Art and Design.

the Middle Ages, they were probably made of linen, and ours were elastic cotton jersey. We organized a fashion show of the prototypes for the amused politicians and officials at the Parliament Building in Bern. Most likely a first in those hallowed halls. They loved it—and willingly canceled the official uniform for the turf brick. Our attendants, young volunteers and people on community service, were officially called Greenies, but they dubbed themselves alien aphids and occasionally put on little shows for visitors to pass the time.

JS Did Laurie Anderson like improvisation of that kind over which she had no control?

> JB We did everything in her spirit. She trusted us and she's known me long enough to realize we'd never do anything she doesn't like.

JS Had she ever worked in such a vast framework before?

> JB Laurie has worked in big concert halls, stadiums and museums, all over the world, but she had never created such

a gigantic projection and she hardly ever does anything on commission. But she was interested in the theme and intrigued by the idea of composing an array of images showing a diversity of worlds, situations and moods and which would include the visitors lying below. A few months before the Expo.02 opened, the Arteplage in Yverdon was still a construction site but the structure of the turf brick with its ceiling was already in place. Laurie had sketched the projection on a screen in her studio but had to finalize it on site. She came to Switzerland and created her projection at night in the freezing winter of 2001/02.

JS So that you don't get dizzy when you look at it...

> JB Yes. Remember how she had to keep slowing it down so that the moving pictures wouldn't zip back and forth like shooting stars in those vast dimensions? Laurie wanted an intensely meditative mood, enhanced by the sound into which she wove the questions we had recorded with different voices in several languages, dialects and accents.

JS I wonder, do artists know who we are better than other people do?

> JB Hard to say. It reminds me of that saying again: "Ogni pittore dipinge sé" (painters always paint themselves). Artists are preoccupied with themselves, with what they are affected and conditioned by. In the process, they certainly find out more about themselves than most of us do, because we don't draw on ourselves so much. What do you think?

JS On one hand, I am wary of categorizing people. I'm not too comfortable about associating artists with priests—or priestesses, for that matter. But I do believe they are acutely aware, especially of processes. Spontaneity and trusting

FIG. 108 With Laurie Anderson (lying) and Isa Stürm (right) during a typical discussion about the Expo project *Wer bin ich?* (Who am I?).

FIG. 109 The making of Laurie Anderson's ceiling projection for the pavilion *Wer bin ich?* (Who am I?), 2002.

one's gut feelings are crucial factors. So there we have it again: the inner necessity, all the complex relations it takes to make a work of art, to exploit the right moment, to look for it and be receptive.

> JB That's beautiful, Juri, that's the whole point: being receptive to the moment in which a work of art can emerge.

JS I think art is interesting as a field of research because of its wide-open take on categorization. Which takes us back to Giulio Romano again and the artista universale. I want to know how such artists translate their universe into works of art and how we can understand the process. You satisfied my curiosity brilliantly in that respect at the Expo. The turf brick was very popular. Everybody loved it, young and old. I spent a lot of time there, too, mostly during breaks. It was beautiful, relaxing and even a little intoxicating. Like LSD without the side effects.

> JB Laurie's suggestive ambient sound and the flow of images on the ceiling transported you into an alpha state, and for that to succeed it was important to be lying down, not only because you're relaxed but also because nothing can come between you and the projection. It was like lying on a meadow at night and gazing at the stars overhead—an extraordinary luxury in this mega-event where, more often than not, you only get to see things between the shoulders of the people crowded around you.

JS Yes, an alpha state as peaceful effusion and expenditure of energy. But asking "Who am I?" is a delimiting question...

> JB ... and incredibly sobering. Who am I? A grain of sand in the infinity of time and the universe, but nonetheless granted the chance to live that slice of time with self-confidence.

JS A narcissistic grain of sand and a beautiful one.

 JB We wish that for everyone.

JS Do you remember Robert Storr's title for the Biennale di Venezia in 2007, "Think with the Senses—Feel with the Mind"? That's a paradox. But in art, the challenge to break down conventional categories works. You can rub reason the wrong way, though there is, of course, a kind of natural inner resistance. Pipilotti Rist and Laurie Anderson are both brilliant at subverting it; it would never enter your head to switch on your own superego in their presence.

 JB They are such masters at seducing people with images and sounds. Laurie's mesmerizing voice says it all in *Closed Circuit*:

"Well I know who you are, baby.
I've seen you go into that meditative state.
You're the snake charmer, baby.
And you're also the snake.
You're a closed circuit, baby.
You've got the answers in the palms of your hands."

JS I wonder if the closed circuit includes the sublime in this case.

 JB The term sublime applies to Katharina Fritsch's sculptures and to their iconic presence. Watching her making a work, I can actually see that state or condition slowly emerging where everything is right: subject matter, form, material, texture, size, color—at which point, nothing can change anymore, not a single speck. In addition, Fritsch chooses contexts for her sculptures with extreme precision: the yellow *Madonna* in Münster in 1987 right on the street between a

church and a department store, or the gigantic blue rooster, the symbol of France, on the plinth in London's Trafalgar Square, a humorously subversive location behind Nelson's column—Admiral Nelson who defeated the French at the Battle of Trafalgar. SEE TEXT P. 340

JS I will try to describe the sublime with an image: you are sitting on the terrace of a palace hotel on Lake Lucerne around 1890—a British aristocrat enjoying all the comforts conceivable in those days. Electric light illuminates the scenery. You are sitting in central Switzerland, drinking the best tea imported from Ceylon. You are completely sheltered, gazing at the backdrop of the Alps, a panorama that opens up before you as if you were in a 4D movie theater. You see a thunderstorm brewing and watch it break. A slight shudder runs down your back. To me that's a sublime moment. As if you were existentially challenged on this terrace. If you were outside when lightning strikes, it would be the end. But you are ensconced in a security network, from the lightning rod of the palace hotel to the liveried waiter with an umbrella and the perfect temperature of the tea that you've just been served. Everything seems to be under control. But the disaster unfolds before your eyes and you are watching it. You don't have to defend yourself; you don't have to worry; you can surrender to the spectacle.

> JB The gods of nature stage a moment like that and J.M.W. Turner captures it with magnificence. Queen Victoria longed for that moment when she painted watercolors of the mood around Lake Lucerne, still disconsolate, mourning over the loss of Prince Albert and trying to find comfort.

JS That's what I meant about the play of the sublime. For example, Pipilotti Rist's works on menstrual blood could instantly trigger resistance. But the exact opposite happens.

With Rist, we willingly submit to something that might otherwise arouse shame, fear, aggression and the instinct to escape. But nothing of the sort happens; we simply capitulate to the situation.

> JB You overcome the resistance by broadening the play of associations. Why should blood, that "very special fluid," as Goethe's Mephisto calls it, be disgusting? Sometimes art is like jumping into cold water: after the initial shock, you begin to enjoy the swim. For Pipilotti, everything bodily has the same value, be it skin, hair, organs or fluids, be it inside or outside. She studies and reveals things that are hidden. If you accept this, you don't have feelings of shame or repulsion, which are based on educational conventions anyway. Instead you become aware of vulnerability and transience, feelings that are more sublime than shame and repulsion.

JS Art steps across borders and addresses things that are ordinarily swept under the rug. That has to do with taste as well, or rather with the boundaries of taste.

> JB The sublime—as the word itself says—is beyond boundaries, beyond labels, trends or conventions and even beyond art historian Winckelmann's "noble simplicity and quiet stature." The sublime is not just beautiful.

JS So looking beyond these boundaries is also part of making things that are taboo conceivable. Do you sometimes face taboos of your own where you think: I don't want to be confronted with that, I don't understand it and I don't want to have anything to do with it?

> JB Yes, that has happened to me. For example, in 1992 when Oliviero Toscani made a billboard for Benetton of an emaciated, dying AIDS patient, surrounded by mourners.

I felt that was an assault on an unwitting public. It depends on the context. In art spaces or publications, people are aware of what they might see. They have a choice, but not people on the street. When he was director of the Museum of Modern Art in Frankfurt, Jean-Christophe Ammann exhibited Toscani's Benetton posters as poster art. I thought that was good because you have a different approach in that context while I think you should be more careful and empathetic with passers-by on the street. Oops, I've just walked into the lion's den because it's not easy to define the pain threshold for art or advertising in public space. Graffiti artist Harald Nägeli demonstrated that to us in Zurich for years until he was finally awarded the Zurich Art Prize at the end of 2020.

JS And in the "sanctuary" of art?

JB Even there things can happen that really disturb me. Take Santiago Sierra, for example. He paid prostitutes, drug addicts and the jobless to get tattoos or to do horrible jobs. To me, making such painful and irreversible marks is a drastic exploitation of misery that indicates a lack of empathy and a macho attitude. In his actions, Sierra abused not only people but also art and institutions. What do you think about "taboos" in art?

JS Within the professional context of the summer academy, you can openly address artistic transgression, because the artists and the faculty are schooled in probing dark sides and taboos. They integrate such aspects into their own horizon, like laying out an experiment, in order to acquire new insights into what it means to be human. Ultimately, that's what art is about. When we make the leap from the summer academy to the pavilion of a national exhibition, we have to ask ourselves if we want to leave the comfort zone there as

well. I interpret this in your clear distinction between triviality and popularity. We're talking about motivation and perception.

I think public perception is quick to jump the gun. Disturbing art is labeled and instantly written off as provocation instead of trying to understand the motivation behind it.

> JB Provocation or *épater le bourgeois* for its own sake can be extremely tiresome. But it's a different matter if it succeeds in cracking crusty views. Then the effect can be cathartic.

JS Provocation can be a method—a kind of trademark. Take Damian Hirst; he has become part of the collective consciousness through provocation. I don't think his first calf, cut in half, was intended to shock the bourgeoisie. Hirst shifted perception among a large slice of the public and visualized something unspeakable in an age of factory farming and mad cow disease. On the other hand, the diamond-studded skull, made later, presumably took the maximum variant of a methodical run-through. Hirst keeps increasing the dose of economic obscenity. Does the substance remain the same in the process?

> JB I have to admit that I saw a huge show of his in Venice and found it more tiring than inspiring. But the early works, the calf cut in half in formaldehyde, are more about an enlightened investigation of things that are ordinarily hidden, like with Pipilotti. And the macabre photograph of himself at the age of 16, grinning next to the head of a dead man—deader than dead, in fact, because the head was severed from the body—speaks of his relationship to death, of wanting to conquer his aversion to it and literally buck the fear and horror. I'm grateful to him for that. As for the diamond-studded skull, I can only say that the ancient Egyptians or Aztecs—and he

is referring to them, of course—spent astronomical sums on their death cult. They believed in an afterlife. This is still of interest to artists today because they are concerned about the survival of their works even if they don't want to admit it. Hirst is and remains a key figure. In the late 1980s, he seminally influenced the Young British Artists (YBA), not only as an artist but also as a curator. He and his co-artists revitalized contemporary art in Britain and it made a huge international splash.

JS Art is a universal field with many irrationalities. Those who commit to it, walk into the lion's den, as you put it. Once inside, there's no telling if, how and when you will be devoured. Families visiting museums on Sundays are not really aware of that. Or is being disturbed part of the thrill?

JB Most certainly. One of the demanding tasks of curating is to present collections in meaningful mise-en-scènes, including everything that seems alien or unpleasant, so that you can understand the concerns of artists through the ages.

JS This would mean that unpleasant aspects are part of the principle as well, even or especially in popular art.

JB Obviously. It is necessary to show the horrors of the world, to make people conscious of their existence, but also to name them, to think about them, to exorcise them and ultimately to even gratify our desire to get a kick. We love thrills from a safe distance, the way you conjured the storm in the sublime scene on Lake Lucerne. Thrills are generally more exciting than the idylls of paradise with angels and their accessories.

JS Yes, and it's hard to bring the fairness of artists into play. I don't think being fair is their primary task.

JB When it comes to their work, though, integrity is crucial for artists, sometimes to the point of being obsessed and tormented by it. They don't want to fool themselves. But in life, "nobody is perfect" applies to everybody; there can be an immense gap between aesthetics and morals.

JS Which makes me think of Giulio Romano again. You write that one might call him a "court artist" but alongside his penchant for the sublime, he was certainly not averse to taking a popular approach. Besides, the exchange between Giulio and Federico was not always humanistically inculpable. Ordinary life encroached on their relationship: delays, overspending, breaking contracts and disregarding agreements...

JB ... of course, but they're not mutually exclusive. On the contrary: so many circumstances and details played a role in carrying out a commission. In letters to Federico, Giulio complains about his moody horse, recalcitrant workers or sustained rainfall. Information of that kind shows how closely the Prince followed the artist's work, how deeply interested he was in it. As an *uomo universale*, a universal man, Giulio was versed in a variety of fields, a thinker and a doer, intellectual and conceptual as well as practical and hands-on. That's why there are many pointers in his art that allow for a popular interpretation. His wall paintings picturing the great narrative cycles of Greek mythology prefigure scenes in Hollywood movies. His paintings are pretty wild and can even be shocking, especially the scenes in the Palazzo Te's Sala dei Giganti, which he had to finish in a great hurry in time for Charles V's visit in 1532. Standing on the mosaic floor with its whirlpool motif in the midst of the cycle, the emperor supposedly paled in horror at the sight of the apocalyptic scenes of massive destruction, the likes of which he had never seen before. As adults, when we watch

entire universes collapse in 3D science-fiction movies, all we feel is a pleasurable frisson. It's impossible for us to imagine how people must have been affected in those days by the sight of Giulio's murals. Obviously, the Palazzo Te wasn't open to just anybody, only to servants, the people at court and guests. It's interesting, however, that Giulio Romano is coming into his own again and is gaining in popularity today. When I was doing research on him, Mantua was still off the beaten track. Now the city is easily accessible by car and train. Giulio has become a major tourist attraction, along with Pisanello, Alberti, Mantegna and the tortelli di zucca.

V

Limbo,

Spaghetti al Sugo,

Tipp-Ex and Octopus,

My Commedia dell'Arte

JS So far we've had four sessions. Our fifth and final conversation is taking place during the second wave of Covid. To warm up, we went over what we had talked about before and read the transcript and you instantly returned to the subject of restoration because it is where theory and practice come together in a universal approach to diverse areas of expertise. Restoration is essentially a litmus test of competence. You operate on the animate object, so to speak, and bear the responsibility that goes with it.

JB That's related to the "dual historical nature," especially since restoration addresses issues of forgery, copy and original. Restorers can be irreversibly involved in damaging, destroying or falsifying a work.

JS You also said that the process of restoring starts with an intense commitment to the object and proceeds from the detail to the whole. Actually, I wonder: Have you reached a point where you have some kind of overview of your own work?

JB Well, with my extremely selective overview, I do see threads that run through all of my activities. One constant is the pleasure of direct encounters with works of art and working together with artists. That was part of being a restorer, a curator of performances or site-specific art, or an editor of *Parkett*. Restoring murals and studying Giulio Romano sparked my interest in the Gesamtkunstwerk, and this interest in turn motivated me to accept mandates in cultural promotion on the boards of museums and kunsthalles, because that's where prerequisites and conditions are created that contribute to the production and presentation of art and ultimately to its critical reception.

JS In our context, you are actually part of this "dual historical nature" yourself. You are still producing and active. But there's also a transition, a reflection apart from your authorship and the immediate context, so that everything you've done is placed in a larger, different, broader context that you cannot necessarily guide or control.

JB It's very important to me to be able to let go and to benefit from the experiences I've had in order to dedicate myself to something new. But before that happens, there is a period of time that Cesare Brandi aptly calls the "interval." He

means a very precious moment, namely the phase between the completion of a work and handing it over to the public. Because that's when you step back and examine it with critical detachment, when you ask yourself if it looks right now, if it's mature enough to let it go, or if you shouldn't touch it up here and there—or even set it on fire because it's no good. It's in a kind of limbo at this point. The "interval" is what you might call a privileged moment of critical perception when people you trust are honest enough to tell you whether or not they think your work is relevant to a wider public. If you don't take advantage of that interval, you'll regret it, because there's much you can't undo afterwards.

JS Oh yes, it can be devastating to let things go too quickly. I always dread the moment when I send a text to an editor, knowing it'll get stuck in the dependency loop of interpretation. You know this ingrained, professional process extremely well and clearly appreciate it. It's the moment of transition when you are thrown back on yourself again. The current preoccupation with your life is also a kind of interval and it will lead to detachment.

JB This book is not in limbo yet. I'm still rummaging around in memories and sifting through texts and pictures, making selections, editing things. But I always look forward to the "interval," if only because it means moving on afterwards. After all, this book isn't my tombstone.

JS What you are emphasizing is the liberation. The bigger picture can produce a kind of euphoria. For instance, you work on a painting, centimeter by centimeter, and then at some point, you step back to look at it. And yes: it works. All those single square centimeters actually merge into a whole.

JB As a restorer, I've had that feeling of euphoria after completing a task, but I've rarely noticed it among artists. They have moments of euphoria in the process of creation, when they come up with a good idea or are surprised by a serendipitous event, or when a manipulation succeeds to perfection. But when the work is completed, they're already focusing on the next one or, on the other hand, suffering from postpartum blues. That rarely happens to restorers or artisans because they are much less involved in a creative process. It seems to me that people of an artistic nature are often driven by this feeling of "I can't get no satisfaction." That may have the effect of a positive catalyst because the driving force is the idea. But the idea doesn't always happen right away, and you can never capture it definitively in a picture or in language or in music. The articulation of an idea is by its very nature *non-finito*, unfinished, and keeps appearing in a new guise.

We used to print our *Parkett* editions in Zurich with Peter Kneubühler, a world-renowned printmaker now sadly deceased, for instance, those by Enzo Cucchi, Eric Fischl, Jannis Kounellis, Markus Raetz, Francesco Clemente, Mario Merz and Rosemarie Trockel. It was part of the ritual to toast the completed print run every time the last sheet came off the press, but what we were celebrating was the success of the printer's craft rather than the work of art itself. That's what the artists wanted.

You have a lot of experience with writers. What is it like with them? Are they euphoric when a publication comes off the press, or are they already thinking about their next book?

JS That varies, of course, depending on the person. I was just speaking to the writer Lukas Bärfuss about that last week. I think in his case reading and writing are somehow overlapping layers. Reading is part of a writer's work.

According to him, the great thing about the profession is not the writing but the reading. That applies above all to foreign texts. He told me he had recently acquired a biography of Catherine the Great in a second-hand bookstore, and he could already feel how his own style was blossoming with pastiche, was playing around with the style of the biography. But back to what the "interval" means for writers; there's such a long break between the transcript you submit to the editor and the printed book. By the time it's published, you've probably long been at work on the next project, so that you already see it in retrospect when the book is reviewed in the newspapers, and you go on a book tour.

I'm reminded of your text on Jean-Luc Mylayne, where you write about the Italian concept of *disegno* as drawing and *disegno* as idea. The latter is a never-ending process that keeps producing blossoms. But drawings do have a *finito*, an ending. SEE TEXT P.337

And that is in turn related to stabilizing the world of ideas or representation. Art can process diverse constellations to represent chaotic feelings and give shape to abstract or diffuse ideas. You describe restoration as a process, basically as the recovery or at least approximation of a state that was lost. It's about the value and visibility of a loss. In another context you talked about the danger of losing the past. Is melancholy, or the nostalgia of an ideal, perfect, original situation, part of the fantasy of restoration?

> JB It's impossible to recover an original state. But you can do your best to preserve the physical condition and aesthetic integrity of a work. You're so busy doing that in the process of restoration that you have no time to be nostalgic for an original state.

JS Is there a specifically Swiss approach to historical art?

JB We're a special case in Europe because only few internationally relevant pieces of historical art and architecture have grown on Swiss soil. The Ticino architects Fontana, Maderno and Borromini couldn't build on Zurich's Paradeplatz, and we don't march across the Piazza Navona as proudly as the Italians do. We wanted to be "a united people of brothers," as Schiller puts it in *William Tell*, so there was no room for the great patrons, for the popes and the princes with their penchant for grandezza. Especially given the tendency in Switzerland to regard grandezza as pathological megalomania. Maybe that explains a certain resistance among students and artists to the historical heritage prior to the 19th century because that was before Swiss cultural practitioners with whom we can identify had acquired an international reputation.

 I once gave a lecture to master's art students in Zurich and hardly anybody had heard of Giotto, Watteau or even Max Ernst. Only few students here go to museums as often as they do in most European countries or in New York, Boston and Philadelphia. In French and Italian schools, courses in art history are taken for granted, or at least they were. When Franz West was a professor at the Academy of Fine Arts in Vienna, he regularly took his students to the Kunsthistorisches Museum. I joined them once and when they sat down on the floor in front of Rembrandt's great self-portrait like primary schoolchildren, West indignantly declared that one does not sit in front of an artist of this caliber—one stands. Katharina Fritsch was just as respectful as a professor at the Kunstakademie Düsseldorf; she had a dusty collection of plaster casts installed in her classroom and breathed new life into the historical figures.

 It's extremely fruitful to treat history as a present-day phenomenon, to exploit its potent energy, to eliminate the

FIG. 110 Bice Curiger with Katharina Fritsch in Fritsch's studio at the Kunstakademie Düsseldorf, 2019.

detachment of time, to converse with artists of the past as if they were contemporaries, to use them as a benchmark or to pit oneself against them. There is something suicidal about disinterest because it implies that one's own work will soon be worthless as well and relegated to oblivion. Memory is the only thing that has a future. You can find kindred souls or enemies from the past, who will be at your disposal 24/7 all your life. That broadens your horizon, which does not mean that you should cling to them. Though I wouldn't want to do without the nerds who rummage around like mad in the substance of the past and make sensational discoveries. It's just important to remember how fruitful it is to inquire into the past in order to take a look at the future from the perspective of the present.

Italians are generally more uninhibited about their cultural past. They exploit the potential of history; they are

masters at transforming and revitalizing. With enviable nonchalance, they turned the Venus of antiquity into the Madonna and Eros into the Christ child. They built churches in Roman temples or apartments in the arcades of the ancient Teatro Marcello in Rome.

JS You almost sound like Boris Groys when you describe that vibrant archive. I recently read a fundamental critique of Italian cooking. Nonna is the eternal benchmark. No innovation there. Spaghetti sugo is only good if it tastes exactly the same as Nonna's. But at some point you have to emancipate yourself and strike out on your own—make your own sugo!

JB This sugo is exquisite. Nonna, beloved for all eternity, has created something incomparably delicious and simple, affordable for everyone, just as Grosi (grandma) makes our beloved rösti and meatloaf. Some things are simply too delicious to be changed. Just don't lose the recipe. That's the only imperative.

JS Maybe other cuisines are more liberal, capable of benefiting from the past to create something new. In Nonna's case, the original intention does not mean dogmatism. Maybe for you, coming from Mannerism, this original intention is of

FIG. 111 Nonna's sugo assumes the form of the Roman Empire on the spoon and has conquered the world.
FIG. 112 With Pietra, a Sicilian nonna and outstanding sugo cook, 1990.

interest as a kind of creative and subjective misunderstanding or a free interpretation of something that already exists?

> JB Exactly. Works of art are always open to interpretation. An intentional or unintentional misunderstanding can be an inspiring influence on something new of one's own. But as a restorer or critic, I can't afford creative misunderstandings. That's when skilled professionalism comes into play as well as factual and literary expertise, but it still requires passionate reason and fantasy or at least a practiced imagination.

JS We're speaking in clichés, mea culpa. Creativity that doesn't obey but rather breaks conventional rules. It is, of course, also a mark of genius. After the sugo, let's venture a leap into the next subject: your work is full of theatrical metaphors, from *Parkett* to the book that we're working on now.

> JB Absolutely. *Giulio Romano, Regisseur einer verlebendigten Antike* or *Parkett* and obviously *My Commedia dell'Arte* all refer to theater. *Parkett* (parquet) in German is the term for the seating in front of the stage, and the stage is clearly the space of art and artists, and we all know "all the world's a stage." So the magazine *Parkett* is a place where artists act and where art is perceived close up. Artists created editions for *Parkett*: multiples, unique works and inserts in the journal. They wrote texts and often contributed to the design of the magazine. It was Enzo Cucchi's idea, for example, to have the *Parkett* logo embroidered; Bice's mother accommodated. She even embellished the A, R and T to draw attention to the magazine's subject matter. The embroidery not only pays tribute to a popular craft, it also shows metaphorically how important it was for us to go into depth. Artists like Hannes Brunner, Kilian Rüthemann, Pamela Rosenkranz and Shirana Shahbazi invented scenographies for our *Parkett* exhibitions.

FIG. 113 The *Parkett* logo embroidered on linen by Bice Curiger's mother Livia, 1984.

The titles of the sections in *Parkett* also use theater terminology: "Balkon" or "Les Infos du Paradis." The latter alludes to the legendary French film *Les enfants du paradis* (1945) from the days of poetic realism, and "paradis" is the colloquial French term for the cheap seats, or rather standing room usually occupied by a critical, vociferous audience. And that's where we published rather pointed fantasy essays on the boundary between literature and art criticism. Another section was "Garderobe" (cloakroom) for spontaneous communications and aperçus, and in "Cumulus from Europe" and "Cumulus from America" writers from both continents sent their thoughts on selected events across the Atlantic.

JS The world was different, flat in comparison to today, before the onslaught of globalization. Would you say, in retrospect, that it was more carefree?

> JB We founded *Parkett* in 1984 and *1984* is the title of George Orwell's novel published in 1949. It's an apocalyptic vision of the future, in which the world is under Big Brother's cruel control. Luckily, this dystopia never materialized so brutally in our neck of the woods. But the Cold War was still

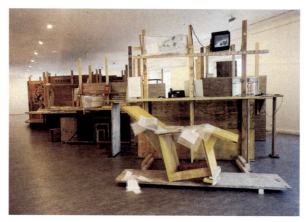

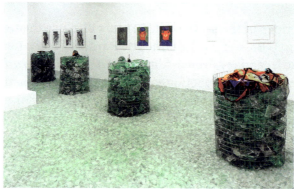

FIGS. 114–116 Exhibitions of the *Parkett* editions. Scenographies by Hannes Brunner in the Helmhaus in Zurich in 1989 and by Kilian Rüthemann and Shirana Shahbazi in the *Parkett* Space in Zurich in 2015 and 2017, respectively.

on, so it was hard to address the East, we concentrated on the European-American axis. Postmodernism was in full swing, pitting diversity, openness and Paul Feyerabend's controversial "anything goes" against the rigor of Modernism. And, most importantly, we took a playful and non-ideological approach. Looking back, it's clear that the art world was extremely Western oriented and—like you say—the earth was still flat for us. As editors we had the privilege to move around in a relatively familiar world, and speaking four languages (German, French, Italian, English) we were able to engage in a direct and fruitful exchange with artists and writers. But today, the world is round, and you would have to know many more languages and cultural-political systems in order to acquire the professional competence to say something about art that is less familiar to us.

JS The emancipation of the US-American art scene after the Second World War was closely related to deliberately jettisoning European ballast, all the archetypes and structures in Europe that had led to disaster—including the question of the avant-garde's potential complicity in the atrocities of the 20th century.

JB In the States in the early 1980s, the institutional system for contemporary art was still in its infancy. There were outstanding galleries and some privately funded institutions like the Dia Art Foundation that exhibited, supported and collected art, but it was mostly American art. When the Guggenheim Museum in New York dedicated its first-ever monographic show of a living German artist to Joseph Beuys in 1979, it was not surprising that many critics in the United States had never heard of him. At the opening, Bice and I had the privilege of witnessing a historical moment: the first summit meeting between the two highest-ranking artists on either side of the Atlantic—Warhol and Beuys.

Later, as interest in contemporary European art gradually gathered momentum, *Parkett* became an important vehicle for first-hand information in the context of transatlantic exchange. In fact, many Swiss artists attracted international attention thanks to *Parkett*. The very first issue had an article about Vivian Suter, who now enjoys international prominence.

After the Second World War people in Europe, and especially in Switzerland, knew more about American art than the Americans themselves did. In the 1950s, at kunsthalles and museums in Basel, Bern, Lucerne and Geneva, such people as Max Huggler, Arnold Rüdlinger, Franz Meyer and later Harry Szeemann, Jean-Christophe Ammann, Adelina von Fürstenberg and Martin Kunz showed Abstract Impressionism, Minimal Art, Conceptual Art, Pop Art and Performance Art. There was nothing in the States comparable to the major European surveys, like the Biennale di Venezia, documenta in Kassel, or Art Basel. The latter is already 50 years old and didn't open in Miami until 2002.

JS That gave *Parkett* drive as well: the "import" of American practitioners and the new street credibility of art criticism. Your hero Cesare Brandi wrote popular art reviews for the *Corriere della Sera*.

JB Brandi was an intellectual, whose popularity in the media was indebted to his refreshing style both as a writer and a speaker. This is also a quality of American writers. Only rarely did essays come fluttering into our editorial offices from the States that were so lumbering and dry that Bice warned us not to drop the paper because "it would break into a thousand pieces."

JS The early 1980s were a time of protest and upheaval—we've already spoken about that period in Zurich. And it was

FIG. 117 *Parkett* covers (selection).

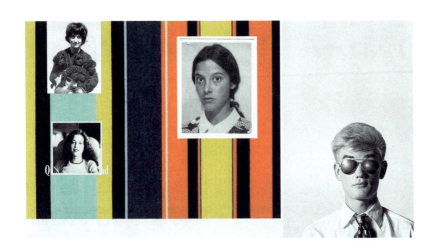

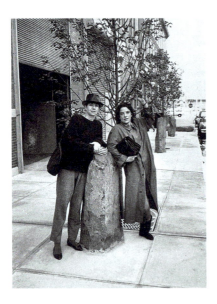

FIG. 118 Rosemarie Trockel, *A Portrait of the Artist as a Young Man*, 2014, silkscreen on paper, *Parkett* edition for no. 95, 54 × 100 cm (21 ¹⁷⁄₆₄ × 39 ⅜ in). The title is based on the eponymous novel by James Joyce. We three *Parkett* editors aged around 20. From left: Bice Curiger (above), Nikki Columbus (below), me, and Trockel's alter ego.

FIG. 119 With *Parkett* editor Karen Marta in front of the Dia Art Foundation next to an oak tree with a basalt rock by Joseph Beuys, New York, 1989.

FIG. 120 With *Parkett* editor Louise Neri in a chair by Richard Artschwager, New York, 1995.

FIG. 121 Mark Welzel, *Parkett* editor, and Catherine Schelbert, translator and English copyeditor, 2006.

FIG. 122 *Parkett* editor Ali Subotnick and Beatrice Fässler, who is responsible for the *Parkett* editions, at the opening of the *Parkett* exhibition in MoMA, New York, 2001.

FIG. 123 From left: artist Monica Bonvicini, *Parkett* editor Cay Sophie Rabinowitz, me, Bice Curiger, New York, 2005.

often instigated by protagonists in the States. In the gender debate, for example, there were voices of a kind that didn't exist in Europe. And then there was the Andy Warhol phenomenon.

> JB When Jean-Christophe Ammann curated the exhibition *Transformer: Aspekte der Travestie* at the Kunstmuseum Luzern in 1974, he presented works by Warhol and Katharina Sieverding, as well as Urs Lüthi, Luciano Castelli, Walter Pfeiffer and Alex Silber. I didn't see it because I wasn't in Switzerland at the time, but I heard and read about its electrifying effect. You and Stefan Zweifel also talked about that show in your exhibition *Der erschöpfte Mann* (The Exhausted Man); you called it a cult event in Swiss culture.
>
> The point is that there was also a lively scene in Europe, especially in London. I was crazy about David Bowie alias Ziggy Stardust and in 1973 I saw the *Rocky Horror Picture Show* live at the Royal Court Theatre. It pulled in the crowds, and everybody went wild when the protagonist Frank (an allusion to Frankenstein) sang "I'm not much of a man by the light of day / But by night I'm one hell of a lover / I'm just a sweet transvestite / From Transexual, Transylvania." The movie version of the musical became a cult classic even in the States.

JS Frank sings an ode to self-determined and gay life beyond heterosexual conventions and dressage. It's about inventing and transforming the self...

> JB ...which makes me think of Laurie Anderson again, that hypnotic storyteller, poet, filmmaker, musician, who invents her own instruments. In her multimedia performances, she transforms her persona; she's woman, man, clone, robot and even an entire choir. The first time I saw her was in 1980 at the Biennale di Venezia. She performed in the church of San

Lorenzo and I was utterly enthralled. We became friends, along with her husband Lou Reed. We joined forces on several projects besides working together for the Expo.02.

SEE INTERMEZZO P. 232 + TEXT P. 284

JS She is one of your constants. Does she also play a specific role model for you as a woman?

JB Oh yes. I'm fascinated by the dedication with which she mines her many talents. But there have always been women I looked up to. When I studied in Rome in the late '60s, early '70s, there was hardly any talk about gender theory. I took my cue from visible role models, like the two grandes dames at the Istituto Centrale del Restauro: Chief restorer Laura Mora and Chief archaeologist Licia Vlad Borrelli. The writer Dacia Maraini was in the limelight when she publicly championed the women's movement in 1970, and you could read articles on the socially critical writer and feminist Sibilla Aleramo (1876–1960). As early as 1906, Aleramo condemned domestic violence from her own experience in her autobiographical novel *Una donna*. Actually, her name is a pseudonym and an anagram of "amorale." Palma Bucarelli was also one of my heroes. During the war years, women started taking leading positions in cultural institutions, and she was the director of the Galleria Nazionale d'Arte Moderna. I always attended the performances she organized, for instance, with Tadeusz Kantor or a concert with Nuova Consonanza. I was also (and still am) a great fan of actresses like Sophia Loren, Anna Magnani or Silvana Mangano. I deeply admire the directors De Santis, De Sica, Fellini, Visconti and Pasolini, who gave these strong women the opportunity to act out their self-confident womanhood. I also met my parents' friend, the writer Marie-Louise Kaschnitz in Rome and I danced with Ingeborg Bachmann and friends at the Piper, the most popular nightclub in Rome.

FIG. 124 Pipilotti Rist, Bice Curiger, me, Laurie Anderson in Zurich, 1993.

FIG. 125 With Laurie Anderson in Zurich, 1981.

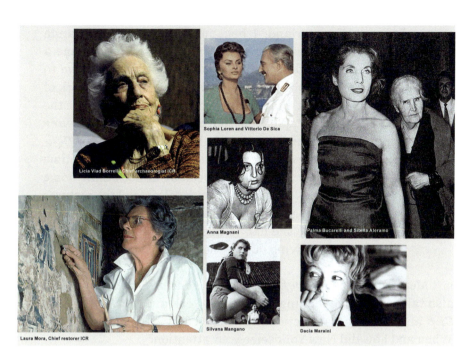

FIG. 126 My heroines in Rome in the early 1970s.

FIG. 127 With Meret Oppenheim during restoration work in her family home in Carona, 1983.

Later in Switzerland, I became friends with Marianne Feilchenfeldt-Breslauer, and Meret Oppenheim became a role model. She defended her conviction that you have to seize freedom; nobody will give it to you, and every work of art is the product of an androgynous spirit. Bice wrote the first ever monograph about her, *Spuren durchstandener Freiheit*, 1983, which came out in English in 1989, titled *Defiance in the Face of Freedom*. Bice and I spent a lot of time with Meret in her late years, especially at her family home in Carona, Ticino. Meret and I restored some of the pictures that were hanging on the walls there. She knew a lot about the craft because she had to take on work as a restorer in Basel to make a living during the Second World War.

JS Meret Oppenheim's *Defiance in the Face of Freedom* also takes us to the melting pot in New York and her *Fur Cup* at MOMA: an attraction in the mecca of attractions! When and how did New York seize your attention?

JB In the late '70s, early '80s, New York was *the* attraction. The city was Rem Koolhaas's *Delirious New York* where the mood of Tom Wolfe's *Bonfire of the Vanities* prevailed. Everything was compressed in this exciting, marvelous, but also brutal melting pot. Bice and I had already been there several times before we started *Parkett*. We stayed with friends and later at Waverly Place with our New York *Parkett* editor Louise Neri. Our schedule was always packed with meetings, working at our New York office, studio visits, tours of galleries and museums. In the evenings, we attended as many performances as possible, went to the Mudd Club where Peter Gordon, Kathy Acker, David van Tieghem performed. One of the best-informed art critics in the '80s and '90s was Edit DeAk, a close friend of Jean-Michel Basquiat. She took us to the Performing Garage, where the Wooster Group performed with Spalding Gray and William Dafoe.

FIG. 128　With Helmut Federle and Bice Curiger in the New York subway, 1985.

FIG. 129　With Bice Curiger in the Jeffrey Deitch Gallery, New York, 1999. Sculptural reproductions by Émile Guebehi & Nicolas Damas based on photographs taken by Malick Sidibé in nightclubs in Bamako between the 1950s and the 1970s.

FIG. 130 Edit DeAk alongside a poster of her idol, Iggy Pop, New York, 1982.

FIG. 131 Invitation to Edit DeAk's presentation of New Wave films in Movie 1 in Zurich, 1982.

We went to the CBGB with Edit and heard Alan Vega alias Suicide sing his unforgettable "Frankie Teardrop." After 1986, we occasionally went to the Palladium with its wall paintings by Francesco Clemente, Keith Haring and Jean-Michel Basquiat.

Edit DeAk came to Zurich in June 1982 with a suitcase full of Super-8 New Wave films that she presented late at night at Movie 1, one of This Brunner's movie theaters.

JS The way you describe it, the atmosphere must have been electrifying in those days, bursting with energy. But AIDS was rampant, too.

JB We had no idea what that was back in the early '80s. Only gradually, in the wake of those exhilarating times, did we recognize the pain and horror of AIDS. In 1988, General Idea, a collective of three artists, created an Insert for *Parkett*, consisting of the letters AIDS printed as a look-alike of Robert Indiana's LOVE logo on sheets of perforated postage stamps. Two of the artists, Felix Partz and Jorge Zontal, later died of AIDS but luckily the third, AA Bronson, survived. Robert Mapplethorpe, who succumbed to the illness in 1989, also designed an Insert for *Parkett* in 1986. And in 1994, we did a "Collaboration" with Félix Gonzáles-Torres, who was already HIV positive at the time. For his edition, he created a poster, 3 × 7 meters, picturing the traces of sneakers on a sandy beach, a gigantic symbol of transience and a tribute to the deceased.

In the double issue, 40/41, published to celebrate *Parkett*'s 10th anniversary, there were seven "Collaborations" and many references to AIDS. We called the issue "Snakes & Ladders" after the board game that originated in India; the game symbolizes the fateful ups and downs of life. Jenny Holzer's edition consisted of a silver ring in the shape of a winding snake, which she had engraved with the words

"With you inside me comes the knowledge of my death." Over the years, other artists, authors and friends died as well, like Thomas Ammann in 1993. We owe so very much to him. That was a terribly painful loss.

JS AIDS also meant being ostracized. In the beginning, there were people who called it the "gay plague." Ostracism caused by the collective fear of minorities?

JB Yes, you were stigmatized if you tested positive for HIV. Lots of talk behind people's backs, and what was even worse was the schadenfreude of homophobes and holier-than-thou moralists.

JS Actually, *Parkett* has raised awareness in the widest sense of the term through artistic means. People who should not yet be dealing with death, biologically speaking, began thinking about the memento mori, began integrating existential loss into their own worldview, into their own lives. Art became the medium to give death a face.

JB Nan Goldin's work is a deeply moving example of that. Her imagery reveals how intensely involved she is in what she shows us; she doesn't just look at people through the camera lens. Several photographs from the 1990s show terminally ill people or friends, victims of AIDS, in coffins, like Vittorio Scarpati or Cookie Mueller, the underground star in John Waters' movies. We were pretty worried about Nan herself, a couple of times, because of her drug abuse and alcohol consumption. We were particularly close to her because she came to Zurich several times to work on her books, which Walter Keller published at Scalo. In 1995 she wrote a gripping text for *Parkett* about the photographer Peter Hujar, who also died of AIDS. She felt a kinship with him. Bice and I met Hujar through Jean-Christophe Ammann

FIG. 132　General Idea, insert, AIDS stamps in the style of Robert Indiana's *Love* logo from 1957, *Parkett* no. 15, 1988.

FIG. 133　Jenny Holzer, silver ring with the text "With you inside me comes the knowledge of my death," edition for *Parkett* no. 40/41, 1994.

FIG. 134　Cover of *Parkett* no. 40/41, 1994, on the subject of *Snakes and Ladders*.

FIG. 135　Francesco Clemente, *Sorrow*, photographic etching on paper, 29.5 × 21 cm (11 ⅝ × 8 ¼ in), edition for *Parkett* no. 40/41, 1994.

in 1982, when he showed his work for the first time in Europe at the Kunsthalle Basel along with Robert Mapplethorpe and Larry Clark. We invited Nan Goldin a second time in 1999 to do a "Collaboration" with *Parkett*.

JS You built this complex, transatlantic antenna with a playful, postmodern concept and you were always on the air, up and running. But AIDS wasn't playful, and it certainly didn't brook an attitude of ironic detachment. You were suddenly in the middle of a nightmare. Is that like the shock we felt when Covid hit? Is the current epidemic comparable in any way to what it was like then?

JB For me, AIDS had a much greater emotional impact. We were confronted with the death of our peers, friends and acquaintances of the same age. So far, I only know one victim of Covid personally. And Covid not only has disastrous consequences; it also gives us a chance to cultivate patience, to take a creative break. It's a challenge to step back and think about how we can improve, and, above all, it gives us an opportunity to concentrate more on essentials.

Besides, unlike AIDS, Covid can affect anyone in the world, regardless of age or gender. Covid victims aren't accused of being debauched, and since they are isolated, you don't see them getting sicker and sicker, emaciated, as we did with AIDS victims. I don't agree with President Macron when he says that we are at war with Covid. It's not a question of enmity: it's about our disregard for animals and the natural environment.

At the moment, I can't imagine how the pandemic will be reflected in art. But I was completely overwhelmed by the drone footage that showed pictures of such unsettling beauty: Venice and Rome in the crystal-clear light of day, two enchanted ghost cities, not a soul in sight. Nobody, not even the birds, had ever seen these tourist meccas so deserted.

I wonder if it's as "easy" to make stirring images of Covid as it is of AIDS or of terrorism, violence, racism, war or natural disasters. What do you think?

JS At the time, everybody was waiting for the first great AIDS novel or Hollywood film. I do believe that such powerful events have an impact on the arts. Very directly, in fact, when people start asking about the meaning of art and whether culture is relevant to the social system or questions like can we close down cinemas, theaters and art museums? But you can't ban soccer, people would go bonkers. Arts practitioners themselves wonder about the relevance of what they're doing. That changes in times of crisis: then it's about isolation and the question of participation in society.

JB Art always faces the question of "What to do?" Mario Merz used it as the title of several works that allude to Lenin. Peter Fischli & David Weiss are specialists in asking questions. Their art is such a solace in the stress of today's world, so profound and yet so nimble. When things are out of joint, like they are now, I don't think you can simply write off art and culture as prestige, luxury and recreation. Because in times like these, for a lot of people, it's part of their survival strategy. Even after the Covid vaccination, we can't just go back to normal; we have to change the paradigm. There's not enough public talk about this yet, even though artists would have a lot to say about it.

JS The world has indeed become more complicated or, as Madeleine Albright put it long before the pandemic: "The world is a mess." Not only are we endangered by the global pandemic; we are surrounded by humanitarian catastrophes and engulfed in a climate crisis. If people do less flying and if being at home in lockdown raises awareness of mindless

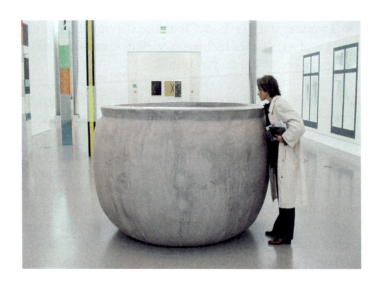

FIG. 136 Peter Fischli & David Weiss, *Grosser Topf*, 1984, carved and painted polyurethane.

FIG. 137 Interior view of *Grosser Topf*.

overconsumption, then those are welcome side effects. But they are still side effects in a sea of multiple crises.

From the start *Parkett* put its finger on the pulse of the times and not just on one pulse but on a vibrant, pulsating universe. So let's play with the idea of *"Parkett* reloaded" today. What bridges would have to be crossed? Political, social bridges between various cultures or tribes? How would the dialogue continue? Would the openness and lightheartedness of *Parkett* still work today? Or do you think that's over in an age of bullheaded, polarized debate?

> JB It's not easy to rethink *Parkett* in an increasingly globalized and digitized world. I would never want to publish an exclusively online magazine, although that would tie in with reading habits today. The physical properties of *Parkett* were such an integral part of the project: the format, the paper, the weight, the pleasure of leafing through the pages. A lot of those qualities would be missing if we were just an online publication. You wouldn't have anything in your hands. But the magazine has become a collector's item.
>
> In addition we have produced over 270 artist's editions, and the journal has a distinctive feature: artists also designed the spines so it's a delight to see the entire row of volumes on a shelf. Franz West celebrated 20 years of *Parkett* with his edition, which is a bookcase with room for 40 years of our periodical. We made it to 33 years, and all the books lined up bear measurable and tangible witness to a period in the history of art that is intertwined with the journey of *Parkett* itself.

JS The bookcase is on wheels, so it also transports the transition from analog to digital that took place in the course of those 33 years. How did you produce your magazine before the World Wide Web existed?

JB When we started out, nobody had a computer yet. We worked with electric typewriters and Tipp-Ex. We wrote letters to the States on thin airmail paper and kept expensive phone calls to a minimum. Sometimes the Fogal legwear shop on Claridenstrasse in Zurich would let us use their fax machine. They had a branch on Madison Avenue, New York. Karen Marta, then our US *Parkett* editor, would be there at a prearranged time to pick up the fax messages.

JS When your designer Trix Wetter created the distinctive style of *Parkett*, she did it all by hand; everything was analog.

JB Exactly. Conceived and carried out with no computer. The graphic design was an incredibly complicated process. Trix would receive the finalized manuscripts and send them to the typesetter with specifications: font, point size and line spacing. The typesetter would send the galleys back to her; she cut them into columns and then ran them through the wax machine so that she could paste them on an art board and easily modify them as required.

Nowadays the computer does everything for you in the sense that you can just drag and paste texts and pictures with the mouse to put them wherever you want them. We spent days and in fact entire nights with Trix at the printers to supervise everything and make color corrections because the galleys and the cyanotypes were not yet in color. Sometimes we had to replace printing plates, which could take hours. As you can see, our production process was closer to Gutenberg's in the 15th century than to the digital age.

JS Let's go back to "*Parkett* reloaded."

JB As we said, the world has become round; nowadays *Parkett* wouldn't be able to put as much weight on the Western world. But how could it represent all the cultural, political,

FIG. 138 Franz West, *2 × 20 Jahre Parkett*, bookshelves, edition for *Parkett* no. 70, 2004.

FIG. 139 Trix Wetter, the graphic designer of *Parkett*, with Bice Curiger, 1990.

sociological, religious, historical or specific referential systems that exist in all the different corners of the globe and, on top of that, all the newly configured transcultural societies? *Parkett* would have to rely increasingly on competent informants and specialists, and as editors we would ultimately have to hand over the reins for the most part.

"*Parkett* reloaded" would have to be like an octopus (not only mine but Katharina Fritsch's favorite animal, too) with its eight tentacles probing in all directions. If a tentacle gets lost, it grows back again. With their 1600 suction cups, octopuses don't just feel and grab things, they also smell them. They have nine brains, eight of which branch out into the tentacles and their three hearts are also in different sections. They have a unique circulatory system that delivers oxygen throughout their bodies. They are curious and playful; they can spray ink, camouflage themselves and change shape, slipping through narrow holes and cracks and then pumping themselves up again. They are a natural marvel and extremely intelligent. In a world that has become so complex, the octopus would be my symbol of a new *Parkett*.

FIG. 140 Katharina Fritsch, *Oktopus/Octopus*, 2010, polyester, paint, 21 × 45 × 60 cm (8 ¼ × 17 ⁴⁵⁄₆₄ × 23 ³⁹⁄₆₄ in).

JS These days, any form of authoritarian cultural grip provokes vehement protest. Curiosity and attempts at tolerance are interpreted as power-hungry arrogance. That can make critics think twice before writing about Chinese art, for example.

JB I'm glad you bring that up. I could never speak with authority about Chinese art because I'm simply not well enough informed. Whatever I do know is thanks to four Swiss people. First, Uli Sigg, who began collecting in the 1970s and has since built the largest and most substantial collection of contemporary Chinese art in the world. I saw much of it in 2005 at the two-part exhibition *Mahjong* in Bern and at Holderbank and also when visiting him at his castle in Mauensee. Then Lorenz Helbling, who opened his first gallery in Shanghai in the 1990s and later another in Beijing, and Urs Meile, who owns two galleries, one in Lucerne and the other in Beijing, and finally Harald Szeemann, who showed Chinese art at the Biennale di Venezia in 1999. So, initially Swiss people spearheaded contemporary art in China. The field has since broadened, and the Chinese are increasingly managing the art trade themselves.

When Philip Tinari, the American director of the UCCA (Ullens Center for Contemporary Art) in Beijing, presented an overview of all the *Parkett* editions in 2012, he also organized a seminar to which he invited young Chinese critics and students. We were so impressed with them, with their curiosity and knowledge of Western art. We spoke English and Tinari translated for us. But to really understand what's happening in the art world there, you would have to speak Chinese, live there for a long time and do a lot of research.

On another trip to China, I went with Felix Lehner (he runs an art foundry in Switzerland) to visit Zeng Fanzhi at his studio in Beijing. His paintings are a mixture of styles and motifs from Chinese and Western art. We saw these huge

FIG. 141 Yue Min Jun, *Silly Man*, 2005, group of sculptures with self-portraits of the artist in the exhibition *Mahjong: Chinese Art from the Sigg Collection* in Holderbank.

canvases, painted with such bravura and a visual appeal that makes them easily accessible. In fact, they're so popular that they are traded for millions of dollars. But their underlying cultural, political or social implications are lost on me. Fanzhi doesn't speak a word of English and I don't speak Chinese. I've only been to China three times, so as a white, European art critic, I certainly can't speak as an expert there.

JS Playfulness has been lost by the wayside because the supposed ease went hand in glove with colonialist power structures, which we may not even have noticed. In any case, we are definitely outside of our comfort zone. Does it make you feel uncomfortable?

> JB It does! But that's also productive. I am all for questioning our norms and values. It's so important to counteract the cultural dominance and arrogance of the white world, to raise awareness of minorities and marginalized people and to have a mix of cultural practitioners. It's high time for

harsh criticism of intellectual and cultural colonialization. I remember the 1989 exhibition *Magiciens de la terre* at the Centre Pompidou, which featured Western and non-Western art and artifacts. It provoked a lot of negative criticism due to its Eurocentric perspective, as did the earlier exhibition *Primitivism in 20th Century Art* at New York's Museum of Modern Art in 1984. But I admire the political commitment of Peter Brook and Ariane Mnouchkine. For decades they produced stunning plays with ethnically mixed ensembles of professionals and laypeople.

JS Aesthetic transgression seems to be under siege by political correctness. But art needs that to veer away from the highway of consensus. Don't you think?

 JB I agree. The pendulum of political correctness has gone wild. But maybe we need that to give us a jolt.

 For me, what happened at the Whitney Biennial in 2017 is still devastating—the scandal that Dana Schutz provoked with her painting *Open Casket*, which was based on the photograph of 14-year-old Emmett Till in his open coffin. The Black boy was tortured and lynched by two whites in 1955 because he had supposedly made advances to the wife of one of them. The murderers were never charged. The FBI reopened the case in 2017, which attracted the attention of Dana Schutz.

 But the English artist Hannah Black and some activists demanded that the painting be instantly removed, and some people even thought it should be destroyed. The argument was that as a white woman, Dana Schutz had no right to capitalize on Black trauma. What she had done was hurtful and she was only out to make money and have "fun." Those were hefty accusations, especially since Schutz's work has often addressed social, political and environmental issues or mental aberrations. Besides, you can't possibly mistake the

power of her art and the sincere emotional commitment in her wild, convoluted compositions of colliding color schemes and energetic, but confident brushstrokes. In 2005 she made an edition for *Parkett*, a combination of lithograph and woodcut picturing Timothy Leary's severed head in a giant ice cube.

After the tornado, Schutz declared that the Emmett Till painting was not for sale and had never been intended to be.

JS Your example shows how complex the processes, how varied the attitudes and how sensitive the feelings can be in art and society. It takes profound understanding and a very broad horizon to appreciate and solve a problem of that kind. Do you know anybody who has those qualities?

JB Do you mean someone driven by curiosity and with a cosmopolitan outlook, someone obsessed with keeping track of the latest in art all over the world? Well, I'm proud of our unstoppable Hans Ulrich Obrist and admire his passion and energy. I've known him since he first started out. *Parkett* published his very first text about Roman Signer in 1990. Obrist is a great admirer of Édouard Glissant from Martinique and his idea of "creolization," a productive form of a postcolonial melting pot of cultures, in which divergent influences remain complex and flexible, thus counteracting arid homogenization.

JS I was thinking of somebody from a much younger generation. After all, that defines our epoch: suddenly there are young people like Greta Thunberg, who advance disruptive points of view with little regard for wisdom, age and historical ballast. Her "listen to the scientists" doesn't refer to the scholarship of niche disciplines like ours.

JB Greta Thunberg and more recently Amanda Gorman are lucky flukes, highly talented young women, role models who have captured the limelight because of their clearsightedness. [Thunberg's great commitment to climate policy cannot be discredited by her stance in the fall of 2023 regarding the Middle East conflict.] I admire Thunberg's and Gorman's persuasive fervor and the intelligence with which they communicate the urgency of the situation. The moment Joe Biden was sworn in, Gorman read her poem and ignited a worldwide, unprecedented "listen to the poet" that was more riveting than the "listen to the politician." Then there are wonderful young artists of the "listen to the scientist" variety who experiment with materials. For example, Pamela Rosenkranz with her intense and enlightening reference to natural science or Raphael Hefti, who produces the strangest things by using flawed physical and chemical processes. The effect of his work is incredibly refreshing in our digitalized world.

JS Do you know who Greta Thunberg sometimes reminds me of with her cardboard poster?

JB Thomas Hirschhorn?

JS Exactly: fighting the rest of the world with cardboard?

JB This poor material is ubiquitous, piling up at home every time the postman delivers a package. It's on the street for everybody to grab, it provides homes for the homeless and can also be used for protest posters. It's practically the most important material in Hirschhorn's practice. His extremely critical, social and political work flies in the face of the aesthetic orthodoxy of what works of art should consist of and it never takes a cold, methodical turn.

JS That's particularly apt in the art world, which doesn't produce truths, which doesn't make any hard-and-fast empirical scientific claims, which is speculative by nature. That gives me an idea: could your fascination with restoration have something to do with its proximity to forgery?

> JB Restorers—especially of the Brandi school—are required to make the distinction between original and restoration unmistakably clear and transparent. They keep meticulous records of all interventions in their reports. But I have no qualms about admitting that famous forgers fascinate me. They have talent, knowledge, a fantastic eye and critical insight. Otherwise, they wouldn't be able to deceive even top-notch specialists.

JS Let's address a recurring theme: art and utopia. Let's try and filter out what it is that interests you about committed art with its social dimensions and potential. In 2008 you published a text titled "Utopie und Gegengift" (Utopia and Antidote). So far, when I tried to ask you about the utopian potential of art, you said that utopias have too much pathos and it's hard to treat them with ironic detachment. Your essay helps me bring up the subject again. I suspect that it explains the basic framework of your interests. My thesis: in your case, utopia is related to situations, spaces, configurations, theater, to emotions and to the opposition between intimacy and "exhibition" in the broadest sense of the terms. But let's start with the title. What is the subtext of this duo, utopia and antidote?

> JB Utopia and art are closely related. Although art is a very palpable entity in the here and now, its umbilical cord is still intact, connected to what lies beyond reality and purpose-oriented reason. I shy away from utopian concepts that crop up in the neighborhood of stringent ideologies. Only when

the utopia contains its own antidote do I feel safe. But I do like the term "Utopia Station" that curators Molly Nesbit, Hans Ulrich Obrist and the artist Rirkrit Tiravanija coined for their contribution to the Biennale di Venezia in 2003. They organized Utopia Stations on other continents as well, interpreting the term as designating something transitory because the stations take shape differently in time, place, content and combination of contributors and then disband again. In the article you mentioned, I also wrote about Thomas Hirschhorn and his exhibition of 2005 in Chicago, *Utopia Utopia = One World, One War, One Army, One Dress*. It was about camouflage, a phenomenon that played an emblematic role as much in fashion as it did in the army. After 9/11, the United States was at war against Al-Qaeda and the Taliban regime in Afghanistan. Hirschhorn, a conscientious objector, exposed how camouflage is both a utopian and a dystopian attempt to make an absurd unity out of everything and everyone.

JS Camouflage is a good metaphor for the power of art. In a conventional context, camouflage makes things invisible but in art it has the opposite effect. There, it exposes conventions and draws attention to precarious moments or fragile situations.

JB And by repeating the term "utopia" in the title, Hirschhorn also draws attention to its ambiguity.

JS This leads, if you will, to a further utopian dimension. It's like breaking the sound barrier. The antidote protects you from fanatical pathos, like a helmet or protective goggles or hearing protection, in order to mitigate the shock of the epiphany of showing and revealing. When you're protected in this way, it's a little bit easier to submit to an unanticipated or overwhelming situation in order to find out more

about yourself. In this context you make unexpected reference to Richard Serra: "What interests me is the opportunity for all of us to become something different from what we are, by constructing spaces that contribute something to the experience of who we are." Laurie Anderson and also Thomas Hirschhorn create situative spaces.

> JB Let me explain the reference. One of Richard Serra's sculptures—it's on the main street of the Novartis Campus in Basel—is made out of five huge elements reminiscent of a pod of whales. When you wind your way between the elements, you are enveloped in a rich array of ocher-colored rust on the Cor-Ten steel. While walking you can see the play of lines created by the sweeping silhouettes and you notice how the shape of the spaces in between keeps changing. At the same time, you realize how the acoustics change in and around the sculpture. The sculpture is immersive, appeals to all of your senses and by the time you step out of this sluice of perception, your mood has changed. So for me, this artwork is also something like a Utopia Station. You can keep recalling the experience and you can imagine new situations in and with the sculpture, for example, how it might sound when it gets pelted with hail.

JS Serra in a hailstorm—a fitting image for the interaction between art and everyday phenomena.

> JB Just a few steps away from Serra's dramatically physical sculpture, you come across Laurie Anderson's diametrically opposed, weightless and invisible sound sculpture *Green*. It's located in a small park in front of Frank Gehry's building and feels like another Utopia Station. Loudspeakers are tucked into bird's nests woven out of willows and hidden in the trees or suspended from the branches as audible maple leaves. You hear recordings of subtle, exotic birdsong

or electronically generated high frequencies that sound like chirping insects or ticking clocks. Low frequencies make a bench placed around a tree trunk start vibrating. When you sit on it and put your feet on a metal plate inserted in the ground, you can feel the frequencies traveling through your body from head to toe. Elsewhere, you hear Laurie telling stories, her voice coming out of an Audio Spotlight. When you're in the park, you don't realize right away that you are in the midst of an artwork. Only when you start consciously listening to the disconcerting sounds do you realize that you are in a cloud of sound that subtly modifies the everyday atmosphere around you. SEE INTERMEZZO P. 238 + TEXT P. 239

JS The same space is perceived in a different way. So here again we're faced with a dual historicity: on one hand, the idea behind the artwork and the process of its creation, and on the other hand, the history of its reception. It depends on you as the viewer whether the creative force of the underlying idea can impact this history of reception, whether you can commit to the idea in a specific situation. Something like detachment as involvement?

JB Exactly. You have to get involved in detailed perception and extend your antenna to do so. This applies to everyday situations as well, for example, when you're surprised by a natural phenomenon. Remember our last Zoom conversation, you in Lausanne and me in Zurich? Suddenly the evening sun shone through your window and the rays fell across your monitor; you were bathed in a sea of radiant light and encircled by a halo. You were the epiphany of Apollo in the digital age. I took a picture of this miracle.

JS But we were also more than receptive to a mini miracle after three hours on Zoom. "Umbilical cord" is what you call the phenomenon—an umbilical cord of art to the sphere

FIG. 142 Juri Steiner, an Apollo of the digital age.

beyond logic and rational thinking. Artworks like Richard Serra's are made of solid material; they are weighty, massive intelligible blocks. But you can't appreciate them with rational thinking alone. Visual forces give form. They stabilize feelings.

> JB I like your idea that art stabilizes feelings or emotions. That means art gives them a form in which you can discover your own feelings and moods, good and bad. That creates a sense of familiarity.

JS Yes, a kind of coagulation that releases another process of fluidity. You say that a work of art never comes to a definitive conclusion. It closes and opens, allowing for both intimate and collective experiences. That's also related to theater, a group experience in which a shared dynamic plays a crucial role. Have you experienced moments when intimacy and collectivity became especially entangled?

> JB Yes I have. I had an extremely bewildering experience of that kind In Laurie Anderson's show *Dal Vivo* in

the spring of 1998 in Milan. She was doing a teletransportation of the multiple murderer Santino Stefanini from the San Vittore penitentiary into the Fondazione Prada. There was only a small group of people at the preview. Eros, the prisoner's 12-year-old son, was there with his mother and of course Laurie with Lou Reed, Germano Celant, the curator of the show, Miuccia Prada with her family, Bice and me. The moment the video projection of Stefanini from his cell appeared live on the full-size, seated plaster figure of him in the space was overwhelming. You couldn't help wondering what's going on, who am I looking at eye to eye, what is Stefanini thinking and feeling? How will Eros cope with the transfiguration of his father, seen for the first time outside the prison walls? We stood in silence in front of the figure for maybe 15 minutes; it seemed like an eternity. Laurie had told Stefanini how he should sit: straight ahead on a chair, hands on his knees, looking directly into the camera. He was to remain completely immobile and the sound was turned off. The prison administration had, in turn, stipulated that he was not to give the least hint of a sign, otherwise the video would be instantly interrupted. In the cell there was a monitor beneath the camera on which Stefanini could see the contours of his seated figure so he could make sure that he was precisely congruent with the projection on the sculpture a few kilometers away in the Fondazione Prada. Even though he could neither see nor hear us, he knew exactly who was standing and watching him in the space to which he had no access. The tension of the teletransportation was almost unbearable, not least because of Stefanini's longing to be with us through this virtual escape; it was so palpable that it filled the entire room. I had never experienced anything like that before.

JS The situation at Fondazione Prada perhaps exemplifies what you mean when you talk about a mindset. It clearly

FIG. 143 Laurie Anderson, *Dal Vivo*, live projection of the imprisoned Santino Stefanini from his prison cell onto his full-sized plaster figure in the Fondazione Prada, Milan, 1999.

reveals the intense curiosity with which you approach an object, and how meticulous you are, both practically and theoretically, your awareness of how time complements space and your concern regarding integrity, wondering if the prisoner is being exploited to satisfy the voyeurism of a privileged upper-class in Milan. At the same time, your interpretation incorporates Laurie Anderson's intention of creating an archetypal setting, evoking extremes from the electric chair to the throne of the Pharaoh. Her representation of humanity relates to Homo sacer, to sacred but also outlawed humanity. And all of that appears to you in an epiphany, a representation that bundles cultural, artistic and aesthetic strands into one concentrated focal point—a quintessential example of art as you understand it.

And it is not "simply" about the fine arts, about a painting or a sculpture. Laurie Anderson's work is also theater and happening. That makes me wonder what role you yourself play within the complex drama that unfolds before you.

> JB Because works of art play such an important role for me, I try to respond in kind by playing the role of the best possible viewer, by encountering them with the utmost concentration

and letting the associations play out. And when I write about them, I put on the hat of a mediator and communicate my perception.

JS For me, your evening at Prada could be interpreted more as an overarching metaphor than a concrete situation.

> JB It was both. We were intensely present for Santino Stefanini and he was intensely present for us. Unconditionally in the here and now, exclusively and mutually focused on each other. At the same time, in the epiphany of the teletransportation from the penitentiary to the art space, Laurie gave him leave to be a human being with all, literally all of his potential—regardless. By presenting him in the classical position of a seated figure, who, as said, could as much be a man on the electric chair as a Pharaoh or Pope on his throne, she also highlighted the fundamental dignity of humankind.

JS These codes have to be recognized and deciphered, otherwise all that remains of the video installation is the projection of a somewhat blurred figure sitting on a chair. So you are much, much more than an audience. But you are neither the actor nor the author. A director perhaps?

> JB The director of my own perception, my intuition, my thoughts and my faith in the artist. But it was only afterwards that I was able to make some kind of sense out of the event. At first, I was quite simply overwhelmed.

JS And you never run out of stimuli. Even when you're bored, right?

> JB I'm never bored; there is always a stimulus of some kind. Actually I long for boredom, just plodding along, dolce far niente...

JS ... when you feel that from now on things will take care of themselves and you can just lean back. In reality, you have to start from scratch every time.

> JB I'm driven by curiosity and curiosity drives me to art and that's full of energy.

JS What would you say to a young person who is passionate about art but without your experience and practice, someone who still has to learn the craft?

> JB Spontaneously I would say: choose some role models, maybe study Joseph Beuys, who was a utopian thinker or social utopian and declared that everybody can be an artist. Obviously, he didn't mean that everybody should start drawing or painting or sculpting or filming. Rather, he introduced an expanded concept of art and encouraged creativity in everything people think and do in everyday life and in every job.
>
> Herbert Lachmayer takes a similar approach when, as mentioned, he distinguishes between lifestyle and *Lebens-Art*—with a capital A. Lifestyle intrudes everywhere but the Art of life is personally motivated, though of course, not without the inspiration and influence of others. So you have to become a *Lebenskünstler*, a practitioner in the art of living. That's extremely demanding and has to be questioned again and again. That's what I would want to pass on to a young person.

JS Your curiosity—cultivated as best you can—so that you can defend and assert it?

> JB Yes, that's a source of energy and enhances the quality of life.

JS But you still need a certain detachment from what you do—which is the playful aspect in our case. Not just as in Schiller's notion of merging into pure existence but rather as an antidote to pathos, as a lightheartedness of the kind that enables you to find the frequency with which you can "receive" a sculpture by Richard Serra.

> JB That's true. I shy away from things that are too exaggerated, affected or melodramatic; I prefer the gentleness of elephants, which is what you find in Serra's gigantic sculptures.

JS "The gentleness of elephants": that's extremely Italian!

> JB That's why I like the commedia dell'arte; it's farcical and always improvised, mostly with exaggerations that are surprising and entertaining—profundity wrapped in lighthearted slapstick. The commedia dell'arte dates back to ancient times. Since the 16th century it has enjoyed great success as popular theater, with itinerant troupes performing in the streets and at court. Shakespeare, Molière, Goldoni, the Dadaists, Giorgio Strehler, Robert Wilson: commedia dell'arte inspired them all, directly or indirectly.
>
> The characters are typecast, masked and costumed. They are parodies of human weakness and they expose hypocrisy. Even in the darkness of plagues and wars, the commedia dell'arte maintains its gallows humor instead of sinking into the doldrums. That is what we all want.

JS The characters are surprising because they show depth even as stereotypes. They're spontaneous; they're not just the stereotypes they represent because they're not melodramatically exaggerated; suddenly, they become radiant. And of course, irony undermines moral pretensions.

JB One of the characters is Pulcinella, who plays the country bumpkin but is actually extremely clever like the classical fool, a character who also comes from that tradition. I think everyone in power today should have a fool on their staff. We would have a better world and certain presidents would not have to play the fool themselves, and badly at that.

FIG. 144 Nicolas Bonnart, *Pulcinella*, ca. 1650, etching.

JS There's something touching about the image of a gentle elephant. It's not just about unmasking a bogeyman; it's a tragic attempt to see at least some sort of grace and tenderness in the clumsiness that is inscribed in the figure. The effect can be amusing but it's also empathetic. This kind of humor is not cynical, not exclusive.

> JB But we also like the lechery and the perversion on the stage. You would probably rather play the cannibal Hannibal Lecter than the Archangel Gabriel. After all, evil is humane, too.

JS "Humane" is a quality that thrives on ambivalence. It's like juggling, you have to keep the ball in the air. *Mia Commedia dell'Arte*—the title of the book is endearing. I almost miss the antidote.

> JB The antidote is inherent in the commedia dell'arte—in the ambiguity of its texts and actions or in the trick of unmasking through masks. Come to think of it, isn't every work of art a kind of mask that hides and reveals at the same time?

JS I think you have to warm up a little bit to understand that. There probably aren't too many English-speaking people who are familiar with the principles that underlie the commedia dell'arte. The word "comedy" has a touch of slapstick about it, like an actor dressed as a woman storming in stage right, twirling around, farting and slamming the door as he storms out again stage left. Commedia dell'arte is chiseled, sounds like Ristorante Alfredo in New Jersey, you can hear the popularity. In contrast, *My Commedia dell'Arte* sounds almost like a pasta commercial, like a duplication of the cliché. But I think this kind of jolt is interesting because the title suggests a lightness although it's not so light when you think about it. Besides, it's related to everything we've been talking about since we started with your cultural, Italian anchor points. We were circling around this title, trying to keep it up in the air until the end. Do you know what I mean?

> JB I certainly do. I like your associations with the title. They widen the span to include the popular. But the word "commedia" can be misleading. It's not just slapstick. Think of Dante's *Divina Commedia*, the journey through Hell and Purgatory on the way to Paradise. The title *My Commedia dell'Arte* was a spontaneous idea. I had first thought of

"In the Magnetic Field of Art" to express how strongly I am attracted to art, how it energizes and moves me. But nobody liked it, and in the end me neither.

JS It would have been more pretentious.

JB Exactly. When we were discussing the title at a meeting at the publishing house, Patrick Frey said it could also be something in Italian, and instantly, without thinking, "la commedia dell'arte" occurred to me. Laurie Anderson was in Zurich at the time and suggested that I make the title more personal: "My Commedia dell'Arte." It would give me more leeway. Everybody liked it.

To make the cover of the book match the title, we asked Herbert Lachmayer and Kai Matthiesen—they often work together—if they would design what Herbert calls a "hermeneutic wallpaper." Herbert, who has never been fond of white cubes, stages kind of performative exhibitions somewhere between art and theory, pursuing a strategy that he calls "Staging Knowledge." That's why for his mise-en-scènes he has furniture, carpets and wallpapers created with motifs related to the exhibition. Here, on the cover of the book, wonderful people are playfully linked, people to whom I am deeply indebted and who have contributed pictures and words to this book. Among them you, Juri, as well as Laurie Anderson, Herbert Lachmayer, Kurt Forster, Katharina Fritsch and Pipilotti Rist. It features the heads of Giulio Romano, Isabella d'Este and Kairos and includes my favorite animal, the octopus, as well as a multifunctional tool to show how much I love craftsmanship.

JS *My Commedia dell'Arte*: it's a dazzling title, perhaps because it comes from language. You tend to play more with images than texts anyway and you've said that you're more detached as a writer. You seem to be more personal, to go

further in visual arts, maybe because it's a non-verbal referential system of showing. Texts are trickier. You either say something, or you don't.

> JB I feel freer as a curator hanging an exhibition than in the role of the art historian or critic. But as a restorer I'm literally the butler who bows to the needs of the artwork, especially because I can do much more damage to the painting with solvents and a scalpel than I can do with the wrong words.

JS That has to do with integrity. But you're not a stickler either, and when you fib—and I think you like to fib—you fib more when it comes to visual worlds. The text seems to be too serious a matter for you.

> JB Quite so. When I study an image, a whole host of associations instantly comes to mind and my imagination goes wild. When I'm writing, I also weave the outside perspective into the text. And later the labyrinthine thoughts and phrases have to be whipped into shape. Obviously, in the professional code of restorers and art historians there's no quibbling with the truth, that's a matter of honor. But when artists, writers, or filmmakers succeed in creating glorious flights of fancy by piecing together fabulous stories and interpretations, that's art. But let it be said: good fantasists who create an authentic work must also be good realists. Reason and intuition always go hand in hand.

JS Are linguistic transgressions more powerful or harsher acts of liberation than visual transgressions? What do you think?

> JB When Laurie Anderson sings "language is a virus," she's quoting William Burroughs and acknowledges the

power of language to spread and hold sway over people. Juri, you know all about the games Dadaists play in advancing thoughts that know no boundaries, spontaneous, unbridled thoughts that come in a flash and are written down like "écriture automatique" (automatic writing). These acts of liberation are just as radical as visual signs. But it's a different matter when you have to weigh, bundle and write down your thoughts in a specific discipline. Then you do have to conform to the rules of grammar, spelling and style.

JS Dada's *décervelage*, a kind of literal brainwashing, had an incredibly liberating effect on language. With their "fmbsbäwätätäs" and "rrrrrrrrrrrrrrrrrrrrrrrrrrrrrrrrrrrs," all the Balls, Schwitters, Tzaras and Hausmanns attacked supposedly rational language—and without a safety net. They dared to defy a society that was choking on its own principles and lies. Dada gave art leave to exploit caprice, wit and idiocy. That's not quite up academia's alley.

JB Artists, writers and poets can do that. It's part of their discipline; it's not arbitrary. There are also talented scholars and theorists, who have the gift of making their writing urgent and vibrant. But what is hard to take is pompous drivel, wordy, rambling purple prose, incomprehensible paraphrases, or poor translations. Readers should always have room to think for themselves and read between the lines. Sometimes small, precise hints are all that is needed. We cultivated a wide range of styles in *Parkett*. We didn't want standardized writing, and we didn't have a team of writers. Instead, for each issue we invited specialists from different fields to write for us or writers like Kathy Acker, Elfriede Jelinek, John Waters and Marina Warner. And depending on the character of the texts, we would choose a suitable translator. From the very beginning, we worked with Catherine Schelbert, who translated from German into

English. She has such a good feel for language that I occasionally adjust my text to match her translation. Her motto: "You don't lose things in translation; you find them." It's no wonder that she became the first translator to receive the Prix Meret Oppenheim, which is awarded to practitioners and mediators in the arts.

JS A word about your relationship to "foreign" languages...

JB Foreign languages and idioms have always been part of my life. Besides, we live in a country with four official languages and numerous dialects and accents, so we're always translating anyway. I grew up in five different countries and in addition to the Basel version of Swiss German spoken by my parents and my nanny's Bernese dialect, I automatically picked up Swedish, English, Italian and French as a child, though obviously with a reduced vocabulary. The only thing I really had to work at was High German. When I moved from Bern to Rome at the age of 11, I spoke perfect Bernese German but had no idea where the city's landmarks were—the Zeitglockenturm, the bear pit or the Parliament House—let alone the Jungfrau, Mönch and Eiger mountains. In school they thought I was brain-damaged or had spent my childhood locked up in a cellar. The teacher had to summon my mother to get things straight. Place and language were often dissociated. Now, after living in Zurich for over 40 years, I speak a watered-down version of the Basel dialect.

JS The search for style and identity in various spheres of expression is fascinating. *Parkett* was a magazine in words and pictures with a museum annex. It was a small world theater in its own right, consisting of various components. The makers of the publication wanted *Parkett* to be an experience. Image and word were equal. Does the same principle apply to *My Commedia dell'Arte*? What is included there?

How many personal pictures? That would also be a matter of "interval," wouldn't it?

> JB We'll see what needs to be illustrated or can only be expressed in words—or where there's too much vanity. For example, the photo in Schloss Gümligen near Bern, where we lived for a while. My mother is dressed to the hilt and we two children are all dressed up as well. My editors Mirjam Fischer and Theres Abbt thought the picture should be in the book, but I was a little reluctant. I didn't want people to get the impression that we lived like that all the time.

JS Yes, that reminds me of Annie Ernaux. We talked about her at the very beginning in our preliminary conversations. She was very blunt about showing pictures of the past; she wanted to make what is subjective, intimate, seem more objective. Each photograph speaks to us from a very specific time. The content gradually becomes either more personal or more collective. In your case, the Christmas photo at Schloss Gümligen is more bourgeois, almost aristocratic.

FIG. 145 With my mother Lucie and brother Muck in Gümligen, 1950.
FIG. 146 I've had a preference for tools since my childhood.

FIG. 147 Photograph for the exhibition *SUBJEKTe.AT* in Feldkirch, 2019.
FIG. 148 Peter Fischli & David Weiss, *Theorie und Praxis*, 1981, unfired clay, 11 × 25.5 × 13 cm (4 ⅜ × 10 × 5 ⅛ in), an image that symbolizes all that is important to me.

JB I paired it with another childhood photo to show how much I always loved crafting things. I'm holding my beloved wooden hammer instead of a doll.

JS You edited a small autobiography of your mother's. Didn't I see the Gümligen photo there? But the picture of you and the little hammer is missing.

JB That Christmas photo is more about my mother than my brother and me. My parents moved in diplomatic circles at that time. There were a lot of these gala dinners. But the setting nevertheless shows how privileged I was growing up. I can't pretend that I had to fight hard by myself for everything that has happened in my life.

JS You certainly lay no claim to being a self-made woman. For you it's about the distinction between lifestyle and *LebensArt*. Pictures can illustrate this difference very well. Besides, we are interested in the pulse of the times. How does something subjective become collective and, above all,

how does a hermetic, subjective moment open up to society when it comes from art? To me, that's where *Parkett* comes in, with its refreshing, surprising, unexpected approach. What is the secret of this surprising effect? It's related to the people behind it, the combination of the people involved, who dared to follow their intuition. That's why it's interesting to ask where Jacqueline comes from. What is her mindset? How did she influence the times? Annie Ernaux is interesting in this context. In her autobiography, she talks openly about everything, no taboos. But the word "I" never appears. That is where she draws the line. She makes it possible to be discreet in a project of exposure. That suits me; I'm not an investigative journalist.

I would like to be given insight into a principle of curiosity through your intellectual biography, a reading list, if you will, and a reflection through your life companions who try to focus on complexity. And I'm glad that it's not going to be a Festschrift, presented to you, to touch you and that's going to surprise you. I think it's crucial for you to be personally involved. It has to be your statement: a story that you tell and you decide what you want to tell. But you're not like Leni Riefenstahl, who had to bowdlerize her biography.

> JB By using the passive tense instead of writing in the first person, Annie Ernaux succeeds in blending her own memories with the collective memory. In my case, it's a little different. The idea of my editors, Mirjam Fischer and Theres Abbt, was to present me as a being who, in her commitment to art, always takes on different roles. Your questions made me think and made me aware of the connections between the things I've done, which never followed a plan. It's as if things were destined to develop through a series of coincidences or crucial encounters or maybe thanks to Kairos, the Greek god of the right moment. He has wings and a lock of hair on his forehead, but he's bald in back, so you have to grab him right

FIG. 149 Francesco Salviati, *Kairos*, ca. 1545, fresco in the Palazzo Vecchio in Florence.

away. Once he passes, it's too late, because you can't grab him from behind. In English they take the bull by the horns but in German they talk about *die Gelegenheit beim Schopf packen* (grabbing the opportunity by the tuft of hair), meaning Kairos.

JS In our lengthy conversation, we've tried to establish favorable moments. What follows is an editorial process, coiffing the mane, if you will. While reading the transcript, you'll notice where you have synthesized or smoothed transitions or where you've argued for the sake of effect. What comes next is like another bout with the lie detector, where you have to make sure your nose doesn't start growing.

JB That raises a question: How much control do we have over our own biography and its junctures? But do you know what? I think we'll just turn off the recorder. Stop . . .

PIPILOTTI
RIST

KATHARINA
FRITSCH

HERBERT
LACHMAYER

LAURIE
ANDERSON

ERNST H.
GOMBRICH

KURT W.
FORSTER

CATHERINE
&
TARCISIUS
SCHELBERT

PIPILOTTI RIST
Zurich, 2019.
p. 207: Jacqueline's passport photograph, 1966;
p. 208/09: Jacqueline with her father and brother Muck
in Sweden, 1954;
p. 210: Jacqueline in Sweden, 1953.

KURT W. FORSTER

Jacqueline on the Trail of Giulio Romano
A Letter from Como, Summer 2019

*Why instruction without invigoration
should be despised.*[1]

Jacqueline, when you started showing an interest in Giulio Romano, you were no longer an art-historical greenhorn. Your training as a restorer had established intimacy with objects, sharpening your appreciation of materials and how they are processed. You graduated from the Istituto Centrale del Restauro, a school that is not content to simply teach the craft but also aspires to a critical view of the past. The Istituto spearheaded a number of new techniques for restoring works of art, especially wall paintings. You occasionally recall how you worked on archaeological diggings in your youth, willingly sticking your hands in sand and dust in the scorching heat. That may not have led you directly to Giulio Romano, but it may well have smoothed and eased your path. It was not for want of resolve that made you decide, in 1977, to make Giulio's rather convoluted oeuvre the subject of your master's thesis at the University of Zurich. The Loggia dei Marmi—designated after the fact as so often in works of the Renaissance but nonetheless apt given that marble makes a crucial, though sparse, contribution—is located in the castle complex of Mantua where it forms the glorious conclusion of a new wing that Duke Federico Gonzaga commissioned in the 1530s. In your meticulous contribution to the noteworthy Giulio Romano exhibition of 1999, you trace the history of the architect's building campaign, having immersed yourself, as a true historian, in documents, drawings, fragments and divergent opinions. You later elaborated on your findings in your dissertation, *Giulio Romano, Regisseur einer verlebendigten Antike* (Director of a Revivified Antiquity), delineating

[1] Friedrich Nietzsche, "On the Use and Disadvantages of History for Life," in: *Untimely meditations*, trans. R. J. Hollingdale (Cambridge: CUP, 1907), p. 59. Written by Nietzsche in response to his reading of Schopenhauer and the impression made by Jacob Burckhardt's Basel lectures on antiquity and the study of history.

a picture of Giulio and the way he works that far transcends any conventional motivation for writing a thesis. As if to substantiate the possible connection between your interest in Giulio and your devotion to *Parkett* and the contemporary fine arts, the journal published your discerning character study in volume 21. You flesh out a stick figure to draw a striking portrait of him that brings to life not only his art but also the very man himself.

You say that you chose to overlook publishing of the book yourself rather than producing a conventional dissertation. The result unmistakably proves your point although one must add that, being privately printed, it has not received the attention it deserves. That's a pity because you offer new insights that refine our understanding of Giulio's art and show surprising ties to modern art practices, both agreeing with and opposing prevailing opinion.

Why is Giulio Romano's work so appealing to a growing number of art historians and even to people in general? One wonders, especially since, in the first half of the 20th century, he was largely stylized as an exponent of psychologically ambivalent times, as being typical but not particularly original. I must admit I can't think of a plausible answer to that question, but I will never forget a rainy day in October 1957 when I was standing with friends on the northern side of the Palazzo Te in Mantua; we had become involved in hot debate about which parts of the facade obeyed the rules and which didn't. I resorted to my red touring club guide to support my argument, using it to measure the distance between the windows and the pilasters to confirm what I thought was obvious and my friends didn't: something was wrong. There was something about this moss-encrusted, slumbering building that exerted a latent appeal, tremors of frailty underneath what was presumed to be familiar.

You also came across curious discoveries while studying the Loggia dei Marmi and unearthed Giulio's ideas in the process. For one thing, he used the papal chambers and their view of the Cortile del Belvedere in his native Rome as his measure; then again, he tried to incorporate the artworks of others in his interiors. Titian was meant to supply likenesses of the Caesars, which led to protracted correspondence and irritating delays and, above all, Giulio wanted to insert sculptures from antiquity (and ones that claimed to be) in the stucco frames and niches of the Loggia.

On comparing the drawings made of the completed work in 1567, after Giulio's death, with the present condition of the Loggia, you learned that several pieces were missing and the fittings as a whole had suffered considerable losses. You do not fail to prove that, through the centuries, others had managed to undo what Giulio had so ingeniously united, namely old and new, genuine and replicated, then and now. In so doing, Giulio had garnered the explicit praise of a writer who severally joined artists and clients, interfering in their affairs in proper Venetian fashion. Namely, one Pietro Aretino. He celebrated Giulio's art as a singular example of his time, describing it with remarkable *sprezzatura* as "anticamente moderno e mondernamente antico" (modern in an ancient fashion and ancient in a modern fashion). Rightfully so, one might add, and even more so after you proved with hairsplitting acuity how and where Giulio had embedded the ancient fragments in his newly invented context. Unfortunately, his work was dismantled, and it is thanks to your studies that its phenomenal character has been reconstructed. For once, destruction reinforces an original state *ex negativo*.

These unusual circumstances unite several aspects that relate to your education, activities and initiatives. Don't protest, especially since Giulio Romano's oeuvre is contemporaneous with not just one, but two people of importance to you. On one hand, the Duke's mother, Isabella d'Este, who died in 1539 by which time the Loggia was practically finished. She had installed two residences for herself in the same complex of buildings, with artists designing the interiors thanks to her multifarious connections. Her interests ranged from intricate sculptures and delicate arts and crafts to sophisticated literary paintings, from the cultivation of music mostly by Dutch composers to the study of literature and even ancient hairdressing. Her son Federico II, in his youth, had been under papal house arrest in Rome for several years while his mother served as regent of Mantua. Federico later commissioned Giulio to work for him and the artist became a driving force behind substantial change in Mantua. The city soon acquired a reputation in Europe, exerting an influence on Fontainebleau, Vienna and even Landshut in Bavaria, its radiance not fading until the 17th century upon the spectacular sale of the immense collection of Mantuan paintings to the English king.

There you have it: only a kind of clever "stage direction" that assembled artists in an arena, only an activity indebted to "personal acquaintance" with artists, and only a cultural, political "objective" managed to rescue the small county from being eclipsed by the contentiousness of the Renaissance courts. Even the state—one of the cardinal achievements of the Renaissance in addition to the personality, according to Jacob Burckhardt—defined itself largely through diverse works of art and through a politics and diplomacy that could not forgo works of art. Once again one cannot help comparing the way in which patrons in Mantua and your art journal *Parkett* managed to make an impact. An atlas of art such as *Parkett* would be inconceivable without the interplay between artists and collectors, without close acquaintances and empathetic participation. The archive of these activities necessarily includes the countless moments that can still be identified today in the correspondence of Isabella and Federico II with agents, artists and humanists, not in the dead digits of the past but in the sediment of a culture that well knew how to benefit from art.

You, Jacqueline, have clearly demonstrated how "clever" you are in working out larger contexts for your clients, whether it be an art grant, the design of business headquarters or, indeed, planning for an entire industrial complex. Like Giulio, who did it brilliantly, you too acquired insights into the work of specific contemporary artists and ran riot with them. You, too, discovered secret tangents in incongruity, and underlying tension in affinities. In Giulio's case, one might easily suspect that he dabbled in capricious surprise while actually making meticulous calculations, yet in the final analysis, something always remains that can only be read as emotion. I'm sure you'll agree that under a raw and rustic veneer, there lay a tactile and extremely subtle director of his own impact. Harshness occasionally proves to be soft, solidity to be decorative, as if not only our words but also the things themselves were interchangeable or at least unstable, depending on how we perceive them, whether in the crystal-clear light of morning or through a haze of autumnal mist. Your sensitivity to the larger context, your sense of nuance and responsiveness to changes in mood, give you an inexplicable confidence in establishing the ties that tip the scales between mere competence and singular success in any major undertaking. You have the

traits that distinguished both Isabella and her son, even contrasting ones, as illustrated by the undaunted balance that you maintain between single-mindedness and generosity. You have learned from Isabella and Federico much more than knowledge conveys and much deeper than feeling alone permits without donning that little jacket that Isabella stoically accepted, since her motto was *Nec spe nec metu* and she acted neither out of hope nor out of fear. Nor do you share her son's motto, for you are neither cold-blooded, nor driven mad by passion. Moreover, your profound commitment and cheerful nature stand opposed to Federico Gonzaga's almost confessional *Quod huic deest me torquet*, in which he turned the salamander into his creature of contrast. That rare harmony bestows a happy active life and shines united out of moments in rare works of art that would not have come about without you. When you speak of "revivifying" as Giulio's preeminent achievement—also for the pleasure of viewers—you arrest dry antiquarian interest in the past just as Goethe did and Nietzsche as well, quoting Goethe in the second of his *Untimely Meditations*: instruction without invigoration is not the answer. You sensed that before you knew it; therein lies the felicity of your achievement.

p. 217: Giulio Romano, preparatory drawing for Federico Gonzaga's lizard emblem in the Sala di Psiche, Palazzo Te, ca. 1527, pen, sepia, and crayon-drawn grid on paper, 13×27 cm (5¼×10⅝ in), private collection, New York. Text on the banner: "QUOD HUIC DEEST ME TORQUET" (What he lacks, torments me).

Giulio Romano, fresco with incorrectly reversed letters where a mirror image of the word HUIC should appear on the banner.

The lizard hasn't got what it takes. As a cold-blooded animal, it lacks the warmth of blood. By making it the subject of a confession, Federico Gonzaga has assigned the role of victim to the reptile. Federico enlists this emblem to confess that he is tormented by passion, while the cold-blooded lizard is spared the torment that the passionate lover must endure. But the lizard is also tormented—with fire—and punished with ink. The putti lose control while writing and mix up the letters. The words come skidding out of the banderole, leaving restorers still bewildered hundreds of years later. Had they taken a look at Giulio's preliminary sketch, they would have been spared their hypothesizing.

Giulio Romano's sketch of the airy loggia links flowing pen strokes with sepia colored brushstrokes. It was the manual of instruction for his team working on the frescoes of the Sala di Psiche (1526-28), but the artisans were obviously more interested in tormenting the lizard than in understanding the inscription. Even so, it is remarkable that a nimble lizard has to suffer for its lack of passion in this pavilion, while disinterested chroniclers do nothing but knit words of wisdom out of this torment.

CATHERINE & TARCISIUS SCHELBERT

A Dissertation Delivered

In 1995, we wrote to Ernst Gombrich, or rather "Sir Gombrich," to request an audience. To our surprise and delight, the great art historian instantly replied, informing us with delicious irony that upon being knighted, his dear wife had been deprived of her first name and he of his last; she had become Lady Gombrich and he Sir Ernst . . .

When we told Jacqueline about our imminent adventure, she wondered whether we might give him her dissertation, *Giulio Romano, Regisseur einer verlebendigten Antike* (Director of a Revivified Antiquity), since Giulio Romano had also been the subject of Gombrich's dissertation (1934/35). Hers had unearthed new information about Giulio's Loggia, based on drawings by Ippolito Andreasi (1567/68) that she had found in archives thanks to a tip from Kurt Forster. (see fig. 9, p. 29 and text p. 44)

When we arrived, Sir Ernst and Lady Gombrich welcomed us with Sachertorte and coffee in the modest parlor of their modest home, where they had been living for a long, long time. A grand piano with a cello stashed away underneath dominated the room. It was covered with sheet music; Lady Gombrich was a pianist and Sir Ernst played the cello, though not particularly well, he informed us with a chuckle. And, by the way, he had a good friend in Zurich, the artist Max Hunziker, for whom he had written a tribute in 1975.[1] Did we know him? We had no idea.

We four sat happily squeezed around a small table in the corner, speaking about the purpose of our visit. Tarcisi was compiling a fifth-grade reader for schools in Switzerland and wanted permission to reprint a passage from his book *Eine kurze Weltgeschichte für junge Leser* (1935)[2]—our flimsy excuse to visit the great art historian. Having been approached by Walter Neurath, a young Viennese publisher, Gombrich, then 26 years old, had written the book in a brief three months. The result was highly acclaimed and Gombrich remarked that its success may have been due to his

conviction that whatever you want to say can be said simply and clearly enough to be comprehensible to a child.[3]

Except, of course, in the case of the German verb *schlagen*. In English it means both "to strike" and "to knight," for which reason a 12-year-old girl in Zurich asked us: "Did it hurt when the queen knighted him?" When we told this to Sir Ernst, he responded: "Tell the little girl that she's a very gentle queen."

On our return to Zurich, the first thing Jacqueline asked had nothing to do with Giulio or her dissertation. All she wanted to know was what pictures Sir Ernst had chosen to hang on the walls of his home. We hung our heads in shame. We didn't know; we had only looked at his book and talked about words and music. We have never stepped foot inside anyone's home again without checking out the walls—even furtively if need be.

A Letter Lost

"Did Gombrich ever get in touch with you?," I asked Jacqueline when she presented her book *La mia commedia dell'arte* at Galerie Paravicini in Lucerne.

"Yes, of course, and we wanted to publish his letter in the German edition. I turned the whole house upside down with my two editors trying to find it. I'm distraught, it's just plain lost—forever, I'm afraid."

1 On the occasion of receiving the Kulturpreis der Stadt Zürich. See: https://atelier-max-hunziker.ch/251-2; see also: Hans Neuburg, "Glanzvolle Verleihung des Kulturpreises an Max Hunziker," in: *Die Tat*, no. 200 (Tuesday evening, August 26, 1975), p. 8.
2 Gombrich's unfinished translation into English was completed and published posthumously by Gombrich's assistant Caroline Mustilla and his granddaughter Leonie Gombrich. At the end of his chapter, "A New World," Gombrich writes, "This chapter in the history of mankind is so appalling and so shameful to us Europeans that I would rather not say anything more about it." Ernst H. Gombrich, *A Little History of the World*, trans. Caroline Mustill (New Haven and London: Yale University Press, 2005), p. 179.
3 Ernst H. Gombrich, *A Lifelong Interest: Conversations on Art and Science with Didier Eribon* (London: Thames & Hudson, 1993), pp. 43-44.

"That's no problem. You Zwinglians in Zurich with your *bilder-verbot*—no pictures, no saints, no anything—you underestimate our divine deputies. We have St. Anthony; you just have to drop a few coins in his offertory box for him to take action." So the next day I put a 20-franc bill for St. Anthony in my pocket and on my way out, walking past our bookcase, I espied—flanked by Arnold Bennett's *Literary Taste* and Buckminster Fuller's *I Seem to Be a Verb*—the radiant white spine of Jacqueline's dissertation. When I took the book down, it fell open to a page containing a slightly crumpled piece of paper: lo and behold, a letter from Gombrich, not the one he wrote to me (I've been looking for that one ever since) but Jacqueline's, which she had faxed us at the time. So: no need to give St. Anthony the 20 francs: the thought was instantly quelled by my Catholic conscience. The offertory box in the local church is for St. Joseph and "bread for the poor," but saints are generous.

A few days later we received a letter from Jacqueline addressed to "Sant' Antonio, c/o Tarcisi & Catherine Schelbert." It contained a 20-franc bill. No second thoughts this time, I went straight to St. Anthony's, alias St. Joseph's offertory box. Maybe Gombrich's letter to me will make a comeback as well. I'll let you know in the second edition of this book.

pp. 221-22: Ernst H. Gombrich, London, 1995.
Reproduction of the photocopy of the refound fax of
Gombrich's letter from February 26, 1995.

19 Briardale Gdns
NW3 7PN
26.II.1995

Sehr geehrte Frau Dr. Burckhardt,

You have given me great pleasure by having Mrs. Schelbert deliver your interesting doctoral thesis to me, and I thank you warmly. The Loggia dei Marmi has always interested and, indeed, intrigued me because it was obvious to me that we no longer see it as it was planned.
All the greater my delight that you have tracked down the matter. And your interpretation seems most persuasive to me. I'm convinced that ancient statues were "revivified," the way a child brings its dolls to life. I do hope the comparison doesn't shock you. There is, after all, something playful about the whole. I am reminded, for example, of a letter by Bembo in connection with Raphael's stufa (I don't have the text at hand) in which he writes about the statue of Venus and Mars.
Even Francesco Pico's approach, which I once published in the Hypnerotomachia, moves in this direction. (Symbolic Images)
On the other hand, I must confess that the role of Neoplatonism, as described at the time by Panofsky, Wind and also by me, hardly seems so crucial anymore. My younger colleagues at the Warburg Institute contributed to my disillusionment!
It would be to a pleasure to converse with you about one or another of these open questions. You come, no doubt, to London occasionally? Then call me at (071 435 663 97). Once again thank you!

Most respectfully yours,
E Gombrich

KURT W. FORSTER

A Tribute to Jacqueline Burckhardt
New York, Fall 2019

Talent attracts attention, and if it is not entirely self-contained but rather tutors action, one takes note. Laypeople are wont to be surprised and specialists wonder because specialists are not only piqued by curiosity but consistently collect new insights. Jacqueline Burckhardt's talents point in several directions and unite much that we ordinarily encounter separate and distinct. Her finely chiseled aptitudes, springing from family sources, are close at hand, but they also make far-flung and surprising connections. The tension generated by the familiar-unfamiliar and by ambiguity sets the pendulum of her interests in motion. Its centrifugal force vanquishes weight and has done so for years. And like the pendulum, Burckhardt's interests describe more than their span because the ground underneath moves, the earth rotates, and the scene changes in the course of days and times. In contrast to the pendulum, the world turns slowly and at times almost imperceptibly, but the eye remains alert and the beat steady.

Where did she learn that, one wonders, and how does she sustain the movement? Certain things are self-evident given her steadily evolving faculties; others raise questions and elicit hypotheses. Jacqueline spent her youth in several countries and conducted her studies as a restorer and art historian in Italy and Switzerland, a circumstance indebted to her family's funambulism between Italy and Switzerland. An Italian cadence still resonates in her Basel dialect, though without renouncing hearty dollops of Zurich dialect. This Italian-Helvetian twin heritage has a venerable history across generations, even through decades of political contrasts and economic conflict. The gravity of the Basel lifestyle and education may well have reinforced the bond, in conjunction with still another trait rooted in both families: Jacqueline is also motivated by the love of something that is not amenable to being loved, that becomes lovable only through devotion and commitment. A grandfather, part owner of a tannery in Italy, made the acquaintance of a singularly unappetizing parasite, the botfly,

and its damaging impact on the leather business. A circumstance that merely served to enhance his entomological interest. His expertise and his considerable collection of multifarious flies impressed Jacqueline, for though different and distinct in countless ways, the specimens were clearly governed by a systematic order. The balance between fascination with these exotic creatures and their unsavory associations may well have exerted an early influence on Jacqueline's tolerance of mixed feelings.

She is quite capable of recognizing the faddishness and machinations of artists without the least belittlement of art or impairment of her unerring instinct. Dubious output or even falsities may well sharpen the perception of things that home in on essentials. Such a vibrant faculty is buoyed by a diversity of observations; it springs from almost instinctive behavior in which she always questions herself as well. Jacqueline does not draw conclusions based on opinions; instead, she takes an anticipatory, open-ended, but never calculating approach. Only after the fact does calculation lead back to the trail that makes conclusions possible. A circle has to submit to being squared without omitting or eliminating anything but also without a surplus of preconceptions.

The extent to which Jacqueline's relationship to art rests on a mindset and not on convictions is proven by the breadth of her activity and the multiplicity of roles that she plays. As a longtime member of expert committees, she knows that arguments cannot remain abstract and private but have to lead to decisions. Art committees and grant panels are sandboxes for debates against the backdrop of a broad horizon. For decades Jacqueline has endured and made fruitful use of these tensions to foster relations between committee and artist, and thus to serve the cause of art. Not only has many a candidate proved to be a genuine artist and not a mayfly, but promotion itself has been foregrounded in discussions and has yielded consequences that can be traced over many years.

Upon founding the journal *Parkett* (1984-2017), Jacqueline, Bice Curiger, Walter Keller, and Dieter von Graffenried shared the business of selecting artists and staff, without impinging on the casting vote of editor-in-chief Bice Curiger. The upshot of their

enterprise was a singular inventory of what artists achieved in the course of three decades, decades that have been written off by many as a mire of arbitrariness and even triviality. Others conventionally countered this opinion by banking on the art world's luminaries and market leaders and effectively dulling a perceptive response to contemporary, splintered diversity. Acting on juries and expert panels, Jacqueline kindled debate that paved the way to an appreciation of offbeat and unorthodox output, while also steadily refining another of her talents: intuition and a distinctive skill that relies not on preconceived notions but on her own experience.

An aspect difficult to explain among prominent patrons of the past sometimes remains unanswered in Jacqueline's case as well, in fact must remain open ended like the subject matter itself, since exclusion of any kind (for which one can only put forward arguments and hardly an appreciation of the situation as it stands) has always contradicted her convictions. For instance, the intelligence that guided Isabella d'Este's relationship to artists near and far, and the persistence with which she kept track of what was yet to be created demonstrate, in retrospect, an almost somnambulistic ability to be on target. It is this ability that defines the distinction between a collector and a patron. One might well invoke Isabella d'Este and even Christina of Sweden as precedents, given that Jacqueline is also inspired by the vision of connecting with artists rather than buying and accumulating works. One is tempted in this context to conclude that the difference between male appropriation of art and female patronage of artists is not incidental but defining. The modern *salonnière, nascent* in Isabella d'Este and Christina of Sweden and marked by a passionate interest in art that is inseparable from the enthusiastic embrace of important minds and new ideas, did not come into full flower until the 17th century in France and the 19th century in Berlin. Catalytic and indeed magical are Jacqueline and Bice as contemporary counterparts. The consequences of their encounters with artists will not be forgotten, implicit as they are in such important public works as Sigmar Polke's 12 stained-glass windows in Zurich's Grossmünster, their path paved and smoothed by Jacqueline. Modest in her role as collector, Jacqueline has proven to be anything but in negotiating commissioned work. More than once she succeeded in putting the one predestined, unmistakably

right artist in a position that enabled a work to emerge, not only finding but even creating the one right spot for itself.

Commissions differ from collections and from patronage through an engagement both social and intellectual; they rely on cooperation and call for commitment to an outcome whose definitive shape is as yet unknown to both artist and client. Jacqueline has commissioned countless artists, in most cases not at her own bidding but on the behalf of public and private museums and enterprises. Cases in point are Polke's windows and some twenty unique projects for the Novartis Campus in Basel.

The impact of the journal *Parkett* is enduring and worldwide; the works of art on the Novartis Campus make a similarly striking impression on those who assemble on campus to do research day after day. On one hand, *Parkett* fostered artists, much like *Pan*, *Genius*, and a few other publications did before and after the First World War; on the other hand, *Parkett*'s multiples substantially extended not only the scope of artistic categories but their aesthetic range as well.

The driving force behind the magazine *Pan* and the distinctive publications of the Cranach Press, which excelled with its striking artist's books, was the figure of Harry Graf Kessler, prime mover and nonetheless elusive. Initiator, matchmaker, propagandist in one, he disappeared from this complex equation of several unknowns almost without a trace, exercising a singular impact on the art of the 20th century. In this respect, Jacqueline's impact at Novartis is not only comparable to Kessler's at institutes in Weimar; she essentially set the goals for postindustrial research facilities. Projects of this caliber are, of course, still few and far between and rarely show comparable coherence even in university terrain. Besides, one must speak in the past tense because the time span between Harald Szeemann's plan and Jacqueline's campaign extended from 2005 to 2014. The then CEO and chairman of the pharmaceutical company's board, Dr. Daniel Vasella, launched an ambitious plan following the fusion of the two pharmaceutical giants in Basel. As a physician, who had married into the family of the chairman of the board at Sandoz, he transformed the Sandoz premises on the Rhine to the right and left of the old Fabrikstrasse into a "campus of knowledge" for future research at

Novartis. Although everything proceeded along seemingly well trodden paths, entirely new conditions have been created. The pattern of the turn-of-the-century factory complex delineates a curiously confined pedestrian zone, which Vittorio Magnago Lampugnani incorporated into this master plan, when he lined the streets with new buildings. To date, 17 renowned architects (Ando, Navarro Baldeweg, Chipperfield, Diener, Gehry, Herzog & de Meuron, Krischanitz, Lampugnani, Maki, Märkli, Mehrotra, Moneo, Taniguchi, SANAA, Marco Serra, Siza, Souto de Moura) have each designed a building and Frank Gehry placed a center of relaxation at a diagonal between the strictly orthogonal layout of administrative buildings and laboratories. The whole makes an impression that is more like a university than an industrial complex, but it would still lack a sense of leisure and a feeling of roominess were it not for another piece of land on the bend of the Rhine. Landscape architect Günther Vogt has transformed it into paleoterrain, as if the Rhine had long since exchanged its old bed for a rapid course and were now offering its sediments as gigantic folios to be read by astonished visitors. An artificial landscape as instructive material to illustrate natural history nestles up to an artificial urban complex (with an assemblage of—equally artificial—architectural artifacts) and therefore probably betrays the intention of putting up something that is anything but familiar despite the continuity.

How can works of art settle down and have the desired effect in their assigned location? That was the question Jacqueline faced in view of two extremely massive objects left behind at Novartis, like erratic blocks, by her predecessor Harald Szeemann. Ulrich Rückriem's long, oval-shaped, split boulder at the entrance and Richard Serra's undulating volumes at the tail end of the street axis guarantee a contemporary presence for stone and steel. It's a curious thing that the father of aesthetic *Attitudes* chose to bank entirely on matter and mass in precisely this location as if to shoulder the entire weight of its industrial past. Jacqueline's ideas would ensure an impressive contrast, ultimately pitting fragility against might and binding together the buildings of the Novartis campus with a delicate yarn of artistic invention.

In retrospect, three decades of *Parkett* might be seen as an
unintended prelude inasmuch as the artists Jacqueline recruited
for Novartis had already delivered evidence of their skill.
In addition, most of them were friends, which facilitated the
communication of clear ideas: ideas, not specifications, because
every building, every space in between has its own distinctive
needs. Ever since her years at the Istituto Centrale del Restauro,
Jacqueline has been well-versed in the materials from which
works of art emerge and, vulnerable as they are, into which they
threaten to disintegrate again. Anything that falls apart or
takes shape through movement alone does not slip through her
fingers but makes her even more alert. She was quick to discover
the quality of, say, Laurie Anderson's daring performances
or Pipilotti Rist's video art, not found in the work of many other
artists who rely exclusively on the impact of abstraction.
At Novartis Campus, the transition from Szeemann's plans to
Jacqueline's program took on the nature of a revolution in sensi-
bility and a transformation of the familiar. The outcome, she
hoped, would be a "constellation," an interrelated whole that would
transcend each single work of art. That meant finding the right
spot for each one and, at the same time, effecting an atmosphere
that embraces the entire complex. The notion of a constellation
implies that neither plan nor accident suffice. A group of stars—
or works of art—becomes a constellation only when the parts
relate to each other. This ordinarily succeeds only with minds
capable of forging intuitive connections out of vague circum-
stances. Jacqueline had undoubtedly cut off a slice of Giulio
Romano's talent given that he found himself transported somewhat
abruptly from sumptuous Rome to the provincial city of Mantua,
where, within narrow bounds, he was to salvage a semblance of the
severely tarnished city's former glory. Jacqueline had chosen
to make Giulio's novel art practice the subject matter of her
dissertation. In the process and despite the distance of history,
she became intimately acquainted with the problems posed by
polyphonic works of art, somewhat like a dress rehearsal for an
unknown play. Rarely is direct profit to be garnered from history;
all the more serendipitous when this succeeds. And, in this
case, serendipity clearly held its own, for it loomed large not
only in the reestablishment of a pharmaceutical concern under
the leadership of a man whose appreciation of history went hand
in hand with explicit visions of the future. The time was also

ripe to jettison hoary notions of art in the context of architecture and march off into the unknown with an entire corona of artists—truly kairos. Jacqueline rose to the occasion and survived. Art, like scientific work, holds the promise of a future and we sense the "air from another planet" as did others 115 years ago.[1]

1 Stefan George, "Entrückung" (Rapture, 1907), set to music by Schönberg in his String Quartet no. 2 with soprano solo.

pp. 230/31: Kurt W. Forster, 2021, *Pausen Flausen*, impromptu based on Isabella d'Este's emblem, featuring the depiction of musical pauses and beats on the ceiling of her grotto in the Palazzo Ducale in Mantua, ca. 1520. See conversation, pp. 49, 52.

Pausen Flausen

Wenn pausbäckige Posaunisten pausieren, dann tritt

Pausieren geht über Studieren, Weglassen über Kalkulieren

Unpässliche pausieren unfreiwillig,

Stille an ihre Stelle

Wer verstimmt ist, hat bestimmt verstanden, worüber andere schweigen

aber passgenau

Auch Einsilbige lispeln manchmal, bevor sie verstummen

LAURIE ANDERSON

Jacqueline and Me
New York 2019

My memory has many strangely shaped holes in it so drawing a time line of my long friendship with Jacqueline is difficult. It's filled with sharp spikes and bright lights followed by lulls when we didn't see each other, sometimes for long periods of time. And fact and fiction blur since spinning stories and alternate plots has always been our hobby. That said, ever since we first met I've felt that our eyes and minds were somehow trained in the same direction.

I'm thinking now of some long warm evenings on the Caribbean island of Mustique where we spent time together with friends on the winter holidays. Every sunset Jacqueline and I stared at the horizon straining to see the green flash. We never saw the flash but if our friendship were viewed as a story it wouldn't be a story, it would be many bright green flashes strung together on a very tall and magnificent Christmas tree, moments of great delight and insight spread over time.

We met in 1980 in Venice where I did a performance in a church as part of the Biennale. I remember that I set up my equipment on an altar and it was eerie telling stories and singing songs knowing that right behind me the whole time there was an enormous well-lit plaster cast of the crucifixion. Because of this performance I was often booked into churches in Italy when theaters weren't available. Maybe Italian promoters thought that I somehow preferred to sing in churches, I'm not sure. But I began to tell a joke about Jesus as a way of starting the concerts. It was a tasteless joke but it was fun to tell it anyway to see how far the audience was willing to go. I always thought that Jacqueline had told me this joke but she now claims I told it to her. So much for history.

It's a physical joke but I'll include the gestures.
Here's the joke:

Why is it a good thing that Jesus was born in New Testament times instead of Old Testament times?

And the answer is that in Old Testament times death was by stoning and that in New Testament times death was by crucifixion. So instead of people going like this (*makes the sign of the cross*) they would be going like this (*moves arms in front of face as if dodging stones*) which would have changed a lot of things about architecture. So for example instead of the cross-shaped ground plan of the church the buildings would be sort of strewn all over. Much more abstract.

Coming back to Zurich from Venice that June we arrived in an unrecognizable city. Many of the windows had just been broken, people were still wilding around in the streets. Violence had erupted in staid Zurich. Young people were demanding to be included in the cultural scene. At the time this rebellion seemed shocking and random but seismic things have a way of arriving at first as small signs.

Since 1980 many big events have shaken and reshaped the world and sometimes Jacqueline and I saw them together. I remember one night watching images of Iraq with Jacqueline as the Gulf War began before our eyes, the one in which the made-for-TV explosions were ecstatically compared to "fireworks on the fourth of July."

Shortly after we met on my 33rd birthday we had dinner in Zurich and Jacqueline made a meat corsage for me. She fashioned it quickly and expertly out of—I'm guessing—prosciutto ham, its pork petals drooping, shot through with delicate dark pink veins.

Other flashes include visiting the grave of Hermann Hesse
near Lugano. I'm guessing we had been nearby at the Locarno film
festival. Next to Hesse's grave was his wife's. Ausländer was
inscribed on her stone. I didn't realize that Ausländer was her
actual surname and we quickly began to imagine that she had
been assigned the heartless nickname Ausländer and squeezed into
a modest plot next to her husband's tombstone which was the
size of a small marquee with its Helvetica Bold HERMANN HESSE
inscription. With that wholly invented story we gradually worked
up a grudge towards Hesse and decided to leave some flowers
on his tomb along with a mean note.

Even though you're not
our favorite writer—
by a long shot.
We leave these flowers
On your resting spot.

When we first met I had only a hazy idea of what Jacqueline did. She mentioned some arcane facts about Giulio Romano and a thesis she was finishing. She also mentioned a job she had touching up old paintings. I pictured her wearing an old smock and carefully filling in the hairline cracks in Cubist masterpieces.

Around that time she showed me some old armor of her small ancestors leaning in a row against a wall in her house. She told me how ladies in Milan in the 50s would glue jewels directly onto their skin instead of wearing necklaces (more chic!) and she told me about her eccentric grandfather, whose name I no longer remember, who had two hobbies—studying flies and Roman leather. He even had a fly named after him. And apparently one day these hobbies collided when he found a fossil of his namesake fly in a piece of Roman leather and as a consequence slowly began to lose his mind.

One of my most vivid pictures of Jacqueline is swimming in the rain in Mustique where we were all the guests of our friend Franz Wassmer. The sun was at a low angle sending sparkling light raking across the surface. Rain and sun at once. We were disembodied heads floating in the sea watching the rain as it pelted down making millions of crystalline craters.

When we got the chance to work together we made things that seemed like strange dreams. The Green on the Novartis campus in Basel was a singing garden of trees with speakers in them. The speakers sang and whispered, harmonized and harangued in the branches. We made a pavilion for Swiss Expo in 2002 that gave the visitors a heavenly view of things sailing around on a tall ceiling.

I have so many other images that go on this big green light tree:
working with Jacqueline on an edition for *Parkett* of *Hearring*
(a small earring that screamed into your ear), a visit to Blinde
Kuh, hiking in mountains, talking late at night, trailing after her
around Zurich where she is basically the mayor, and looking
into Jacqueline's eyes where you can see the greatest kindness,
a lot of mischief, and a bright light in the center.

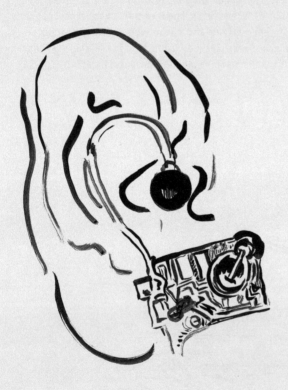

And now that we're old our friendship enters another phase.
As energy sometimes eludes me and we prepare to leave the planet
there are lots of new things to think about. I often ask her
opinion and when I asked her what to do about too many projects
she advised staying in bed in the morning. "Get a bed tray,
put your laptop on it, add some books, a cup of tea. Just stay in
bed. All day if you want," she said.

That sounds good and sometimes I do it. It rings a bell with
an experiment I made when I was 26. So I'll tell you one last story
about history. Here it is:

When I was 26 I had no idea what to do, so I decided to stay in
bed until I could think of a really good reason to get up. I stayed
in bed for months and I would just lie there and look at the
sky and sort of drift. At the time I could afford to do this because
I taught at night school. The students were mostly accountants
and secretaries who were on the slow track, going to school
two nights a week for about ten years. So I didn't have to get
to work until around six in the evening and mostly the students
were really late anyway or just too tired to concentrate.
I was teaching Egyptian architecture and Assyrian sculpture but
I wasn't keeping up with the Egyptological journals so a slide
would come up in class and I would look at it and draw a complete
blank. I couldn't remember a single thing about it. So I would
just make things up about this or that pharaoh and the students
would write it down and I would test them on it. I figured that
so much of history is speculation anyway that it was maybe
important to design theories for certain unexplainable things—like
in some of the pyramids there were these holes on the exterior
the shape of mail box slots and they were connected by a long
shaft that ran at an odd angle into the core of the pyramid down
into the mummy's chamber. And nobody knew why the shafts were
there and so what I told the students was that the slots and shafts
were oriented to the sun so that on only one day a year—let's
say for the sake of argument the mummy's birthday—the sun would
stream down the shaft into the inner chamber and shine into
the mummy's eyes and wake him up. Eventually I did feel a bit of
guilt about this, since this was supposedly a history course
and not free-form fiction, so I quit. Not before I was fired but it
was very very close.

As I look at my life now—sometimes back, sometimes forward—
I love to think of music and making things and beautiful scary or
strange places. But most of all I think of people I have loved.

And I think of Jacqueline who is a shining star.

HERBERT LACHMAYER
Zur Erbaulichkeit (For Your Edification), 2017,
colored pencil and ink on paper, 18 × 24 cm (7 ⅛ × 9 ½ in)

HERBERT LACHMAYER

Taste Intelligence
What is that?
What does this neologism have to offer as a concept?
Vienna, 2019

Suppose you find yourself in the position of having to bring endlessly protracted negotiations to a favorable conclusion in the newly occupied executive suite of a "major concern." What you need then is a spot-on assessment of the situation: that's where "taste intelligence" comes in. Whether you win or lose may well depend on the "first look" that has taken little more than a split second.

Splinters of associations, projections and other sensitive sensibilities are indebted to successfully checking things out. Aesthetic judgment is required to establish a balance between variously diverging and inherently contradictory components. And this very specific, fragile balance is generated by a spontaneity of judgment based on taste intelligence. The ability to make a quick, off-the-cuff assessment given a configuration of contradictory premises (without hypotheses and protracted falsification procedures) relies on balancing "contradictory aggregates": conscious/unconscious, dislike/like, empathetic/apathetic, knowing/feeling, naïvely wallowing/critically detached.

This bizarre array of antagonistic combinations becomes the stage where imagination and fancy are played out, allowing for the inspirations sired by the "interpretations of our taste intelligence." The rightness of the aesthetic verdict is instantly revealed by whether or not it takes the lead. Confirmation once again of the practical, real-world ability of our imaginative prowess to be concrete, to create reality with utmost precision out of a potpourri of possibilities.

And where does that leave art, the artist and Jacqueline Burckhardt? How can one envision or, more specifically, convey and establish a relationship between the everyday business world and the panopticon of artistic inspiration? What does Mozart's idea

for the melody of "A Little Night Music" have to do with the invention of LSD, especially since the chemist Albert Hofmann from Basel was actually trying to concoct a cough remedy? How can you make something incommensurable commensurable, incomparable comparable? It takes taste intelligence as "focus imaginarius," as a "secret focal point," which we need in order to disentangle the contradiction of "conscious/unconscious" while creatively reuniting the two at the same time. A paradox par excellence? Yes, indeed, and productive to boot.

The "sizzling" spontaneity (onomatopoeia intended) of taste-intelligent judgment is actually indebted to the hype of an extremely intensified attentiveness. This is not about the eternal dispute of "good" versus "bad" taste, which spawns endless argument. On the contrary, this is about spontaneously rising to the challenge, coming to a cognitively relevant conclusion with lightning speed at a moment of heightened attentiveness, arriving at a conclusion that "holds up."

It is here, in an unprecedented flash of taste intelligence, that the critically exacting reception of art and the production of art "at its finest" touch base together. What is happening? Every time the mind succeeds in bending the iron bars of logic, another kind of judgment is spontaneously activated, subtly paralyzing, demolishing, deflecting and wiping out the tyranny of logic and subversively granting entry to an entirely different dynamic of induction and deduction, namely, the unconscious. Then and only then do we apprehend the quintessence of taste intelligence, which comes into play at exactly that moment, namely when this regulating balance is activated, bringing the contrasting and contradictory flipside of presumed contingencies into permanent and accelerated play.

A singularly distinctive faculty for judgment bursts upon the scene for which there is no scenario; it goes by the same name as the title above. The author took inspiration for this concept from Jacqueline Burckhardt, merci.

KATHARINA FRITSCH
Düsseldorf, 2019.
p. 247: Tierbildchen Schlangenechse /
Animal card snake lizzard;
p. 248: Muschel / Shell;
p. 249: Hand / Hand;
p. 250: Die Nanis in den Bergen /
the Nanis in the mountains.

II
Texts

Jacqueline Burckhardt

O like Oppenheim or "× = hare"

Meret Oppenheim

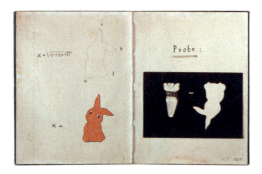

This text is based on an article in *Parkett* no. 4, 1985, as well as on two lectures, at La Loge in Brussels and Kunsthaus Aarau, 2018, and an article in *Quarto*, the journal of the Swiss Literary Archives, no. 48, 2020.

FIG. 1 M.O., *Schoolgirl's Notebook*, 1930, ink and collage, 20.5 × 33.5 cm (8 1/16 × 13 3/16 in).

Toward the end of her life Meret Oppenheim often came to Zurich, mainly to work with Bice Curiger, who was writing the first monograph about her. This gave me the privilege of getting to know her better. Meret was very involved in reviewing her life and work at the time, especially since the publication would contain a catalog raisonné that she was meticulously preparing with Dominique Bürgi. The German monograph came out in 1982, titled *Spuren durchstandener Freiheit*[1] in reference to a key statement Meret made during her acceptance speech for the Art Award of the City of Basel on January 16, 1975: "Nobody will give you freedom, you have to take it."[2] This was a pivotal statement for her as a woman and an artist. She never wanted to confine herself to a specific style and the pronounced discontinuity of her oeuvre was also a deliberately risky form of rebelling against routine. Defying classification, her work posed a conundrum for art critics. For decades whatever she did was reduced to Surrealism because of the mythical reputation of her *Fur Cup* (1936). She suffered from being pigeonholed.

The situation changed when Pontus Hultén, founding director of Moderna Museet in Stockholm, organized her first solo exhibition in 1967. She finally began to attract much-deserved international attention. In the mid-1970s, retrospectives followed in Solothurn, Winterthur, and Duisburg. After Rudi Fuchs invited her to contribute to Kassel's documenta 7 in 1982, she had an exhibition that toured Italy. Her 1984 retrospective at Kunsthalle Bern and the Parisian Musée d'Art Moderne later stopped at Frankfurt, Berlin, and Munich in the months prior to her death in 1985.

She moved steadily from the margins to the center of attention. The postmodern spirit had sparked a process of cultural transformation. The shackles of formalist thinking and

[1] Bice Curiger, *Meret Oppenheim. Spuren durchstandener Freiheit* (Zurich: ABC Verlag, 1982).

[2] Bice Curiger, *Defiance in the Face of Freedom* (Zurich: Parkett Publishers Inc., 1989), p. 30.

Modernism's rigid rules of perceiving the world were loosened, allowing once again for increased experimental leeway.

We were a small circle of friends who regularly gathered around Meret, visiting her homes in Paris, Bern, and Carona. She used to spend her summers at the family residence in Ticino, which became a special place for us to meet with her and exchange ideas. In 1985, a few months before she died, we dedicated the fourth issue of *Parkett* to her, for which we produced an artist's edition of blue suede goatskin gloves with veins of handstitched piping. She had sketched the design for *Gloves with Veins* in 1936, the same year that she created *Fur Cup*—a form of disguise in both cases. But while the latter work combines fur and porcelain, two materials that evoke entirely different haptic sensations, the former reveals what gloves ordinarily cover: skin and veins.

FIG. 2 M.O., *Pair of Gloves for Parkett*, 1985, finest sueded goatskin with piping and silkscreen, handstitched veins after the sketch *Glove with Veins*, 1936, edition for *Parkett* no. 4, 1985.

In Europe Meret received the attention she deserved during her lifetime, but the United States lagged behind. Ten years after her death, Bice Curiger and I curated *Beyond the Teacup*, her first exhibition to tour there, which opened at the Guggenheim Museum in New York.[3] It was a discovery for viewers, especially for artists. Richard Prince attended the opening and Richard Artschwager wrote a letter expressing his enthusiasm.

Becoming an Artist

When she was 17, she made an entry in her notebook: "× = hare," whereby she completed the equation with a picture of a hare, rather than writing out the word itself. Meret gave the notebook to her father for his birthday, declaring that she wanted to stop going to school and be an artist. Although her plans only met with lukewarm approval, the notebook became a testament to her departure from school and the start of her life as an artist.[4]

For Meret, image and language were equivalent forms of expression; there is a synergy between her works and her titles although her definitions of equations and formulas were never clearcut. The sign "×" in her notebook can be classified as both language and image. It obviously refers to mathematics as well, although Meret had little interest in this subject, except when the "×" stood for any random variable or for multiplication. "× = hare" did not doubt the meaning of reason and logic; it was her whimsical way of showing that she was at home in the world of ideas and poetic associations, as demonstrated by the many linguistic elements in her oeuvre.

The Family

Meret was supported by her cosmopolitan, well-educated family. Her grandfather Theodor Wenger had a cutlery manufactory in Delémont, which produced the inimitable Swiss army knife, among other things. Her grandmother Lisa Wenger, a model for Meret, was an impassioned suffragette and painter, the only woman in her day to study at the Kunstakademie Düsseldorf; she was also a writer and created children's books, such

[3] Additional stops: Chicago, Museum of Contemporary Art; Miami, Bass Museum; Omaha, Joslyn Museum. Catalog: *Meret Oppenheim: Beyond the Teacup*, Independent Curators Incorporated and D.A.P., 1996.

[4] André Breton considered Meret's equation quintessentially Surrealist and published her notebook in 1957 as *Le cahier d'une écolière* and in a second edition of *Le Surréalisme même*.

as *Joggeli söll ga Birli schüttle!* (Joggeli Should Shake Down Pears, 1908). Her father Alfons, originally from Hamburg, was practicing medicine in Berlin when Meret was born in 1913. With war threatening, her mother moved to her parents in Delémont in the Jura, while her father served on the front. Her mother's sister Ruth was briefly married to Hermann Hesse.

Meret's parents named her after a character in Gottfried Keller's *Green Henry*. Little Meret is a child witch of noble heritage, enchantingly beautiful and clever, who has been placed in the care of a strict pastor to be cured of her godlessness. In vain. Men fall in love with her. She runs away and lives alone in the wild where she seduces fish, tames birds, and holds sway over poisonous snakes. She dies alone in a cave, at a tender age.

One is inevitably tempted to compare Keller's Little Meret with our Meret. Her brother Burkhard Wenger remarked "nomen est omen" and recounts how she imitated Little Meret as a child.[5] Similarities are not far afield: exquisitely beautiful, scandalously audacious, religiously detached and with a delicate instinct, sharp intellect, and the desire to probe the secrets of nature. Keller's witch child died young, in 1713. Meret

FIG. 3 M.O., *Strangling Angel*, 1931, ink and watercolor on paper, 34 × 17.5 cm (13 ⅜ × 6 ⅞ in).

Oppenheim was born exactly 200 years later and died at the age of 72, something she predicted long before. We will return to that later.

She was still a teenager when she cast off the straitjacket of convention to explore her own personality. She wanted to refine her own perception and sensibility, explore states of consciousness and create works of art based on these experiences. She was 18 when she painted *Strangling Angel*, a votive picture long kept hidden because it was such a radical and macabre condemnation of reducing women to the role of child bearers. It speaks of her aversion to misogynists who, like Nietzsche, believe that "Everything in woman is a riddle and everything in woman hath one solution—it is called pregnancy."[6] Meret's reaction: not me. The picture shows a being wearing a star-studded garment, her wings garnished with pine trees. She is holding an infant with blood gushing from its slit throat. A fallen angel, it would seem, or a *femme fatale*, echoing a statement made by scholar Camille Paglia: "Daemonic archetypes of woman, filling world mythology, represent the uncontrollable nearness of nature."[7] Legs with high heels on their feet are sticking up out of the ground. Or are they snakes with maws open wide or maybe even lustful phalli? Meret herself remained childless.

Strangling Angel mirrors Meret's humor, or rather gallows humor, through which she made life bearable for herself and for others without disguising her own feelings.

Paris among the Surrealists

Meret was not yet out of her teens when she moved from Basel to Paris in 1932 with the exuberant artist Irène Zurkinden. She

5 Elke Heinemann, *Meret Oppenheim, eine Porträt-Collage* (Hamburg: Edition Nautilus, 2006), p. 9.
6 Friedrich Nietzsche, *Thus Spoke Zarathustra*, trans. Thomas Common (Edinburgh: T. N. Foulis, 1909), chapter 18.
7 Camille Paglia, *Sexual Personae: Art and Decadence from Nefertiti to Emily Dickinson* (London: Yale University, 1990), p. 13.

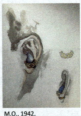
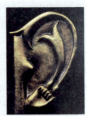

M.O., 1933, *Giacometti's Ear*,
Pen and sepia ink on paper, 10 ⅝ x 8 ½ in.

M.O., 1942,
sketch for an ear decoration,
watercolor, 9 ¼ x 6 ¾ in.

M.O., 1977,
Giacometti's Ear, bronze,
3 ½ x 2 ⅞ in, ed. 500.

Thomas Hirschhorn, winner of the Prix Meret Oppenheim 2018.

FIG. 4 Slide from Jacqueline Burckhardt's lecture in Kunsthaus Aarau, 2018.

stayed there for five years, often changing hotel, apartment, and studio. The last line of a note written in May 1932 reads, "Late to bed, late to rise, lots of alcohol. But Irène is busily painting."[8]

Through Irène Zurkinden she met Alberto Giacometti and Hans Arp. Once when sitting in a café with Giacometti, she thought his earlobe looked like a small fist with the rest of his ear forming two plants sprouting out of it. She was so taken with this motif that she returned to it several times in the following decades.

Giacometti and Arp in turn introduced her to André Breton and the Surrealists, among them Salvador Dalí, Marcel Duchamp, Paul Éluard, Max Ernst, Leonor Fini, Man Ray, René Magritte, Francis Picabia, Pablo Picasso, Dora Maar, and Yves Tanguy as well as writers like Tristan Tzara and André Pieyre de Mandiargues. She was immediately welcomed into the group and joined their meetings at the Café de la Place Blanche. Although she was much younger than the group of Surrealists with whom she associated, she proved a kindred

spirit, flouting convention and taking inspiration from the unconscious. They nurtured her talent, attracted by her beauty, spirit, and charm, wavering between shyness and proud abandon. They gave her the opportunity to contribute to the Association artistique des surindépendants, where she showed a work poetically titled *La nuit, son volume et ce qui lui est dangereux* (1934).

It was marvelously serendipitous that she fell in with the Surrealists at the beginning of her career. She had gone to Paris, the great art capital, to study at the Académie de la Grande Chaumière, but rarely made an appearance there, having chosen to be unofficially tutored by her new circle of friends.

However, all her life, she refused to be labeled "Surrealist" and firmly rejected all "isms." She resolutely defended her identity and her independence. If anything, Meret was born a Surrealist through and through. By nature she shared most of André Breton's principles such as the cult of the imagination and the playfulness of associations. Nor was there ever a conflict between dream and reality.

She had begun writing down her dreams at the age of 14 and her father stirred her interest in the writings of C.G. Jung. She even visited Jung at his practice in Zurich. She always listened to her dreams and cultivated perception in all possible states of consciousness, as indicated in the title of a short text written in 1943: "So much like seeing listening awake in sleep."[9] In addition to recording her dreams, she wrote poems, prose, and countless letters. Writing was a daily habit that also served to elaborate and refine her thoughts.[10]

8 Lisa Wenger and Martina Corgnati, eds., *Meret Oppenheim. Mein Album My Album* (Zurich: Scheidegger & Spiess, 2022), p. 98.
9 Christiane Meyer-Thoss, ed., *Meret Oppenheim. Husch, husch der schönste Vokal entleert sich. Gedichte, Prosa* (Frankfurt a.M.: Suhrkamp, 1984), p. 59.
10 Most of her writings have been published, many still in her lifetime by editor Christiane Meyer-Thoss, and posthumously by her niece Lisa Wenger with Martina Corgnati.

FIG. 5 M.O., *Sitting Figure with Folded Hands*, 1933, oil on cardboard in artist's frame, 46 × 39.9 cm (18 ⅛ × 15 ¾ in).
FIG. 6 M.O., *Well, We'll Live Later Then*, 1933, ink and gouache on paper, 21 × 27 cm (8 ¼ × 10 ⅝ in).

Despite early recognition and encouragement, Meret often went through difficult periods. She said that even in the circle of artists in Paris, she felt the centuries of discrimination against women weighing on her shoulders. Since her life and art are closely interwoven, her work also expresses her state of mind, as in the almost statuary, faceless portrait *Sitting Figure with Folded Hands*.

Her existential anxiety was aggravated by the disturbing political climate. Hitler became chancellor in 1933, giving rise to an atmosphere of aggressive anti-Semitism. Her mood is reflected in *Apocalypse (if danger)* (1933), a drawing of the Eiffel Tower, all that is left rising above the devastated city. Only a stray dog, snakes, and birds that look like dive bombers seem to have survived; the trees are as if scorched. On a signpost reading "if danger," an index finger points in the direction of escape, probably west toward the distant United States.

Resignation is expressed in *Well, We'll Live Later Then*. But the time to live has not yet come for the pitiful, spectral creature, carried off into the night by a dark figure descending a broad staircase beneath a kind of temple. Its arms are laconically spread wide.

FIG. 7 M.O., *Quick, Quick, the Most Beautiful Vowel Is Voiding*, M.E. by M.O., 1934, oil on canvas, 45.5 × 65 cm (17 ¹⁵⁄₁₆ × 25 ⅝ in).

The Most Beautiful Vowel and the Fascinating Model

In 1933 Meret and Max Ernst, then 22 years her senior, fell in love. Their intense relationship ended abruptly only one year later when Meret declared out of the blue that she didn't love him anymore. She realized she would never be able to make progress of her own at the side of this well-established artist. She painted a "portrait" of him as a farewell gift and titled it after the last line of the three-line poem she wrote in accompaniment: *Quick, Quick, the Most Beautiful Vowel Is Voiding*.[11]

The "most beautiful vowel" cannot be an E, I, or U because of the sound. That leaves A and O, with the latter more suitable for voiding because of its shape. Interjections like "Ah" and "Oh" imply pleasurable feelings and in speaking of voiding the "most beautiful vowel," something pleasurable is about to end.

The picture shows a ball and a chain of the kind once used to shackle prisoners. But the ball is fluffy, weightless, and attached to a golden chain that hangs from a floating and tilted rod. Six shapes that look like illegible letters are lined up on the rod. Warmth characterizes Meret's parting gift and the two did remain lifelong friends. Max Ernst was not able to keep the painting. When the war broke out, he was interned in France several times. With the help of Peggy Guggenheim, he managed to flee

11 Meyer-Thoss 1984, p. 23 (see note 9).

Man Ray, *Erotique voilée*, 1933/34, photograph taken in Louis Marcoussis' studio, published in: *Minotaure* No.5

M.O.'s handprint and poem, 1935

La rosée sur la rose,
Qui l'a touché avant?
Avant la nuit?
Elle a gardée sa chair,
Sa cire. Blanche et noire
Elle re(a)paraît dans les nuages,
Mangeant du massepin.

M.O., 1959, *My Handprint*, monotype 8 ¼ x 4 ¾ in.

FIG. 8 Slide from Jacqueline Burckhardt's lecture in Kunsthaus Aarau, 2018.

via Portugal to the United States in 1941. It is unlikely that he had room for Meret's painting in his luggage. An art dealer later found it at a flea market in Paris and Meret bought it back from her.

Captivated by her beauty and her fluctuating moods of melancholy diffidence and uninhibited abandon, Man Ray asked Meret to pose for him in the nude. She agreed and even permitted him to publish the photograph in the fifth issue (1934) of the magazine *Minotaure*. However, she did not pose for him as a submissive model, exposed to the male gaze. Motivated by an anti-bourgeois attitude, she stripped herself not only of her clothing but also of the propriety that governed a young woman of good family. *Erotique voilée* became a *succès de scandale*. The boyish hairdo and the phallic position of the handle of the printer's wheel gives Meret a slightly hermaphrodite touch. The staging is thus an allegory of the deep conviction expressed in her above-mentioned speech on receiving the Basel art prize in 1975, namely that every work of art is the product of an androgynous spirit: a muse is for men what a genius is for women.

A few months later, she returned to the motif of her hand smeared with printer's ink in Man Ray's photograph. As if only a few seconds had passed and the ink were still wet, she produced a monotype of the impression of her hand, boldly creating a work of her own. She wrote a poem along with it, the first line reading: "La rosée sur la rose" (the dew on the rose).[12] The alliteration, evokes Gertrude Stein's famous line in her poem *Sacred Emily*, "Rose is a rose is a rose," much bandied about among intellectuals in those days.

The Universal Will to Create

With art and life so closely intertwined, the creative urge applied to everything that affected and surrounded the artist. She already started designing extravagant models, furniture, and jewelry in Paris, especially for Elsa Schiaparelli, who wanted to incorporate Surrealism in her fashion designs. On a sketch for seductive lingerie, Meret wrote "Slip mandrill," noting that women should paint their behinds. The drawing shows a pair of panties open in the back and fur trimmed over the pubic area in front, charmingly oscillating between propriety and shamelessness. Customers found most of her designs too daring. But Meret had no intention of conforming. She wanted to give her imagination free rein and cheerfully took the shock effect in stride.

In spring 1936 she met Picasso and his then partner, photographer Dora Maar, at a café. Meret was wearing a bracelet she had made out of a brass pipe covered with fur. Picasso liked it; he thought it was funny and remarked that you would cover anything with fur. Why not the cup in front of me, Meret quipped. The thought occurred to her again when Breton invited her to contribute to a Surrealist exhibition in Paris shortly afterwards. She bought a cup, saucer, and spoon at the Parisian department store Monoprix, covered them with gazelle fur and gave the work to Breton. She often told that story to underscore the

12 Ibid.

casual origin of the object that catapulted her into an icon of Surrealism. However, we also know how much alert instinct, perceptive acuity, and skill it takes to recognize and act on such ideas.

Fur Cup would become both a blessing and a curse for Meret. Delighted by the object, Breton called it *Déjeuner en fourrure*, loosely quoting Édouard Manet's painting *Déjeuner sur l'herbe* and Leopold von Sacher-Masoch's novella *Venus in Furs*. The idea of drinking out of the fur cup invariably evokes erotic and philosophical fantasies, as emphasized in interpretations that even consider the object a fetish. In 1970, to undercut the *chef-d'œuvre* aura of her work, Meret created a kitsch sequel titled *Souvenir du déjeuner en fourrure*. It took decades for her works, created in the wake of *Fur Cup*, to emerge from the shadows cast by the famous object.

A bicycle saddle on which a swarm of bees has settled belongs to the larger context of *Fur Cup*. Meret discovered the photograph in an illustrated magazine in 1952, had it rephotographed and declared it a work of her own as an *objet trouvé*. Breton exhibited it in the 1959 *Exposition inteRnatiOnale du Surréalisme (EROS)* in Paris, and Meret wrote to him at the time that *Bicycle Saddle* could be paired with her *Fur Cup*.[13] Like the latter, the sight of the saddle provokes a similarly unsettling feeling.

Sometimes, as here, Meret created works with a minimum of effort, as encapsulated in a much-quoted line from one of her poems: "With a vast enormous tiny bit of a lot."[14]

Ma Gouvernante—My Nurse—Mein Kindermädchen dates from the same year as her *Fur Cup*. She tied a pair of whitewashed high heels together, adorned them with poultry cuffs, and placed them on an oval silver platter, like a chicken ready to be served. The work is entirely open to interpretation. In addition to all of the erotic ones, another interpretation was that the object was a dedication to Meret's nursemaid to whom she was very attached.[15] It could also be associated with the French idiom *mettre les pieds dans le plat* (to put your foot in it) and may even pay tribute to the Surrealist writer René

FIG. 9 M.O., *Ma Gouvernante—My Nurse—Mein Kindermädchen*, 1936, whitewashed high heels, poultry cuffs, oval metal platter, 14 × 33 × 21 cm (5 ½ × 13 × 8 ¼ in).

FIG. 10 M.O., *The Couple*, 1956, a pair of short brown ankle boots with tips joined, 20 × 40 × 15 cm (7 ⅞ × 15 ¾ × 5 ¹⁵⁄₁₆ in).

Crevel, author of the novel *Les pieds dans le plat* (*Putting My Foot in It*, Dalkey Archive Press, 1994), with whom Meret was acquainted and who killed himself in 1935.[16] In any case, she presented the object in her first solo exhibition at Galerie Marguerite Schulthess in Basel in 1936. A facsimile of a text by Max Ernst graced the invitation. "Woman is a sandwich of white marble." And down below: "Who covers the soup spoon with precious fur? Little Meret. Who has outgrown us? Little Meret."[17]

Le Couple of 1956 is related to *My Nurse*. It also shows the inseparable liaison of a pair of shoes and is often exhibited and reproduced with shoelaces tied. This is wrong. Meret insisted they be untied; having them tied would undermine the tension between being unleashed and fatally linked.

13 Cf. letter to André Breton, February 15, 1953, in: Lisa Wenger and Martina Corgnati, eds., *Meret Oppenheim. Worte nicht in giftige Buchstaben einwickeln* (Zurich: Scheidegger & Spiess, 2013), p. 275: "Je joins une photo que j'ai fait faire, d'après un objet trouvé dans un journal, et qui pourrait faire un joli pendant de la tasse en fourrure: la selle de bicyclette couverte d'abeilles."
14 In: Meyer-Thoss 1984, p. 81 (see note 9).
15 Meret's nanny "Wirthi" was Margarethe Wirth Schilling (1895–1988). See Wenger and Corgnati 2013, p. 450 (see note 13).
16 Crevel was a devotee of Breton. Cf. Hans Peter Wittwer, "René Crevel," in: Peter Fischer and Julia Schallberger, eds., *Surrealismus Schweiz* (Cologne: Snoeck, 2018), p. 25.
17 Curiger 1989, p. 29 (see note 2).

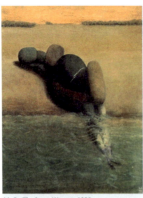

M. O., *The Stone Woman*, 1938, oil on cardboard, 23 ¼ x 19 5/16 in.

Reproduction of its original state in: *Almanach neuer Kunst in der Schweiz*, 1940, p.80.

Man Ray, Untitled 1933, photograph, 3 15/32 x 4 59/64 in.

FIG. 11 Slide from Jacqueline Burckhardt's lecture in Kunsthaus Aarau, 2018.

Back in Switzerland

Meret's time in Paris ended in 1937. The imminent war and financial straits forced her to return to Basel. Her father was no longer able to support her. Because of his Jewish origins, he had been forced to emigrate to Switzerland before the war broke out but was not permitted to practice medicine because the Swiss did not recognize his German credentials.

Meret decided to enroll at the Basel Academy of Applied Art. Being self-taught as an artist, she wanted to earn some money as a restorer, which required learning more about painting techniques and acquiring practical skills.

She fell into a depression that would last 18 years until she pulled out of it abruptly and inexplicably in 1954.

The Stone Woman of 1938 reveals not only her newly acquired knowledge of oil painting but also her state of mind. Hopelessly stranded at a shore, the woman is petrified, turning not simply into a rock but into several small stones. In the process of metamorphosis, her lifeless human legs and delicate,

FIG. 12 M.O., *War and Peace*, 1943, oil on canvas, 80 × 140 cm (31 ½ × 55 ⅛ in).

shoed feet are still underwater. The motif of stones seems to have been inspired by a picture Man Ray took in 1933.

Comparison of *The Stone Woman* with its reproduction in a 1940 brochure, issued by the Swiss artists' group Allianz, reveals that Meret later reworked the painting. Some of the trees in the background have been overpainted, wiped out so to speak, making the composition and the landscape seem even more desolate.

Life in prudish Basel was not easy for a single woman with a Jewish name, and her flamboyant reputation as an artist certainly didn't help. Luckily, she found good friends among the artists of Gruppe 33—Otto Abt and Walter Bodmer, Hans Rudolf Schiess and, of course, Irène Zurkinden and Walter Kurt Wiemken. She was very close to the latter and deeply unsettled by his suicide in 1940.

Living in Basel, so close to the raging war, people were acutely aware of its imminent danger. In 1943 Meret painted *War and Peace*, with will-o'-the-wisps, eerie marsh lights, ghostly lights, lights of the dead all reaching for a horizon where there is no dawning day or setting sun but only the apocalyptic reflection of conflagrations caused by the war. The lamb, a symbol of innocence and peace, is next to the seated figure and looks out over the menacing landscape with fear and vigilance while surreal figures wielding glinting knives—or are they rods of light?—sit abandoned in the swamp. Still practicing style and

technique, Meret studied Arnold Böcklin's landscapes in such works as *Megalthic Tomb* (1847).

Wolfgang La Roche entered Meret's life in 1945. He was an unsuccessful businessman but extremely poetic and he owned a Harley Davidson.

Meret dedicated an enchanting *Déjeuner sur l'herbe* of a special order to him: *Hornet and Bumblebee*. The picture reveals their relationship: tender but with no strings attached. They got married in 1949 and enjoyed a warm, loving relationship until Wolfgang died in 1968.

FIG. 13 M.O., *Hornet and Bumblebee*, 1945, oil on cardboard, 14 × 23.5 cm (5 ½ × 9 ¼ in).

Change of Style

Meret considered the paintings she made during that period "romantic-anecdotal-illustrative." She felt the need to change direction and renewed her efforts to make works that were "not merely the image of an idea but the thing itself," as she put it.[18]

Taking a leap in time to the 1969 relief *Octavia* illustrates what she meant. Once again, the protagonist is an *objet trouvé*, a tree saw, its mirrored silhouette completing the body of a birdlike, animal-human figure. The tip of the figure rests on the painted stump of a tree. Meret exploited the bold idiom of Pop Art. *Octavia* does not refer to a mythological figure. The seductive gaze through the hole in the handle of the saw and the three-dimensional tongue lasciviously licking its sharp metal

edge suggest a provocative, tantalizing, and humorously dangerous being. In her dissertation, Isabel Schulz speculates that Meret might have been alluding to Pauline Réage's scandalous, erotic novel *L'Histoire d'O* of 1954.[19] With O for *Octavia*, we meet up once again with the most beautiful vowel mentioned in her portrait for Max Ernst. Meret's friend Christoph Bürgi drew my attention to the fact that the colored lines at the edges of the figure allude to the twelve semitones of the octave, which explains the name of the work. Unmistakable demonstration, once again, of the cornucopia of potential interpretations that characterizes Meret Oppenheim's oeuvre.

FIG. 14 M.O., *Octavia*, 1960, oil on wood, molded substance and saw, 187 × 47 × 4 cm (73 ⅝ × 18 ½ × 1 ⁹⁄₁₆ in).

FIG. 15 M.O., *La condition humaine (Man's Fate)*, 1973, oil on canvas, 90 × 100 cm (35 ⁷⁄₁₆ × 39 ⅜ in).

"Condition humaine"

Later in life, Meret mentally traversed space, time, and cultures more and more. She ventured out beyond experience, gazing far into the limitless realm of non-experiential reality and viewing herself as the instrument of something world-encompassing. Two cosmic works testify to these journeys: *La condition humaine (Man's Fate)*, which once belonged to David Bowie, and *A Pleasant Moment on a Planet* (1981).

18 Ibid., p. 50.
19 Isabel Schulz, *Edelfuchs im Morgenrot. Studien zum Werk von Meret Oppenheim* (Munich: Schreiber, 1993), pp. 120 ff.

FIG. 16 M.O., *X-ray of M.O.'s Skull*, 1964, 25.5 × 20.5 cm (10 ¹/₁₆ × 8 ⅛ in).
FIG. 17 M.O., *Self-portrait and Curriculum Vitae Since the Year 60,000 B.C.)*, 1966, India ink on paper, 35 × 23.5 cm (13 ¹³/₁₆ × 9 ¼ in).
FIG. 18 M.O., *Portrait with Tattoo*, 1980, stencil and spray on a photograph of Heinz Günter Mebusch, 29.5 × 21 cm (11 ⅝ × 8 ¼ in), edition of 50.

In 1964 she had an X-ray made of herself in profile; she is wearing earrings and has raised one hand that shows rings on her fingers. We see bones and jewelry, that is, the remains that will survive long after she has died. The X-ray can be associated with the drawing *Self-portrait and Curriculum Vitae Since the Year 60,000 B.C.*, in which Meret does not picture herself as a person but rather as a conglomerate of archaic natural and architectural shapes with plants shooting up out of them like flames. She depicts herself as a being that bears within itself the evolution of the earth and humankind. As an admirer of C. G. Jung, she was well-versed in the creative, prehistoric context of the unconscious. It is the reverberation of such references that she wanted to track down. The butterfly fluttering away in the picture symbolizes beauty and metamorphosis. Among the ancient Greeks, it embodied the soul of the deceased.

Meret considered her 1972 *The Secret of Vegetation* a kind of self-portrait and one of her most important paintings. Its source was a dream, she writes in a letter.[20] A flurry of vegetal and geometric shapes is scattered across the basically static and symmetrical composition. The image speaks of chaos and cosmos. The two snakes slithering vertically into the sky stand

FIG. 19 M.O., *The Secret of Vegetation*, 1972, oil on canvas, 195 × 97 cm (76 ¾ × 38 ³⁄₁₆ in), Kunstmuseum Bern.
FIG. 20 M.O., *Fountain*, 1983, water, plants, concrete, metal, and intermittent lighting, 800 × ⌀140 cm (316 × 55 ⅛ in diam), Waisenhausplatz Bern.

for opposing forces: positive and negative, life and death. The snake, with which Meret positively upgrades the Fall, makes a frequent appearance and is no doubt the most important symbol in her oeuvre. Not only did it seduce Eve into tasting the apple from the tree of knowledge, it also possesses the marvelous faculty of repeatedly shedding its skin. It is thus only fitting that the ouroboros symbol of a snake biting its own tail should encircle Meret's name on her tombstone in Carona.

The artist's *Fountain* on Waisenhausplatz in Bern also evokes the image of a snake with its two metal channels spiraling around the concrete shaft. One channel of separate segments carries the water, the other is intended for vegetation. Many people in Bern were "not amused" when it was unveiled in 1983. They did not appreciate Meret's idea of the fountain playing with the future, as it were, of creating a small vertical park whose beauty would unfold over the years. Meret reckoned with the lime deposits, the plants, and the icicles that would build up on the column and settle in the channels, constantly changing

20 Letter to Alain Jouffroy, September 9, 1977, in: Wenger/Corgnati 2013, p. 355 (see note 13).

its appearance. She entrusted the care of this duet of nature and art to others. The revolving light on top is like a night watchman making his rounds.

The artist Thomas Hirschhorn has declared with profound conviction that this is the best work he has ever seen in public space.

When Meret began to attract growing attention in the 1980s, she made a stencil and sprayed a kind of tattoo on a photograph of herself, reminiscent of the ritual ornaments on the face of a tribal chief. It is a tongue-in-cheek comment on the personality cult that had emerged around her. She captivated people with her charismatic appearance and moral stance, devoting herself to essentials in works, often inspired by literature and flying in the face of convention with dark humor.

The qualities that she emphasized in her 1975 speech in Basel acquired even greater traction toward the end of her life: emotions, intuition, and wisdom. Her friends knew full well how exceptional her perception was. Take for example, a dream that she wrote down in 1949: "Am in a Gothic cathedral. Standing in front of a carved wooden statue of a saint (no color and full of wormholes). He is holding an hourglass in his hand. While I'm looking at him, he turns it upside down. (The dream was shortly before or after my 36th birthday, half of my life?)."[21]

I was familiar with this dream. But when she invited me to come to Paris for her 72nd birthday on October 6, 1985, remarking that it would be her last, that she was going to die before the first snowfall, I firmly refused to accept the invitation. I did not want to believe her, even more so, since I had just seen her shortly and in the best of health. On November 15, 1985, she died of a heart attack in Basel, while signing *Caroline*, an edition of etchings and poems. It snowed soon afterwards.

Caroline, her last work, is dedicated to Karoline von Günderrode. In 1983, having read Karoline's correspondence with Bettina von Brentano, Meret painted a picture for each of them. She felt a profound affinity with the two writers of Romanticism and wrote in *Parkett*: "The idealized love between the

two women triggered a literary product that is flooded with life and light. Just as an oyster needs a foreign particle to form a pearl."[22]

21 Christiane Meyer-Thoss, ed., *Meret Oppenheim: Träume. Aufzeichnungen 1928–1985* (Berlin: Suhrkamp, 2010), p. 26.
22 Meret Oppenheim in *Parkett* no. 41 (1985), p. 45.

Rocaille
Rock Eye

Pipilotti Rist

This text is based on an essay by Jacqueline Burckhardt and Bice Curiger that first appeared in the catalog to the touring exhibition *Pipilotti Rist. 167 cm. I'm not the Girl that Misses Much. Ausgeschlafen, frisch gebadet und hochmotiviert*, Kunstmuseum St. Gallen, 1994, Neue Galerie am Landesmuseum Joanneum, Graz, Kunstverein in Hamburg, 1995.

The handbag of the somewhat stiff, robust variety has a great deal to offer as an attribute of an outdated image of women because in its format, it echoes the privilege of imperiously ruling and running a home. Mrs. Rist has long enjoyed making use of this object not only to show the route women have taken over the past decades but also to glory in the perky, liberating swing of the little bag. The sub-rosa significance of this feminine pouch, technologically transformed into a video carrier, is not lost on us. Pipilotti Rist has stored and arranged images in it to ensure that the bit of privacy carried at her side while walking the streets in public will fortify her for all the emergencies and duties of life.

When thieves steal a handbag, they can instantly tell what to keep and what must be discarded, specifically evidence that would reveal the origin of the owner and thus trap the criminal. The more personal and emotional the items are—a letter with a photograph of a secret love—the more worthless for the thief.

Rist does what a pilferer doesn't; she fills other people's handbags with new content and readily permits herself to be caught by leaving behind the evidence of her seductive signature, for instance in her 1994 installation at Galerie Stampa, titled *Yoghurt on the Skin—Velvet on TV*. Where is she spiriting us away? She once said, if you want to see the world, open your handbag.

FIG. 1 Pipilotti Rist, *Yoghurt on the Skin—Velvet on TV*, Collection VZK, Kunsthaus Zürich, 1994, installation view (detail), Kunstverein Hamburg, 1995, video/audio installation, one shell and one handbag with small inbuilt LCD displays, on velvet cushions on stands, each with one player and its own sound.

Red and blue cones of light straying about, brushing and caressing the darkened space of the exhibition, and a video projection of ocean breakers filmed at beach level, suggest the undulating movement of a cheerfully intense ocean voyage.

Gazing deep into the depths of open handbags confirms the fact that there is as much artistic potential to be found in good taste as there is in bad, and we discover that it is possible for art to make an appearance in three big seashells. Triton blew into them with all his might thousands of years ago until Rist replaced their animal flesh, instead populating them with her enthralling imagery. Handbags and seashells produce voices and sounds; images filmed in the Red Sea and manipulated à la Rist flicker on small monitors.

In *Eindrücke verdauen* (Digesting Impressions), a round monitor dangling in a woman's yellow bathing suit revealed the artist's penchant for probing innards. On the textile-reinforced screen belly, we follow the camera making its way from the gullet to the intestines.

FIG. 2 Pipilotti Rist, *Eindrücke verdauen* (Digesting Impressions), 1994, video, spherical display, yellow bathing costume, player, yellow bows.

Rist's enduring desire to escape the confines of space is inescapably manifest. Just as she dances the round with her band Les Reines Prochaines, just as she twirls about until throttling her tempo and jumping up against the wall (in the flipbook she made for *Parkett* no. 37), she also seeks transgression in

her feminine subjugation of technology. Video, ordinarily considered a cold medium in contrast to film, acquires entirely new temperatures through her handling of expressions and images, their warmth increasing through mutual enhancement. Thus, the moonstruck menstruation that pervades *Blutraum* (Space of Blood, 1993/1998) becomes a warm counterpart to the analytical, cool installation of 12 black-and-white monitors in Nam June Paik's *Moon is the Oldest TV* (1965–76).

On a tiny monitor in a broken parquet floor, we find the artist standing in purgatory, reaching up, writhing and crying out for help—as seen in the exhibition *Welt-Moral* (World Moral), at Kunsthalle Basel, 1994, in the work *Selbstlos im Lavabad* (Selfless in the Lava Bath).

FIG. 3　Pipilotti Rist, *Selbstlos im Lavabad* (Selfless in the Lava Bath), 1994, video installation, monitor inserted into the ground, player.

Both installations in Basel (Galerie Stampa and Kunsthalle) remind us that cheerfulness and terror are bedfellows in Rist's work, as shown by the oscillating movement of the colors in her videos or the pulsating, iridescent mother-of-pearl in the seashells. She keeps penetrating further and further in pursuit of a paradise lost or still unattained, along a path that leads past purgatory. It is her and our quest for the history of identity in territories governed by no one, neither God nor the devil.

Sip My Ocean

Pipilotti Rist

This text is based on a text about Pipilotti Rist's *Sip My Ocean* in the catalog to her monographic exhibition *Open My Glade* in Louisiana Museum of Modern Art, Humlebaek, 2019.

FIGS. 1+2 *Sip My Ocean*, 1995, installation views, New Museum of Contemporary Art, New York, 2016.

In the corner of a room, where four surfaces and five borders meet at right angles, there is no escape. Cornered people and animals are vulnerable; they are thrown back on themselves, which makes them exceptionally alert and vigilant. Art does not often choose to settle down in a corner. In fact, great care is taken to place works of art as far away from corners as possible to prevent them from appearing crowded and unappreciated.

The use of that location for a work of art indicates a choice made with deliberate care and intent. The art world has seen countless superb corner sculptures, from El Lissitzky to Richard Artschwager. Take, for instance, James Turrell's enchanting *Corner Projections* of cubes or pyramids of light, Joseph Beuys's *Fat Corner*, or Félix González-Torres's corner sculpture of wrapped candies. The latter equal the weight of his partner Ross Laycock, who died of AIDS, and viewers are invited to help themselves from the "cornered" heap.

Even more explicit is Martin Kippenberger's whimsical self-portrait of 1989: *Martin, Into the Corner, You Should Be Ashamed of Yourself.* On looking at this parody of old-fashioned punishment once cultivated in the West, one cannot help feeling sympathetic with the touching figure of a childlike adult wearing high-water pants and suspenders, his hands folded on his back, his head hanging low in shame as he gazes down at the very quintessence of a corner.

In contrast, Pipilotti Rist lures us into a corner, from which we already hear from afar the soundtrack of Chris Isaak's earworm *Wicked Game* (1989), sung and played by Rist and Anders Guggisberg. The video is projected in mirror image on two sides of a corner, usually from floor to ceiling depending on the architecture of the location.

For three decades, Rist has been a virtuoso choreographer of colored light and sound in video art; she is an alluring activist of moods and feelings. Here, she has liquefied a corner with seemingly effortless ease. Breaking free of any spatial constraints, she stages a digital coup, dissolves the walls on starting the projectors, and opens the corner of the room onto

FIGS. 3+4 *Sip My Ocean*, 1995, video stills.

the floodwaters of a utopian outside world. We are enveloped in the events, inundated, hypnotically immersed body and soul in the ornamental flow of vibrant, colorful images. The kaleidoscopic underwater landscape filmed in the Red Sea seems perfectly natural, a harmonic capering interplay of people, animals, plants, and objects—all non-hierarchical players in a pulsating universe of expanding and shrinking time and space. Maelstroms demonstrate their vital, self-cleansing energy and climb up to the glistening surface of the sea.

Rist has filmed her eye replete with tiny veins and eyelashes in the extreme close-up of a rotating camera. The lens and her eye, which she describes as her "blood-driven camera," examine each other: "I want to see how you see. You want to see how I see. I want to show how I see. You want to show how you see," she intones in *(Absolutions), Pipilotti's Mistakes*, an early video of 1988, uncannily presaging the dialogue between her eye and the camera in *Sip my Ocean*. In the symmetrical reflection, the eye grows out of itself along the axis, like cell division, and flows back into itself until it dissolves.

Floating figures come into view—a man, a baby, and repeatedly the artist herself in various bikinis. In two sequences, the

figures each hold a mirror so that the reflections are again reflected in the symmetry. Fish and jellyfish cavort in the lush coral landscape.

The artist draws us from the oceans up into the air, where a snake of light takes an acrobatic tour under sumptuous Baroque clouds, until we fall back to the surface of the sea and down again into the water, where the prismatic play of the reflecting crests of the waves glides above the sandy seabed. Unspectacular everyday objects float and tumble down to the ground in slow motion: a cheese grater, patterned cups, jugs, a single record, small plastic toys, a TV set, and a decorated heart. A few motifs from earlier works reappear, such as the origine-du-monde motif of a small globe on a woman's genitals from Rist's film *Pickelporno* (1992). We swim after her like fish in a swarm, she and her yellow bikini luring the "voyeuristic" gaze from behind, her legs seen first as a pair of twins in the symmetrical image and then fusing into Siamese twins only to become uncoupled again.

If there were no symmetry in *Sip my Ocean*, the on-screen images could be read as an arbitrary floating and flowing. However, the axis of symmetry where the walls meet at the corner becomes the stabilizing foundation of the work. It is a vibrant line of orientation, a symbol of eternity that ceaselessly generates and swallows the ornamental flow of images. To design and check the symmetrical effect while cutting and editing her takes, Rist attached a mirror to her monitor at a right angle, thus creating a miniature model of her installation.

Symmetry in visual design, whether in art, architecture, or advertising, can be interpreted as an absolutist approach. Here however, Rist's mirror-image projection is diametrically opposed to a self-confirming, authoritarian image. Instead, the artist underscores the open, changeable, and often ambivalent way in which people experience themselves. The human body is largely a symmetrical phenomenon; it is divided into many pairs: the halves of the brain, eyes, ears, breasts, lungs, kidneys, ovaries, testicles, arms, and legs.

If the symmetry is disrupted, we run the risk of losing our balance, physically and mentally. Without the axis of symmetry in *Sip my Ocean*, we would lose our footing altogether and drift through the visual ether like disconnected astronauts. But we are not only in a comfort zone in this installation. The song itself, Chris Isaak's addictive *Wicked Game*, conjures the subversive power of longing for love and the danger of symbiotic unification, which can lead to the loss of self. Driven by the desire to probe the lost paradise, Pipilotti sings Isaak's song herself, repeatedly screaming the line, "I don't want to fall in love with you," beseeching, hysterical, knowing full well that the path to paradise inevitably leads past purgatory.

Odysseus comes to mind. In order to prevent himself from succumbing to the fatal wiles of the demonic sirens without being deprived of their beguiling song, he had the foresight to have himself bound to the mast of his sailing boat. In *Sip my Ocean*, the symmetry axis becomes the rescuing mast.

The genesis of *Sip my Ocean* took more than two years. Pipilotti Rist rearranged the video sequences, changed the title of the work and the soundtrack, and created seven versions in as many exhibitions.

The first large-scale presentation of the underwater video in 1994 consisted of a three-channel projection at the São Paulo Biennale. In a triptych, shots of the ocean were seen in mirror image left and right, with a video placed between them of the Brazilian dancer Cintia, accompanied by her soundtrack. Subsequently, Rist created a self-contained work of the Cintia portion and added the soundtrack of Chris Isaak's *Wicked Game* to the underwater video. The work, on view in the 1995 exhibition *Zeichen und Wunder* (Signs and Wonders) at Kunsthaus Zürich, was still titled *Search Wolken/Such Clouds*, with the subtitle, *Elektronischer Heiratsantrag* (Electronic Marriage Proposal). Not until 1996, when the Louisiana Museum of Modern Art acquired the work, did it receive its definitive title: *Sip my Ocean*.

This purchase came as an extraordinary surprise to Pipilotti Rist; it had never occurred to her that a museum would want to collect such an installation. As a result, however, she edited *Sip my Ocean*: she synchronized image and sound in the final version so that it is twice the length of the song and made a loop that now lasts nine minutes and thirty seconds. In addition, she decided to issue the installation in an edition of three copies.

When she returned to the Red Sea almost 25 years later to shoot some more film, she saw to her dismay that the coral reefs she had filmed for *Sip my Ocean* had died and the radiant colors of the underwater world had all turned a bleak grey. Back from this second trip, shocked and with no film footage, Rist aimed her camera at the Old Rhine in Switzerland's Rhine Valley near Grabs, where she was born. Titled *4th Floor To Mildness*, the sequence shows melancholy, bewitching images of the underwater world in murky freshwater; it was first projected onto the ceiling at the New Museum in New York in 2017.

FIG. 5 *4th Floor to Mildness*, 2016, installation view in the New Museum, New York, 2016.

In October 2018, in collaboration with the WWF, she invited the public to witness and be part of a performance in Bern at the Hirschengraben indoor swimming pool. It was a plea to rescue the coral reefs. She projected a colorful symphony of light into the pool, illuminating the many people swimming in it.

In the Nerve Stream

Laurie Anderson

This text is based on the article about Laurie Anderson
in *Parkett* no. 49, 1997.

FIG. 1 Cover of the CD-ROM *Puppet Motel*
by Laurie Anderson and Hsin-Chien Huang,
1995.

Laurie Anderson draws inspiration from daily experiences and reflections on everyday life. She was born outside of Chicago in 1947 as one of eight children into a family of Swedish origins. There, in the wide-open expanses of the flatter than flat landscape with its low-lying horizon, she thought the sky was lapping around the soles of her shoes and that she was actually standing in heaven. This childhood perspective has greatly influenced her artistic themes and expressions and explains why she often talks about things in space: moon, stars, planets, celestial bodies, airplanes, satellites, and radio and television programs that have been sashaying around outer space for decades.

She has been active since the early 1970s as a highly gifted pioneer of Multimedia Performance Art, a universal artist in the experimental realm in which she has jettisoned the leaden rituals of art, music, film and theater. There is nothing linear about her work, no specific perspective nor any sedimentation into phases or periods. Everything she does is inscribed into an endlessly expanding universe, creating a unique and immersive experience for her audience. Superbly trained, Anderson ignores the boundaries of artistic genres; she writes, makes music, draws cartoons, paints, sculpts and produces films; her reflections on social and political conditions, utopias and religion, the future, art, mass, science and technology are as poetic as they are critical. She recorded much of this array in her 1993 book *Stories from the Nerve Bible: A Retrospective 1972–1992*, while the largest and most recent of her many exhibitions *The Weather* at the Hirshhorn Museum in Washington, 2021/22, gave a vast public an insight into her art over a five-decade career.

In 1975 she issued a digital publication, an interactive CD-ROM titled *Puppet Motel*, then an extraordinary novelty in the field of artistic publications, now unplayable thanks to advances in computer technology. Laurie invited her audience to take a labyrinthine walk through a virtual motel. Users started in the navigation center, the so-called "Hall of Time," where, upon clicking one of 30 digitally linked, cartoonlike drawings of

rooms, they could freely explore countless variations in Laurie's mental, musical and visual universe. It was like straying around in her brain. There was also a palm reader, a planetarium and an aquarium as well as a junk room that you could light up with the cursor. You could unexpectedly land in a room that permitted you to rewrite Tolstoy's *War and Peace* to suit your fancy. And electrical outlets that kept making a ghostly appearance looked like the face of a small, astonished creature with big eyes and an open mouth. It stood for the indispensable power source that feeds Anderson's magic.

She studied art at Columbia University, but her career already began when she was still in school and played the violin in the Chicago Youth Orchestra. She refers to the violin as her second voice: the range corresponds to the spectrum of the female voice and it is her favorite instrument. In the 1970s, taking the notion of her second voice quite literally, she replaced the bridge on one of her violins with a tape head and the horsehair of the bow with magnetic tape. In one case, she recorded Lenin's sentence, "Ethics are the aesthetics of the future." By varying the speed and length of the bowing, she distorted or mocked the quotation. When drawing the bow very slowly, her voice sounded like the deep bass of a Santa Claus; when speeded up, it sounded like a quacking Donald Duck, and at the end listeners heard: "Ethics are the aesthetics of the few ... of the few ... churr."

A custom-built, electronically modified violin is still her most important instrument today. She conjures countless effects with it and used it for the live performance of her composition *Landfall*, recorded with the Kronos Quartet. The album won the Grammy Award for Best Chamber Music in 2019. She is constantly breaking new artistic ground by experimenting with the latest technologies, and yet, as she herself says, she practices the most archaic of all art forms: storytelling. We associate that venerable art with sitting around a fire and listening to a storyteller. Anderson has replaced the fire with high-tech electronics, but the spellbinding magnetism of her voice is legendary and the density of astonishing reflections, anecdotes and aperçus

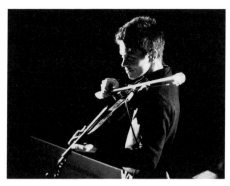

FIG. 2 Laurie Anderson with her tape bow violin during the rehearsal in Kunsthaus Zürich, 1980.

overwhelming. The story of her trek in the Himalayas where she almost died from altitude sickness epitomizes the importance of the voice. Her life hung on the voice of a Sherpa; it was like a long, thin line to which she clung in a state of delirium as he spoke to her nonstop for hours while she was being carried down the mountain on a stretcher.

With such friends as William S. Burroughs and Allen Ginsberg, protagonists of the beat generation, she shares the conviction that the "living word" and its rhythmic declamation is the most direct and effective form of all communication. Time and again she quotes what Burroughs said about the invasive, all-pervasive power of language: "Language is a virus from outer space." She introduces one of her performances by explaining that the evening will be about the connection between politics and music, that speeches by politicians are elaborate musical events. Hitler was the drummer: "Boom chic, baba boom chick," while Mussolini sang all the voices in an opera: "Frontiere, frontiere." She manipulates her own voice by distorting it electronically, changing her persona from woman to man to child to an entire choir to a robot. In her Norton Lectures of 2021 at Harvard University, transmitted digitally due to Corona, she even morphed her face into that of William Burroughs and had him speak with her voice.

Her trademark hedgehog hairdo makes her look as if she herself were one of those electrified cartoon figures with their fingers stuck in a socket. It is motivated by practical considerations. By wearing dark clothing, we see only her face and hands on stage, but they may also disappear into the darkness when a neon violin lights up or she projects images. Sometimes she seems like a vulnerable or familiar partner, at others like a sinister shaman of the merciless digital world.

She purchased a loft on Canal St. in New York in the 1970s and has acquired additional rooms over the years to accommodate her growing arsenal of projectors and sound equipment standing ready for use alongside the latest electronic devices, keyboards and several computers for text, music and animation. She masters them all, exploiting their potential and making astute observations about the age of digital information. In 1989 she wrote about her song "Strange Angels": "Developments in telepresence, surveillance and social media have tied people together in radically different ways—and freed them as well. More and more we are becoming beings without bodies, beings that can time travel and operate in electronic worlds. But unlike angels we are more like people who are learning to fly in their dreams often clumsy and unsure about how to take off."

She has assistants and colleagues coming and going in her loft. It used to be mostly her husband Lou Reed. Having found each other in Munich in 1992, the two stars remained intimately associated until Lou died in 2013. His life was voice and sound, and it still is for her. They sing a duet on the CD *Bright Read* produced by Brian Eno in 1994:

"In our sleep as we speak

Listen to the drum's beat

As we speak."

The sound studio in her loft used to look out at the Hudson River through a soundproof window; a new high-rise now blocks the view. Before that, she used to watch the freighters, the cars and the airplanes flying overhead above Newark Airport all in eerie silence. On September 11, 2001, two airplanes

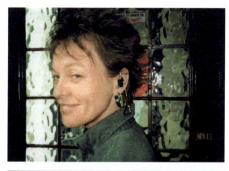
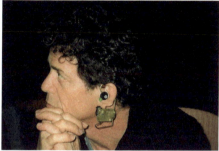

FIGS. 3+4 Laurie Anderson and her husband, Lou Reed, wearing Laurie's *Hearring*, the small, sculptural audio object that she designed as a *Parkett* edition in 1997. One hears her play the violin and whisper a short message. See Laurie's text in the Intermezzo, p. 240.

flew through those same vast skies to the Twin Towers one mile away. Anderson was on tour that day, but her thoughts keep circling around that hellish attack.

She prefers to use her system at night when rational thinking is muted and people are usually plugged into the dream stream. In *Institutional Dream Series (Sleeping in Public)* from the early 1970s, she slept in selected public places both indoors and out to find out how the atmosphere on the beach in Coney Island, for instance, or in a ladies' restroom and in a courtroom affected her (day)dreams. These experiences and perceptions later took poetic shape in her writing and photography.

She briefly taught art history and wrote reviews for *Artforum* and *Art News*. This gave her the chance to explore what happens when facts are interwoven with free association, as a result of which her employers put a speedy end to a career in journalism, citing her notorious disregard of fact. From then on poetry and truth lived together happily ever after in her own art.

I met her for the first time in 1980. Having been invited to the Biennale di Venezia, she presented "Americans on the Move," the first act of her eight-hour "Ring" *United States I–IV*, in the deconsecrated Church of San Lorenzo. The stage consisted of the stairs to a Baroque altar, in front of which she stood like a black angel from satellite heaven. With her music, her hypnotic voice, with images, texts and fascinating sign language, she immersed us in a vibrant array of moods and swept us through vast zones of time and space.

Every movement she makes is as nimble as it is disciplined, no gesture without a precise target, not the least hint of distraction. At times she almost seems as if remote-controlled; at others she is all flesh and blood again. She started out by introducing the harebrained theory of an American sect, according to which studies of the wind and air currents that guided Noah's Ark to Mount Ararat, prove that the Garden of Eden is located in the region of New York City. As if possessed by a spirit, she

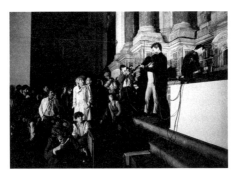

FIG. 5 Laurie Anderson's performance in San Lorenzo church in Venice, 1980.

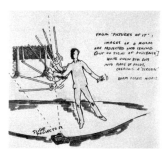

FIG. 6 A sketch by Laurie Anderson, showing how she intercepts slides projected in the space using her violin bow, 1979.

periodically used a metallic electronic male voice to ask, "Hello, please, can you tell me where I am?" This question crops up repeatedly in her performances and lectures, drawing attention to a loss of orientation.

Waving her violin bow back and forth, she caught slides freely projected in space and flickering in the air like false holograms. Then she started tapping the beat with a small plastic hammer, transforming the sound electronically into a metal heartbeat. Suddenly she turned herself into a machine by putting a luminous bright red device in her mouth. Her voice sounded like touchingly melodious violin music, which soon morphed into a menacing snarl that filled the entire space of the church. Anderson's magical mass wiped out the timeworn opposition between poetry and technology, human and machine, before she dispatched us, electrified, into the Venetian night.

The following day we took the train back to Zurich with a group of friends. I had engaged Laurie to perform at Kunsthaus Zürich. Standing on the platform with her equipment stashed in two black boxes on wheels, like a magician's baggage, she looked so athletic and all alone on the move. What a difference when she came back to Zurich again 15 years later to perform *The Nerve Bible* at the Kongresshaus: she and her crew pulled up in a huge bus to tour 20 European cities; it also served as their sleeping quarters. The convoy included two trucks with tons of equipment. A mighty laser beam generator was lifted out of one

FIG. 7 At Milan Railway Station in 1980. From left: Jacqueline Burckhardt, Martin Disler, Jean-Christophe Ammann, Laurie Anderson, Judith Ammann.

of them. Used on stage, it made her look like a violin-playing visitor from outer space or a cross between a virtuoso Paganini and a 20th century Orpheus on the way to the underworld in a stupendous, roaring tempest of sound and light.

Back to 1980. When we arrived in Zurich, we found ourselves in a city very different from the one we had left just a few days ago. *D'Bewegig* (the youth movement) had taken to the barricades, because the city planned to spend millions on restoring the opera house with just a few pennies left over for alternative culture. Street riots had erupted. We were confronted with smashed shop windows, blocked streets and teargas lingering in the air. The vibrant gravity that informed the uprising fascinated Laurie. However, a grand total of some 20 people attended her performance; she was still under the radar in Switzerland. Not so a year later, when she accepted my second invitation, this time accompanied by Perry Hoberman, a musician and ingenious manipulator of projectors. When they performed her political piece, *United States Part II*, there was not a single empty seat in the house. By then, radio channels all over the world, from Bangkok to Ostia, from Stockholm to Mexico City, were belting out her song *O Superman*. Everywhere you could hear the hypnotically stuttered syllable "ah ... ah ... ah ... " in eerie contrast to the soft, flattering sound of her voice singing

"O Superman, o judge, o Mom and Dad." The song is dedicated to Jules Massenet's opera *El Cid* (1885), in which the hero addresses God as "Ô souverain, ô juge, ô père . . ." Like the opera, Anderson's song is about the bitter battle between Christians and Muslims, specifically about the 1979 occupation of the American Embassy in Tehran by Islamist revolutionaries to protest the admission of Shah Reza Pahlavi into the United States. In her song, she converts Herodot's praise of the postal riders in the ancient Persian Empire into a metaphor that acquires a threatening undertone:

"Neither snow, nor gloom of night
Shall stay these couriers from the swift completion
Of their appointed rounds."

Created as an audiovisual collage under the looming threat of the First Gulf War, *O Superman* also limns a vertiginous vision of the United States as an electronically controlled everyday and phantom world. Her song closes with the following lines:

"'Cause when love is gone, there's always justice.
And when justice is gone, there's always force.
And when force is gone, there's always Mom. Hi Mom!
So hold me, Mom, in your long arms.
Your petrochemical arms.
Your military arms.
In your electronic arms
. . . ah, ah, ah . . ."

They are a striking variation on a passage from the *Tao Te Ching*, book 2, 38: "When Tao is lost, there is goodness. When goodness is lost, there is kindness. When kindness is lost, there is justice. When justice is lost, there is ritual. Now ritual is the husk of faith and loyalty, the beginning of confusion."

The celebrated American Dream bows out and dystopia is ushered in. But *O Superman* is mesmerizing even without this background information. Our senses are deluged by the music alone, not to mention Anderson's sign language and the cartoons she projects. No one in Performance Art had ever before been able to blend so successfully and touch so profoundly the

nerve of the avant-garde, popular culture and lonelier E-culture. The song went viral, rocketing up to number two on the UK Single Charts, instantly followed, of course, by the media hype: gigs all over the world, recordings, music videos, talk shows. As a result, Laurie refused to sing the song for years—until a week after the attack on the World Trade Center, when she incorporated it into her performance *Life on a String* at New York City's Town Hall. The song had suddenly been reinvested with devastating relevance, once again demonstrating how easily reality can eclipse the horror of fantasy.

Anderson appeared at Kunsthaus Zürich for the third time on January 16, 1991, in a solo performance of *Voices from Beyond* with a minimum of technology due to the size of the space. That was on the eve of the Second Gulf War when Saddam Hussein ignored the UN ultimatum for unconditional withdrawal from Kuwait. We were both glued to the TV for two nights watching CNN journalist Peter Arnett's live reports of the Allied "surgical bombing" of Baghdad, broadcast simultaneously around the world. I was able to experience firsthand how Laurie investigates and absorbs events into her work and how, in this case, she interpreted Arnett's perception of the beauty of horror in her performance *The Nerve Bible*: "Oh it's so beautiful, it's like the Fourth of July. It's like a Christmas tree, it's like fireflies on a summer night. And I wish I could describe this to you better. But I can't very well right now 'cause I've got this damned mask on."

Laurie's renown and her explicit interest in space exploration motivated NASA to invite her in 2003/04 as the first artist-in-residence to observe the activities of NASA and study their visual archives. NASA was founded in 1958 as the National Aeronautics and Space Administration in order to explore space with "a strong focus on understanding and protecting Earth, investigating the universe and searching for signs of life beyond our planet." Laurie, however, disillusioned by her experiences, produced *The End of the Moon*, in which she reveals that research was conducted primarily for military purposes and that the extremely sophisticated spacesuits had been developed not so

much for astronauts as for the soldiers in the Iraqi desert. She has unsurprisingly gone down in history as the first, last and only artist to participate in NASA's artist-in-residence program.

A devastating event in her life was hurricane Sandy on October 29, 2012, when the rising Hudson River flooded her cellar with mud, engulfing and destroying practically her entire archive and the works of art in storage there. However, the initial shock of irreparable loss gave way, in time, to a sense of liberation from the burden of possession. In 2018 she dedicated a book to the event: *All the Things I Lost in the Flood*. In the process of going through her inventory, she was once again struck by how much words can stand for things, how vividly stories represent life and how intensely this is perceived in an increasingly dematerialized world. In the introduction to the book, she writes: "In Buddhist thought there's the thing and there's the name of the thing. And often there's one too many." She has become a Buddhist and her metaphysical thoughts on immateriality and on the meaning and value of virtual commodities or NFTs (Non-Fungible Tokens) reflect her interest in facts and theories that are mutually contradictory. This also explains her desire to explore virtual reality. Three virtual reality installations, among her most ambitious works to date, were created with Hsin-Chien Huang, a new-media artist and virtual reality expert from Taiwan, with whom she already produced *Puppet Motel: Aloft*, *Chalkroom* und *To the Moon*. They were awarded the "Best VR experience" for *Camera Insabbiata* at the 74th International Festival in Venice 2017.

In *Chalkroom*, as in *Puppet Motel*, visitors navigate through black rooms consisting only of sound and white chalk drawings, floating letters, words, stories and fragments of text. In *To the Moon*, we become astronauts traveling to planets, where crystal models and letters take shape as living dinosaurs, airplanes or whales, where time and scale, near and far become indistinguishable. Images, sounds and the artist's voice transport us along an emotional nerve stream into the infinite space of the imagination.

Apocalypse and Silver Lining

Mona Hatoum

Reprint of a text by Jacqueline Burckhardt, "Mona Hatoum: Apocalypse and Silver Lining," published in: *Taking a Stand–Käthe Kollwitz with Interventions by Mona Hatoum*, exh. cat., Kunsthaus Zürich, 2023, Kunsthalle Bielefeld, 2024, Hirmer Verlag, Munich, 2023. English Translation: Gérard Goodrow.

FIG.1 Thilo Hoffmann, *Mona Hatoum*, behind her work *Hot Spot*, Paris, 2015.

Mona Hatoum comes from a Christian Palestinian family that was forced to flee from Haifa when the State of Israel was founded in 1948 and settled in Beirut where Mona was born in 1952. Her father, who had long been employed by the British Mandate government in Palestine, was able to work at the British Embassy in Beirut and also to become a British citizen, so that eventually the whole family held British passports—a great privilege, since Palestinian exiles remained stateless, without papers.

When Mona Hatoum, at the age of twenty-three, made her first trip to London in the spring of 1975—only a short stay was planned—civil war unexpectedly broke out in Lebanon. Beirut, the thriving "Paris of the Orient," a place of immigrants and multilingualism, a melting pot of faiths and cultures, had become the center of a brutal, political, social, and sectarian war that lasted for 15 years. This is the subject of the poignant novel *Sitt Marie Rose* by the poet, philosopher, and painter Etel Adnan (1925–2021), another prominent Lebanese artist.[1]

Adnan was in the midst of the war at the time and wrote the novel in just one month as a mixture of eyewitness account, sharp social analysis, and fiction: "On the 13th of April 1975 Hatred erupts. Several hundred years of frustration re-emerge to be expressed anew."[2] Already three months before the fighting, as if foreshadowing the catastrophe, Adnan penned *L'Apocalypse arabe*, her long poem about the sun. The verses are full of love, beauty, rage, and terror. The lines are interspersed with hieroglyphic symbols that Adnan drew to indicate what cannot be put into words.[3]

1 Etel Adnan, *Sitt Marie Rose* (Paris, 1977). Published in English as: *Sitt Marie Rose*, trans. Georgina Kleege (Sausalito, CA, 1982).
2 Adnan 1982 (see note 1), p. 11.
3 Etel Adnan, *L'Apocalypse arabe* (Paris, 1980). Published in English as: *The Arab Apocalypse*, trans. Etel Adnan (Sausalito, CA, 2006). See Etel Adnan's quote in French here: https://www.luma.org/fr/live/project/apocalypse-arabe-bcce125a-06c2-4255-ba52-81ded879d812.html [all URLs accessed in May 2023].

Arriving in London at the age of twenty-three, Hatoum was at an age when she would probably have been happy to make the leap from Beirut to new horizons of her own free will. But the civil war meant radical uprooting for her. There was no going back to the city of her birth, to her family, to her friends, and to the cultural region that was as complex as it was familiar. Beirut had turned into hell, and exile became a physical, as well as a psychological and mental reality. But despite the burden of worry, she did not succumb to crippling bitterness. Her talents, creativity, and courageous intelligence were too vital for that. Recognizing the opportunity to explore new avenues in London, she enrolled in art courses, first at the Byam Shaw School of Art, then at the Slade School of Fine Art. Soon after graduating in 1981, the international art world began to take an interest in her work. Today Mona Hatoum is a world-renowned artist, the recipient of honorary doctorates and awards such as the Roswitha Haftmann Prize (Zurich, 2004) and the Käthe Kollwitz Prize (Berlin, 2010). She continues to live in London, and is frequently in Berlin. Ultimately, she finds her home in her work. To this end, she lives a nomadic life, often as an artist-in-residence in places of special interest to her, such as in Jerusalem in 1996 or, that same year, at the last Shaker community in Maine, together with the American artist Janine Antoni.[4]

Hatoum's early work in the 1980s is characterized by body-related performances and video works with political, social, and feminist content. One example is the performance *Live Work for the Black Room* (1981).[5] In a darkened room where all the surfaces were painted black, Hatoum repeatedly fell on the floor and traced the contours of her own body in white chalk. In each of the resulting body outlines, she placed a lit-up candle. Gradually, a ghostly play of lines emerged in the flickering light, reminiscent of forensic chalk drawings at the scene of a massacre or a memorial service for the fallen. The performance could also be interpreted as a metaphor for the constant relocation of oneself, for migration and the search for identity. Of her videos, *Measures of Distance* (1988) stands out as the

most autobiographical of her works.[6] It is based on photographs of her mother, naked in the shower in Beirut, superimposed with the Arabic script of her handwritten letters to Mona in London. The lines cover the image like a veil or rather like a fine, barbed-wire grid separating them. On the voice-over, Arabic conversations between mother and daughter can be heard. At times they laugh, then Mona's quiet voice can be heard as another acoustic cross-fade, reading passages from her mother's letters in English translation. These reflect the intimate bond between them and the painful feeling of being separated. The mother speaks of the burden of living in exile, in a country where war rages, and Palestinians are not welcome. One of the themes is womanhood, and the mother reveals that the father cannot bear to have Mona photograph her naked and talk to her about sexuality, because she is supposed to be a sexual being exclusively for him. Much of Hatoum's work has a biographical underpinning. The harsh experiences provided material for her artistic and intellectual positioning in a world that was newly mapped for her in the West. This led her to seek a disengagement from personal experience in her work after the 1980s, so that now, as a citizen of the world, she could find more general, cosmopolitan perceptions and questions from broader perspectives.

From Edward W. Said (1935–2003), a kindred spirit who, like her, was a Palestinian in exile, she borrowed the title of the publication that accompanied her solo exhibition at Tate Britain in 2000: *The Entire World as a Foreign Land*.[7] In the text, he writes: "Hatoum's art is hard to bear (like the refugee's world, which is full of grotesque structures that bespeak excess as well as paucity), yet very necessary to see as an art that travesties

4 See "Mona Hatoum by Janine Antoni," in: *Bomb* 63 (April 1, 1998), pp. 54–61.
5 See Hatoum's discussion of this work at https://vimeo.com/24541176, min. 03:11–04:34.
6 Mona Hatoum, *Measures of Distance*, 1988, https://www.youtube.com/watch?v=eKGPefM-Uf8.
7 See Edward W. Said, "The Art of Displacement: Mona Hatoum's Logic of Irreconcilables," in: *Mona Hatoum: The Entire World as a Foreign Land*, ed. Edward W. Said and Sheena Wagstaff (London, 2000), pp. 8–18.

the idea of a single homeland."[8] This interpretation is also attested to by Hatoum's recurring preoccupation with city maps and geopolitical maps of the world, most notably her iconic *Hot Spot*, a work from 2006 that also exists in later versions.

It depicts the globe as a giant, glowing gridded sphere on which the outlines of the continents are drawn with thin, glowing red neon tubes. These overlap as you look through the work, speaking of the connections and conditions that hold the fragile fabric of the world in shape. A hard blow anywhere could shatter it all. The low hum of the transformers seems like an ominous growl. High tension in the conflict-ridden political and climatic world situation is suggested.

From the 1990s onward, almost no people appear in Hatoum's oeuvre. From then on, the protagonists are manipulated, found, and assembled objects. However, they appear not as static apparitions, but rather as aesthetically fascinating phenomena that hint at their dynamic and ambivalent potential through their staging, scale, and the haptic quality of their combined materials. Intertwined associations, memories, and feelings of uncertainty are aroused, turning the encounter with these uncanny installations into a sensual and intellectual experience.

In the exhibition at the Kunsthaus Zürich, the work *Worry Beads* lies elegantly on the floor, embodying pop-like black rosary beads blown up to gigantic proportions. The symbol-laden object seems massively alienated by its ominous presence. While a rosary is usually strung with colored semiprecious stones, pearls, coral, wood, or amber, here it is heavy balls cast in bronze. And what would usually be a supple piece of jewelry that glides playfully through one's fingers is too much for one person to handle here, for each bronze bead is 20 centimeters in diameter. Hatoum's "worry beads" hints at transcultural customs, as well as the troubled history of religious rituals and wars.[9] For Buddhists and Hindus, as well as for Muslims and Christians, the rosary serves as an instrument of prayer, often consisting of 33 main beads for ritual reasons, as do Hatoum's *Worry Beads*. As a talisman, it dangles from rearview mirrors in cars, and

FIG. 2 Mona Hatoum, *Worry Beads*, 2009, patinated bronze and mild steel, 20 cm (7 ⅞ in) × variable length and width, installation view at Beirut Art Center.

for millions of Greeks, the *kombolói*, as they call it, is merely a piece of jewelry and a stress-relieving finger toy because of its pleasant feel. By contrast, Hatoum's beads evoke past and impending doom, reminding of those balls that were chained to the shackles of criminals, or of cannonballs. The shaft of the tassel also resembles a cannon barrel, so that, when standing in front of the work, one can also imagine sounds: on the one hand, the fine clicking of the beads of the *kombolói* falling on each other, and on the other, the deafening bang of a cannon salvo. The object thus refers to various ambivalences: religion, violence, play, destruction, ornament, bugaboo, and much more.

In lectures and interviews, Hatoum expresses how she was inspired by Surrealism, Conceptual Art, and Minimal Art—and this is evident in her oeuvre. Standing in front of *Worry Beads*, the play of associations leads the viewers to René Magritte's *Ceci n'est pas une pipe* (1929). In both works, iconic objects appear oversized, irritating the commonly held experiences one associates with them and prompting questions about their artistic representation, titling, and symbolism. However, in exploring its manifold and ambivalent

8 Edward W. Said, "The Art of Displacement: Mona Hatoum's Logic of Irreconcilables," reprinted in: *IEMed: Quaderns de la Mediterrània*, no. 15 (Barcelona, 2011), p. 110, https://www.iemed.org/wp-content/uploads/2011/09/The-Art-of-Displacement.pdf.

9 For more on worry beads in general, see Daniel Da Cruz, "Worry Beads," *Aramco World Magazine* (November–December 1968), pp. 2–3, https://archive.aramcoworld.com/issue/196806/worry.beads.htm.

levels of reality and interpretation, *Worry Beads*, unlike Magritte's pipe, radiates the uneasy mood that flows like a basso continuo beneath the surface of Hatoum's entire oeuvre. Like the minimal artists, Hatoum prefers the genres of object art and installation, and she also uses a reduced, abstract vocabulary of forms and industrial materials. However, she deviates drastically from the views of key figures of American Minimalism, such as Sol LeWitt, Donald Judd, and Carl Andre, who emphasized the importance of formal abstract content over narrative, illustrative, and emotional aspects. In contrast, in Hatoum's work, every form, material, dimension, and detail is sensual, emotional, powerfully poetic, and narratively charged on a subliminal level.

Cellules consists of several slightly tilted steel cages, the tallest of which notably corresponds to Hatoum's own height. Each holds one or two red, amorphous, and fragile glass objects that look like animated organs, breasts, bladders, or stomachs. Imprints of steel bars in their forms suggest that the strange creatures have tried to squeeze through the mesh to break free. The way Hatoum manages to intertwine her critique of repressive power structures and corporal punishment with a beautifully horrific aesthetic literally gets under your skin. Early on, she had read texts by Michel Foucault and Georges Bataille and studied the concepts of surveillance and other state control mechanisms.

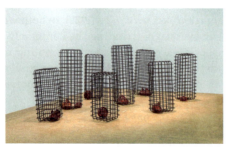

FIG. 3 Mona Hatoum, *Cellules*, 2012–13, mild steel and hand-blown glass in eight parts, 170 cm (66 ⁵⁹⁄₆₄ in) × variable width and depth, installation view at Centre Pompidou, Paris.

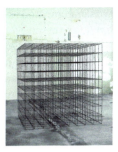 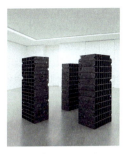

FIG. 4 Mona Hatoum, *Cube (9 × 9 × 9)*, 2008, black finished steel, 181 × 182 × 182 cm (71 ¹⁷⁄₆₄ × 71 ²¹⁄₃₂ × 71 ²¹⁄₃₂ in), installation view at Galerie Max Hetzler, Berlin.
FIG. 5 Mona Hatoum, *Bourj A*, 2011, *Bourj II*, 2011 and *Bourj III*, 2011, mild steel tubing, dimensions variable, installation view at MdbK Leipzig.

Her *Cube (9 × 9 × 9)* from 2008 strongly resembles Sol LeWitt's *Nine-Part Modular Cube* from 1977. Both sculptures consist of a strictly geometric latticework of 9 by 9 by 9 cubes stacked on top of each other. While in LeWitt's work the bars are smooth and white and have nothing at all hostile about them, in Hatoum's *Cube* they are thin, black, and equipped with injurious spikes. When her *Cube* and his are visually compared from different perspectives, from near and far and all around, both unfold a myriad of similar geometric charms. Hatoum's sculpture, however, additionally evokes a rich spectrum of associations, such as pain, barricades, or prison camps. Paradoxically, for all the anxiety one feels in front of the work, her *Cube* also seems insidiously fragile.

Uncanny ideas are also evoked by the installation with *Bourj*, *Bourj II*, and *Bourj III*. The human-size ensemble looks like a large, charred model of a modernist urban district. *Bourj* is the Arabic word for tower, and the first one of the series was originally created for Hatoum's 2010 solo exhibition in Beirut. The individual towers are constructed of layered rectangular steel tubes to which Hatoum inflicted massive injury. They are reminiscent of the bullet and rocket holes in the ruins of the

former Holiday Inn in Beirut. The hotel was inaugurated in 1974, just months before the civil war broke out, as the city's most impressive building, a landmark of the Middle East's Golden Age. As the fighting escalated, it became the most strategically important base for heavy exchanges of artillery and sniper fire. The battle for the Holiday Inn and the surrounding luxury hotels divided Beirut into a western and an eastern part, whose demarcation line, called the "Green Line," could only be crossed at checkpoints. For nearly 50 years, the gigantic, massacred shell of the Holiday Inn has towered into the sky, attracting tourists as a terrifying symbol of unhealed wounds and inspiring artists like Mona Hatoum.

The furniture in *Remains of the Day* appear as if they were the ghostly remnants of a domestic-family environment inside the irreparable *Bourj*. Here, only chicken wire holds together the charred fragments of adult and children's furniture and a toy car, saving them from final decay. This installation evolved from work Hatoum made for her exhibition in conjunction with the tenth Hiroshima Art Prize in 2017, which was awarded to her in the city where the first atomic bomb in history was dropped.

A bold fantasy of the final dissolution of the political world and its system of power is embodied in *Silver Lining*, a room-sized neon work featuring the luminous profile drawings of the 192 member states of the United Nations.[10] Hatoum conceived the work site-specifically for the ceiling of the 70-meter-long passageway at Bern Academy of the Arts (HKB). There, it occupies an area of approximately 560 square meters, as large as Michelangelo's ceiling painting in the Sistine Chapel. *Silver Lining*, the title of which denotes a "glimmer of hope," is filled with metaphor and ambivalence, oscillating between attraction and threat, between utopia and dystopia. All of the states here are disconnected from each other, fragmented and dispersed—there are no longer any common borders. Nevertheless, the shapes of the radiating profiles reveal how the world was once divided into nations, whether by natural, geographical demarcations, as in the case of Italy through the Alps and the sea, or by

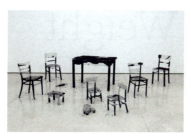

FIG. 6 Mona Hatoum, *Remains of the Day*, 2016–18, wire mesh and wood, dimensions variable.

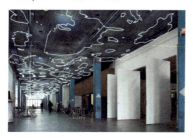

FIG. 7 Mona Hatoum, *Silver Lining*, 2011, neon tube, 419 × 730 × 7000 cm (164 ⁶⁴⁄₆₄ × 287 ¹³⁄₃₂ × 2755 ²⁹⁄₃₂ in), permanent installation at Bern Academy of the Arts.

colonialists on the drawing board through brutal, straight-line drawings, as in Africa.

To finance the project, the neon contours were offered for sale. Thus, today there are 192 owners, one nation each, but they are denied any colonialist chance of exploitation. In fact, the nations have set out, have broken away from the world community in order to be free, to breathe a sigh of relief, to roam the universe transcended and radiant in paradoxical independence and splendid isolation, peacefully coexisting.

10 South Sudan became the 193rd UN member state in 2011, shortly after *Silver Lining* was created. For more on this work, see Hans Rudolf Reust, "Die Weltdecke," in: *Kunstbulletin* 1–2 (2011), https://www.artlog.net/de/kunst bulletin-1-2-2011/mona-hatoum-die-weltdecke; Jacqueline Burckhardt, "Mona Hatoums Silberstreifen," *Parkett* no. 89 (2011), pp. 245–49.

The Weight of a Grain of Dust

Robert Wilson and *Le Martyre de Saint Sébastien*

This text is based on an article by Jacqueline Burckhardt and Bice Curiger, "The Weight of a Grain of Dust," *Parkett* no. 16, 1988.

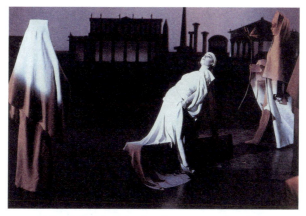

FIG. 1 Robert Wilson's production of *Le Martyre de Saint Sébastien*, Opéra de Paris, 1988.

It came as a surprise when in 1988 Robert Wilson decided to accept Rudolf Nureyev's invitation to stage *Le Martyre de Saint Sébastien* by Claude Debussy and Gabriele D'Annunzio with the Paris Opéra Ballet.

D'Annunzio had written the play for a woman, the dancer Ida Rubinstein, having thrown himself at her feet in rapturous adoration after a performance of the Ballet Russe in 1909.[1] When it premiered at the Parisian Théâtre du Châtelet on May 22, 1911, it lasted five hours. Wilson reduced the performance by half and hired 33 of the Opéra's dancers as well as two narrators, Sheryl Sutton and Philippe Chemin. He cast three principal dancers in the leading roles: Sylvie Guillem as Saint Sébastien, Michael Denard as Sébastien the sailor and Patrick Dupond as both the Emperor Diocletian, who condemned Sébastien to death, and a ship captain. Bice Curiger and I, the two authors of this essay, had the opportunity to watch a few rehearsals in preparation for *Parkett* no. 16 devoted to Robert Wilson. Wilson

1 See François Lesure, "Naissance et destin du Saint Sébastien," in: program of *Le Martyre de Saint Sébastien*, Théâtre Bobigny, Paris, March 1988.

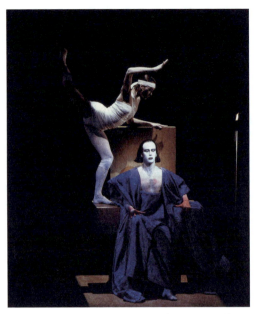

FIG. 2 Robert Wilson's production of *Le Martyre de Saint Sébastien*, Opéra de Paris, 1988.

did not want to use classical ballet for his production. As critic Benjamin Henrichs put it in 1979, "He is not interested in the art of dance, but in the happiness of the dancers."[2] And indeed, the first rehearsals already attested to the audacity of Wilson's plan when he confessed to the assembled dancers: "What bothers me about classical ballet is its aggressive presence. The movements are too forced, which is somewhat vulgar."[3] He then introduced a woman he has been working with for years, Suzushi Hanayagi, a choreographer and dancer of both classical and experimental forms of Japanese dance. Wilson explained that performers in Japanese theater are given much greater latitude in defining their presence on stage, and the audience also has greater freedom in following the events. Emotions are not displayed with force and exaggeration but rather take place within, as

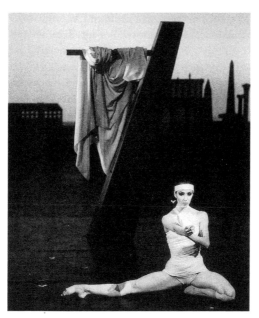

FIG. 3 Sylvie Guillem as Saint Sébastien.

do movements as well. That is why emotions show such great authenticity in Japanese theater.

Five weeks of rehearsals revealed Wilson's willingness to take risks and his ability to unite his idea of dance with the formidable professional mastery of each individual dancer through an exceptionally unconventional approach—from the wings, as it were, rather than head on. It also revealed his ability to tease new aspects out of the play with its eroticism and even a touch of kitsch.

2 Benjamin Henrichs, "Willkommen im Paradies, zu DD & D 1," in: *Die Zeit*, March 2, 1979, pp. 41/42.
3 This quote and other statements are taken from a conversation between Robert Wilson and Heiner Müller, recorded by Bice Curiger at the Hotel Castiglione in Paris on February 24, 1988.

In our conversations Wilson's profound appreciation of Sylvie Guillem came to the fore; her art, her intelligence and her body were quite simply perfect for him. She translated his ideas of movement into dance with consummate ease. Not so for most of the other dancers with their ingrained classical training; it was almost like exorcising the devil. Guillem had been an athlete before she decided to study classical ballet. She effortlessly did what Wilson asked of the dancers, namely, to listen with the body of someone who is deaf. She has a charismatic presence even when immobile, even when a line of a movement seems to freeze for a split second before continuing. She was a perfect match for what Wilson and Hanayagi envisioned in the sequences of movement they had invented with their subtle allusion to the tradition of Japanese dance—sequences based on the notion that there is immobility in movement and movement in immobility.

It was important to Hanayagi that a dancer land on the floor "like a samurai" after executing a jump or that a dancer's expression remain utterly impassive while executing a vigorous movement of the arms away from body. At the same time, however, Wilson and Hanayagi gave the dancers a certain freedom in developing movements of their own. In rehearsal, they paid meticulous attention to the positions of hands, fingers and especially toes. The pompous behavior of Diocletian, accompanied by twitching reminiscent of an imperious bird, culminated in his pose on the throne when the spotlight fell on his foot with the big toe standing upright. In the end, we had the impression of having witnessed events of singular beauty like a densely "woven image." It was possible to follow the narrative structure conveyed by the actions, which is not ordinarily the case in Wilson's work. Events on stage, the stage set, props and costumes were often literal interpretations of D'Annunzio's text, indicating that, as Wilson says himself, he did not feel constricted by it as he has been in many other cases. D'Annunzio and Debussy had already conceived the piece as an elaborate production with symbolic and innovative use of lighting, costumes and sets. However,

Wilson introduced layers of his own in *Le Martyre de Saint Sébastien*, somewhat like a painted, fragmented backdrop within the complex overall interplay of diverse elements.

Rehearsals were in progress when we organized a meeting with Robert Wilson and Heiner Müller in the bar of Hotel Castiglione (see note 3, p. 309). Müller was in town because Jean Jourdheuil was directing his piece *La route des chars* at the Maison de la Culture in Bobigny. The conversation was recorded and, at the time, Wilson said, "Beckett is a visual artist. In the works he wrote for the stage he established an image in the text, and this restricted the staging. You also have to deal with it historically, like a museum piece, and you're constantly wondering how Beckett himself would have staged it."

Thereupon Heiner Müller described how he works the other way around: "It is as if I were writing texts that are in search of a place. But there is no place for the text, it is placeless. It is waiting for a place, while you create spaces that are waiting for a text or for something else. And an encounter can take place anywhere, in New York, Honolulu or on the moon, or nowhere in particular. This has something to do with paradox, with an experience, with this communist dream that does not materialize, that is merely a dream, without a place, without a space, a dream in search of a place. You're an American, and Americans are obsessed with space." And Wilson replied: "Yes, space without boundaries."

In his stage productions, Wilson has always been at odds with all things illustrative, all kinds of parasitic redundancy, such as that so often produced in the media of theater and film with unwitting generosity, as if guided by the ineluctable laws of nature. Instead, one might speak in *Le Martyre de Saint Sébastien* of multiple, transparent layering. The narrative reaches the audience only via changing "agents of communication."

The two narrators are stationed at the front of the stage, but they speak for the figures on stage and are occasionally heard off voice on a tape recorder. Their voices show no emotion,

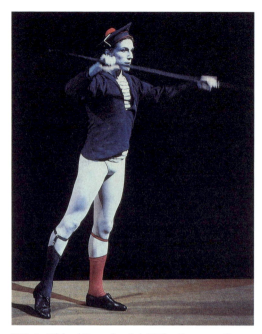

FIG. 4 Michael Denard as Saint Sébastien as a sailor.

no pathos but they are not indifferent either. They sit on chairs that shift imperceptibly to the right as the piece progresses, as if to record the passage of time. Sometimes the dancer playing the Saint Sébastien sailor speaks live.

Most of the dancers do not embody actual roles and do not advance the linear progress of the story. Instead, they create richly faceted figures that lead to surprising, wide-ranging associations. As D'Annunzio originally intended, Wilson's Saint Sébastien is cast as a woman. For this role Wilson was inspired by Andrea Mantegna's *San Sebastiano* from the Louvre. He always kept a reproduction of this painting on his director's desk.[4] The second Sébastien is borrowed from a 1934 painting by the French artist Alfred Courmes, now held at the Centre Georges Pompidou. The painting shows Saint Sébastien as a

sailor, naked from the waist down, wearing only shoes and socks with suspenders. In Wilson's production he appears as a homoerotic kitsch icon, moving about in dreamy self-oblivion, and watching his own martyrdom. Since he dances on the proscenium for the most part, the spectators look at and past him at the changing tableaux. There are flashes of literary allusion in all layers of the performance as when this sailor, with Pierrot-white face and cheeky buttocks, strays unseeing through a "crowd" or when he is Thomas Mann's Tadzio or Jean Genet's Querelle, thus associating eroticism with innocence and underworld. For Wilson, the figures that populate this drama are ambiguous archetypes. Emperor Diocletian appears as a sea captain in the prologue and in a few interludes. His movements range from jerky and martial to lurching and stumbling. He is something between an admiral in a silent film and a vaudeville Tarzan.

Wilson has staged a martyrdom that is played out on many levels and relies on the imagination as a collective instrument. He reveals nothing too much and nothing too early, but he does provide an opening, an opening which in turn provides access to a language that is at everyone's disposal: the language of association. In writing the alphabet of this language, Wilson cuts through times and cultures, from hieroglyphs to Walt Disney, and in so doing he relies on our ability to decode it. Time and again he has shown his preference for simple and yet all-embracing visual ciphers that represent a kind of elementary or primal image of our world. The titles of the chapters in his 1982 video *Stations* read "Forest," "Fire," "Glass," "Dust," "Temple," "Water," etc. It is as if he were constantly rearranging the components of our world: an architect with divine intentions. In the conversation with Wilson Heiner Müller said: "The poet W. H. Auden put forward the thesis, oversimplified perhaps, that there are two kinds of people: doers of deeds and makers of things. The doers view the makers with a certain disdain. This is an important distinction. Most people who work in theater want to

4 See fig. 31, p. 49.

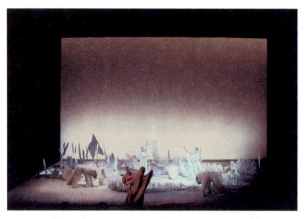

FIG. 5 Robert Wilson, *Le Martyre de Saint Sébastien*, fifth and final act ("*Le Paradis*"), Paris, 1988.

do things, not make them. Another problem is that theater directors ordinarily try to relate their productions to reality. In contrast, Wilson seeks to relate his work to his dreams. Reality on stage is different from reality in the outside world. If you cannot insist on this fact, then you shouldn't start working on stage."

There is an urgency to all of the things, all of the appearances in Wilson's universe. They each stand alone in radiant independence and yet they are woven into the whole. The strict nature of his tableaux reveals the will to create a compelling composition that works with light and with a clear transparent structure of the kind that might have sprung from Cézanne's mind.

Since no single building block dominates in Wilson's productions, an element may occasionally turn into something else in all fluent clarity: movement is line, music is light, a gesture is sound, objects are actors. Wilson stages certain parts of the ballet in silence, without Debussy's music; elsewhere, he adds sequences of sound composed by Hans Peter Kuhn: piano notes, someone striking metal, bees buzzing or dogs barking in the distance. And in the intermezzi we hear Debussy's *Pour le piano*.

Wilson added a prologue to *Le Martyre de Saint Sébastien*, a scene on the deck of an ocean liner in which everyone is dressed in white. It harks back to the era in which Debussy and D'Annunzio composed their mystery play, as it evokes the menacing atmosphere prior to the First World War, prior to catastrophe, even if it is "merely" the sinking of the Titanic. But Wilson also directs his gaze at Sébastien's imminent martyrdom. It is as if the figures were under an iron grip, enacting the ritual of a ritual. The only colorful figure in this glittering mother-of-pearl tableau is sailor Saint Sébastien (Michael Denard). Saint Sébastien (Sylvie Guillem) is also present and directs his attention to Veronica's Sudarium. The detonation of slamming doors bursts in on this tense, pent-up atmosphere, acoustically releasing all of the violence contained in the piece. We hear the arrows piercing Sébastien's body.

Wilson told Müller: "Theater is time and space compressed. It is different from any other kind of space. Subway space, restaurant space or whatever, they are all different. Time is different in the space of the theater, too. In your *Hamletmachine*, which I staged in Hamburg and New York in 1986, the text becomes a vast space, vast freedom. It is as if someone were standing in a long tank with their head sticking out, a 3000-year-old human being, a human being of the future—and the space belongs to this person, no one else can enter. Therefore, the vast freedom, and this suits the theater."

Müller added: "There is this quote from Hölderlin in the *Hamletmachine*: 'wild awaiting / in the fearful armor / centuries.'" Under Robert Wilson's direction, Debussy and D'Annunzio's *Martyre de Saint Sébastien* is transformed into a sea voyage through space, times and ideas, during which we expose ourselves to the "substance" from within. Instead of espying the dust that lies on this piece from afar, Wilson measures the weight of each grain of dust with *sprezzatura*. And while the arrows pierce the audience through sound, the prospect of paradise in the final tableau can only be borne under suffering. The light is too bright.

Dance About Dance About Me About Us

The Dance Performer Dana Reitz

This text is based on an article in *Parkett* no.1, 1984.

FIGS. 1+2 Dana Reitz, *Journey for Two Sides: A Solo Dance Duet*, 1978.

Hours before the performances begins, Dana Reitz lies on the stage, shifting her body over small rubber balls, thus giving her muscles a gentle massage that renders them "fluid." Carefully exercising, she stretches her limbs and increases her flexibility until she has reached a state of physical readiness and played through the full range of possible movements. She then repeatedly tries out and invents sequences of movements while exploring the space in which she will perform.

This method of training and preparing for performances is quite distinct from that of dance performers of the younger New Wave generation in the United States. The latter coach their bodies through tough, often athletic or even acrobatic training, molding them in order to achieve a peak physical capacity. This is what Molissa Fenley or Karole Armitage do in their energetic, lusty choreographies, driven by New Music related to rock and punk where body presence and speed are celebrated.

In contrast, Reitz cultivates a body awareness inspired by the conceptual ideas of American postmodern dance. She explores the potential of simple everyday movements. Experiences as a 17-year-old while in Japan in 1965 led to her decision to study dance and theater. In 1966 she began a four-year program at the University of Michigan. In 1970 she moved to New York, where she worked for three years at Merce Cunningham's studio, and later joined Twyla Tharp's and Laura Dean's companies, while also studying classical ballet, Tai Chi Chuan and Indian dance. In 1976 Robert Wilson and Philip Glass engaged her for their opera *Einstein on the Beach*, and in 1977 and 1978 she performed with Wendy Perron and Andrew de Groat. She absorbed all of these influences and experiences, gaining awareness of what her body, as a medium, was best able to do, allowing her own artistic personality and authentic expression.

Her pieces build on simple formal movements, seemingly casual gestures that she repeats in elementary rhythms. They serve as a blueprint for action, as a plan and raw material for improvisation, gradually growing through variations and metamorphosis into complex, interwoven adventures. The most delicate and thrilling moments in her improvisations are the changes and transitions. Her finely tuned intuition and meticulously trained body guide her in finding the "right" movement at the "right" moment from a wide spectrum that encompasses everything from a gracefully organic change of flow to an abrupt break that is as unexpected as the flick of a fish. She captivates her audience not only because of her charismatic stage presence and enigmatic body language, but also because of her ability to instantaneously convey and evoke subtle emotions. Her dance is humorous at times, then again sober, soon passionate or nonchalant, playfully appealing or aggressive and witchy.

"It starts like this," she might say, swinging her hand up and down in front of her body, while setting a rhythm by performing a series of steps on the spot. As her complex dance unfolds, the movements follow naturally and yet surprisingly. She seems to draw them out of her own body or to catch them in motion like a

juggler, as if they were already sweeping through space. Rarely does she dance across the stage, choosing instead specific spots, where she remains for a time allowing the movements themselves to fill the surrounding space. Her arms and neck seem elongated, accompanying and receiving the flow of movement, which appears to have neither beginning nor end. The tiniest gesture, a meaningful glance or the swirling of her loose, shoulder-length hair: everything is included in the play. At times, she is even taken aback by certain moments in her improvisation, giving rise to trouvailles or questions that she will explore in a new dance. In this way, one piece naturally evolves into another.

Given her approach, it becomes evident that Reitz necessarily sounds out her mental and physical condition with great care before each performance. She says that she has both a "verbal mind" and a "body mind," two different things that are frequently not in sync. That is why she refrains from imposing precisely predetermined movements on her body; if she did, the movements would become stiff and labored. Testing her daily condition is all the more important, as she dances without any stage sets, music or a narrative plot. She does without these supporting accompaniments in exploiting all the nerves in her body and mind to choreograph her sign language.

FIG. 3 Dana Reitz, *Duet no. 1 from the Field Papers*, 1982, charcoal and ink on paper, 113 × 76 cm (44 ½ × 29 ⁵⁹⁄₆₄ in).

In her New York loft, Reitz creates drawings and paintings in which she pulls out all the stops, from intricate lines to wild brushstrokes. These works are not conventional choreographic scores; instead, they show traces from the energy of her movements and serve as studies for her dance. Dancers cannot stand back and look at their work like painters; mirrors or video recordings are inadequate tools for self-critical reflection. For Reitz, the drawings are a means of analyzing her emotions, intuition and natural inclinations, as well as her rational and mental persona. Since 1982 she has been exploring this dichotomy in works on paper that are reminiscent of Far Eastern calligraphy. She uses Chinese brushes and ink to paint with her left, less well-trained hand, and charcoal with her right, more practiced hand, and in the intricate interplay of the lines and strokes, she discovers much that is related to the essence of her dance. She addressed this existential dichotomy in 1978 in *Journey for Two Sides: A Solo Dance Duet*. The performance varied from night to night, in response to her state of mind and physical condition, the atmosphere in the house and the nature of the venue.

Since Isadora Duncan, modern dance has been liberated from conventions and formalism. But it was actually Reitz's close relationship to music that led her to exclude it from her dance. She had originally wanted to become a musician and started out studying the oboe and piano. But then she shifted her focus to the intricacies of musical impulses, their effects and dynamics, using her body as an instrument to conjure silent, visual music in space. In 1974 she played with the effect of transforming movement into sound by attaching little brass bells to her ankles, letting them register all the nuances in phrasing and changes in rhythm.

In *Field Papers*, which premiered in February 1983 at the Brooklyn Academy of Music and was subsequently performed in Linz and Paris, she worked with two dancers and the violinist Malcolm Goldstein. Reitz and Goldstein had previously collaborated to experiment with the analogies they had recognized

in their art. In *Field Papers*, the dancers and the musician never appeared on stage at the same time, because they were not meant to illustrate each other. "I am a dancer," Goldstein declared, reinforcing his statement by playing his music barefoot, like the dancers. Following Reitz's principle of combining a basic structure with improvisation, the dancers each developed their own motifs individually, even when they were performing synchronized movements.

Reitz designed the lighting as an immaterial, structured framework in collaboration with Beverly Emmons, assigning a specific light field to each dancer. Sarah Skaggs received a horizontal field in the background, Bebe Miller one directed towards the audience and Reitz herself a diagonal light field. With great intensity, the dancers first claim their own territories and then, mutually challenging one another, they penetrate those of the others. In the end, the light fields are gradually dimmed so that the immaterial stage architecture slowly fades and with it, the dance. In this way, Dana Reitz underscores the compelling interplay of space, light, movement and rhythm that is inherent in her dance.

Studio Visit

Alex Katz

This text is based on the essay "Katz and Kairos," in the catalog
to the exhibition *Alex Katz. Small Portraits and Large Landscapes*,
exh. cat., Monica de Cardenas Gallery, Zuoz, 2003.

FIGS. 1+2 In Alex Katz's studio, New York, 2003.

In the 1980s and 1990s, SoHo was the home of an exciting international art scene and we, the *Parkett* editors, used to spend our time in New York hurrying from one gallery to the next, from one appointment to another. Visiting Alex and Ada Katz at their West Broadway loft was always a welcome relief.

Walking straight off the elevator into their apartment, we would take a deep breath; it was like inhaling a distilled vacation that takes instant effect. The loft was bright and airy, the interior deliberately minimal, manageable and well organized. Nothing jarred, nothing was lying around—actually quite surprising considering the fact that the two had been living and working there for several decades. The art, the furnishings, the objects—everything felt right and characterized the owners: Alex Katz, tall, athletic, full of controlled energy, his mind as quick and incisive as his speech; Ada Katz, a classic Mediterranean beauty, serenely focused, radiating a natural nobility.

FIG. 3 Alex Katz, *Rudy and Edwin*, 1968, cutout, oil on aluminum, 110 × 122 cm (43 ⁵⁄₁₆ × 48 ¹⁄₃₂ in). Rudy Burckhardt right, Edwin Denby left.

The cutout of Rudy Burckhardt (1914–1999) and Edwin Denby (1903–1983) of 1968 was standing in the first room. It still is. Not quite life size, these two friends, the photographer/filmmaker and the writer/dance critic, sit facing each other on folding chairs, both elegant and in a dandy-like, casual pose as if they had all the time in the world to be engrossed in conversation.

They embody "style," a favorite term in Katz's vocabulary. This hybrid work, half painting, half sculpture, eloquently

testifies to the fact that portraits of people close to Katz—artists, writers, musicians, his son Vincent and daughter-in-law Vivien, and always Ada—form the core of his oeuvre.

In the adjoining studio, large, unfinished paintings hang on the walls, lean against them or rest on easels. Drawings, oil sketches and the tools of painting are neatly arranged on worktables. Obviously, nothing is done here in a frenzy of creativity.

Katz told us about his *modus operandi*, a meticulous process. The drawings and oil sketches on hardboard form the basis of the large-format paintings. They are spontaneous notations of moments captured after the model or before a motive, either in the studio or outdoors, often in Maine, where the couple have a second home. Katz perceives these serendipitous moments in the light, in constellations of forms and colors, in the fleeting attitudes and gestures of his models, in the way clothing falls and fabrics are patterned and even in birch leaves fluttering in the wind or in cresting waves.

His great mastery lies in taking advantage of Kairos, in skillfully and speedily harnessing the vibrant poetic energy of the so-called right moment and translating it into a sketch. Kairos, the Greek god, is the embodiment of the right moment and stands for qualitative time. He is depicted in antiquity as an ephebe with winged feet, similar to Hermes. In contrast Chronos, the god of quantitative time, is often represented as a cadaverous old man who eats his own children, the hours. Kairos can only be caught from the front by a shock of hair on his forehead. Since he is otherwise bald, he cannot be grasped from behind. Given Katz's affinity with Kairos, the metaphor applied to the artist by John Russell, former chief art critic of the *New York Times*, is most apt. He describes Katz as an "Olympic high-flyer."[1]

As mentioned, sketches precede elaborate preparations for his large-format paintings. The next step is to make line drawings of the image, which Katz then enlarges to full scale in charcoal on paper. He then makes use of a venerable European tradition, the "cartoon." With a special tool, a roulette, he scores

FIG. 4 Alex Katz, *Woman with a Hat*, 1993, oil on painting board, 41 × 31 cm (16 ⁹⁄₆₄ × 12 ¹³⁄₆₄ in).

perforated lines on the full-scale drawing, places the drawing on the primed canvas, applies burned sienna or charcoal dust to the drawing and thus transfers the contours of the image to the canvas underneath through the tiny holes.

When a large canvas is prepared in this way, such as *Lincolnville, Labor Day* (1992), which is almost 236 inches wide and 118 inches high, Katz proceeds to paint the picture, wet in wet, in extraordinarily concentrated hours and, if possible, in one go. He performs each gesture with masterly deliberation and great economy, like the dancers and cool jazz musicians he admires, or a samurai wielding his sword, in fact, like any virtuoso who works with body, mind and time. Over the years, Katz has developed and perfected a sophisticated technique and a unique style. He himself as well as the prolific body of writings about him make it unmistakably clear: the essence of his art is not revealed by inquiring into the meaning of pictorial content, by trying to pin down obsessions, political agendas or psyches, or by seeking to determine degrees of resemblance. Never does a portrait attempt to steal the subject's soul. Katz's paintings are not only painting through and through; they also have an

1 John Russel, "An Olympic High-Flyer," in: *Parkett* no. 21, 1989, p. 16.

inimitably distinctive aura. Unerringly he homes in on the distinguishing features of his subjects, reduces them to essentials and shows us ordinary everyday things that we've seen hundreds of times before, but never as he sees them. Note the details in *Woman with a Hat* from 1993: the yellow contours that make the skin shimmer and the face glow, the rich palette of grays joyfully explored to render a fur hat, wool sweater and cloth jacket.

During his almost performance-like act of painting, Katz has to make many almost instantaneous decisions, but he also leaves himself room for improvisation. It is an act that demands great experience and mastery in blending spontaneity and precision. If the painting succeeds, Kairos is well served, and a thoroughly American work has come to light: it is flat, all-over, cool and big, and yet it also radiates something that Frank O'Hara, the poet and close friend of Katz, called "oriental calm."[2]

2 Frank O'Hara, in: http://www.alexkatz.com/bibliography/selected_articles_and_reviews/Starting_Out-Katz_Alex_New_Criterion_21.

Bio-Graphy

Jean-Luc Mylayne

This text is based on an essay by Jacqueline Burckhardt
that appeared in French, English, and German in the catalogs of the touring
exhibition *L'automne du paradis. Jean-Luc Mylayne*,
Fondation Vincent van Gogh Arles, Arles, Aargauer Kunsthaus, Aarau,
The Long Museum, Shanghai, Kestnergesellschaft, Hannover, Huis Marseille,
Museum for Photography, Amsterdam, 2019/20.

It's hard to say in which medium Jean-Luc Mylayne actually expresses himself. Photography, one would think at first sight, because what we see are prints of negatives, large-format photographs that were taken with a camera. But the more we find out about their complex production and Mylayne's intentions, the more questionable this assumption becomes. Jokingly, he recently said to me that he captures an entire feature film in each of his tableaux and is actually making movies.

The designation *tableau vivant* appeals to me because, as an allegory of life, it encapsulates symbolically staged life. A case in point is the picture of the fragile hummingbird in *N°319 avril mai 2005*, which hovers in the air by beating its wings at phenomenal speeds. In the composition, we see it fluttering upright, interrupting the horizon line and boldly standing opposite the mighty tree.

FIGS. 1+2 Jean-Luc Mylayne, *N°319, avril mai 2005*, C-print, 190 × 153 cm (74 ⁵¹⁄₆₄ × 60 ¹⁵⁄₆₄ in), detail to the right.

Jean-Luc was a mere five years old when he found himself utterly captivated by a trusting wren (troglodyte) at the river running through his grandmother's farm in northern France. That experience inflamed a lifelong passion for songbirds. Later, his interest in photography motivated his parents to give him a box camera for his first communion. The artist, largely an autodidact, was introduced to art early on by his half-brother, older by a decade and a talented draftsman and painter.

Mylayne's decision to become an artist came late. In 1978 at the age of 32, he gave up his job and, with his wife Mylène, seized the opportunity to disengage from a life in which time is always short or wasted. He was driven by the desire to chart territory in which time was plentiful and amenable to being fashioned. The couple sold Jean-Luc's house along with all the bits and pieces they no longer needed and invested the revenue in a Hasselblad with all the accessories and a van large enough to sleep in. Their decision had little to do with escapism. It was not a flight from reality; on the contrary, increasingly concerned about our treatment of the blue planet, they had chosen to address reality head on.

Mylayne comes from a farming background, where animals and land take priority. He now cultivates nature as an artist and his harvest is a prolific crop of tableaux. At the very beginning of his artistic career, a friend and his grandmother's neighbor, Monsieur Eustache Clabaut, a farmer with a large property, put his land at the couple's disposal. They had the privilege of using it at any time and as long as they pleased in order to observe the birds and set up their studio *en plein air*. The couple took advantage of the offer for 11 years, and in gratitude, Mylayne has since dedicated all of his exhibition catalogs to Eustache Clabaut.

Tableau N°22 juin juillet 1979 is one of the first works created on Clabaut's estate. It pictures a rural ideal of harmony

FIG. 3 Jean-Luc Mylayne, *N°22, juin juillet 1979*, C-print, 183 × 183 cm (72 ¾₄ × 72 ¾₄ in).

and attests to the great trust the breeding linnet (Linaria cannabina) has in the artist, permitting him to work right next to her in her vulnerable situation. The blurred shrubbery in which she is nesting has shimmering white blossoms and is enveloped in a composition of dancing light. It fills the entire foreground of the picture diagonally to the right and stands in contrast to the sharply drawn background with two cows and a distant range of hills on the high horizon line. On asking Mylayne about his staging of light, he tells me: *"Je sculpte la lumière."* From a current perspective, a picture of that kind might be considered anachronistic, indeed oppositional, considering the fact that nowadays art tends to de-idealize the world and take a closer look at its anti-idyllic aspects.

All of the details in Mylayne's tableaux, no matter how minute, are selected with meticulous precision and assembled to form a compelling, meaningful whole. He borrows his stage set from the landscape and his architecture from farms and ranches: the birds are his *acteurs*, as he calls them. Like a casting agent, Mylayne selects those birds that display a particularly distinctive body language, both in movement and at rest, and whose plumage is best suited to the scene. Sometimes they positively flaunt themselves for his benefit. The nomadic artist and his wife sought them out from 1979 to 2008, traveling through northern and southern France, through Texas and New Mexico.

The methodical care in preparing for one single shot involves reconnaissance of the location and observing the birds; it takes weeks and months, and sometimes even more than a year. As one of the world's most accomplished ornithological connoisseurs, Mylayne establishes a relationship to the birds with single-minded devotion, never feeding and certainly not taming them. He does not chase after pictures; never do we see a surprising snapshot; never does he resort to artifice. He puts his cards on the table; his tableaux are based on unconstrained, mutual trust. In time, the presence of the two people and their equipment—camera, tripod, umbrella lights—become such a

familiar part of the birds' surroundings that they no longer feel threatened, but instead show a trusting curiosity.

And only when the time of year, the time of day, the sun (in a position that might only occur twice a year), the play of light and shadow, the cloud formations, in short, the entire setting with its imperceptibly configured props, culminating in the anticipated magical moment when the bird unwittingly appears in its designated role—in other words, only when absolutely everything corresponds to his meticulously designed scenario does Mylayne press the shutter.

The tenacity and patience with which he endures hours of waiting behind the camera, alert, mute and motionless even through heat and cold, sandstorms and blizzards, is indebted not only to his obsessive devotion to art, to the birds, and to nature, but also to the unconditional collaboration of his partner Mylène. Jean-Luc Mylayne signs off on his works but his wife's name is also his own. They both had different last names until Jean-Luc embarked on his artistic journey and they decided to use Mylène's first name as their last name, with the same pronunciation but spelled differently. Mylène is Jean-Luc's alter ego in thought and deed.

Several tableaux are dedicated to their fellowship, especially those in which a male and female appear, for instance in the diptych *N°498–499 janvier février mars 2007*. Against a dreamy backdrop of blue mountains, a pair of mountain bluebirds are each seen perched on two agaves that the Mylaynes

FIG. 4 Jean-Luc Mylayne, *N°498–499, janvier février mars 2007*, diptych, C-print, each 183 × 228 cm (72 ¾₄ × 89 ⁴⁹⁄₆₄ in).

planted in the deserted Mexican plateau of Chihuahua. The panels look identical at first sight, but the pair have changed places from one picture to the other and the birds are gazing in slightly different directions.

The motif of togetherness is most surprisingly rendered in the spiral arrangement of nine photographs in *N°47, 48, 49 octobre 1984 à juillet 1986*. In these portraits, the Mylaynes study their own reflections in the eyes of the birds and on the lens of the camera, resulting in a reversal of roles: the bird has become the director in the branches of a tree and the Mylaynes are the actors. In three of the pictures, the great tit peers at the two artists and clings to the tripod, with the camera on top of it directed toward the couple. The surrounding close-ups show how the reflection of the couple in the convex eye of the bird and the lens is compressed and expanded at once. In the multilayered lenses of the camera, the couple appear in miraculously multiplied overlapping reflections and even in reflected reflections.

Looking at this ensemble, I cannot help thinking of the convex mirror that Jan van Eyck placed in the center of his *Arnolfini Portrait*. It shows the pair from the back and possibly van Eyck's self-portrait in the doorway. The manufacture

FIG. 5 Jean-Luc Mylayne, *N°47, 48, 49, octobre 1984 à juillet 1986*, C-print, 120 × 160 cm (47 ¼ × 62 ⁶³⁄₆₄ in).

FIG. 6 Jean-Luc Mylayne, *N°47, 48, 49, octobre 1984 à juillet 1986* (detail), C-print, 120 × 160 cm (47 ¼ × 62 ⁶³⁄₆₄ in).
FIGS. 7+8 Jan van Eyck, *The Arnolfini Portrait*, 1434, oil on wood, 82 × 60 cm (32 ²³⁄₃₂ × 23 ⅝ in), National Gallery, London, detail in the middle.

of such a mirror was a great scientific achievement in 1434 and required exceptional skill; the object was a treasure. The ability to expand the angle of view with a convex mirror, a sensation at the time, acquired symbolic significance. Because its range of vision was greater than that of the human eye, it was popularly called a "witch's eye."

580 years after van Eyck, Mylayne similarly uses the best equipment available to reflect the world from several perspectives. He takes the square pictures with his Hasselblad 6 × 6 cm (2 ²³⁄₆₄ × 2 ²³⁄₆₄ in) camera and uses a professional Sinar camera 20 × 25 cm (7 ⅞ × 9 ²⁷⁄₃₂ in) for the rectangular tableaux. The Hasselblad is easier to handle but the Sinar is more precise in controlling the depth of field and making other adjustments, while the negative format has even greater resolution in detail than the Hasselblad. For both devices, Mylayne designed a number of cut and polished lenses and had them custom-made by a maker of telescopes. As needed, the artist can stack up to three layers of lenses to generate multifocal images or blurred patches, as well as redirecting the incidence of the light and lending some elements in the framing a phantom-like appearance or even making them disappear altogether. Mylayne pulls all the stops offered by his prepared cameras. He is a *peintre-photographe*, who takes a painterly approach to his compositions.

Transparent paper mounted on the grid focusing screen of the Sinar camera serves as a support on which Mylayne draws the exact position of the bird and all the important elements of

the scene—like a storyboard. This is necessary because he has to take down all of the equipment he has set up every night and reinstall it the following day in exactly the same spot that he has defined down to each inch. When the moment has finally come to insert the film cassette into the camera, the focusing screen turns black, but by the time he presses the shutter, the image has long since been indelibly imprinted on his mind.

Mylayne has never had to destroy a negative; all of the 565 pictures he has produced have been successful. The birds do not make any mistakes; the only potentially disruptive factor is human interference. Because the envisioned and long-prepared moment can never be repeated, it is Mylayne's artistic principle to have only one print made of each picture. Four small-format editions are the only exceptions: three for the art magazine *Parkett* and one for INK Tree Editions.[1]

The tableaux are not patent eye catchers. They are challenging; they invite us to stroll through them visually. The blurred and illegible areas are zones of uncertainty without a vanishing point, indicative of Mylayne's eschewal of the anthropocentric perspective. Often we look for the bird, think we have found it in the blurred silhouette of some leaves and instead discover a lynx, only to be proved wrong again, but then seem to distinguish a bird of prey next to the lynx, which turns out to be a gnarled piece of wood.

The energy that emanates from the richly varied elements of the tableaux liberates the wide-ranging potential of perception, encouraging us to embark on personal discoveries and explore the byways of associative seeing and thinking: herein lies the qualitative essence of Mylayne's art.

Study of his work proves even more challenging on delving deeper into the thoughts inspired by our viewing, for Mylayne is a philosophically meditative artist. He also channels his ideas into writing and poetry, availing himself of a language that is

1 *Parkett* no. 50/51, 1997; no. 85, 2009; no. 100/101, 2017. INK Tree Editions, 2003.

FIG. 9 Jean-Luc Mylayne, *N°524, février mars avril 2007*, C-print, 228 × 183 cm (89 ⁴⁹⁄₆₄ × 72 ⁵⁄₆₄ in).

livelier than the conceptual terminology of philosophy. He studied philosophy and continues to devote himself to ornithological and scientific literature. His thoughts on observing nature and his perception of concrete empirical reality rest on a solid theoretical foundation.

Little has been written about Mylayne's treatment of birdsong. Music is a constant in his life; he considers it the most communicative art form in the world. The couple constantly "talk" to the birds in their surroundings by whistling.

N°524 février mars avril 2007 pays homage to a great singer, the American thrasher (Toxotoma rufum) in a delightfully humorous arabesque dedicated to birdsong. Prominently seen in the foreground, the soloist attracts our attention, fervently singing his heart out, while a Baroque twig elegantly traces his song, sweeping up into the air to unite animal and nature.

Not only does Mylayne meticulously orchestrate his elaborate productions; he pays equal attention to the layout and grouping of his tableaux in exhibitions. The exhibition for which this text has been written provides a distilled insight into the core of an oeuvre spanning the past three decades. The selection spans his oeuvre from the first to the last tableaux. This is of

particular significance to the artist today since he is suffering from a severe loss of vision and is unable to create any new tableaux—at least for the time being. Luckily, he remembers every picture he has ever produced with incredible precision. He has become sedentary; he "speaks" with the birds, writes and composes poems.

Three main themes can be detected in his oeuvre: the phenomenon of time, the drawing (*le dessin*) and the color blue as a symbol of water, sky and the blue planet. The titles of the tableaux invariably follow the same pattern: they are numbered chronologically and state the months and year of their production. No reference is made to location or ornithological species; time is the dominant factor. The titles read like headings in a diary. In fact, each of the tableaux reveals in detail the substance of life for the Mylaynes during the defined period of time. The pictures trace the couple's biography.

To explain his understanding of temporality, Mylayne refers to Chronos and Kairos, the two divine embodiments of time in Greek mythology. Chronos personifies the continuous passage of time while Kairos stands for the unique, opportune moment. Both determine Mylayne's work and life. He is particularly taken with Lysippos's sculpture of Kairos, which has survived only in copies and in an epigram by Poseidippidos, a poet of antiquity.[2] Like Mercury, Kairos is naked and athletic, with winged feet, but he is also completely bald except for a forelock, signaling that he can only be stopped in coming but not once he has passed. The allegory lives on in the German saying, *die Gelegenheit beim Schopf packen* (literally: "grab the opportunity by the forelock"). In one of his poems, Mylayne coined a neologism for human beings, *les kairiciformes*, because only human beings possess the ability to plan ahead in order to grab Kairos by the forelock. Only human beings are aware of the future, the present and the past, and only they are capable of expressing this awareness in drawing or writing, in short:

2 For the epigram in English, see https://en.wikipedia.org/wiki/Caerus.

FIG. 10 Jean-Luc Mylayne, *N° 446, novembre 2006–janvier 2007*, C-print, 183 × 183 cm (72 ³⁄₆₄ × 72 ³⁄₆₄ in).

in everything they design.³ This distinguishes them from birds, which in turn have the privilege of doing other things denied to human beings.

The term *dessin* is closely aligned with the concept of time. Mylayne uses the word in the spirit of the Italian Renaissance term *disegno*, a concept referring both to the physical, practical aspect of drawing as well as the metaphysical, imaginative work that underlies all creative activity and can be equated with the word "idea."

Time is emblematically epitomized in *N°446, novembre 2006–décembre 2007*. The Mylaynes turned a dry Texan prairie under an immaculate blue sky into a sundial and photographed it with a fisheye lens. The cactus they planted is exactly centered in the picture, forming the gnomon. It casts its shadow across the golden grass, its radial arrangement suggesting rotation. In the lower left corner of the picture, the head of a towhee (Pipilo maculatus) blends in with the surroundings, camouflaged by the colors and structure of its plumage. The shadow of the gnomon touches its beak. Am I deceived again in distinguishing a skull in the grass, its eye sockets directed toward the bird gazing in melancholy?

N°398, avril mai 2006 is also an image of melancholy, as if in counterpart to *N°22, juin juillet 1979*. The dead leaves fill the lower left half of the picture at a diagonal under the bushes

FIG. 11 Jean-Luc Mylayne, *N°398, avril mai 2006*, C-print, 103 × 103 cm (40 ³⁵⁄₆₄ × 40 ³⁵⁄₆₄ in).
FIG. 12 Jean-Luc Mylayne, *N°25, juillet août 1980*, C-print, 33 × 33 cm (12 ⁶³⁄₆₄ × 12 ⁶³⁄₆₄ in).

and the bird on a branch seems to be looking at them. The view into the distance under the arch of a bent tree trunk shows the blurred landscape of uncertainty.

In the Arles exhibition, Mylayne installed *N°25, juillet août 1980* next to a skull painted by Vincent van Gogh. This tableau as a memento vitae stands in resolute contrast to van Gogh's memento mori. A sturdy little short-toed tree creeper (Certhia brachydactyla) is perched on a branch all aquiver with a full beak, about to head off and feed its young.

3 *Parkett* no. 50/51, 1997, p. 130.

The Octopus's Strategy

Katharina Fritsch

Based on a text in the catalog for the exhibition *Katharina Fritsch*, curated by Jessica Morgan at the George Economou Collection, Athens, 2022.

FIG. 1 The Nanis, Katharina Fritsch's private mascots.

In *Night at the Museum* (2006), the popular Hollywood film based on Milan Trenc's eponymous children's book (1993), all of the exhibits in New York's Museum of Natural History come to life at night: dinosaurs, stuffed animals, cave dwellers, pharaohs and the wax effigy of Theodore Roosevelt. They play games with the night watchman inside the museum; they escape into the street and Central Park; and by day, when visitors arrive, they retire and become their usual inanimate selves, as if nothing had happened.

On looking at Katharina Fritsch's sculptures, I can't help suspecting that they are also animate and lead a secret double life. Fritsch has always been attracted to the world of wonders and the nocturnal side of life. For this reason, I asked her whether she had read E.T.A. Hoffmann's *The Nutcracker and the Mouse King* when she was a teenager, whether the *Rat King*, one of her most famous works, might have something to do with Hoffmann's multi-headed Mouse King. No, it didn't, she told me; the mood in Edgar Allan Poe's writings had been the greater inspiration, though my interpretation was perfectly acceptable as well. Whatever the case, she certainly doesn't disguise her delight in ambivalent playfulness, particularly conspicuous, for instance, when she occasionally permits a band of cheerful plush bananas to make a cameo appearance, cuddling up and proudly posing for a photo shoot, like the artist's *Group of Figures* at New York's MoMA.¹

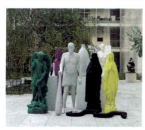

FIG. 2 Katharina Fritsch, *Figurengruppe/Group of Figures*, 2006–11, bronze, electroplated copper, stainless steel, lacquer, 200 × 320 × 200 cm (78 ¾ × 126 × 78 ¾ in), installation view, MoMA, New York, 2011.

1 Iwona Blazwick, ed., *Katharina Fritsch* (London: Tate Publishing, 2002), p. 97. The Nanis also appear in Katharina Fritsch, ed., *Katharina Fritsch* (Cologne: Verlag Walther König, 2006), pp. 43/44, and in Milovan Farronato, ed., *Katharina Fritsch* (Modena: Galleria Civica di Modena, 2007), rear endpaper.

Inspiration Marionette Theater

On the occasion of her first major exhibition of 1996 shown in San Francisco and Basel, Fritsch had Heinrich von Kleist's essay *On the Marionette Theater* (1810) reprinted in its entirety in the accompanying catalog. She considers it "one of the most beautiful key texts for the whole of art."[2] Fritz Schwegler, her professor of sculpture at the Kunstakademie Düsseldorf (1975 to 2001), had recommended this philosophical piece when she was a student in his master class along with Martin Honert, Thomas Schütte, Thomas Demand and Gregor Schneider.

The essay consists of a conversation between a first-person narrator and a ballet dancer, both aficionados of puppet theater.

The dancer is enthralled by the grace of the animated puppets, whose limbs, being attached to strings, move with such immeasurable fluidity, barely grazing the ground, like elves defying gravity under the guidance of the invisible puppeteer. For the dancer, the movement and the weightlessness represent an unattainable ideal, from which much can be learned.

The conversation between the two shifts to the biblical fall, through which humankind lost its innocence but acquired knowledge. The narrator remembers having once watched a youth sitting on a stool in front of a mirror, drying himself off after bathing, his appearance wonderfully natural and enchanting. It reminded him of the *Spinario (Boy with Thorn)*. With narcissistic delight, the youth had caught sight of himself in the mirror and tried repeatedly to duplicate the sublime beauty of that pose, but to no avail.

The dancer in turn contributes another parable-like example: the story of a bear, with which he had once fenced. The bear had skillfully parried every thrust of the rapier with its paw, not falling for a single feint, no matter how sophisticated, so naturally and unconsciously did it circumvent deceit.

[2] Gary Garrels and Theodora Vischer, eds., *Katharina Fritsch* (San Francisco: Museum of Modern Art, Basel: Museum für Gegenwartskunst, 1996), pp. 32–38.

It follows from the conversation in the *Marionette Theater* that achieving perfection requires either a divine awareness or no awareness at all. Artists like Fritsch, on the other hand, garner their energy not only from insight and enlightened awareness but also from an inexplicable liaison with the unconscious and intuition. Her antennae are always fully extended, probing in all directions. With an unerring sense of form and after having made countless decisions, she finds the one and only definitive iteration for each of her works. She meticulously stylizes her figures until reaching that point of delicately poised abstraction where nothing is too much and nothing is missing.

Presence and Appearance

FIG. 3 Katharina Fritsch, *Elefant/Elephant*, 1987, polyester, wood, acrylic paint, 420 × 160 × 380 cm (165 ⅜ × 63 × 149 ⅝ in), Kunstsammlung NRW K21, Düsseldorf.

Through their emblematic purity of form, arrangement of focal points and evanescent touch of vibrant monochrome colors, her figures oscillate between physical presence and metaphysical appearance. They seem to be enraptured, even the life-sized, disconcertingly dark-green *Elephant* on its oval pedestal, created in 1987 for the Kaiser Wilhelm Museum in Krefeld, as well as the vastly enlarged *Rat King*, made in 2001 for New York's Dia Art Foundation and now on permanent view at Schaulager, Basel.

The hyper-recognizable, charismatic presence of Fritsch's works is reinforced by their catatonic immobility. Even the *Lantern* (2017) and the *Black Vase* (1984/2020), on view in Athens at the George Economou Collection, seem to be holding their

breath, as if time were standing still in a state of complete rest. However, this oeuvre is not about the "noble simplicity and quiet grandeur" of ancient statues as famously proposed by 18th-century German art historian Winckelmann. Sculptures by Katharina Fritsch do not convey sublime serenity but rather the tension and energy of a lurking cat or a strapping Swiss guard at the Vatican. They trigger a diversity of ambiguous sensual impressions, of wide-ranging associations and perceptions, and inscribe themselves in memory as iconic and aloof.

FIG. 4 Katharina Fritsch, *Madonnenfigur/Madonna Figure*, 1987, epoxy resin, acrylic paint, 170 × 40 × 34 cm (66 15/16 × 15 ¾ × 13 ⅜ in), installation view, *Skulptur Projekte Münster*, 1987.

The life-sized, resplendently yellow *Madonna Figure* created for the 1987 exhibition *Skulptur Projekte* in Münster caused a stir among both viewers and the media. Modeled after the kitsch figurines sold in Lourdes, the sculpture stood in the midst of pedestrians on the busy Salzstrasse. Tellingly placed between a Dominican church and a department store, the figure provocatively invoked the relationship between religion and commerce. Twice the sculpture fell prey to vandalism.

That same year Fritsch produced 288 small yellow plaster Our-Lady-of-Lourdes Madonnas, which she neatly stacked on the nine circular shelves of a department store

FIG. 5 Katharina Fritsch, *Warengestell mit Madonnen/ Display Stand with Madonnas*, 1987/1989, aluminum, plaster, acrylic paint, 270 × 82 × 82 cm (106 5/16 × 32 5/16 × 32 5/16 in).

display rack. Earlier, in 1982, she had already produced the small figure as a multiple in an unlimited edition echoing the spirit of a fetishized souvenir. The reproduction of works in different sizes and materials, a constant in her artistic career, takes its cue from a crucial source of inspiration: the universal treasure of collective imagery.

The Right Wrong Color

FIG. 6 Katharina Fritsch, *Hahn/Cock*, 2013, polyester, stainless steel, lacquer, 440 × 440 × 150 cm (173 ¼ × 173 ¼ × 59 ⁴⁄₁₀ in), installation view, Trafalgar Square, London, 2013.

In 2015, the then Mayor of London, Boris Johnson, unveiled the artist's second much larger and far more provocative sculpture in public space: the ultramarine blue, almost more than 4 m (157 in) tall, majestic rooster on Trafalgar Square. For two years, the Gallic symbol stood at attention on its plinth, parodying historical monuments to great heroes astride horses or on foot, and patently stealing the show from Admiral Nelson and his guard of four bronze lions.

Color has no illustrative function for Fritsch. It is an autonomous means of expression on a par with the respective sculpture and embodying what Yves Klein called "materialized sensibility" in speaking about his own ultramarine blue. Fritsch's paint cabinet in her Düsseldorf studio resembles an object in a *Wunderkammer*; she has, in fact, dedicated eight monochromatic iconic paintings in massive but simple matte gold frames to her colors. It is as if each color had actively chosen its support, lying down on it and spreading out in all directions. Although Fritsch is primarily perceived as a sculptor, she also calls herself a painter and has every one of her sculptures painted in a precisely calibrated monochrome color. This is in fact an identifying feature of her work.

FIG. 7 Katharina Fritsch, *Acht Bilder in acht Farben/Eight Paintings with Eight Colors*, 1990/91, wood, foil, lacquer, untreated cotton cloth, acrylic paint, overall 140 × 1500 × 8 cm, (55 ⅛ × 590 ⁹⁄₁₆ × 3 ³⁄₁₆ in), each 140 × 100 × 8 cm (55 ⅛ × 39 ½ × 3 ³⁄₁₆ in) installation view, Carnegie International, Pittsburgh, 1991.

On the other hand, she is also intrigued by subverting her once established assignment of color. She will apply the "wrong" color to a sculpture or, conversely, give a color the "wrong" shape. Her group of figures in the Arsenale at the 2011 Biennale di Venezia is a case in point: The snake ordinarily black, was white; St. Nicholas, to whom purple is usually assigned, was a radiant yellow green; and the skull was bright yellow instead of white. Fritsch confides that she found inspiration in James Ensor's fantastical still lifes. And it is indeed as if the figures were in a masquerade, one of Ensor's favorite motifs. But this

FIG. 8 Katharina Fritsch, *6. Stillleben/6ᵗʰ Still Life*, 2011, polyester, epoxy resin, paint, bronze, lacquer, 190 × 255 × 285 cm (74 ¹³⁄₁₆ × 100 ⁷⁄₁₆ × 112 ¼ in) installation view, 54ᵗʰ Biennale di Venezia, 2011.
FIG. 9 Katharina Fritsch, *2. Stillleben/2ⁿᵈ Still Life*, 2009/10, zellan, high speed resin cast, paint, 42 × 42 × 30 cm (16 ½ × 16 ½ × 11 ⅞ in), a project to mark the 25ᵗʰ anniversary of the founding of the art journal *Parkett*.

capriccio also relies on an acute sensibility; the artist does not allow chance to decide which color is used when. It has to be the "right wrong color," such as the petroleum green for the otherwise bright yellow *Madonna* in another group of figures with the wrong colors, which the artist assembled for the art journal *Parkett*. In Athens, none of the sculptures were the wrong color.

Handicraft

The memorable quality of Katharina Fritsch's works is further indebted to the uncompromising perfection with which they are crafted. With her well-trained hand and the assistance of specialized collaborators, she shapes her figures from scratch in plaster or after a model (human or object). More recently she has started scanning her models, printing them in 3D to the desired size and then casting them again in plaster, a material that can be easily processed. This is followed by the archaic craft of remodeling in the course of which the details are reduced to abstract, idealized essences of a perfection that makes their razor-sharp outlines appear like silhouettes. The figures are then cast in polyester, epoxy resin or bronze and spray-painted in acrylic. This last step also requires considerable practice and skill. Well-informed of the latest developments, Fritsch may vary the tools, technologies and materials of the entire

FIG. 10 Katharina Fritsch, *Hand (Menetekel)/Hand (Menetekel)*, 2020, plaster, acrylic paint, 17.5 × 8.6 × 7.5 cm (6 ¹⁵⁄₁₆ × 3 ⁷⁄₁₆ × 3 in).

FIG. 11 Katharina Fritsch, *Hand/Hand*, 2020, plaster, acrylic paint, 4.8 × 11.8 × 17.5 cm (1 ¹⁵⁄₁₆ × 4 ¹¹⁄₁₆ × 6 ¹⁵⁄₁₆ in).

process accordingly. No matter what the case, however, she acts on the motto, "The devil is in the detail," or as Aby Warburg puts it, "God is in the detail."

Two sculptures on view in the Athens exhibition are based on casts of the artist's right hand. One, a shimmering light green *Hand (Menetekel)*, was placed upright, the other black *Hand* lay palm down on a pedestal.

We all know how challenging it is to draw or paint a hand, and its representation is a genre in its own right. Fritsch's hand sculptures are "self-portraits," and just as plaster or bronze casts of Chopin's or Franz Liszt's hands belong to the pianists' devotional objects, Fritsch's two sculptures reflect on her métier as an artist. Her right hand is the most valuable tool she has: she does her own crafting, she does not work conceptually only to entrust the execution of her work to collaborators. The final form emerges gradually during the intimate and contemplative process of working the material. Hand and mind are joined, and a thought often ascribed to St. Francis of Assisi aptly describes artists of Fritsch's ilk: "Those who work with their hands are laborers, with hands and head are craftsman and with hands, head and heart are artists."

The gestures of the two hands are fundamentally different. The black *Hand* is at rest before or after engaging in a craft while the *Hand (Menetekel)*, being upright, appears slighter, more weightless, its gesture enigmatic as if to indicate something metaphysical. Fritsch took inspiration for the latter from a Bible illustration of Belshazzar's Feast, where a floating, disembodied human hand writes the ominous words of warning on the wall: "Mene Mene Tekel u-pharsin."

Mise-en-scène

Fritsch had just completed her studies with Fritz Schwegler—he had supported her interest in transtemporal imagery, in which the personal is absorbed into the validity of a larger whole—when the curator Kasper König invited her in 1984 to contribute

FIG. 12 Katharina Fritsch, *Acht Tische mit acht Gegenständen/Eight Tables with Eight Items*, 1981–84, MDF boards, steel, objects, 155 × 480 × 480 cm (61 × 189 × 189 in), in the exhibition *Von hier aus*, Düsseldorf, 1984.

FIG. 13 Katharina Fritsch, *Rattenkönig/Rat King*, 1991–93, polyester, acrylic paint, 280 × 1300 × 1300 cm (110 ¼ × 511 ¹³⁄₁₆ × 511 ¹³⁄₁₆ in), installation view, Dia Chelsea, New York, 1994 (installation from April 1993 to June 1994).

to the Düsseldorf exhibition "Von hier aus," as the youngest of some 80 artists, including Beuys, Polke, Richter and Warhol. She showed *Eight Tables with Eight Objects* (now in the holdings of Schaulager, Basel), consisting of eight adjoining, trapezoidal tables that, together, form an octagonal surface of almost 189 inches in diameter with an octagonal opening in the middle.

Eight still-life objects are placed on the table, most of them made by hand and some of unaccustomed scale: two large aluminum saucepans; a gigantic, oval cardboard box; an extremely thin, tall polystyrene candle; an oversized bluish-white, plexiglass bowl; a large wheel of cheese made of colored silicon; a metal key ring with eight keys laid out in strict radial form; and a hard white, lacquered metal plate containing a tight circle of eight, small orange squid. The arrangement of the latter looks like a tiny precursor of the great *Rat King* and the orange anticipates the color of the sculpture *Octopus*.

There is also a tall black vase on the table, which was placed on a separate stand in Athens. The choice of form and color, the modification of scale and the layout invest these objects, trivial in themselves, with an iconic presence. It has always

been obvious, since the beginning of Fritsch's career, that she slips into the role of critical director of her own works when mounting her exhibitions. She creates a fabric of many associative connections and leaves none of her works on its own, instead integrating them all into a larger context. Each of her atmospheric mise-en-scènes becomes an artistic statement, forming a whole that is more than the sum of its parts. The thoroughness with which Fritsch takes context and space into account is demonstrated by her ideal, octagonal *Museum Model 1:10*, which she customized to match the architectural proportions of the German Pavilion at the 1995 Biennale di Venezia.

In 2017 she had the opportunity once again to indulge her penchant for the total work of art in *ZITA— ЩАРА Chamberpiece*, a show conceived with the artist Alexej Koschkarow at Schaulager, Basel. The two artists coordinated not only the content of their works, but also the dimensions and their arrangement to ensure that the works made the impact they envisioned. They inserted an alien, artistic element into Herzog & de Meuron's architecture, a structure containing a linear sequence of three rooms, each differing in proportion and even in height.

FIG. 14 Katharina Fritsch, *Teller mit Meerestieren/ Plate with Sea Creatures*, 1984, metal, varnish, silicon, 30 × 30 cm (11 ⅞ × 11 ⅞ in).

FIG. 15 Katharina Fritsch, *Museum Modell 1:10/Museum Model 1:10*, 1995, wood, aluminum, plexiglass, foil, acrylic paint, lacquer, 330 × 1040 × 1040 cm (129 ¹⁵⁄₁₆ × 409 ⁷⁄₁₆ × 409 ⁷⁄₁₆ in), installation view, 46th Biennale di Venezia, 1995.

Twilight, Frisson and Crackling Cold

Staging the exhibition in Athens was a challenge since it was presented on three floors, each consisting of one room. It is easier to arrange works in a horizontal sequence of spaces where they can be seen from one room to the next and thus related to each other. But there are also advantages to works being separated by stairs and elevators. Interruptions invite the element of surprise. Climbing the stairs can heighten curiosity and the elevator door is like a theater curtain opening to reveal a new scenario.

First Room

The three works that Fritsch placed on the ground floor in Athens generated a twilight atmosphere of the kind that the artist finds so fascinating in Giorgio de Chirico's paintings and René Magritte's Surrealist work. She juxtaposed a human artifact, a hexagonal *Lantern*, with two gigantically inflated natural figures—an upended *Egg* and a *Skull*.

FIG. 16 Katharina Fritsch, *Schädel/Skull*, 2017, polyester, paint, 116 × 147 × 94 cm (45 ¹³⁄₁₆ × 57 ⅞ × 37 in).

FIG. 17 Katharina Fritsch, exhibition view, George Economou Collection, Athens, 2022.

The *Egg* (2017), painted in a baffling combination of half orange and half yellow, looks different from every angle. One would hardly envision a monster chick hatching from this egg; instead, one wonders if it might contain a split, Janus-faced being.

The *Lantern* (2017), tapered from top to bottom and placed on the ground with neither pole nor stand, also looks different from every perspective. It is lacquered in

a matte black, and the light pink insets that would ordinarily be panes of glass keep changing in the light. Sometimes cold, sometimes warm, the play of light is indefinable and provides no illumination.

Second Room

The first thing that struck viewers in the second room was a large, black-and-white silkscreen of a small woodcut from an illustrated magazine of 1872, which Fritsch discovered in the section titled "Accidents and Crimes."[3] She transformed it into a silkscreen and enlarged it to the format of a museum painting. The picture illustrates a woman whom a rescue diver found dead in the steamship *Brünig*, which sank in Lake Lucerne on September 24, 1871. The accident was caused by an inebriated captain whose poor judgment failed to prevent a collision with another ship.

The illustrator has created his version of the disaster in a melodramatic composition, for he was neither witness to the accident nor was there anything such as underwater photography in those days. He gave his imagination free rein and drew the corpse in the spirit of Edgar Allan Poe's statement, "The death, then, of a beautiful woman is unquestionably the most poetical topic in the world."[4] There she lies draped on a recamier, like Titian's *Venus of Urbino* or Canova's *Paolina Borghese*, while the rescue diver adopts an ambivalent pose of horror or rapture.

FIG. 18 Newspaper illustration, (*"Auffindung des Leichnams eines weiblichen Passagiers in dem Salon des auf dem Vierwaldstätter See gescheiterten Dampfschiffes Brünig"*)/("Finding the Corpse of a Female Passenger in the Salon of the Steamship Brünig Wrecked on Lake Lucerne"), 2006, silkscreen, plastic, 140 × 200 cm (55 ⅛ × 78 ¾ in)

The magazine containing the woodcut was among the most widely

FIG. 19 Katharina Fritsch, *Oktopus/Octopus*, 2006/2009, metal, polyester, acrylic paint, wood, 140 × 120 × 120 cm (55 ⅛ × 47 ¼ × 47 ¼ in).

FIG. 20 Alphonse de Neuville, illustration in Jules Verne, *Vingt mille lieues sous les mers*, Edition Hetzel, Paris, 1871, p. 400.

read in the days of the German Empire, with a print run of 172,000 copies. Fritsch has been captivated by publications of this kind since her childhood in the 1960s, and as Max Ernst and Sigmar Polke did before her, she has been working since 1996 with illustrations from encyclopedias, books and postcards, which provide access to the entire world. She is fascinated by the memorable depiction of legends, fairytales, or ideal worlds, specifically by the way in which a shared heritage can be rendered in concise, typified representations.

In Athens, Fritsch placed the orange *Octopus* with its sumptuously draped and furled tentacles on a modeling stand in front of the silkscreen, its 19th century flair relating to the scene of the shipwreck.

The octopus has a little man wearing historical black diving gear in one of its tentacles, proudly holding him up like a trophy or toy. The scene evokes Jules Verne's *20,000 Leagues Under the Sea* (1870). But for Fritsch the octopus is not a frightening creature like the monster that attacks Captain Nemo's submarine Nautilus and

3 In: *Illustrirte [sic] Chronik der Zeit, Blätter zur Unterhaltung und Belehrung* (Stuttgart, 1872), illustration p. 208, text p. 223.
4 Edgar Allan Poe, "The Philosophy of Composition," in: *Graham's American Monthly Magazine* 28, no. 4 (Philadelphia, April 1846).

strangles human beings; the attitude of Fritsch's diver held up by the octopus is ambivalent. As so often, she gives viewers a slight frisson of excitement and uncertainty.

The octopus is Fritsch's favorite animal. It is not only a master of transformation, mimicry and camouflage, but also an extremely intelligent, playful, nimble and incredibly adept creature. Above all, it can spew ink—the dream of every artist and writer—and it has eight tentacles. Fritsch is fascinated by the number eight, as demonstrated in numerous works involving both the number itself as well as its division and multiplication: *Eight Tables with Eight Objects*, 16 rats in the *Rat King*, 32 identical men sitting opposite one another in her *Company at Table* (1988) and the *Star* (2021) with 16 points in the Athens exhibition.

The second room also contained the pitch-black *Knot* resting on a pedestal. It is a small version of the ominous, fateful, entangled knot of rat tails in the great *Rat King*, which can only be partially espied in the center of the gigantic ring of animals at Schaulager, Basel. There, we encounter the number eight once again, for the 16 tails are divided in half, each half running parallel and joined in an ornamental Turk's head knot.

FIG. 21 Katharina Fritsch, *Schwarzer Knoten/Black Knot*, 2021, Acrystal, acrylic paint, 26 × 26 × 30 cm (10 ¼ × 10 ¼ × 11 ¹³⁄₁₆ in).

FIG. 22 Katharina Fritsch, *Stern/Star*, 2021, aluminum, dibond, lacquer, ø 240 × 0.6 cm (ø 94 ½ × ¼ in).

The fourth object in this room, placed on a stand, was the enigmatically gesturing *Hand (Menetekel)* described above.

Third Room

The sculpture *Figure* dominated the third room on the floor above. This anthropomorphic hybrid with a head in the form of a shell, one half lacquered in a semi-matte black and the other in a semi-matte silver, was perched atop a cone-shaped, pleated light-gray dress. Placed on a 32-sided stand, it looked to me like a chimera from a legendary underwater world in dark counterpoint to Fritsch's carefree rococo *Woman with Dog*. This marvelous pink seashell woman who takes her shimmering white seashell dog for a walk was not, however, on view in Athens.

The *Figure* (90 cm / 35 7/16 in) with pedestal (80 cm / 31 ½ in) is 170 cm (66 59/64 in) tall, as is the artist herself. And when the life-size *Black Hand* appears alongside *Figure*, there is no mistaking that Fritsch has used her own body measurements as a reference.

The oldest work in the exhibition, *Dark Green Tunnel* (1979), was placed on a stand in this room. The sculpture of colored wax resembles Minimal Art and evokes the

FIG. 23 Katharina Fritsch, *Frau mit Hund/Woman with Dog*, 2004, polyester, aluminum, iron, acrylic paint, 175 × 176 × 107 cm (68 55/64 × 69 19/64 × 42 1/8 in).

FIG. 24 Katharina Fritsch, sketches for the third space, 2019.

collective memory of a model railway when the train disappears into a tunnel and never fails to surprise and delight every childlike spirit, even though it reappears at the other end with utter predictability. But *Dark Green Tunnel* also evokes that uncanny gut feeling of being plunged into a real-life tunnel, into abrupt darkness and waiting for the sudden liberation of rushing back into the light.

The third room was striking for its understated colors. Black is also the color of another early work from 1984 (*Black Vase*). It represents one of the most universal objects in the history of our civilization, acquiring immense significance as a vehicle of ancient Greek painting although, formally and typologically, it has not changed substantially up to the present era of contemporary design.

When I asked Katharina Fritsch what mood she wanted to evoke in this third room, she said it should be flooded with "a sense of mysterious, crackling cold." The aluminum *Star* (2021), towering above the scene with its 16 red and silver points, clearly contributed.

The exhibition in Athens reinforced the artist's delight in creating visual chamber pieces. Once again her precise staging related the works to each other in countless

FIG. 25 Katharina Fritsch, *Tunnel/Tunnel*, 1979/2021, tin, acrylic paint, 8 × 8 × 80 cm (3 ⅛ × 3 ⅛ × 31 ½ in).

FIG. 26 Katharina Fritsch, *Schwarze Vase/Black Vase*, 1984/2020, epoxy resin, polyurethane, lacquer, 42 × 20 × 20 cm (16 ⁹⁄₁₆ × 7 ⅞ × 7 ⅞ in).

FIGS. 27–29 Katharina Fritsch, *Figur/Figure*, 2019, epoxy resin, polyurethane, acrylic paint, aluminum, plastic, each 170 × 40 × 40 cm (66 १⁵⁄₁₆ × 15 ¾ × 15 ¾ in).

ways, generating different moods on every floor and stimulating thoughts and memories. Walking through these spaces made manifest that Fritsch does not define a specific viewpoint; it is through the wealth of perspectives that we gain an insight into her universe.

Smearings in the Ernst & Young Building

Alexej Koschkarow

This text is based on a text by Jacqueline Burckhardt
that appeared in *Art Inspires at EY Zurich*, Zurich, 2016.

FIG. 1 Alexej Koschkarow hanging his *Smearings*, April 24, 2013, EY Building, Zurich.

FIG. 2 Alexej Koschkarow, *Smearings*, from left: *Thief*, 100 × 104 cm (39 ⅜ × 40 ¹⁵⁄₁₆ in), *Hephaestus and Mercury*, 208 × 462 cm (81 ⁵⁷⁄₆₄ × 181 ⁵⁷⁄₆₄ in), *Prisoner*, 100 × 95 cm (39 ⅜ × 37 ¹³⁄₃₂ in), all 2012, graphite on primed, synthetic textile, EY Building, Zurich.

A triptych by Alexej Koschkarow is mounted in the largest conference room of a new building by Gigon/Guyer Architects that houses the Zurich headquarters of Ernst & Young, an international accounting firm. The ensemble of three *Smearings*, made in 2012, is mounted on the wall unframed. The artist has coined the word "smearings" to describe his rubbings of reliefs made of graphite on textiles. This is essentially frottage, a technique introduced by Max Ernst in the 1920s and popular among the Surrealists.

The large *Smearing* in the middle shows two gods of antiquity with their attributes: seated to the right, Mercury, symbolic figure of trade, and to the left, Hephaestus, here the personification of industry. They sit symmetrically facing opposite directions with a round slate gray blackboard set into the fabric between them, at the bottom of which a small bit of wood provides a shelf for chalk and sponge.

This large *Smearing* is flanked by two smaller ones with scenes from the life of a crook; he is seen in the act of stealing to the left and behind bars to the right.

Alexej Koschkarow, a Belarusian born in 1972, initially studied at the Art Academy in Minsk, where education focused on solid craftsmanship and technical skills. He also received instruction in monumental painting in the style of Socialist

Realism, still practiced after the collapse of the Soviet Union. After his studies in Minsk, he went to the renowned Kunstakademie Düsseldorf as a classical all-rounder and studied with the professor of sculpture Fritz Schwegler, as did Katharina Fritsch and Thomas Schütte.

Subsequently, Koschkarow continued to work in a variety of media, drawing and painting, making pottery and staging performances. For his now legendary pie fight with 800 kilograms (1763.7 lbs) of cream pies at the Düsseldorf Malkasten in 2001, he invited an illustrious company to have a ball: action painting on living sculptures. The video of the performance was acquired by Kunsthaus Zürich, among others. His installations, for which he spares neither expense nor effort, may well acquire considerable proportions. He is a devil for detail and with indefatigable energy executes everything himself that does not require specialized skills or equipment. In 2002, he transformed the Galerie Jablonka Lühn in Cologne into a Baroque library with a faux coffered ceiling and an imitation wood and marble floor. Visitors paradoxically enter the room through a large fireplace to encounter wall shelves stuffed with artificially yellowed bundles of files and punctuated with the occasional Vanitas symbol of a skull.

After a few years in Düsseldorf and Berlin, Koschkarow moved to the United States in 2011. He lives in Brooklyn, in a historically and sociologically interesting neighborhood on the East River, still dominated by the atmosphere of sailors' alehouses, small trades and warehouses. He has installed his studio in what was once a former Jewish hat factory, adjoining a neighborhood of mansions built by well-heeled Huguenots and immigrant merchants.

Koschkarow is a passionate flaneur. Roaming with him through the stimulus-overkill streets of Brooklyn and Manhattan, I realized how quickly and astutely he takes in the everyday surroundings and decodes historical clues, simultaneously espying moments of inconspicuous excitement. During our walks together, he told me about the living conditions of the

FIG. 3 The former Jarmulowsky's Bank, Brooklyn, New York, 1912.
FIG. 4 Relief above the entrance portal of the former Jarmulowsky's Bank, Brooklyn, New York.

early immigrants, the attendant urban development and the influence of architectural style. The reliefs, of which he makes rubbings for his *Smearings*, clinging to historical facades at daredevil heights, bear witness to this history, as do the reliefs he sourced for his ensemble in the Ernst & Young Building.

The large *Smearing* in the center of the ensemble in the conference room is sourced from a relief above the corner entrance to the former Jarmulowsky Bank on the intersection of Canal Street and Orchard Street in Manhattan. Mercury is sitting on the pelt of a lion that has been tossed over a vat, holding his Caduceus, his winged herald's staff with two snakes winding around it. Anchor and chain lie at his feet on a coil of rope, and in the background a fence and a seascape with sailing ship. The smearing shows neither these nor the architectural motifs next to Hephaestus, who embodies the productive energy of the machine age with his attributes of hammer and anvil and a gearwheel. The round hole in the center, framed by laurel branches and crowned with a small head of Mercury wearing a winged helmet, once accommodated a clock. Koschkarow has filled the hole with a slate gray blackboard.

Koschkarow produces his *Smearings* by pulling primed, slightly elastic textile taut over the relief and then making a rubbing with graphite. Rubbings of sculptures, coins, or metal

FIG. 5 Michelangelo Buonarotti, *Ignudi*, 1508–12, ceiling fresco (detail), Sistine Chapel, Rome.

engravings, particularly of interest to scientists and collectors prior to the age of photography, had to be legible down to the tiniest detail. In contrast, Koschkarow is guided by personal artistic criteria when deciding what should appear on the frottage and to what effect. He seeks not accuracy but rather expressiveness and painterly qualities. He uses the historical relief as a readymade and transforms it into a diametrically opposed medium, lightweight and flexible, its expression standing in great contrast to the sculpture and the original motif infused with new life.

The full scale of Koschkarow's *Smearings* exudes a mysterious and even spectral aura. They bear unmistakable traces of immediate contact with the historically charged object and resemble photographic negatives, oscillating between appeal and alienation. The lighter the raised portions of the reliefs, the darker they become in the graphite cloud of the *Smearing*—as if the artist were foregrounding the unfathomable nocturnal side of the relief.

Koschkarow has not included the inscription placed above the allegorical figures on the building: "S. Jarmulowsky's Bank Est 1873." Sender Jarmulowsky (1841–1912), the founder of the bank, was an orphan of Polish Jewish origin, who grew up with the family of a Rabbi in Grajewo. He married the daughter of a

FIG. 6 Williamsburgh Savings Bank Tower, Brooklyn, New York.
FIG. 7 Rene Paul Chambellan, *Thief*, 1928, relief on the facade of the Williamsburgh Savings Bank Tower, Brooklyn, New York.

wealthy merchant and, as a young businessman in Hamburg, established a transatlantic shipping company for travelers and goods. In 1873, he emigrated to New York, where he founded a bank that would become one of the most successful in the city. Targeting primarily Jewish immigrants, his bank offered inexpensive passage for the voyage from Europe on the bank's own ships, so that the newcomers would open accounts with the bank in New York or take out loans. Jarmulowsky turned his building into the then tallest on the Lower East Side by adding a domed pavilion on top of the roof, which has since been removed. The bank was inaugurated in 1912 shortly before his death. His sons briefly took over until the beginning of the First World War, when the bank suffered severe losses and had to declare insolvency in 1917. The building has been variously used since then and has now become a landmark site.

The relief of the Greek gods above the entrance shows the veneration of antiquity in harmony with faith in industrial progress, alluding to Jarmulowsky's conviction that his bank was deeply rooted in the heritage of a flourishing European culture. The as yet unidentified artist based his composition on Michelangelo's *Ignudi*, the 20 male nudes on the ceiling of the Sistine Chapel, paired off and, in contrast to the gods on the relief in New York, facing each other in various athletic positions.

Koschkarow discovered the reliefs for the smaller *Smearings*, which flank the larger one in the center, on the entrance facade of Williamsburgh Savings Bank, One Hanson Place in Brooklyn, an Art Deco building of the 1920s. Once the flagship of the financial world, it is the tallest building in Brooklyn, at 512 feet. In this case we know who sculpted the reliefs: Rene Paul Chambellan (USA, 1893–1955). They are pendants, showing the career of a crook. To the left, the coarse thief wearing a visor cap is ready for action with a sack of burglary tools slung over his shoulder. He is holding a flashlight in his right hand and the barrel of his revolver in the left. In the second relief, he is sitting slumped over behind bars, his head listlessly resting on his hand.

FIGS. 8+9 Rene Paul Chambellan, *Thief*, 1928, and *Prisoner*, 1928, reliefs, Williamsburgh Savings Bank Tower, Brooklyn, New York.

The two scenes of the ruffian stand in contrast to the classical, idealized figures of Mercury and Hephaestus. They are meant to ward off disaster like the monstrous gargoyles and other such figures on Romanesque and Gothic cathedrals, which embody evil in order to banish it and thus have an apotropaic function. The message was clear and confident: thieves don't stand a chance in this Savings Bank and will land in the clink.

In selecting the *Smearings* for the EY conference room, Koschkarow and I gave a lot of thought to format and subject matter, to what would best suit the location. We finally settled on the two male duos, the two classical allegorical figures and the two scenes of the crook as their antithesis. This made sense

FIG. 10+11 Alexej Koschkarow, *Thief*, 2012 and *Prisoner*, 2012.

to us because the company is named after Alwin C. Ernst (1881–1948) from North America and Arthur Young (1862–1948) from Scotland. The two businessmen never actually met and their companies did not merge until 1989, long after they had died. However, as far as the subject matter of the *Smearings* is concerned, Ernst & Young pursued the goals that every company has of aspiring to ideals as profitably as possible and of banishing or circumventing negative developments.

On April 13, 2013, the day the three *Smearings* were mounted on the wall of the conference room, Alexej Koschkarow drew the company logo "E & Y" on the blackboard and expressed the wish that anyone who feels like communicating something should take a sponge and wipe off whatever is on the blackboard in order to write or sketch something themselves. Koschkarow wanted to scrape off the carpet underneath the blackboard to create the impression that it had been hanging there for so long that it bore traces of the countless people who had already stood in front of it. This would have underscored the character of the ensemble as an installation, but the company management decided not to intervene artistically and instead allow time to produce that effect on its own. In short: anyone who contributes becomes part of the installation, an additional protagonist in the work, engaging in a performative act, whether consciously or unconsciously, that thus fulfills the artist's intention.

Wall Sculpture
Tismemskiblo

El Anatsui

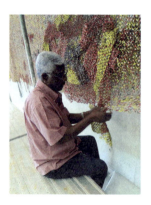

This text is based on an essay in
Novartis Campus—Fabrikstrasse 28, Tadao Ando, Basel, 2011.

FIG. 1 El Anatsui during the hanging of *Tismemskiblo*, 2011.

Integrating art that would engage in a harmonious yet contrasting dialogue with the architecturally crystalline forms of Tadao Ando's building on the Novartis Campus was a challenge that held a special appeal. The striking entrance hall with its broad staircase provided the ideal location. The space narrows dramatically to a sharply angled corner flooded by daylight from the skylight seven stories above. Another striking visual element here is Ando's typically pristine, fair-faced concrete walls in which the traces of the formwork are imprinted in patterns reminiscent of tatami mats, each of them bearing six intact formwork holes. They define a stringent order that the artwork must address. The triangular nature of this space is further reinforced by the view through the lobby's glass facade facing the massive flank of Richard Serra's painterly rusted CorTen steel sculpture *Dirk's Pod* outside on a plaza.

FIG. 2 El Anatsui, *Tismemskiblo* in Tadao Ando's building on the Novartis Campus in Basel, 2011, metal.

Choosing an artist therefore required careful consideration. The choice fell on El Anatsui, whose breathtakingly beautiful Gobelin-like *Wall Sculpture*s have become renowned the world over with their subtle reference to the interconnectedness of global cultures and histories. They can now be found in the collections of several major international museums.

El Anatsui, born in Anyako, Ghana, in 1944, has been living and working in Nigeria since 1975. As Professor of Sculpture at the University of Nigeria in Nsukka, he has already influenced

several generations of artists. Since 1993, he has been working in collaboration with the October Gallery—a non-profit arts organization, which was also consulted in the commission for the Novartis Campus. In the spring of 2010, about a year before the unveiling of *Tismemskiblo*, El Anatsui came to visit the Novartis Campus to take stock of the situation and study the plans before agreeing to accept the commission. He worked a full year on the project.

When El Anatsui was a student at the College of Art of the University of Science and Technology in Kumasi, Ghana, in the mid-1960s, training was entirely in the hands of European teaching staff and based along the lines of Goldsmiths College in London. There was little reflection on the art and craftsmanship of African cultures. The urge to understand his own heritage gradually led El Anatsui to explore the expressive potential of such basic materials as ceramics, wood, and metal, and to work with found objects widely regarded as useless scrap in a throwaway, consumer-oriented society. Re-crafting damaged everyday items into new utensils has always been part of the indigenous way of life, as a matter of economy, long before calls for ecological recycling became common.

It was sheer serendipity that introduced El Anatsui to what has become one of his most important materials: while walking near Nsukka in the late 1990s, he happened to find a heap of discarded liquor-bottle caps and immediately recognized their potential. He began using them to create his new and mesmerizing Wall Sculptures, which immediately attracted the attention of art critics. In 2002, the British Museum became the first institution to acquire not just one, but two of them, the pendants *Man's Cloth* and *Woman's Cloth*, each with the gigantic dimensions of around 13,950 square inches.

El Anatsui used to collect the discarded bottle caps on scrap heaps but now needs so many of them for his work—thousands upon thousands—that he gets them straight from the bottling plant. The aluminum printed with brand names in various colors, partly with gold and silver effects, offers countless design

FIG. 3 El Anatsui, *Tismemskiblo* (detail), 2011, metal.

possibilities, and the soft, malleable aluminum is easy to flatten, fold, bend, and cut. El Anatsui exploits his material to the full and once remarked in an interview that he had by no means exhausted its almost unlimited potential.

The tops of the caps are, for the most part, cut into discs and rings, while the sleeve that fits around the neck of the bottle is cut into angular shapes. Symbolically, the round elements invite associations with the female, while the angular elements have connotations of the male. The works themselves invite a broad and profoundly complex reading in conceptual, sociological, and (art) historical terms. Tiny holes are pierced into all the aluminum elements, through which copper wire is then threaded to knot them together. This extremely labor-intensive task is achieved with the aid of up to twenty assistants, each of whom can complete an average of some six square inches of this metal textile in the course of a day. Although El Anatsui supervises his assistants closely, he also allows them considerable freedom in their work, as they possess a high level of skilled craftsmanship. However, the artistic decisions regarding texture, form, and color are all made by El Anatsui himself, and the compositional arrangement of the fragments into an assemblage such as the work in the Ando building is also orchestrated, down to the very last detail, by him alone. The *Wall Sculpture* is built up gradually and organically and can be adapted or changed with ease in the course of the process, during which parts may be removed, altered, reworked, and repositioned. When the silver-colored

backs of the bottle caps face front, they resemble fish scales, shimmering here and there in the ever-changing light.

When they are cut into rings, the metal weave appears light and transparent, like a delicate veil allowing a glimpse of the background behind. Elsewhere, the caps are knotted together in ways that conjure notions of flamboyantly baroque brocade, of Pointillism teeming with dots of vibrant color, or of the fantastical forms and colors of gestural painting.

As you walk up the stairs and along the hanging, the overwhelming opulence of its tactile and aesthetic qualities becomes strikingly apparent. This is a work that triggers many associations with painting, textile art, and sculpture. To assess the banal capsules as a material travesty, as if they wanted to mime silver, gold, and silk, is wrong. The aim is not to create a mirage; on the contrary, the discarded trash has undergone a metamorphosis that reveals the remarkable and unexpected wealth of its performative potential. Discovering this potential, releasing the material's hidden beauty, exploiting its full effect, and charging it with new energy—this is what El Anatsui does. In that sense, his approach to what has become his signature material is very much on a par with the approach that Richard Serra and Tadao Ando take to theirs: CorTen steel and raw concrete, respectively.

El Anatsui's *Wall Sculptures* are discussed in the context of the classic kente cloth that is one of the foremost icons of African cultural heritage. In times gone by, kente cloth was reserved for royalty. It was truly the cloth of kings, with a new pattern woven for each public appearance. Its colors and patterns contained a symbolism that was legible to tribal members, sending out specific messages for certain political and ceremonial occasions. Only selected master weavers, who kept their techniques a closely guarded secret, were allowed to produce kente cloth. Woven in narrow strips of cotton and silk, the cloth could be stitched together in any desired format. El Anatsui's father was one such master weaver from the Ewe people of Ghana.

El Anatsui's intimate knowledge of what underlies African culture belongs to the tools of his trade. At the same time,

FIGS. 4+5 El Anatsui, *Tismemskiblo* (detail), 2011, metal.

however, his work shows clear connections with western movements and traditions. The many tiny pieces of aluminum, which seem to take on a mysterious life of their own within the organic and gestural abstraction of the work, also recall the patterns of print media or computer pixels from which texts and images are composed. They are redolent, too, of the infinitesimally small particles that make up our universe and which Sigmar Polke referenced in his *Rasterbilder* over the decades. The enigmatic title *Tismemskiblo* is a portmanteau word, consisting of the first three letters of the words tissue, membrane, skin, and blood, ideas present in the artist's mind, at both macro and micro levels, whilst creating this site-specific commission for the Novartis Campus.

Tismemskiblo has an aura of great dignity, which is paradoxically underscored by El Anatsui's slightly tongue-in-cheek use of the brand names printed on the bottle caps. A variety of fonts and logos trumpet Liquor Headmaster, Victory Distillers, First Lady or Flying Horse. The play on brand names may be seen as a form of Pop Art. Yet it is also a reference to the social and economic background of West Africa's colonial history and the transatlantic slave trade. Liquor was once used to barter for slaves, and it was also used to make the slaves themselves dependent. Today, these brands are produced in the domestic market.

While the bottle caps clearly refer to the ambiguity of West Africa's drinking culture, a certain aspect of the region's

culinary heritage is also interwoven with the fundamental theme of the human condition. El Anatsui's assemblage contains clear references to the unwieldy, rusty graters used primarily for the preparation of cassava (manioc) foodstuffs. (Nigeria is the world's largest producer of cassava.) What were once metal roofing panels have been remodeled by piercing them roughly with nails to form graters. This somewhat unattractive utensil is now integrated, free of purpose and thus sublime, as an aesthetically seductive and spiritually/intellectually charged component of the artwork.

When El Anatsui visited Basel in July 2011 for the installation of *Tismemskiblo*, there were two huge crates standing in the entrance hall of the Ando building. Inside them, the artwork lay folded and layered in loose fragments of varying sizes. The parts were spread out on the floor, measured, linked together with copper wire, and shaped. As many as nine people were on the scaffolding at any one time, holding up the fragments against the wall for El Anatsui to instruct them on the definitive alignment. The technical team was joined by Elisabeth Lalouschek and Gerard Houghton, two authorities on El Anatsui's work.

Right up until the installation was completed, the artist continued to make compositional changes to the assemblage, adding volume to individual areas and allowing the fabric of the piece to fold and drape freely according to the inherent qualities of the material and its texture, as though it had simply been hung quite casually on the wall. The weave is of equal aesthetic value when viewed from either side, a two-sided fabric so to speak, that has been doubled over or reversed here and there. El Anatsui's respect for the quality of Ando's raw concrete wall is evident in the fact that, when hanging *Tismemskiblo*, he used only the existing formwork holes to anchor it and so left the surface of the wall completely intact.

Right from the start, the intention was to create an exciting interaction between El Anatsui's *Tismemskiblo*, Tadao Ando's architecture, and Richard Serra's *Dirk's Pod*. That aim has undeniably been achieved. The analogies and contrasts

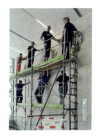

FIG. 6 Hanging *Tismemskiblo*, July 6, 2011.
FIG. 7 El Anatsui, *Tismemskiblo*, 2011, metal. The side of Richard Serra's *Dirk's Pod*, 2004, can be seen through the window.

speak for themselves: Ando, Serra, and El Anatsui belong to the same generation and are all highly regarded in their fields. All three imbue simple materials with aesthetic value by means of exquisite craftsmanship. Both El Anatsui and Tadao Ando base their work on the traditions of their respective cultural heritage with contextual references to western culture. In El Anatsui's assemblage, as in Tadao Ando's architecture, each component is treated equally, much like paratactic syntax in language. Nonetheless, there are very obvious differences in the formal and aesthetic idiom used by the three artists: soft, fluid, and ragged forms versus minimalist composition; textural richness versus uniform surface finishes; sumptuous color compositions versus monochrome.

Whereas Ando's raw concrete walls come into their own in the play of shadow, El Anatsui's *Tismemskiblo* reveals its richness in the play of light.

El Anatsui's vocabulary of form and color is defined by its unique quality and inimitable signature. The vitality of his work, anchored in the tradition and changing social and economic history of West Africa, lies in its ability to invoke a broad and cosmopolitan perception of culture.

Grossmünster Windows

Sigmar Polke

This text is based on the essay "Illuminationen" in the book *Sigmar Polke: Fenster—Windows—Grossmünster Zürich*, 2010, which was written together with Bice Curiger, and on lectures by Jacqueline Burckhardt.

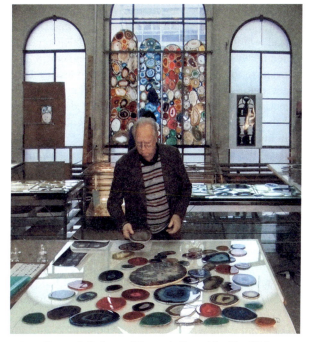

FIG. 1 Sigmar Polke lays out the agate discs at the Glas Mäder company, Zurich, 2008.

Sigmar Polke never considered history a burden to be discarded in order to create something new. To the contrary, he acted on established systems with surprising force. I had the privilege of witnessing this in action, looking over his shoulder as a curator and occasionally assisting him during his work on the 12 windows he created for the Grossmünster church in Zurich. He won the competition for their design in 2005 not only because of his overwhelming artistic energy, his unremitting research and his interest in alchemy, mysticism and spirituality; it was also his fascination with light, translucency and transparency. He spent four years working on the designs and entrusted their execution to the excellent glass painter Urs Rickenbach at the

Zurich-based Glas Mäder company. Having himself trained as a glass painter before studying at the Kunstakademie Düsseldorf, he was well-equipped to discuss his plans with Rickenbach.

When he was diagnosed with incurable cancer in 2008, he had to prepare for the likelihood that the window cycle would be his last major work. He gathered all his strength to complete the project, and he was fortunate to see the windows installed in the church and review the proofs for the publication by *Parkett* Verlag in his final weeks in 2010.[1]

Polke and Zurich: the combination represents a long-standing relationship of mutually seminal resonance. The artist regularly traveled to Zurich from the mid-1970s onwards and clearly impacted the Swiss art scene. The Kunsthaus Zürich dedicated two monographic exhibitions to him, the first curated by Harald Szeemann in 1984, and the second by Bice Curiger in 2005, after she had already presented his graphic work there in 2001.

Polke had long been well acquainted with the unassuming Grossmünster church, where iconoclasts of the Reformation had stripped away all the images, and proclaimed it the mother church of Zwinglian Protestantism. He embraced the task of designing the windows as a challenging echo chamber in which to explore new possibilities in both form and content. He wanted the windows to match the style of the 12th century, the most important chapter in the construction of the cathedral, which meant they should look as if they had always been there. He was particularly fond of Augusto Giacometti's atmospheric stained-glass windows in the choir from 1933 and took inspiration from their content, which features the nativity scene in dark, saturated colors. Since the protagonists in Giacometti's windows were Mary and the Christ Child, the latter marking the beginning of the New Testament, Polke decided to focus on events in the vast time span of the Old Testament with the theme of prefiguration as the common factor. In Christological interpretation, prefiguration refers to Old Testament figures who acted as intermediaries between God and humankind prior to the Incarnation. Polke dedicated five figurative windows to

them, after speaking at length with Grossmünster pastor Käthi La Roche about which figures to include. In addition to the Son of Man, as representing them all, they chose the prophet Elijah, King David, Abraham and Isaac and lastly, the scapegoat. Each of the figures illuminates a different aspect of mediation between divine authority and humankind and is, according to Polke, "always only a shard of the whole." He therefore designed each figurative window as a different and distinct entity, a decision reinforced by the fact that they can never be seen all that once, because the imposing Romanesque pillars largely obstruct the view of the side aisles.

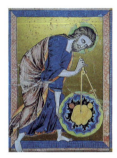

FIG. 2 God as Creator of the World, *Bible moralisée*, 13th century.
FIGS. 3+4 Sigmar Polke's window of agate panes dedicated to the element of water. Grossmünster Zurich, 2009.

The concept of prefiguration is intricately embedded into the theme of the seven windows, which Polke designed excluvsively with agate discs. For him, prefiguration also pertains to the inner artistic process of generating form, describing the self-contained life of form—where the distinction between abstraction and figuration begins to oscillate or even fade away completely.

1 *Sigmar Polke: Fenster—Windows—Grossmünster Zürich* (Zurich: *Parkett* Verlag, 2010). In German and English, with texts by Gottfried Boehm, Jacqueline Burckhardt, Bice Curiger, Ulrich Gerster, Regine Helbling, Claude Lambert, Käthi La Roche, Urs Rickenbach, Katharina Schmidt and Marina Warner.

With the use of natural material, he also refers to the themes of Genesis, the creation of the world. He showed us a miniature from the illuminated French *Bible moralisée* that dates back to the early 13th century.[2] It pictures God, the architect of the universe, measuring heaven and earth, the sun, moon and the four elements with a compass. So striking is the similarity between the 13th-century view of the universe and a cross section of agate that one might think the latter were foreshadowing what the painter of the miniature, probably a monk, envisioned. In any case, the painter could never have seen a slice of agate; the gemstone is much too hard. Only since the age of electrical engineering and the invention of the diamond cutter has it been possible to slice this gemstone. In antiquity, the windows of important buildings were embellished with alabaster panes, a much softer but also translucent material.

Agates form within gas-filled cavities of cooled lava. Metaphorically, their formation can be connected to the birth of the universe and two different experiences of time. On one hand, agates are shaped by dramatic volcanic forces akin to the instant of the Big Bang; on the other, they undergo a transformative process spanning millions of years. The cavities gradually fill with deposits working their way inwards, resulting in the creation of colorful concentric layers of minerals with beautiful intricate patterns and crystalline structures. Agates may even contain water from primeval times trapped inside them.

In contrast to the medieval Bible illustrator, who imagined God as the creator of the universe, Polke permits a preformed natural material to tell the story. His thirst for knowledge motivated him to have daylight shine through the agate discs in order to explore their inner life and make the invisible visible. Their drawings, patterns, variations in color and sparkling crystalline structures evoke countless images that oscillate between abstraction and figuration. One must "read" the agates with an inquisitive and playful spirit. Polke drew our attention to Roger Caillois' *The Writing of Stones*, in which the author writes: "Because they exist in such variety, agates present

a great multitude of different images, though all of them are ambiguous and vague like patterns in the clouds. In order to fix them, the imagination has to play its part and cling to the image it has settled on."[3]

Polke, the unconventional experimentalist, was always committed to giving uncommon materials and substances a voice. He did so with precious and toxic pigments, murex snails, meteorites, potatoes, jade, uranium rock and pyrite suns. He also loved playing with the vagaries of chance and unpredictability, experimenting with unusual techniques and making art that embarked on journeys through the ages and a diversity of media.

FIGS. 5–7 Details from Sigmar Polke's windows. Eye agate in the apex arches of the windows dedicated to the elements, from left to right: Earth, Water, Air.

The window cycle follows a clear sequence. It begins in the northwest corner of the church and proceeds counterclockwise to the scapegoat window. The first four of the seven agate windows allude to the basic elements of earth, fire, water and air, three which can be identified by their dominant colors: ochre for earth, red for fire and blue for water. Polke's sense of humor comes to the fore in the fourth element, air, represented high up in this window. There he has arranged six panes to form a

2 *Bible moralisée, Codex Vindobonensis 2554* (Vienna: Austrian National Library), cover 1-fol. I and 3 (13th century).

3 Roger Caillois, *The Writing of Stones*, introduction Marguerite Yourcenar, trans. Barbara Bray (Charlottesville: University Press of Virginia, 1995), p. 59. https://monoskop.org/images/5/55/Caillois_Roger_The_Writing_of_Stones_1985.pdf.

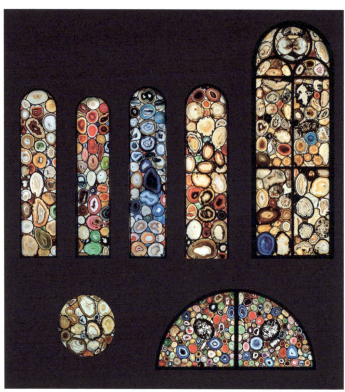

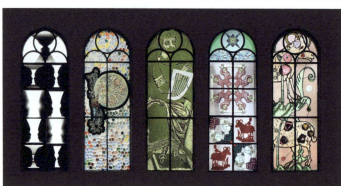

FIGS. 8+9 Sigmar Polke, windows in the Grossmünster in Zurich, 2009. Above, the seven agate windows; below, the five glass windows from left to right: Son of Man, Elijah's Ascension, King David, Abraham and Isaac, Scapegoat.

face, as if an ancient Zephyr with inflated cheeks were blowing vigorously into the room.

In the glass painter's workshop, I watched how Polke selected piece after piece with great care and confidence from the chaos of panes and then assembled them to make specific compositions. He used some 1300 pieces for the seven windows, all of them set in lead using a technique that emerged around the year 1200, with the birth of the Grossmünster as it were. We cannot trace all of the artistic decisions underlying his compositions; some secrets will never be unraveled. But he did give away a few, here and there, such as his allusion to the eye of God in the apex arches of the windows representing the four elements, where he used so-called eye agates. In the blue window for water, he even placed a pair of eyes with an icy gaze.

Alluding to the evolution of life, the compositions of the stones become increasingly complex as the windows proceed from the first to the seventh. Associations are evoked especially by the largest one on the south wall, which also tells of an advanced stage of evolution. Cell division, fetuses, grotesque faces, cross-sections of organs, CT scans and even landscapes might be read into it. Chance patches and shapes have fascinated writers and artists throughout history, from Botticelli and Leonardo da Vinci to George Sand and Victor Hugo. Inspired by Justinus Kerner's *Klecksographien* (Klecksography)[4] and Hermann Rorschach's use of inkblots for psychoanalytical tests, Polke filled several notebooks with experimental inkblots. His playful exploration took shape in the multicolored and largely symmetrical agate window in the lunette above the entrance portal.

Humankind follows the seven agate windows, the seven days of creation, which Polke underscores by changing his medium from a natural gemstone to artificially produced glass.

4 Justinus Kerner, *Klecksographien* (Stuttgart: Deutsche Verlags-Anstalt, 1890). Published posthumously.

Son of Man

The first of the glass windows stands apart in the cycle as a whole, as it is the only one restricted to black and white. Following the theme of Genesis, it might be interpreted as the biblical "Fiat lux," the separation of night and day. However, it is primarily about the Son of Man, who serves the Lord and is, at the same time, a mediator between divinity and humanity. The figure appears as a black silhouette or a backlit shadow. An unsettling restlessness clouds this window, reinforced by nine variations on the flip image of Rubin's vase, as it is called in Gestalt psychology. Named after the Danish psychologist Edgar J. Rubin (1868–1951), the image is a study in perception: What do I recognize first, the faces or the chalice? What constitutes the foreground, what defines the background? The window suggests instability, dialectics, complexity and, in the final analysis, fruitful doubt. Significantly, the Son of Man is not depicted as a being of delimited and delimiting singularity, instead we see several different profiles, some of them grotesquely distorted. The light that seeps into the apex of the window forms large profiles, while the elegant chalice, though veiled and dissolving, is black. In contrast in the remaining eight fields below, the chalice radiates in white immateriality between black silhouettes

FIG. 10 Hidden profiles of the guillotined Louis XVI, his wife Marie-Antoinette and their children in the weeping willow and urn, print, 1775.
FIGS. 11+12 Son of Man, Polke's glass window, detail and whole.

of the profiles. This window invites endless associations. In the context of the Reformation, the ambigrams also allude to the doctrine of the Eucharist, an issue of thorny theological debate: are the bread and wine of Holy Communion the actual body and blood of Christ, as with Luther, or only a symbol thereof, as with Zwingli?

Further associations include Plato's Allegory of the Cave, the legend that the first painting was created by tracing shadows on a rock, and clandestine portraits of the royal family of Louis XVI, guillotined during the French Revolution. The latter were concealed as negative shapes, for example, of an urn or a weeping willow. Polke himself mentioned another association, a tribute to the Zurich philosopher and theologian Johann Caspar Lavater, whose four-volume work *Physiognomische Fragmente*, 1775–78 (Physiognomic Fragments), significantly influenced intellectual and artistic circles in the late 18th and early 19th centuries.

Elijah's Ascension

Source image of the adjacent Elijah window was the scenic P-initial from an illuminated medieval Bible.[5] P as an acronym for prophet or even for Polke? The artist did not tell us. Light shines brightly through this window even on cloudy days; on sunny days, the direct light is almost blinding. Then it becomes radiantly sparking, concentrated light, created by the magnifying effect of the brightly colored semi-spherical lenses that are loosely distributed and baked onto the carrier glass.

The leaded P dominates the window, with the scene of Elijah's Ascent to Heaven on "a chariot of fire, and horses of fire" (2 Kings 2:11) appearing like an embossed medallion in the bowl. It is as if the surrounding colored glass lenses had entered a different material state, as if they had condensed to form this

5 P with Elijah's Ascension in the Sens Bible, 452 × 290 mm (17 $^{51}/_{64}$ × 11 $^{27}/_{64}$ in), Sens, Bibl. Mun.1.fol163v. Illustration, see Walter Cahn, *Romanesque Manuscripts. The Twelfth Century* (Miller: London, 1996), vol. II, fig. 197.

FIG. 13 Elijah's Ascension, Polke's cut-out photocopy from the Sens Bible, 12th century.
FIGS. 14+15 Elijah's Ascension, Polke's glass window, detail and whole.

image. In the finely ribbed glass of the medallion, the colors are "dis-placed" as in an anaglyph image. When viewed with red-green glasses, the 3D effect becomes even more pronounced. The shaft of the P is formed by the figure of Elisha, Elijah's disciple, who is reaching for the miraculous mantle, symbol of the legacy of his departing master. With this heritage, Elisha can part the waters of the Jordan and cross the river on dry ground. Both in substance and form, the shimmering window conveys Elijah's ecstatic state during his ascent from this world to the next, into which he was translated alive as a prefiguration of Christ.

King David

In contrast to the luminous atmosphere in the Elijah scene, King David with his harp strikes a completely different, richer tone. The enthroned figure of the historically documented King David, Christ's ancestor, dominates this nearly monochromatic olive-green window. The color radiates an expansive energy, as no lead bars divide the image. Instead, an unexpected element appears in the drawings, which are finely inscribed into the green surface. When light falls on the dark grooves, they acquire a blue or red inner life. The stylized harp, entirely in white, is like an autonomous heraldic element, indicative of David as a gifted

singer. In art history, representations of David and Orpheus are often similar; they symbolize a profound knowledge of the universal, divine principles of a world order that is embodied in musical harmony. Polke intentionally aligned the regal attitude of his David with the seated figure of Emperor Charlemagne, the legendary founder of the Grossmünster, seen high up on the southern facade of the tower.[6] David and Charlemagne were ambivalent rulers with light and dark sides; they were saints as well as ruthless warriors and conquerors. The olive green of the glass panels in which the figure is embedded can be read as a topographical model of Israel, the "land of milk and honey," which flourished under David, who united all of Palestine and the neighboring regions. However, the color is also the green of military camouflage, and David resembles Che Guevara wearing a gas mask. Not only blue waters but also red blood flow in the green furrows in allusion to the disputed territories, to the irresolvable, never-ending violence of religious conflict.

Abraham and Isaac

In the fourth stained glass window, dedicated to the legend of Abraham and Isaac, Polke combines delicate coloring with a strong, luminous red, conveying both a frantic rotation and a sense of stillness. Once again, he used a medieval Bible illustration[7] to highlight four pivotal moments: Abraham's left hand in Isaac's hair on the sacrificial altar, Abraham with a raised sword, the rescuing angel and lastly the ram as the substitute sacrifice. Mirrored several times, these four elements, arranged like a coded tarot card in emblematic kaleidoscopic patterns, evoke dissonant feelings of innocence and terror. We see Abraham aiming his sword at himself eight times, but since in their mirroring the swords fuse into each other, the force vectors cancel each other out. The image embodies powerful

6 The original figure is preserved in the crypt and a copy is on the tower.
7 See Walter Cahn, *Die Bibel in der Romanik* (Munich: Hirmer, 1982), p. 89.

 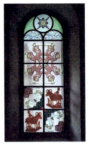

FIG. 16 Abraham and Isaac. Bible illustration from the *Paraphrases* of the monk and scholar Aelfric, early 11th century.
FIGS. 17+18 Abraham and Isaac, Polke's glass window, detail and whole.

mental and physical emotion captured just before the moment of release. The sacrificial animal appears only as a pool of blood, a flat silhouette within the texture of the glass, which varies from playful semi-spherical lenses and sculptural patterns to finely drawn and painted faces.

The nature of this window is enigmatic. In the four sections representing Abraham, one might imagine allusions to a Celtic knot pattern and even a swastika or a mandala. As in the David window, we wonder if we are being confronted with a painful collision between contemplative spirituality and armed authority or a critical allusion to militancy in the three Abrahamic religions. It is no accident that this complex, exceptionally eloquent window is placed directly behind the pulpit from which sermons are delivered to the faithful. Polke's art always serves as a haptic medium of reflection.

The Scapegoat

The ram from the Bible illustration in the Abraham and Isaac window also served as the inspiration for the last stained-glass window with the Scapegoat. A pink-purple background characterizes both windows, indicating that they share a subliminal, psychologically complementary orientation. One is linked

 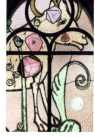 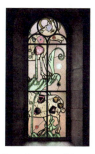

FIG. 19 Detail of the Bible illustration from the Paraphrases of the monk and scholar Aelfric, early 11th century.
FIGS. 20+21 The Scapegoat, Polke's glass window, detail and whole, 2009.

to aporia and existential border experiences, while the other is human and hopeful. The scapegoat symbolizes the prefiguration of Christ as the Lamb of God who "taketh away the sin of the world" (John 1:29). In ancient Judaism, the ritual of absolution goes back to the day when the High Priest transferred the sins of the people of Israel to a ram by laying hands on it and sending it into the wilderness.

Polke has divided the ram into halves, one on top of the other and facing in opposite directions, suggesting that it is not quite so easy to be absolved of sin. Eighteen tourmaline slices, as a symbolic representation of sins and injuries within the animal, unfold a life of their own with their intoxicating red-violet and yellow-green colors and inscribed triangular patterns. Since the time of the Egyptians, tourmaline has been considered a protective and healing stone. Polke, himself critically ill, thus incorporated a "therapeutic" element into his final window. Additionally, tourmaline is much more valuable than agate, and its colors are authentic, while some of the agate slices have been dyed. Choosing tourmaline in the scapegoat window shows a distinctive, surprising approach to the theme of preciousness.

Polke mentioned Abbot Suger in this regard, who in the 12th century initiated the new, light-filled architectural style in French cathedrals, one of the most famous examples being the

Basilica of St. Denis. He also introduced liturgical reforms and used a famous ancient onyx cup as a chalice. For Suger, the celebration of light and precious materials did not serve as ostentatious glorification of the church but rather encouraged spiritual contemplation. It is in this spirit that Polke permits the light, the precious gems, the molded glass and the imagery in the painted scapegoat window to speak for themselves.

The Gift

Having completed his work and acutely aware of his impending death, Polke surprised everyone by announcing that he would bequeath his cycle of windows along with the entire collection of gemstones integrated into them, as his legacy, not specifically to the church, but to the world. Furthermore, it would not be necessary to cover his expenses. The legacy of a woman from Zurich largely covered the cost of the glassmaker, the installation and the remaining expenses.

Polke was one of the most generous people I have ever known. Receiving and giving was second nature to him. The Ascension scene of Elijah, which appears as if stamped on a silver or gold coin, recalls the ancient Greek funeral custom of placing a coin under the tongue or on the eye of the deceased as fare for Charon to ferry them across the Styx to Hades. Polke's act of giving is also to be understood as a gift of gratitude for the inconceivable release and freedom that his final breath would bring after a life lived with unflagging intensity.

He had a Jewish tale of the prophet Elijah printed in the above-mentioned book about the windows. He asked me to read it to the public when he was awarded the Roswitha Haftmann Prize at the Kunsthaus Zürich a few weeks before his death.[8] He was no longer able to write a speech, let alone travel from Cologne to attend the celebration. In the letter accompanying the text, he wrote: "All Oriental religions regard selling oneself as an act of great heroic charity: Buddha does it, and this ancient story is still alive today. Among the Jews, it is the prophet Elijah

who sells himself; among the Muslims, Al-Khidr; and among the Christians, two figures bear the legend: Saint Peter Teleonarius, Bishop of Nola, and Gregory the Great."

Briefly, the tale is about a man so destitute that he can no longer feed his family. He encounters the prophet Elijah who says he should take him to market and sell him into slavery. The man follows this advice and sells Elijah into the service of the king. The king promises to grant Elijah freedom and reward him generously if he can build a palace within six months. Elijah conjures a sumptuous palace in a single night that is a thousand times more valuable than the king's entire fortune. Elijah then vanishes, so that the king can neither give him the promised reward nor grant him his freedom.

In one of our last late-night phone conversations, we reminisced about the first phase of planning the windows when I visited Polke in his studio in Cologne. He had spread out large sheets of paper on the floor, on which he had drawn the outlines of some windows to try out how the agate discs would look. He couldn't wait to watch the play of sunlight through the panes or to see their colored reflections falling on the walls and the floor. Back then, he gave me Antonin Artaud's Surrealist biographical novel about the infamous Late Roman Emperor Heliogabalus. This alleged son of Caracalla, who was murdered at the age of 18, also served as high priest of the Syrian sun god at Emesa, in which role he celebrated orgiastic rituals. He also fervently worshipped stones. Polke marked a passage in the book for me: "Yet there are stones living as plants or animals live, and just as one might say the Sun is alive, with stains which shift, swell and shrink, ooze into one another, merge and are once more displaced—and when they swell or shrink, they do it rhythmically, internally—just as one might say the sun lives."[9]

In that unforgettable conversation, Polke also talked about the magical power of art to bring static matter to life, as

8 As a source Polke gave: Midrash V, pp. 131–41.
9 Antonin Artaud, *Heliogabalus or, The Crowned Anarchist*, trans. Alexis Lykiard (Solar Books, Revised Translation Edition 2007), p. 17.

illustrated in the parable that he had presented in 1994 when the Dutch Prince Consort Bernhard awarded him the Erasmus Prize in Amsterdam. Polke chose an extremely moving way of expressing his thanks. He had spent weeks memorizing Marguerite Yourcenar's tale "How Wang-Fô was Saved" in German and recited it during the ceremony for over half an hour without a prompter. He could have read the story aloud; in fact, many people in the audience didn't realize he hadn't. The effort of learning by heart was a symbolic gesture that gave exceptional weight to his gratitude. By literally absorbing the tale through memorization, Polke also underscored how much it meant to him.

In the story, we learn that the Chinese Emperor of the Han Empire spent his childhood confined to rooms filled with magnificent paintings by the Chinese master Wang-Fô. Finally permitted to enter the real world for the first time when he turned 16, the young Emperor was devastated to find reality so completely different from the exquisite world of Wang Fô's art. Feeling unspeakably deceived by the artist's fraudulence, the Emperor had him arrested and ordered his henchmen to gouge out his eyes and hack off his hands. But before doing so, he ordered Wang-Fô to complete an unfinished landscape painting. The Emperor watched him at work. The artist applied one brushstroke after the other until the pale-blue waters rising in a sea of jade threatened to drown the society at court. When a boat appeared on the roll of painted rice paper mounted on silk, Wang-Fô and his assistant embarked. The boat receded into the distance where they escaped unharmed into the freedom of the artist's sublime art.

Appendix

CONTRIBUTORS

LAURIE ANDERSON is a composer, instrumentalist, singer, poet, photographer, filmmaker, and graphic artist and, thus, one of the boldest pioneers of Multimedia Performance Art. The Grammy Award winner has been touring the world since the 1970s with her performances, which range from simple spoken word events to complex multimedia shows. Her career as a recording artist began in 1980 with the single *O Superman*, which reached number two in the British charts. This was followed by a further seven albums that were released by Warner Brothers and other labels. She composed the music for films by Wim Wenders and Jonathan Demme and dance works by Bill T. Jones and Trisha Brown and has worked with directors such as Robert Wilson and Robert Lepage and with the Kronos Quartet. She has also received huge acclaim for her own videos and films such as *Home of the Brave* (1986) and *Heart of a Dog* (2015) as well as for the virtual reality installations *Chalkroom* (2017) and *To the Moon* (2018), which she developed with Hsin-Chien Huang. Anderson has published several books and composed entries for the *Encyclopedia Britannica*. Her visual work has been presented in important international institutions. In 2021/22, the Hirshhorn Museum in Washington hosted her largest monographic exhibition to date, *Laurie Anderson: The Weather*. Laurie Anderson lives and works in New York.

JACQUELINE BURCKHARDT trained at the Istituto Centrale del Restauro in Rome, completed her studies in the history of art in Zurich in 1978, and published her dissertation *Giulio Romano, Regisseur einer verlebendigten Antike* in 1994. She worked on a range of restoration campaigns in Italy, Spain, Ireland, Romania, and Turkey and spent several years as a restorer at the Kunsthaus Zürich, where she also initiated a performance program. She was a co-publisher and editor of the art magazine *Parkett* for 33 years. She was the director of the Sommerakademie Residency Program at the Zentrum Paul Klee. She has been President of the Federal Art Commission, of the Fondation Nesté pour l'art and of the Schweizerische Graphische Gesellschaft. She taught at the Accademia di architettura in Mendrisio and curated the site-specific art on the Novartis Campus in Basel. Today she is principally engaged in writing art criticism. She is awarded with the Prix Meret Oppenheim in 2024. Jacqueline Burckhardt lives and works in Zurich.

KURT W. FORSTER studied the history of art and literature and archaeology at universities in Berlin, Munich, and Zurich. As a full professor of architectural history he founded the doctoral program at Yale School of Architecture and has taught at Stanford, M.I.T., Cambridge, ETH Zurich, and the Bauhaus-Universität Weimar and as a visiting professor at Princeton School of Architecture. In addition to this, he headed the Swiss Institute in Rome and the Canadian Centre for Architecture in Montreal. As Founding Director of the Getty Research Institute, Los Angeles, he established important collections and an international scholarship program, an archive, and a series of publications. Forster has also organized exhibitions about Karl Friedrich Schinkel, Carlo Scarpa, and the architects Herzog & de Meuron. In 2004, he presided over the 9th International Architecture Exhibition of the Biennale di Venezia. Forster's numerous publications include works about Jacopo da Pontormo, Andrea Palladio, Karl Friedrich Schinkel, Aby Warburg, Frank Gehry, Aldo Rossi, and Peter Eisenman as well as about contemporary photography. He is currently working on a study entitled "Times of Experience," which addresses the impact of geological investigations on modern ideas in the fields of architecture and art. Kurt W. Forster died in New York on January 6, 2024, at the age of 88.

KATHARINA FRITSCH studied history, history of art, and ethnology at the University of Münster and subsequently, from 1977, at the Institute for Art Educators in Münster under Johannes Brus and Hermann-Josef Kuhna. In 1979, she moved on to the Kunstakademie Düsseldorf, where she studied under Fritz Schwegler and graduated as a master student in 1984. Between 2001 and 2019 she was a professor at the University of Fine Arts Münster and, from 2010, at the Kunstakademie Düsseldorf. Her best-known objects and installations include *Elefant* and her life-sized yellow *Madonna* (both 1987), *Tischgesellschaft* (1988), *Rattenkönig* (1993), and the blue *Hahn/Cock*, which occupied the fourth plinth in Trafalgar Square in London between 2013 and 2015. Some highlights from her many monographic exhibitions are: 1988

Kunsthalle Basel and the Institute of Contemporary Art (ICA), London; 1996/97 Museum of Modern Art, San Francisco, and Museum für Gegenwartskunst, Basel; 2001 Museum of Contemporary Art, Chicago, and Tate Modern, London; 2002 the opening exhibition of the Kunstsammlung im Ständehaus, K21, Düsseldorf; 2009/10 Kunsthaus Zürich and Deichtorhallen Hamburg; 2016 Schaulager, Basel: *Zita—Шапа* (with Alexej Koschkarow) and Museum Folkwang, Essen. She received the Golden Lion at the Biennale di Venezia in 2022 in recognition of her life's work. Katharina Fritsch lives and works in Düsseldorf and Wuppertal.

HERBERT LACHMAYER studied philosophy, history of art, and sociology in Vienna, Frankfurt/Main, and Berlin. He has taught in Vienna, Linz, Berlin, London, and Stanford and is now a full emeritus professor. Exhibitions (selection): *Work and Culture* (Linz, 1997); *Alles Schmuck* (Zurich, 2000); *Salieri sulle tracce di Mozart* (Milan, 2004); *Mozart* (Vienna, 2006); *Da Ponte* (Vienna, 2006); *Wolfgang Amadée. Ein ganz normales Wunderkind* (Vienna, 2006); *Wozu braucht Carl August einen Goethe?* (Weimar, 2008); *Haydn Explosiv* (Eisenstadt, 2009); *Das Bernhardzimmer—Beschwörung nationaler Identität* (Weimar, 2010); *Phantasie und Pharmazie* (Vienna, 2011); *Gustav Mahler—Produktive Dekadenz in Wien um 1900* (Berlin, 2011); and *Mediale Lebens[t]räume* (Thüringen, 2011). Lachmayer has written numerous exhibition catalogs and other publications, notably *Staging knowledge. Inszenierung von Wissensräumen als Forschungsstrategie und Ausstellungsformat*, Munich: Fink, 2013. Herbert Lachmayer lives and works in Vienna.

PIPILOTTI RIST has been attracting international attention since the first appearance of single channel videos such as *I'm Not the Girl Who Misses Much* (1986) or her experimental film *Pickelporno* (1992). Her exhibitions now attract record numbers of visitors to art institutions. She is a pioneer of installative video art and was awarded a Premio 2000 at the Biennale di Venezia in 1997 for her first large-format video installation *Ever is Over All*. Numerous solo and group exhibitions have been realized with her participation since 1984. Her most recent shows include: *Behind Your Eyelid*, Tai Kwun, Hong Kong (2022); *Big Heartedness: Be My Neighbor* in Geffen Contemporary, MOCA, Museum of Contemporary Art Los Angeles (2021/22); *Your Eye Is My Island* in MOMAK, The National Museum of Modern Art Kyoto and Art Tower Mito (2021); *Åbn min Lysning: Open My Glade* in the Louisiana Museum of Modern Art, Humlebæk, Denmark (2019); *Sip My Ocean* in the Museum of Contemporary Art, Sydney (2017/18); *Pixel Forest* in the New Museum, New York (2016/17); *Your Saliva is My Diving Suit of the Ocean of Pain* in Kunsthaus Zürich (2016); and *Come On Honey...* in Kunsthalle Krems (2015). Pipilotti Rist lives and works in Zurich.

CATHERINE and TARCISIUS SCHELBERT live in Weggis near Lucerne. He has a PhD in English studies from the University of Zurich; she has a bachelor's in philosophy from the University of Columbia in New York. She has won prizes, he has not. They translate and write together.

JURI STEINER is an art historian and curator and the founder of Juri Steiner & Partner. He has been, amongst other things, the head of Arteplage Mobile du Jura during Expo.02, Director of the Zentrum Paul Klee in Bern, and one of the presenters of "Sternstunde Philosophie" (SRF). He curated the Dada Centenary in Zurich in 2016 and headed a team of curators during the launch phase of the concept for NEXPO, the initiative for a future national exhibition established by Switzerland's ten largest cities. He has curated four exhibitions for the Landesmuseum Zürich together with Stefan Zweifel, most recently *Der erschöpfte Mann* (2020). In mid-2022 he was appointed Director of the Musée cantonal des Beaux-Arts (MCBA) in Lausanne. Juri Steiner lives and works in Lausanne.

Editors

THERES ABBT studied at the Dolmetscherschule Zürich and Sotheby's Institute in London. She was an assistant to Dr Harald Szeemann at Kunsthaus Zürich (1985–91), a co-editor at Scalo Publishers in New York (1996–2001), and a gallery director for Scalo in New York and Zurich (1998–2006). She worked freelance with the gallery Abbt Projects in Zurich (2006–12), and ran the *Parkett* exhibition

space in Zurich (2012–20). She has been the curator of a private collection since 2015. Theres Abbt lives and works in Zurich.

MIRJAM FISCHER studied the history of art and architecture and modern German literature in Bern. Her company mille pages acts as an independent book producer and editor in the fields of art, photography, and design for a range of organizations and publishers. She was previously Head of Publications at the Museum für Gestaltung Zürich and Publishing Director at Edition Patrick Frey. Mirjam Fischer lives and works in Zurich.
millepages.ch

BIBLIOGRAPHY

AS EDITOR

Ein Gespräch—Una discussione (German/Italian edition), conversation between Joseph Beuys, Enzo Cucchi, Jannis Kounellis, Anselm Kiefer, and Jean-Christophe Ammann for the preparation of the exhibition *Joseph Beuys, Enzo Cucchi, Anselm Kiefer, Jannis Kouanellis*, Kunsthalle Basel, March 23–May 4, 1986, Zurich: Parkett, 1986.
Further editions: *Kekustela* (Finnish), Helsinki: Taide, 1988 | *Bâtissons une cathédrale: entretien* (French), Paris: L'Arche, 1988 | *Ein Gespräch* (German), Ostfildern: Cantz, 1994.
Parkett, art magazine (German/English), 1–100/01, 1984–2017, ed. with Bice Curiger, Dieter von Graffenried, and Walter Keller (until 1995), Peter Blum (co-founder).
Giulio Romano, Regisseur einer verlebendigten Antike. Die Loggia dei Marmi im Palazzo Ducale von Mantua, dissertation, Zurich: self-published, 1994.
Rémy Zaugg. Gespräche mit Jean-Christophe Ammann, ed. and transl. of the German edition in cooperation with Michèle Zaugg Röthlisberger, Ostfildern: Cantz/Zurich: Parkett, 1994.
Christian Waldvogel. Earth Extremes, ed. with Christian Waldvogel and Jonas Voegeli, Zurich: Scheidegger & Spiess, 2010.

AS AUTHOR

"Zu Munchs Bildnissen," in: *Edvard Munch im Kunsthaus Zürich* (*Sammlungsheft* 6), 1977, pp. 101–05.
"Performance—was ist das?," in: *DU*—Kulturmagazin, no. 40, 1980, pp. 82–83.
"Antique Relief with the Throne of Jupiter," in: *Splendours of the Gonzaga*, ed. by David Chambers and Jane Martineau, exh. cat. Victoria & Albert Museum, November 4, 1981–January 31, 1982, London: Victoria & Albert Museum, p. 192. ▶ Giulio Romano
"Performance: Zu den neuen Aktivitäten im Kunsthaus Zürich," in: *Mitteilungsblatt der Zürcher Kunstgesellschaft*, no. 3, 1981, pp. 32–35.
"Zu den Performances vom 18. und 23. März 1982, Molissa Fenley, Choreographin, Tänzerin, Musikerin, Dana Reitz Choreographin, Tänzerin," in: *Mitteilungsblatt der Zürcher Kunstgesellschaft*, no. 1, 1982, pp. 34–35.
"Giulio Romano im Wandel der Rezeption," in: *Neue Zürcher Zeitung*, no. 217, September 17/18, 1983, pp. 65–66.
"Dance About Dance About Me About Us," in: *Parkett* no. 1, 1984, pp. 38–44 | "The American Performer Dana Reitz," English translation by Susanne Müller, pp. 45–47. SEE P. 316 IN THIS BOOK.
"Go West! Ein Energieprogramm für die Kunstgeschichte: Interview mit Kurt Forster," in: *Parkett* no. 3, 1984, pp. 65–73 | "Go West! An Energy Program for the History of Art: Interview with Kurt Forster," English translation by Genise Schnitman and Inge Globig, pp. 74–81.

"Vokale und Bilder im Zauber der Reize," in: *Parkett* no. 4, 1985, pp. 20–33 | "Semantics of Antics," English translation by Catherine Schelbert, pp. 20–33. ▶ Meret Oppenheim
"Città irreale," in: *Parkett* no. 5, 1985, pp. 75–77 | "Città Irreale," English translation by Catherine Schelbert, pp. 82–84. ▶ Mario Merz
"Beat Streuli: Sieben Bilder," in: *Beat Streuli, Felix Stephan Huber: Photographie*, exh. cat. Aargauer Kunsthaus, May 10–June 8, 1986, Aarau 1986, pp. 2–3.
"Die Ausstellung *Skulptur Projekte Münster 1987* wird im Juni eröffnet," in: *Parkett* no. 12, 1987, pp. 134–35 | "The Exhibition *Sculpture Projects Münster 1987* to be opened in June," English translation by Peter Pasquill, pp. 136–37.
"Mit Anna Winteler im Gespräch," in: Videokatalog zu Anna Wintelers Ausstellung *Discours des Montagnes à la mere*, Kunsthalle Basel, June 11–August 7, 1988.
"Anna Winteler," in: *Sinn und Sinne, senso e sensi*, ed. by Carla Zickfeld and Stefan Karkow, Progetto Civitella d'Agliano, Italian translation by Angioletta Bovoni, Rome: 1988, pp. 94–99, English translation by Scriptum snc, on supplementary sheet, n.p.
"Das Gewicht des Staubkorns," with Bice Curiger, in: *Parkett* no. 16, 1988, pp. 104–10 | "The Weight of a Grain of Dust," English translation by Martin Scutt, pp. 111–21. ▶ Robert Wilson SEE P. 306 IN THIS BOOK
"Hommage an Giulio Romano," in: *Parkett* no. 21, 1989, pp. 84–96 | "Hommage to Giulio Romano," English translation

by Catherine Schelbert, pp. 97–106.
"La loggia dei marmi," in: *Giulio Romano*, ed. by Manfredo Tafuri, exh. cat. Palazzo Ducale and Palazzo Te, Mantua, September 1–November 12, 1989, Milan: Electa, 1989, pp. 412–17; "Il monumento Strozzi nel Sant'Andrea di Mantova," pp. 561–63; "Il monumento Rangoni, nel duomo di Modena," pp. 570–71.
"Mario Merz, Jannis Kounellis, Giuseppe Penone, Enzo Cucchi," in: *Prêts de la Collection FCM*, ed. by Migros Genossenschaftsbund, exh. cat. Musée Cantonal des Beaux-Arts de Lausanne, 1989.
"Eros in Gestalt von Quadern und Säulen," in: *Die Weltwoche*, no. 39, September 28, 1989, p. 53.
▶ Giulio Romano
"Museumsbau im Widerstreit von Kunst und Architektur," in: *Hochparterre: Zeitschrift für Architektur und Design*, no. 2, 1989, pp. 58–61.
Untitled, in: *Quiet Afternoon*, ed. by Akhnaton Gallery, Cairo, and Pro Helvetia Cairo, 1989, n. p. | Arabic translation.
▶ Peter Fischli & David Weiss
Jan Jedlicka, *Il Paesaggio Echo La Casa*, text on the slipcase (German / English), Basel: Wiese, 1990.
"Beat Streuli: Rom Paris Fotografien," in: *Beat Streuli: Rom: Fotografien 1989*, 2 volumes, Baden: Lars Müller, 1990, English translation by Catherine Schelbert, French translation by Monique Sauter, both on supplementary sheet, n. p.
"Monica Klingler," in: *Monica Klingler: Tanzperformance*, ed. by Deutscher Akademischer Austauschdienst, Berlin: DAAD, 1990, pp. 6–12.

"Untitled," in: *Das Geheimnis der Arbeit: Texte zum Werk von Peter Fischli & David Weiss*, ed. by Patrick Frey, publication accompanying the exhibition at Kunstverein München, March 9–April 16, 1990; Kunstverein für die Rheinlande und Westfalen, Düsseldorf, January 19–March 3, 1991, München & Düsseldorf, 1990, pp. 173–78.
"Jan Jedlicka und Roman Signer," in: *Progetto Civitella d'Agliano, 1990*, ed. by Carla Zickfeld and Stefan Karkow, Scriptum snc: Rome, 1991, pp. 34–55 | "Jan Jedlicka e Roman Signer: Una nota di Jacqueline Burckhardt," Italian translation by Scriptum snc, pp. 141–44 | "Jan Jedlicka and Roman Signer: A note by Jacqueline Burckhardt," English translation by Scriptum snc, pp. 144–47.
"Gemeinsam sind wir individuell," in: *Toyama Now '93: Art Scene in Central Europe*, Toyama, exh. cat. Museum of Modern Art, Toyama, July 3–September 15, 1993, English translation by Catherine Schelbert, pp. 93–110, Japanese translation, pp. 90–92.
"Parkett ist zehn Jahre alt," with Bice Curiger and Dieter von Graffenried, *Parkett* no. 4/41, 1994, p. 4 | "Parkett is ten years old," English translation by Catherine Schelbert, p. 5.
"Rocaille—Rock Eye," with Bice Curiger, in: *Pipilotti Rist: 167cm. I'm not the Girl Who Misses Much: Ausgeschlafen, frisch gebadet und hochmotiviert*, exh. cat. Kunstmuseum St. Gallen, November 12 1994–January 29, 1995; Neue Galerie am Landesmuseum Joanneum, Graz, June 2–July 2, 1995;

Kunstverein in Hamburg, September 8–22, 1995, publication accompanying the Manor Prize 1994, n. p. Reprint in: *Himalaya, Pipilotti Rist, 50 kg*, exh. cat. Kunsthalle Zürich, January 24–March 21, 1999; Musée d'Art Moderne de la Ville de Paris, April 15–June 13, 1999, Cologne: Oktagon / Zurich: Kunsthalle Zürich, 1999, n. p. | "Rocaille—Rock Eye," French translation by Marielle Larré on supplementary sheet.
SEE P. 274 IN THIS BOOK
"Die Kunst des Bergversetzens," in: *video vidim ich sehe*, ed. by Esther Maria Jungo, Katarina Rusnakova, Maria Smolenicka, exh. cat. Povazska galéria umenia, Zilina, SK, September 14–October 30, 1994; Dum umeni, Brno, CZ, December 15, 1994–January 22, 1995; Galéria mesta Bratislavy, Bratislava, SK, February 10–March 26, 1995; Kunstmuseum Thun, April 27–June 5, 1995, Bern 1994, pp. 98–103 | "Umenie hory prenasat," Slovak translation by Alma Münzova, pp. 99–101.
▶ Anna Winteler
"Andreas Gursky: Maler der neuen Schauplätze," in: *Parkett* no. 44, 1995, pp. 68–73 | "Andreas Gursky: Painter of New Theaters of Action," English translation by Catherine Schelbert, pp. 74–77.
"Fabelwesen," in: *Tages-Anzeiger: Das Magazin*, no. 2, January 13–19, 1996, cover and pp. 10–14.
Reprint: "Laurie Anderson, 'Ich bin eine Geschichtenerzählerin' oder Digitale Feuerzeichen: Ein Porträt von Jacqueline Burckhardt," in: *Kunstforum*, no. 134, May–September 1996, pp. 213–19.

"'An Enormously Tiny Bit of a Lot,'" with Bice Curiger, in: *Meret Oppenheim: Beyond the Teacup*, exh. cat. Guggenheim Museum, New York, June 28–October 9, 1996; Museum of Contemporary Art Chicago, IL, November 2, 1996–January 11, 1997; Bass Museum of Art, Miami Beach, FL, February 6–April 6, 1997; Joslyn Art Museum, Omaha, NE, May 10–July 6, 1997, English translation by Catherine Schelbert, New York: Independent Curators Inc. (ICI), 1996, pp. 15–21.
Reprint: "'Mit ganz enorm wenig viel,'" in: *Meret Oppenheim: Eine andere Retrospektive / A different Retrospektive*, ed. by Galerie Krinzinger, exh. cat. Galerie Krinzinger, Vienna, July 7–August 23, 1997; Museum voor Moderne Kunst Arnhem, NL; Uppsala Konstmuseum, Uppsala, SE; Helsinki City Art Museum, Helsinki, FI, Vienna / New York: Edition Stemmle, 1997, pp. 8–11 | "With an Enormously Tiny Bit of a Lot," English translation by Catherine Schelbert, pp. 12–13.
"Im Nervenstrom," in: *Parkett* no. 49, 1997, pp. 146–51 | "In the Nerve Stream," English translation by Catherine Schelbert, pp. 152–57. ▶ Laurie Anderson SEE P. 284 IN THIS BOOK
"Parkett; pas une revue d'actualité?," in: *Quelles Mémoires pour l'art contemporain? Actes du XXX^e Congrès de l'Association Internationale des Critiques d'Art*, Rennes, August 25–September 2, 1996, Rennes: Presses Universitaires de Rennes, 1997, pp. 121–24.
"'Soviel wie wach im Schlafe sehen hören,'" in: *Meret Oppenheim*, ed. by Martina Corgnati, exh. cat. Refettorio delle Stelline, Milan, November 26, 1998–January 30, 1999, Milan: Skira, 1998, pp. 45–49 | "'Come sveglio nell sonno vedere udire,'" Italian translation by Giovanni Quadrio Curzio, pp. 39–43.
"Vorwort," in: *Im Auftrag: Druckgraphik 1918–1998*, ed. by Graphische Sammlung ETH Zürich, exh. cat. Galerie Kornfeld, Bern, November 17–December 19, 1998; Civica Galleria d'Arte, Bellinzona, February 4–March 7, 1999; Cabinet Cantonal des Estampes, Musée Jenisch, Vevey, June 17–September 5, 1999, Zurich, 1998, p. 2.
"Die Herausforderung EKK—La CFBA au défi—Le sfide per la CFBA," in: *Prix conseillé. 1899–1999. 100 ans de Concours fédéral des Beaux-arts / Über Preise lässt sich reden. 1899–1999. 100 Jahre Eidgenössischer Wettbewerb für freie Kunst / Premi apprezzati. 1899–1999. 100 anni di Concorso federale delle belle arti*, ed. by Bundesamt für Kultur, Zurich: Orell Füssli, 1999, pp. 18–19 | "La Commission Fédérale des Beaux-Arts Mise au Défi," French translation by Gilles Cuenat, pp. 20–21 | "Le Sfide per la Commissione Federale delle Belle Arti," Italian translation by Monica Nolli, pp. 22–23. ▶ Eidgenössische Kunstkommission
"Kunst im SVA-Bürogebäude," in: *Der neue Standpunkt: Die SVA Zürich auf dem Röntgenareal, Bürogebäude der Architekten Isa Stürm und Urs Wolf*, ed. by SVA Zürich, 1999, pp. 42–56. ▶ John Armleder, Sabina Lang & Daniel Baumann, Norbert Möslang & Andy Guhl, Jörg Lenzlinger & Patrick Sidler, Claudia & Julia Müller, Christoph Schreiber
"Roni Horn: Jahresgabe 2000—Schweizerische Gesellschaft für Druckgrafik," supplementary sheet.
"Ich hatte gelebt, geliebt und sehr viel gelitten!," in: *"Meine Bilder bleiben, die werden später von mir sprechen": Andreas Walser 1908–1930*, ed. by Marco Obrist, Berlin: Nicolai, 2001, pp. 163–65.
"Wer bin ich?—Ich und das Universum: Ein Expo.02 Projekt," in: *horizonte—horizons—orizzonti—horizons: Beiträge zu Kunst und Kunstwissenschaft*, 50 Jahre Schweizerisches Institut für Kunstwissenschaft (SIK), ed. by SIK, Ostfildern: Hatje Cantz, 2001, pp. 465–72, English summary on p. 472.
"Giving and Giving Oneself on Pipilotti Rist and Laurie Anderson," in: *Dono / The Gift*, ed. by Gianfranco Maraniello et al., Milan: Charta, 2001, English translation by Catherine Schelbert, pp. 345–53 | "Dare e dedicare," Italian translation by Lucia Saetti, pp. 344–52.
"Die Sonnenstele von Max Matter," site-specific art at the Federal Institute of Metrology (METAS), publication accompanying the opening ceremony, May 17, 2001, ed. by METAS, pp. 30–31.
"Switzerland's Roaring Nineties," in: *Art in Europe 1990–2000*, ed. by Gianfranco Maraniello, Milan: Skira / Seuil, 2002, pp. 87–99 | French edition: "Les folles années 90 en Suisse," in: *Art en Europe 1990–2000*, ed. by Gianfranco Maraniello, Paris: Skira / Seuil, 2002, French translation by

Language Consulting Congressi srl., pp. 87–99.
"Bildschirmstürmerin Pipilotti Rist," in: *Doppelung der Bilder im Raum: Aus der Sammlung Eckardt* (publication series by Kunstmuseum Bayreuth, vol. 10), exh. cat. Kunstmuseum Bayreuth, December 16, 2001–January 27, 2002; Stadtgalerie Kiel, November 16, 2002–January 12, 2003, Bayreuth, 2001, p. 55.
"Die Erfindung des SCHAULAGER®," in conversation with Jacques Herzog, architect, Herzog & de Meuron, Bice Curiger, Theodora Vischer, in: *Parkett* no. 67, 2003, pp. 130–39 | "The Invention of the SCHAULAGER®," English translation by Catherine Schelbert, pp. 140–48.
"Katz und Kairos," in: *Alex Katz: Small Portraits and Large Landscapes*, exh. cat. Galleria Monica de Cardenas, Zuoz, November 5, 2003–January 30, 2004, Zuoz, 2004, pp. 48–49 | "Katz e Kairos," Italian translation by Sergio Risaliti, pp. 44–45 | "Katz and Kairos," English translation by Catherine Schelbert, pp. 46–47.
SEE P. 322 IN THIS BOOK
"Vom Geist aus der Sprühdose," in: *Renée Levi. Kill me Afterwards*, ed. by Marcel Schmidt, exh. cat. Museum Folkwang, Essen, June 14–August 12, 2003, Nuremberg: Verlag für moderne Kunst, 2003, p. 6 | "The Ghost of the Spray Can," English translation by Jeanne Haunschild, pp. 7–8 | "Le génie tout droit sorti de la bombe de peinture," French translation by Valérie Dupré, pp. 7–8.
"Architektur aus dem Häuschen," in: *Emotional Landscape: Die Architektur von Mateja Vehovar und Stefan Jauslin*, Basel et al.: Birkhäuser, 2003, pp. 12–14 | "Architecture Unchained," English translation by Adam Blauhut, pp. 12–14.
"Was ist, was könnte sein, was sein soll," in: *Shirana Shahbazi: Risk is Our Business*, Rüschlikon: Swiss Re Centre for Global Dialogue in collaboration with Art at Swiss Re, 2004, pp. 7–9 | "What Is, What Might Be, What Should Be," English translation by Catherine Schelbert, pp. 4–6.
"'Parkett Backstage': Ein Gespräch mit den *Parkett*-Herausgeber:innen Bice Curiger, Jacqueline Burckhardt, Dieter von Graffenried," in: *Parkett—20 Years of Artists' Collaborations*, ed. by Kunsthaus Zürich, exh. cat. Kunsthaus Zürich, November 26, 2004–February 13, 2005, pp. 33–114 | "Parkett Backstage," English translation by Catherine Schelbert, pp. 115–73.
"Der Prix Meret Oppenheim," Preface, in: *Prix Meret Oppenheim 2004*, interviews with Christine Binswanger/Harry Gugger, Roman Kurzmeyer, Peter Regli, Hannes Rickli, ed. by Federal Office of Culture, 2004, p. 5 | "Prix Meret Oppenheim," Introduzione, Italian translation by BAK, p. 6 | "Prix Meret Oppenheim," Preface, French translation by BAK, p. 7; "Grünes Licht für roten Pfeil," conversation with Peter Regli, pp. 49–69.
"Kunst im öffentlichen Raum: Theorie und Praxis": A conversation with Jacqueline Burckhardt, Birgit Sonna and Christoph Schenker, in: *Before the Sun Rises*, ed. by Bice Curiger, publication on the occasion of the fiftieth anniversary of the Walter A. Bechtler Stiftung, Zurich: JRP, 2005, pp. 65–88.
"Harry Szeemann: Letzte Begegnung," in: *Neue Zürcher Zeitung*, February 20, 2005.
"Jacqueline Burckhardt und Christiane Meyer-Thoss sprechen über Johannes Gachnang," in: *Prix Meret Oppenheim 2005, Johannes Gachnang, Katharina Knapkiewicz & Alexander Fickert, Gianni Motti, Václav Požárek*, ed. by Federal Office of Culture, Bern, 2005, pp. 19–31.
"Europas schneeige Pelzboa," in: *Kunst & Architektur*, ed. by Switzerland Tourism, Biel: Weber Druck Biel, 2005, pp. 6–7 | "Europe's snow-laden feather boa," English translation by Hans & Jennifer Abplanalp: in *Art & Architecture*, ed. by Switzerland Tourism, Biel: Weber Druck Biel, 2005, pp. 6–7.
"Es bleibt die Mondsucht. Laurie Andersons *The End of the Moon*," in: *Aargauer Zeitung*, April 26, 2006.
"Aus dem Pelz fahren," in: *Elodie Pong (Collection Cahiers d'Artistes)*, ed. by Swiss Arts Council Pro Helvetia, Lucerne: Edition Periferia, 2007, pp. 44–45 | "Talk About Fur Flying," English translation by Catherine Schelbert, pp. 42–43.
"Free Radical," Jacqueline Burckhardt in conversation with Kurt Forster, in: *Prix Meret Oppenheim 2007*, ed. by Federal Office of Culture, Bern, 2007, pp. 26–41.
"Luxus der Freiheit," interview with Peter Regli, in: *Reality Hacking 256-001*, ed. by Helmhaus Zürich, publication accompanying the exhibition

samesame—but different by Peter Regli, September 14–November 11, 2007, Helmhaus Zürich, Zurich: Edition Patrick Frey, 2007, pp. 2–14 | "The Luxury of Freedom," English translation by Howard Fine, pp. 16–28.

"Is Eternal Nothingness ok?," in: *Daniele Buetti: Maybe You Can Be One of Us*, ed. by Swiss Institute/Contemporary Art New York, publication accompanying the exhibition *Daniele Buetti, Speaking of Physical Attributes*, Swiss Institute/Contemporary Art New York, February 13–March 22, 2008; Kunsthalle Recklinghausen, May 5–July 20, 2008, Kunstmuseum Mülheim an der Ruhr, October 5–November 30, 2008, English translation by Catherine Schelbert, Ostfildern: Hatje Cantz, 2008, pp. 42–45.

"Der Umweg über die Kunst ist einer, der sich lohnt," in: *Novartis Campus*, ed. by Novartis International AG, Ostfildern: Hatje Cantz, 2008, pp. 144–59.

"Eine 'Wandverwandlung' von Sigmar Polke," in: *Novartis Campus—Fabrikstrasse 16, Krischanitz und Frank Architekten*, ed. by Ulrike Jehle-Schulte Strathaus, Basel: Christoph Merian, 2008, pp. 20–21 | "A 'Wall Transformation' by Sigmar Polke," English translation by Michael Robinson, pp. 22–23.

"Kunst im Bereich der Südporte und des Parks," in: *Novartis Campus—Fabrikstrasse 2, Marco Serra, Günther Vogt, Ulrich Rückriem, Eva Schlegel*, ed. by Ulrike Jehle-Schulte Strathaus, Basel: Christoph Merian, 2008, pp. 21–24 | "Art at the South Gate of the Novartis Campus," English translation by Ishbel Flett, pp. 25–28.

"Surface," in: *L/B. Beautiful Book*, ed. by Sabina Lang/Daniel Baumann, English translation by Uta Winzer, Zurich: JRP, 2008, n. p.
▶ Sabina Lang and Daniel Baumann

"Utopie und Gegengift," in: *Utopie heute II: Zur aktuellen Bedeutung, Funktion und Kritik des utopischen Denkens und Vorstellens* (23rd und 24th Colloquium [2005 and 2006] of Schweizerische Akademie der Geistes- und Sozialwissenschaften), ed. by Beat Sitter-Liver in cooperation with Thomas Hiltbrunner, Fribourg: Academic Press/Stuttgart: Kohlhammer, 2008, pp. 291–307.
▶ Laurie Anderson, Thomas Hirschhorn

"Kunst und Natur im Pas de deux," in: *Anthos: Zeitschrift für Landschaftsarchitektur*, no. 1, 2009, pp. 16–19 | "Pas de deux entre art et nature," French translation by Yves Minssart, pp. 16–19. ▶ Katja Schenker

"Trendlese aus der Kunstperspektive," in: *Stadtgestalten: Visionen, Allianzen, Wege (Stadtentwicklung und Denkmalpflege*, vol. 12), ed. by Jürg Sulzer, Berlin: Jovis, 2009, pp. 32–39.

"Katharina Grosses Kunst in Rafael Moneos Laborgebäude," in: Ulrike Jehle-Schulte Strathaus (ed.), *Novartis Campus—Fabrikstrasse 14, José Rafael Moneo*, Basel: Christoph Merian, 2009, pp. 46–48 | "Katharina Grosse: Art in Rafael Moneo's Laboratory Building," English translation by Catherine Schelbert, pp. 49–51.

"Doppelleben," in: *Markus Gadient—Changes*, exh. cat Tony Wuethrich Galerie, November 17, 2009–January 31, 2010, Nuremberg: Verlag für moderne Kunst, 2009, pp. 7–12 | "Double Life," English translation by Steven Lindberg, pp. 14–18.

"Foreword," in: *Utopics: Systems and Landmarks*, ed. by Simon Lamunière, English translation by Judith Hayward, Zurich: JRP, 2009, p. 13.
▶ 11. Schweizerische Plastikausstellung in Biel

"Vermessungen im Unmessbaren," in: *Max Matter: Werke 1967–2009*, exh. cat. Kunstmuseum Solothurn, November 28, 2008–February 21, 2009, Nuremberg: Verlag für moderne Kunst, 2009, pp. 111–13.

"Kunst von Silvia Bächli und Lutz & Guggisberg im Square 3," in: *Novartis Campus—Square 3, Fumihiko Maki*, ed. by Ulrike Jehle-Schulte Strathaus, Basel: Christoph Merian, 2010, pp. 56–58 | "Art by Silvia Bächli and Lutz & Guggisberg in Square 3," English translation by Catherine Schelbert, pp. 59–61.

"Laurie Andersons Projekt einer Sound Sculpture auf dem Green," in: *Novartis Campus—Fabrikstrasse 15, Frank O. Gehry*, ed. by Ulrike Jehle-Schulte Strathaus, Basel: Christoph Merian, 2010, pp. 92–93 | "Laurie Anderson's 'Project for a Sound Sculpture on the Green,'" English translation by Catherine Schelbert, pp. 94–95.

"Preface Jacqueline Burckhardt," in: *Internal necessity: a reader tracing the inner logics of the contemporary art field*, Sommerakademie

im Zentrum Paul Klee, Bern, ed. by Tirdad Zolghadr, Berlin: Sternberg Press, 2010, English translation by Catherine Schelbert, pp. 3–7.

"Laurie Andersons 'Dal Vivo' oder Die virtuelle Flucht aus dem Gefängnis," in: *Art History on the Move: Hommage an Kurt W. Forster*, ed. by Nanni Baltzer, Jacqueline Burckhardt, Marie-Theres Stauffer, Philip Ursprung, Zurich: diaphanes, 2010, pp. 91–97.

"Illuminationen," with Bice Curiger, in: *Sigmar Polke: Fenster/Windows Grossmünster Zürich*, pp. 46–63, Zurich: Parkett Publishers and Grossmünster | "Illuminations," English translation by Catherine Schelbert, 2010, pp. 64–75.

SEE P. 374 IN THIS BOOK

"In-Between-Pieces auf dem Novartis Campus," in: *Eva Schlegel: In Between*, ed. by Peter Noever, exh. cat. MAK–Museum of Applied Arts, Vienna, December 8, 2010–May 1, 2011, Nuremberg: Verlag für moderne Kunst/Vienna: MAK, 2010, p. 68 | "In Between Pieces," English translation by Catherine Schelbert, pp. 76–78.

"Kunstmuseum Liechtenstein—ein Scharnier," in: *Der offene Blick: 10 Jahre Kunstmuseum Liechtenstein*, ed. by Friedemann Malsch, Bern: Benteli, 2010, p. 44.

"'In arts it is repose to life—e filo teso per siti strain' (Primo Levi). Alighiero e Boetti in der Press Art Sammlung," in: *Press Art: Die Sammlung Annette und Peter Nobel*, ed. by Christoph Doswald, exh. cat. Kunstmuseum St. Gallen, January 30–June 20, 2010; Museum der Moderne, Salzburg, July 3–October 24, 2010, Bern: Stämpfli, 2010, pp. 50–55.

"Mona Hatoums Silberstreifen," in: *Parkett* no. 89, 2011, pp. 245–49 | "Mona Hatoum's Silver Lining," English translation by Catherine Schelbert, pp. 250–52.

"**'Tismemskiblo', El Anatsuis Wall Sculpture,**" in: ***Novartis Campus—Fabrikstrasse 28, Tadao Ando,*** **ed. by Ulrike Jehle-Schulte Strathaus, Basel: Christoph Merian, 2011, pp. 58–61 | "'Tismemskiblo,' El Anatsui's Wall Sculpture," Englsh translation by Ishbel Flett, pp. 63–65.**

SEE P. 366 IN THIS BOOK

"Von hohen, tiefen und weiten Horizonten," in: *Beispiel Schweiz: Entgrenzungen und Passagen als Kunst*, ed. by Roman Kurzmeyer and Friedemann Malsch, exh. cat. Kunstmuseum Liechtenstein, September 30, 2011–January 15, 2012, Ostfildern: Hatje Cantz, 2011, pp. 202–10.

"Staging Knowledge: Eine Wissensoper," Conversation with Herbert Lachmayer, in: *Parkett* no. 88, 2011, pp. 196–202 | "Staging an Opera of Knowledge," English translation by Ishbel Flett, pp. 202–07.

"'The Basel Columns' von Pedro Cabrita Reis," in: *Novartis Campus—Physic Garden 3, Souto de Moura*, ed. by Ulrike Jehle-Schulte Strathaus, Basel: Christoph Merian, 2012, pp. 17–19 | "The Basel Columns by Pedro Cabrita Reis," English translation by Catherine Schelbert, pp. 20–22.

"'Meret Oppenheim: Die Schamanin': Zum 100. Geburtstag von Meret Oppenheim," in: *Emma*, issue 5, September/October 2013, pp. 88–94.

"Schmuck macht hier nicht Leute," in: *Otto Künzli—Das Buch*, ed. by Florian Hufnagel, Stuttgart: arnoldsche Art Publishers, 2013, pp. 64–69.

"Architettura e arte: prospettive di un reincontro rischioso," in: *Discorsi d'attualità: Dal "postmoderno" ai nuovi orizzonti della cultura*, ed. by Christoph Riedweg, Italian translation by Roberta Gado, pp. 181–208, Rom: Carocci editori, 2013 | German edition: "Architektur und Kunst: Chancen einer riskanten Wiederbegegnung," in: *Nach der Postmoderne: Aktuelle Debatten zu Kunst, Philosophie und Gesellschaft*, ed. by Christoph Riedweg, Basel: Schwabe reflexe, 2014, pp. 213–47.

"Lapidar," with Bice Curiger, in: *Eva Afhus: Windwürfel. Das künstlerische Werk*, ed. by Marcel Meili, Martin Heller, Frank Zierau, Zurich: Scheidegger & Spiess, 2014, pp. 60–67.

"In der Bergwelt," in: *Das Engadin als Inspiration*, in: *DU—das Kulturmagazin*, no. 846, 2014, p. 67. ▶ Hans Danuser, Nina von Albertini

"In Pursuit of Unlimited Hospitality," in: Donatella Bernardi & Jacqueline Burckhardt, *In Pursuit of Unlimited Hospitality | À la poursuite d'une hospitalité illimitée*, English translation by Catherine Schelbert pp. 9–33 | "À la poursuite d'une hospitalité illimitée," French translation by Marie-Liesse Zambeaux and Donatella Bernardi, pp. 57–75; "Wege einer aufgeklärten Amateurin," pp. 89–92, Geneva: aparté, 2014.

"Walter Keller, Nachruf," in: *Altstadt Kurier* (Zurich), October 16, 2014, p. 4.

"Performance Record," in conversation with Roselee Goldberg, Bice Curiger, and Nikki Columbus, in: *Parkett* no. 94, 2014, pp. 6–17 | "Performance—eine Bestandsaufnahme," German translation by Suzanne Schmidt, pp. 18–29.

"Roboter," a conversation with Rolf Pfeifer, Suzanne Zahnd, Bice Curiger, and Mark Welzel, in: *Parkett* no. 95, 2014, pp. 190–200 | "Robots," English translation by Catherine Schelbert, pp. 201–11.

"Kunst in der Kirche—Ein Plädoyer für einen Iconic Turn," in: *Kunstbulletin*, no. 9, 2014, pp. 30–37. ▶ Sigmar Polke, Bruno Jakob, Mario Sala.

"Visite d'atelier chez Guillaume Bruère (GIOM)," in: *Guillaume Bruère: François I er illimité*, exh. cat. Château de Chambord, April 12–August 30, 2015, French translation by Sabine Macher, pp. 9–33 | "Visiting with GIOM," English translation by Catherine Schelbert, pp. 9–33.

"Pipilotti Rists 'Amorpher Farbenregen,'" in: *Novartis Campus—Virchow 16, Rahul Mehrotra*, ed. by Ulrike Jehle-Schulte Strathaus, Basel: Christoph Merian, 2015, pp. 66–68 | "Pipilotti Rist's 'Amorphous Color Rain,'" English translation by Catherine Schelbert, pp. 69–71.

"Olafur Eliassons 'Oscillation Bench,'" in: *Novartis Campus—Asklepios 8, Herzog & de Meuron*, ed. by Ulrike Jehle-Schulte Strathaus, Basel: Christoph Merian, 2015, pp. 16–18 | "Olafur Eliasson's 'Oscillation Bench,'" English translation by Catherine Schelbert, pp. 19–21.

"'Muschel (Hellgrün)' von Katharina Fritsch," pp. 82–84 |

"'Shell (Light Green)' by Katharina Fritsch," in: *Novartis Campus—Asklepios 8, Herzog & de Meuron*, ed. by Ulrike Jehle-Schulte Strathaus, Basel: Christoph Merian, 2015, pp. 16–18, English translation by Catherine Schelbert, pp. 85–87.

"'What is the city but the people' (Shakespeare, Coriolan)," in: *Female Chic*, ed. by Gina Bucher, Zurich: Edition Patrick Frey, 2015, pp. 217–28.
▶ Thema Selection, Sissi Zöbeli, Susan Wyss.

"Netzwerk der Akteure," Foreword, in: *Art Inspires at EY Zurich*, Zurich: Ernst & Young AG, 2016, p. 8 | "From Artwork to Network," Foreword, p. 9; "Ernesto Netos 'Bridal Knots,'" pp. 18–31 | "Ernesto Neto's 'Bridal Knots,'" pp. 19–31; "Von animierten Tapeten und sprechenden Vorhängen," with Renata Burckhardt, pp. 50–59 | "Animated Wallpaper and Eloquent Curtains," pp. 51–59.

**"Koschkarows Smearings," pp. 60–69 | "Koschkarow's Smearings," pp. 61–69; "Parkett Editions: Weltkunst im Kleinformat," pp. 70–83 | "Heavyweight Art in Lightweight Format," pp. 71–83, all English translations by Catherine Schelbert.
SEE P. 358 IN THIS BOOK**

"Die dumme Blondine, der liebe Gott und das Klischee," in: *Dein Speichel ist mein Taucheranzug im Ozean des Schmerzes*, exh. cat. Kunsthaus Zürich, February 26–May 8, 2016, Cologne: Snoeck, 2016, n. p. ▶ Pipilotti Rist

"Wovon man nicht sprechen kann...," in: *Zita—Щара: Kammerstück von Katharina Fritsch und Alexej Koschkarow / Chamber Piece by Katharina Fritsch and Alexej Koschkarow*, ed. by Laurenz Foundation, exh. cat. Schaulager Basel, June 12–October 2, 2016, Basel: Schaulager, 2016, pp. 69–82 | "Whereof one cannot speak . . .," English translation by Catherine Schelbert, pp. 71–82.

"Und flugs war er auf und davon," in: *Uccelin—ein Werk fliegt aus* (*Hochparterre: Zeitschrift für Architektur und Design*, no. 29), 2016, p. 19.
▶ Hans Danuser

"Fondation Nestlé pour l'Art 1991–2016," ed. by Fondation Nestlé pour l'Art, Lucerne: Edizioni Periferia, 2016, p. 68 | French translation by Monika Korycinska, p. 34 | English translation by Stefan Schaller, p. 102.

"hundert one hundred & 101," editorial, with Bice Curiger and Dieter von Graffenried, in: *Parkett* no. 100/101, 2017, pp. 6–40, English translation by Catherine Schelbert, pp. 6–40; "Das Berlin Gespräch," conversation with Diedrich Diedrichsen, Jörg Heiser, Olaf Nicolai, Susanne Pfeffer, Steffen Zillig, Bice Curiger, and Mark Welzel, pp. 64–75 | "Berlin Round Table," English translation by Ishbel Flett, pp. 76–87; "Trix Wetter im Gespräch mit Jacqueline Burckhardt," pp. 134–37 | "Trix Wetter in Conversation with Jacqueline Burckhardt," English translation by Catherine Schelbert, pp. 138–41; "Hanna Williamson-Koller und Simone Eggstein im Gespräch mit Jacqueline Burckhardt," pp. 142–45 | "Hanna Williamson-Koller and Simone Eggstein in Conversation with

Jacqueline Burckhardt," English translation by Catherine Schelbert, pp. 146–49; "Die Welt als Figur," conversation with Katharina Fritsch, pp. 215–26 | "Atmosphere becomes Form," English translation by Catherine Schelbert, pp. 227–33.

"A productive Pipe Dream," in: Florian Dombois (ed.), *The Wind Tunnel Model—Transdisciplinary Encounters*, English translation by Burke Barrett, Zurich: Scheidegger & Spiess, 2017, pp. 75–83.

"Bio-Graphie," in: *L'Automne du paradis / The Autumn of Paradise* (French/English), ed. by Bice Curiger and Fondation Vincent van Gogh, exh. cat. Fondation Vincent van Gogh, Arles, November 17, 2018–February 10, 2019, French translation by Marie-Claire Massias, pp. 26–41 | "Bio-Graphy," English translation by Catherine Schelbert, pp. 26–41.

German/English edition: "Bio-Graphie," in: *Herbst im Paradies / The Autumn of Paradise*, ed. by Bice Curiger and Fondation Vincent van Gogh, exh. cat. Aargauer Kunsthaus Aarau, May 18–August 11, 2019; Kestner Gesellschaft Hannover, March 6–10, 2020, Berlin: Hatje Cantz, 2018, pp. 26–41 | "Bio-Graphy," English translation by Catherine Schelbert, pp. 26–41.
SEE P. 328 IN THIS BOOK

"Die Energie der fragilen Balance," in: *Anna Winteler: Ligne, Linie, Line*, ed. by Ines Goldbach and Käthe Walser, exh. cat. Kunsthaus Baselland, January 25–April 28, 2019, Muttenz, Vienna: Verlag für moderne Kunst, 2019, pp. 21–24 | "The Inherent Energy of a Delicate Balance," English translation by Aoife Rosenmeyer, pp. 21–24.

"Foreword," in: *Der grüne Henry: Ein Kunstparcours durch Gottfried Kellers Zürich*, ed. by Angelika Affentranger-Kirchrath, St. Gallen: Vexer, 2019, pp. 5–7.

"'Sip My Ocean,'" in: *Pipilotti Rist: Open My Glade*, exh. cat. Louisiana Museum of Modern Art Humlebaek, March 1–June 23, 2019, English translation by Catherine Schelbert, pp. 46–56.
Danish edition: "'Sip My Ocean,'" in: *Pipilotti Rist: Åbn min lysning*, exh. cat. Louisiana Museum of Modern Art Humlebaek, March 1–June 23, 2019, Danish translation by Thomas Harder, pp. 46–56.
SEE P. 278 IN THIS BOOK

"O wie Oppenheim: Porträt einer poetischen Künstlerin," in: *Meret Oppenheim* (*Quarto Nr. 48, Zeitschrift des Schweizerischen Literaturarchivs*), 2020, pp. 13–21.
SEE P. 252 IN THIS BOOK

"Das Gewicht der Leere am hellichten Tag," in: *Plötzlich diese Leere*, ed. by Adrian Krüsi, St. Gallen: Verlagsgenossenschaft, 2021, pp. 40–41.
▸ on the Covid period

"The Octopus's Strategy," in: *Katharina Fritsch*, exh. cat. The George Economou Collection, Athens, June 2022, English translation by Catherine Schelbert, pp. 29–44.
SEE P. 340 IN THIS BOOK

"Hinter der Brillenmaske," in: *Walter Grab (1927–1989): Werkkatalog*, ed. by Julia Schallberger, André Grab, Christoph Kappeler, Zurich: Edition Patrick Frey, 2022, pp. 242–43.

"Orlando," in: *Klodin Erb—A different kind of Furs*, ed. by Gioia Del Molin, Sabina Kohler, Ilaria Bombelli, exh. cat. Istituto Svizzero Rome, March 24–July 16, 2023, Rome, Milan: Istituto Svizzero Rome, Mousse Publishing, 2023, English translation by Alisa Kotmair, pp. 99–100.

"A Model is A Model is A Model is," in: *Lang/Baumann, 95 Modelle*, ed. by Lilia und David Glanzmann, exh. cat. Zeughaus Teufen, July 1–October 1, 2023, Zurich: Scheidegger & Spiess AG, 2023, English translation by Catherine Schelbert, pp. 111–15.

"Mona Hatoum: Apokalypse und Silberstreifen," in: *Stellung beziehen: Käthe Kollwitz mit Interventionen von Mona Hatoum*, exh. cat. Kunsthaus Zürich, August 18–November 12, 2023; Kunsthalle Bielefeld, March 23–June 16, 2024, Munich: Hirmer Verlag, 2023, pp. 208–21.

"Mona Hatoum: Apocalypse and Silver Lining," in: *Taking a Stand: Käthe Kollwitz, with Interventions by Mona Hatoum*, exh. cat. Kunsthaus Zürich, August 18–November 12, 2023, Kunsthalle Bielefeld; March 23–June 16, 2024, Munich: Hirmer Verlag, 2023, English translation by Gérard Goodrow pp. 208–21.
SEE P. 296 IN THIS BOOK

SPEECHES AND LECTURES (SELECTION)

"Colloque mémoire courte, mémoire longue: Parkett pas une revue d'actualité?," AICA, Rennes, FR, August 27, 1996.

"Abschiedsfeier für Kurt Forster im SIK," Swiss Institute for Art Research (SIK-ISEA), Zurich, January 10, 1999.

"Ingeborg Lüscher, Manuale," book vernissage at Kunstgriff, Zurich, January 28, 2000.

Opening speech on site-specific art at the headquarters of Winterthur Versicherungen, Winterthur, April 14, 2000.
▸ John Armleder, Daniele Buetti, Angela Bulloch, Silvie Defraoui, Sylvie Fleury, Alex Hanimann, Claudia and Julia Müller, Bessie Nager, Izhar Patkin, Relax, Franz West

"Shooting Stars," speech at the colloquium *Neue Wege zu Kreativität und Innovation* at Toni Schönenberger's program Art Forum, UBS Center for Education and Dialogue at Wolfsberg, Ermatingen, April 5, 2004.

"Zur Liechtensteiner Alighiero e Boetti-Ausstellung," Kunstmuseum Liechtenstein, Vaduz, March 6, 2005.

"Warum Kunst auf dem Novartis Campus?," Novartis Campus, November 8, 2007.

"Kunst im Alltag—Alltagskunst," University of Zurich, art history seminar by Barbara von Orelli, May 1, 2010.

"Schliessen Sie mir das Kleid, danke," speech at the opening of the exhibition *Sommergäste zum 20-jährigen Jubiläum Museum Langmatt*, Museum Langmatt, Baden, May 7, 2010.
▸ Pipilotti Rist

Laudatory speech for the artist Klaudia Schifferle on the occasion of the awarding of the Kunstpreis der Stadt Zürich 2012, presented on December 10, 2012, at Moods, Zurich. ▸ Klaudia Schifferle

"Blackboard—White Page," speech at the closing event of the exhibition *Blackboard—White Page*, Kantonsschule Zürich Nord, curated by Maud Châtelet and Ana Roldan, March 11, 2014.

Lautatory speech for the artists Pipilotti Rist on the occasion of the Prix Meret Oppenheim 2014, October 28, 2014, Schiffbau, Zurich.

Laudatory speech for Maja Hoffmann on the occasion of the Prix Montblanc 2015, presented with Bice Curiger on June 18, 2015, Kunsthalle Basel.

Laudatory speech for the art collectors Ruedi and Thomas Bechtler on the occasion of the awarding of the Kunstpreis der Stadt Uster 2016, November 12, 2016, Zellweger Park, Uster.

Laudatory speech for the art historian Philip Ursprung on the occasion of the Prix Meret Oppenheim 2017, June 12, 2017, Messe Basel.

Laudatory speech for artisan foundryman Felix Lehner on the occasion of the awarding of the Kulturpreis der Stadt St. Gallen, 2018, November 17, 2018, Tonhalle, St. Gallen.

INTERVIEWS WITH JACQUELINE BURCKHARDT

Monica Glisenti and Brigitte Ulmer, "'Gutes Sponsoring ist nie vulgär': Kunstexpertin Jacqueline Burckhardt zur immer wichtigeren Rolle der Wirtschaft im Kulturbereich," in: *Cash*, no. 10, March 8, 1996, pp. 57–59.

Stefan Banz, "Am hellichten Tag," interview with Bice Curiger and Jacqueline Burckhardt, in: *Artis*, no. 10, 1997, pp. 28–33.

Beat Hug, "Aus einer flauen Idee lässt sich kein Kunstwerk machen," interview with Jacqueline Burckhardt, in: *Moneta*, no. 2, June 23, 2003, pp. 8–9.

Christan Schiess, "De l'avis de Jacqueline Burckhardt, présidente de la Commission fédérale des beaux-arts," in: *L'Emilie: magazine socioculturelles*, no. 92, 2004, 1488, p. 15.

Juri Steiner, "Wir müssen stolz sein können," (cultural criticism), interview with Jacqueline Burckhardt, in: *Die Weltwoche*, December 21, 2005.

Barbara Basting, "Der Bund muss sich zur Kultur bekennen," interview with Jacqueline Burckhardt, in: *Tages-Anzeiger*, December 21, 2006.

Maya Naef, "Kunst ist eine Forderung," interview with Jacqueline Burckhardt and Hans Rudolf Reust, in: *Kunstbulletin*, no. 5, 2007, pp. 74–78.

Fabian Schöneich, "Jacqueline Burckhardt," in: *Oral History Archiv*, www.oralhistoryarchiv.ch/interviews/person/jacqueline-burckhardt, May 7, 2008.

Thomas Hämmerli, "Künstler sind oft schwierig," interview with Jacqueline Burckhardt and

Bice Curiger, in: *Westnetz.ch*, online magazine, February 22, 2014.

Christian Maurer, "Kunst per Definition," interview with Jacqueline Burckhardt, in: *SonntagsBlick Magazin*, November 20, 2016, pp. 6–7.

Ewa Hess, "'Parkett & Beyond,' Tages-Anzeiger-Podium mit Jacqueline Burckhardt," Kunst Zürich, Oerlikon, November 3, 2016, online: https://www.youtube.com/watch?v=wp2B5vC1oJ4.

Michael J. Agovino, "A Universe of Print: Inside the Last Days of Parkett," interview with Jacqueline Burckhardt, Bice Curiger, and Dieter von Graffenried, in: *The Village Voice*, August 29, 2017.

Oscar Tuazon and Dorothée Perret, "Time, Context, Object—The Parkett Story, Bice Curiger and Jacqueline Burckhardt in conversation with Oscar Tuazon and Dorothée Perret," in: *Paris LA*, DoPe Press, a press for artists, Paris, 2018, pp. 54–61.

Finn Canonica and David Iselin, "Renaissancefrau," Interview mit Jacqueline Burckhardt, in: *Das Magazin*, no. 9, 2019, cover and pp. 6–13.

ARTICLES ON JACQUELINE BURCKHARDT

Susanne von Meiss, "I collezionisti: Gli eroi dei due mondi," in: *AD* (rivista internazionale di arredamento, design, architettura), no. 239, April 2001, pp. 240–47.

Brigitte Ulmer, "Was kommt? Was geht? Bilder, die sich in den Köpfen der Opinion-Leaders festsetzen," in: *Bolero*, June 2002, p. 140.

Brigitte Ulmer, "Das Kunst-Monopoly: Jacqueline Burckhardt," in: *Bolero*, June 2004, p. 23.

Jacqueline Falk, Mercedes Matas, Sabine Sarwa, "Kunst Macht Mäzen: Kunstmäzene in der Schweiz," University of Basel, Master' Program in Cultural Management, 2003–05, unpublished master's thesis supervised by Hans Ulrich Glarner, 2007, pp. 85–89.

Rosa Tessa, "La Casa affettiva— è per sempre—della critica e storica dell'arte Jacqueline Burckhardt: A Zurigo," in: *Casa da abitare*, June 2012, pp. 110–17 | "The (definitive) home of affection of art critic and historian Jacqueline Burckhardt: In Zurich," English translation, p. 174.

Mireille Descombes, "Jacqueline Burckhardt: la passion du sens," in: *Le Phare*, no. 10, 2012, pp. 26–27.

Chiara Savino, "Residenza d'arte a Zurigo," in: *La biblioteca dell'Interior design*, Sole 24 ore, Milan 2013, pp. 34–48.

Meike Winnemuth, "Wer wohnt denn da?," in: *A & W (Architektur und Wohnen)*, no. 6, 2016, pp. 98–102.

INDEX

People, gods, prophets, animals, plants, artists collectives, bands, companies, institutions, places, countries, magazines, publications, terms...

Unmarked numbers refer to the conversation, gray to the illustrations, and bold to the Intermezzo and the texts.

Abbt, Theres, 10, 11, 202, 204, 394–95
Abraham and Isaac, 377, 380, 385–86
Abt, Otto, 267
Académie de la Grande Chaumière, Paris, 259
Academy of Applied Art, Basel, 266
Acker, Kathy, 168, 200
Admiral Nelson, 141, 345
Adnan, Etel, 297
Al-Khidr, Islamic saint, 389
Alberti, Leon Battista, 40, 49, 147
Albright, Madeleine, 175
Aleramo, Sibilla aka Rina Faccio, 9, 165, 167
Ammann, Jean-Christophe, 38, 91–93, 94, 95, 143, 160, 164, 172, 292
Ammann, Judith, 94, 292
Ammann, Thomas, 72, 73, 172
Amoore, Jeanne, 68
Anatsui, El, 57, **366–73**
Anderson, Laurie, 8–10, 11–12, 23, 48, 57, 80, 130, 132, 134, 136, 138, 140, 164, 166, 188, 190, 192, 198–99, 206, 228, **232–41**, **284–95**, 393
Ando, Tadao, 227, 367, 369–70, 372–73
Andre, Carl, 302
Andreasi, Ippolito, 28, 29, 31, 44, 218
Angelus Novus, work by ▶ Klee, Paul
Appartamento di Troia, Palazzo Ducale, Mantua, 31

Ararat, Mount Ararat, volcano in Turkey, 290
Arcangel, Cory, 113
Accademia di architettura, Mendrisio, 7, 124, 393
Archivio di Stato, Mantua, 40
Aretino, Pietro, 35, 214
Argan, Giulio Carlo, 17
Armitage, Karole, 317
Armleder, John M., 79, 127
Arnett, Peter, 294
Arp, Hans, 258
Art Basel, 160
Art in America, art magazine, 43
Artaud, Antonin, 389
Artforum, art magazine, 43, 290
Artschwager, Richard, 162, 254, 279
Auden, W.H., 313
Augusta Raurica, Roman settlement in CH, 105
Bächli, Silvia, 57
Bachmann, Ingeborg, 165
Baghdad, 294
Banz, Stefan, 127
Bärfuss, Lukas, 151
Basaiti, Marco, 69
Basel Academy of Art and Design, 135, 136
Basilica di San Francesco in Assisi ▶ St. Francis, Francis of Assisi
Basquiat, Jean-Michel, 168, 171
Bataille, Georges, 302
Baumann, Felix, 38
Bechtler, Cristina and Thomas, 83
Bee Opera, work by ▶ Regli, Peter
Beijing, 81, 181
Belluzzi, Amedeo, 38
Benjamin, Walter, 22–23
Berlin, 81, 225, 253, 256, 298, 303, 360, 393–94
Bern Kantonalbank, 114
Beuys, Joseph, 78, 92–93, 94–95, 129, 159, 162, 194, 279, 349
Biblioteca Hertziana, Rome, 40
Biden, Joe, 185
Biennale di Venezia, 82, 83, 113, 127, 140, 160, 164, 181, 187, 232, 290, 346, 350, 393–94

Bill, Max, 43
Billeter, Erika, 77
Bishop of Nola, Paulinus, 389
Black, Hannah, 183
Blum, Peter, 70, 74
Böcklin, Arnold, 268
Bodmer, Walter, 267
Boetti, Alighiero e, 72
Bonvicini, Monica, 163
Bopape, Dineo Seshee, 113
Borgnini, Maria Pia, 127
Borrelli, Licia Vlad, 165, 167
Borromini, Francesco, 153
Boschetti, Isabella, 34, 46
Botfly, 105, 223
Botticelli, Sandro, 381
Bowie, David, 164, 269
Bowles, Paul, 109
Brandi, Cesare, 16–17, 20, 22, 149, 160, 186
Braque, Georges, 109
Brassel, Martina, 9, 12
Breitz, Candice, 114
Breton, André, 255, 258–59, 263–64
British Museum, London, 36, 368
Brock, Bazon, 91
Bronson, AA, member of the artist collective ▶ General Idea
Brook, Peter, 183
Brooklyn, 81, 320, 360, 361, 363, 364
Bruguera, Tania, 114
Bruhin, Anton, 77
Brünig, steamship, 352
Brunner, Hannes, 156, 158
Brunner, This, 72, 73, 86, 87, 171
Brussels, 81, 252
Bucarelli, Palma, 38, 165, 167
Buchmüller, Albert, 58
Buddha, 388
Bühler, Annette, 83
Burckhardt-Gansser, Jakob Karl, Jacqueline's father, 103–04, 106, 109
Burckhardt-Gansser, Lucie, Jacqueline's mother, 103–04, 109, 110, 202
Burckhardt-Koechlin, Elisabeth, Jacqueline's paternal grandmother, 109, 110
Burckhardt, Carl Jacob, 109

Burckhardt, Jacob, 102, 107, 108, 212, 215
Burckhardt, Johann Ludwig aka Sheik Ibrahim, 104, 106, 107
Burckhardt, Michael aka Muck, Jacqueline's brother, 103, 105, 111, 202
Burckhardt, Renata, 12
Burckhardt, Rudy, 109, 111, 323
Bürgi, Christoph, 269
Bürgi, Dominique, 253
Bürgi, Mendes, 127
Burns, Howard, 38
Burroughs, William S., 199, 287
Cage, John, 52
Cahn, Walter, 383
Caillois, Roger, 378
Callas, Maria, 64
Campbell, Crystal Z, 113
Canova, Antonio, 352
Cappadocia, Turkey, 63, 66
Captain Nemo, 353
Cara, Marchetto, 52
Caracalla, Roman emporer, 389
Carmine, Giovanni, 114, 127
Carona, Ticino, 167, 168, 254, 271
Casa Mantegna, Mantua, 51
Cassano, Rita, 68
Castelli, Luciano, 164
Castiglione, Baldassare, 46–47
Cattelan, Maurizio, 83
CBGB, Club in New York, 171
Celant, Germano, 191
Celentano, Adriano, 77
Centre d'art contemporain, Geneva, 38
Centre Georges Pompidou, Paris, 81, 183, 302, 312
Cézanne, Paul, 314
Chambellan, Rene Paul, 363, 364
Chemin, Philippe, 307
Chihuahua, Texas Plateau, 333
Chiomento, Bruno, 55, 56
Chipperfield, David, 227
Chopin, Frédéric, 348
Christ, 30, 97, 155, 376, 383, 384, 387
Christina of Sweden, 225
Chronos, Greek god, 324, 337
Ciba-Geigy, Basel, 54
Cimabue, 20, 21

Cincera, Ernst, 71
Cinquecento, the 16th century, 30, 62
Clabaut, Eustache, 330
Clara, the weather frog, 105
Clark, Larry, 174
Clemente, Francesco, 72, 151, 171, 173
Clothes Make People, novella by Gottfried Keller, 122
College of Art of the University of Science and Technology, Kumasi, Ghana, 368
Columbia University, 286, 394
Columbus, Nikki, 162
Common linnet (Linaria cannabina), bird, 331
Coney Island, New York, 289
Conti, Cinzia, 68
Corgnati, Martina, 259, 265
Corona or Covid, 11, 85, 148, 174–75, 287
Cortile della Cavallerizza, Palazzo Ducale, Mantua, 27, 51
Couchepin, Pascal, 127
Count Strapinski, Wenzel, 122
Courmes, Alfred, 312
Crevel, René, 265
Cucchi, Enzo, 92, 93–95, 151, 156
Cunningham, Merce, 318
Curiger, Bice, 12, 48, 70–72, 73, 74, 76, 77, 79, 80, 82, 86, 87, 94, 96, 126, 154, 156, 157, 159, 160, 162, 163, 166, 168, 169, 172, 179, 191, 224, 225, 253, 254, 307, 376
Czech Republic, 78
D'Annunzio, Gabriele, 48, 52, 307, 310, 312, 315
D'Este, Isabella, 11, 27, 33, 40, 49, 54, 87, 198, 214–16, 225, 229
da Sangallo, Antonio, 24
Dada, Dadaists, 195, 200, 394
Dafoe, William, 168
Dalí, Salvador, 258
Damas, Nicolas, 169
Dante Alighieri, 197
Darboven, Hanne, 78
David (Michelangelo), 39
de Chirico, Giorgio, 351
de Groat, Andrew, 318
de Kooning, Willem, 109

De Santis, Giuseppe, 165
De Sica, Vittorio, 165, 167
DeAk, Edit, 168, 170, 171
Dean, Laura, 318
Debussy, Claude, 48, 49, 307, 310, 314, 315
Defraoui, Silvie, 97, 127
Deliss, Clémentine, 116, 117
Demand, Thomas, 342
Denard, Michael, 307, 312, 315
Denby, Edwin, 111, 323
Der Alltag, Sensationsblatt des Gewöhnlichen, 84
Dia Art Foundation, New York, 159, 162, 343
Diener, Roger, 227
Dirk's Pod, sculpture by Richard Serra, 367, 372, 373
Disler, Martin, 72, 73, 77, 292
Djordjadze, Thea, 113
documenta, 113, 160, 253
Domus, architectural magazine, 43
Dreifuss, Ruth, 127
"Dual historical nature" (Cesare Brandi), 8, 17, 19, 20, 22, 23, 149
Duchamp, Marcel, 258
Dupond, Patrick, 307
Eggstein, Simone, 12
Ein Gespräch—Una discussione, publication, 93
Eliasson, Olafur, 57, 87, 97, 101
Éluard, Paul, 258
Emperor Charlemagne, 385
Emperor Charles V, 43, 146
Emperor Diocletian, 307, 310, 313
Emperor Titus, 25, 27
Empress Catherine the Great, 152
Enwezor, Okwui, 114, 115
Ernaux, Annie, 202, 204
Ernst & Young, today EY, auditing company, 55, 56, **358–65**
Ernst, Alwin C., 365
Ernst, Max, 153, 258, 261, 265, 269, 353, 359
Etter, Olivia, 72, 77
Evans, Cerith Wyn, 57, 122
Ewe people, a West African ethnic group, 370

407

Expo.01, was pushed back a year to become Expo.02, Swiss National Exhibition, 2002, 128–30, 131, 132, 133, 134–39, 165, 239, 394
Fässler, Beatrice, 163
Federal Art Commission (EKK), 7, 125, 127, 128, 393
Federal Office of Culture (FOC), Bern, 127
Federle, Helmut, 169
Feilchenfeldt-Breslauer, Marianne, 168
Felderer, Brigitte, 122
Fellini, Federico, 165
Fenley, Molissa, 317
Ferino Pagden, Silvia, 38
Feyerabend, Paul, 159
Fiedler, Andreas, 114
Fini, Leonor, 258
Fischer, Beat, 119
Fischer, Konrad, 78
Fischer, Mirjam, 10, 11, 202, 204, 395
Fischer, Peter, 114
Fischl, Eric, 151
Fischli, Peter ▶ Peter Fischli & David Weiss
Fletcher, Alan, 55
Fleury, Sylvie, 79
Fogal, legwear shop, 178
Fondation Nestlé pour l'Art, 55
Fondation Vincent van Gogh, Arles, 53
Fondazione Prada, Milan, 191, 192, 193
Fontana, Domenico, 153
Forster, Kurt W., 9, 10, 11, 30, 31, 32, 38, 52, 119, 126, 198, 206, **212–17**, 218, **223–29**, 230–31, 393
Fotomuseum Winterthur, 84
Foucault, Michel, 302
Foundation TBA21, 54
Freie Sicht aufs Mittelmeer, exhibition, 79
Freund, Gisèle, 40
Frey, Patrick, 9, 12, 72, 74, 198, 395
Fritsch, Katharina, 9, 10, 11, 48, 57, 140, 153, 154, 180, 198, 206, **246–50, 340–57**, 360, 393–94
Frommel, Christoph Luitpold, 38, 41
Fuchs, Rudi, 253
Gaetani, Mollica, 68
Galip, potter in Avanos, 67
Galleria Nazionale d'Arte Moderna, Rome, 38, 165
Gallery Bruno Bischofberger, 78
Gallery Gimpel & Hanover, 78
Gallery Jablonka Lühn, 360
Gallery Jeffrey Deitch, 169
Gallery Konrad Fischer, 78
Gallery Lelong, 78
Gallery Marguerite Schulthess, 265
Gallery Marlborough, 78
Gallery Paul Facchetti, 78
Gallery Stähli, 78
Gallery Stampa, 275, 277
Gallery Ziegler, 78
Gansser-Biaggi, Augusto, Jacqueline's uncle, 106
Gansser-Biaggi, Toti, Jacqueline's aunt, 106
Gansser-Burckhardt, August, Jacqueline's maternal grandfather, 103, 106
Gansser-Burckhardt, Lola, Jacqueline's maternal grandmother, 105
Garden of Eden, 290
Gazzola, Maria Pia, 68
Gehry, Frank, 83, 188, 227, 393
Gelitin, artist collective (Ali Janka, Wolfgang Gantner, Tobias Urban, Florian Reithner), 118, 122
General Idea, artist collective (AA Bronson, Felix Pratz, Jorge Zoltan), 171, 173
George, Stefan, 229
Gerster, Ulrich, 98
Getty Center for the History of Art and the Humanities, Los Angeles, today: Getty Research Institute, Los Angeles, 38, 39, 40
Ghana, 367, 368, 370
Giacometti, Alberto, 258
Giacometti, Augusto, 97, 376
Gigon/Guyer Architects, 359
Giotto, Giotto di Bondone, 153
Giulia, daughter of Emperor Titus, 27

Giulio, Giulio Pippi ▶ Romano, Giulio
Glas Mäder, glass manufacturer, 100, 375, 376
Glass, Philip, 318
Glissant, Édouard, 184
Gober, Robert, 88
Goethe, Johann Wolfgang, 25, 142, 216, 394
Goldin, Nan, 88, 172, 174
Goldoni, Carlo, 38, 195
Goldsmiths, University of London, 368
Goldstein, Malcolm, 320–21
Gombrich, Sir Ernst H., 9, 30, 38, 39, 91, 107, 206, 218–20, **221–22**
Gonzaga, Federico II, 27–28, 31–32, 33, 34, 35, 36, 43, 46, 49, 54, 87, 146, 212, 214–17
Gonzaga, Vicenzo I, 49
Gonzáles-Torres, Félix, 171, 279
Gordon, Peter, 168
Göreme, municipality in central Anatolia, Turkey, 63–64, 66, 67
Gorman, Amanda, 185
Graham, Dan, 57, 58
Gramaccini, Norberto, 114
Gray, Spalding, 168
Greenberg, Clement, 43
Gregory the Great, one of the four Latin Fathers of the Church, 389
Grosse, Katharina, 57, 97
Grossmünster in Zurich, 8, 84, 96–97, 98, 99, 100, 101, 225, 374–90
Gruppe 33, artist's group in Basel (1937–54), 267
Guebehi, Émile, 169
Guevara, Che, 385
Guggenheim Museum, New York, 159, 254
Guggenheim, Peggy, 261
Guggisberg, Anders
▶ Lutz & Guggisberg
Guillem, Sylvie, 48, 49, 307, 309, 310, 315
Gulf War, 234, 293–94
Guyer, Mike, 55, 56
Hanayagi, Suzushi, 308, 310
Hanimann, Alex, 127

Haring, Keith, 171
Harvard University, Boston, 287
Hasselblad camera, 330, 334
Hatoum, Mona, **296–305**
Hefti, Raphael, 185
Helbling, Lorenz, 181
Heliogabal; or The Crowned Anarchist, novel by Antonin Artaud, 389
Heller, Martin, 132
Henrichs, Benjamin, 308
Hephaestus, Greek god, 359, 361, 364
Herder, Johann Gottfried, 25
Hermaphrodite, Roman sculpture, 24, 25
Hermeneutic Wallpaper, concept by Herbert Lachmayer applied to the cover of this book, 11, 55, 56, 198
Hertz, music band, 77
Herzog & de Meuron, 227, 350, 393
Hesse, Hermann, 235, 256
Heusser, Regula, 72
Hiroshima, mon amour, film by Alain Resnais, 24
Hirschhorn, Thomas, 115, 122, 185, 187–88, 272
Hirst, Damian, 144–45
Hitler, Adolf, 260, 287
Hoberman, Perry, 292
Hoffmann, E. T. A., 341
Hoffmann, Maja, 54, 83
Hoffmann, Thilo, 296
Hofmann, Albert, 245
Holzer, Jenny, 171, 173
Honegger, Gottfried, 43
Höner, David, 119
Honert, Martin, 342
How, Winifred, 53
Huang, Hsin-Chien, 284, 295, 393
Hudson River, 288, 295
Huggler, Max, 160
Hugo, Victor, 381
Hujar, Peter, 172
Hultén, Pontus, 253
Hussein, Saddam, 294
Indiana, Robert, 171, 173
InK (Halle für internationale neue Kunst), Zurich, 77
INK Tree Editions, Uster, 335

International Center for Conservation Rome (ICCROM), 12, 63, 64
Ireland, 64, 393
Isaak, Chris, 279, 282
Istituto Centrale del Restauro (ICR), Rome, 7, 17, 20, 30, 63, 69, 165, 167, 212, 228, 393
Istituto Svizzero, Rome, 30
Italianità, 12, 62, 63, 70, 103
Italy, 8, 17, 43, 63, 78, 105, 223, 232, 253, 304, 393
Jarmulowsky, Sender, 362
Jarmulowsky's Bank, New York, 361, 362
Jauch, Ursula Pia, 41
Jelinek, Elfriede, 200
Jesus, 232, 234
Jouffroy, Alain, 271
Judd, Donald, 78, 302
Jung, Carl Gustav, 259, 270
Kahane, Patricia, 83
Kairos, Greek god, 8, 11, 198, 204, 205, 229, 322, 324, 326, 337
Kappeler, Peter, 114
Kaschnitz von Weinberg, Marie-Louise, 165
Katz, Ada, 323, 324
Katz, Alex, 111, **322–26**
Kaufmann, Elisabeth, 73
Keller, Gottfried, 122, 256
Keller, Pierre, 127
Keller, Walter, 70, 71, 74, 84, 85, 172, 224
Kelley, Mike, 88
Kerner, Justinus, 381
Kessler, Harry Graf, 126, 226
Kiefer, Anselm, 92, 93, 94
King David, 377, 380, 384
King Louis XVI, 382, 383
Kippenberger, Martin, 72, 279
Klee, Paul, 7, 22, 23, 24, 91, 116
Kneubühler, Peter, 151
Koechlin, Valerie, 110
Koerfer, Adrian, 83
Kongresshaus Zurich, 291
König, Kasper, 348
Koolhaas, Rem, 168
Koschkarow, Alexej, 57, 350, **358–65**, 394
Kounellis, Jannis, 78, 92, 93, 94, 151

Krischanitz, Adolf, 98, 227
Kruger, Barbara, 88
Kuhn, Hans Peter, 314
Küng, Birgit, 72
Kunstakademie Düsseldorf, 153, 154, 255, 342, 360, 376, 393
Kunsthalle Basel, 38, 92, 160, 174, 277, 394
Kunsthalle Bern, 160, 253
Kunsthalle Krems, 394
Kunsthalle Zürich, 78
Kunsthaus Zürich, 7, 8, 38, 77, 78, 79, 81, 86, 87, 96, 101, 275, 282, 287, 291, 294, 300, 360, 376, 388, 393, 394
Kunstmuseum Basel, 160
Kunstmuseum Bern, 271
Kunstmuseum Düsseldorf, 29
Kunstmuseum Luzern, 164
Kunz, Martin, 160
Kuwait, 294
La Roche, Käthi, 97, 377
La Roche, Wolfgang, 268
Lachmayer, Herbert, 9, 10, 11, 55, 56, 122–23, 194, 198, 206, **243–45**, 394
Ladyshave, music band, 77
Lambert, Claude, 98
Lampugnani, Vittorio Magnago, 55, 227
Lamunière, Simon, 127
Lang, Sabina, Sabina Lang & Daniel Baumann (L/B), 114
Laocoön, Roman sculpture, 24–25
Lautréamont aka Isidore Lucien Ducasse, 25
Lavater, Johann Caspar, 383
Laycock, Ross, 279
Leary, Timothy, 184
Lecter, Hannibal, 196
Lehner, Felix, 181
Lehulere, Kemang Wa, 113
Lenin, Wladimir Iljitsch, 175, 286
Leonardo, Leonardo da Vinci, 89, 381
Leonbruno, Lorenzo, 50
Les Reines Prochaines, music band, 276
Lessing, Gotthold Ephraim, 25
LeWitt, Sol, 302, 303

Liliput, music band, formerly
 Kleenex, 77
Lissitzky, El, 279
Liszt, Franz, 348
Lizard, Federico Gonzaga's
 personal emblem (heraldic
 emblem), 34, 49, 216–17
Loggia dei Marmi, Palazzo
 Ducale, Mantua, 27–28, 29, 31, 40,
 51, 107, 108, 212–14, 217, 218, 221
Lohse, Richard Paul, 43
Loren, Sophia, 9, 165, 167
Los Angeles, 38, 39, 40, 53, 73, 81,
 393, 394
Lucerne, Lake Lucerne, 141, 145,
 160, 181, 219, 352, 394
LUMA Fondation, Arles, 54, 83
Lüthi, Urs, 72, 73, 77, 164
Lutz & Guggisberg, Lutz, Andres
 & Guggisberg, Anders, 57
Lutz, Andres ▶ Lutz & Guggisberg
Lysippo, Greek sculptor, 337
Maar, Dora, 258, 263
Macron, Emmanuel, 174
Maderno, Carlo, 153
Magnani, Anna, 9, 165, 167
Magritte, René, 258, 301–02, 351
Maison de la Culture, Bobigny,
 Paris, 311
Maki, Fumihiko, 227
Malašauskas, Raimundas, 116
Maloo Lala, Kurt Maloo,
 music band, 77
Manet, Édouard, 264
Mangano, Silvana, 165, 167
Mann, Thomas, 313
Mantegna, Andrea, 48, 49, 51, 147,
 312
Mapplethorpe, Robert, 171, 174
Maraini, Dacia, 9, 165, 167
Marden, Brice, 72
Mario, innkeeper in Rome, 25
Märkli, Peter, 227
Marta, Karen, 162, 178
Marti, Andreas, 114
Massenet, Jules, 293
Matthiesen, Kai Damian, 9, 11, 198
Maucher, Helmut, 55
McCall, Anthony, 40
Medea, film by ▶ Pasolini,
 Pierre Paolo

Mehrotra, Rahul, 57, 227
Meier, Dieter, 77
Mercury, Greek god, 337, 359, 361,
 364
Merz, Mario, 78, 151, 175
Meyer-Thoss, Christiane, 259
Meyer, Franz, 160
Michelangelo, Michelangelo-
 Buonarotti, 24, 33, 39, 102, 107,
 132, 304, 362, 363
Migros Genossenschaftsbund, 77
Miller, Bebe, 321
Minotaure, Surrealist-oriented
 magazine, 262
Mnouchkine, Ariane, 183
Moderna Museet, Stockholm, 253
Modi, 16 erotic drawings
 by Giulio Romano, 35, 36, 37
Molière aka Jean-Baptiste
 Poquelin, 195
MoMA, Museum of Modern Art,
 New York, 22, 80, 81, 163, 168, 341
Moneo, Rafael, 227
Monteverdi, Claudio, 8, 49, 50, 51,
 52
Montezuma, Magdalena, 72
Mora, Laura, 20, 21, 30, 165, 167
Mosca, Barbara, 114
Moser, Claudio, 127
Mother's Ruin, music band, 77
Mozart, Wolfgang Amadeus,
 244, 394
Mudd Club, New York, 168
Mueller, Cookie, 172
Müller, Heiner, 311, 313, 315
Münch, Andreas, 127
Muschg, Adolf, 71
Musée d'Art Moderne de la Ville
 de Paris, 253
Museum Haus Konstruktiv,
 Zurich, 78
Museum Ludwig, Cologne, 81
Museum of Contemporary Art,
 Chicago, 394
Mussolini, Benito, 105, 287
Mustique, island in the Caribbean,
 232, 239
Mylayne, Jean-Luc, 152, **328–39**
Mylayne, Milène, **328–39**
Nägeli, Harald, 143
NASA, 294, 295

Navarro Baldeweg, Juan, 227
Needle-Park (Platzspitz), Zurich,
 75, 86
Neri, Louise, 162, 168
Nesbit, Molly, 187
Nestlé S.A., Vevey, 55
New Museum, New York, 278, 283,
 394
New Wave, 77, 170, 171, 317
Newark Airport, New Jersey,
 288
Nietzsche, Friedrich, 212, 216, 257
Nizon, Paul, 78
Noah's Ark, 290
Nobili, Jean-Claude, 114
Norway, 78
Novartis Campus, Basel,
 7, 8, 53–55, 58–60, 61, 96, 98–99,
 116, 188, 226–28, 239, 367, 368,
 371, 393
Novello, Giuseppe, 42
Nureyev, Rudolf, 48, 307
Nutcracker and the Mouse King,
 story by ▶ E.T.A. Hoffmann
O'Hara, Frank, 326
Oberhuber, Konrad, 38
Obrist, Hans Ulrich, 85, 184, 187
October Gallery, London, 368
Octopus, 11, 106, 180, 198, 349, 353,
 354
Oehlen, Albert, 72
Oeri, Maja, 54
Oppenheim, Alfons and Eva,
 Meret Oppenheim's parents,
 256
Oppenheim, Meret, 72, 126, 167, 168,
 201, **252–73**, 393
Orwell, George, 157
Ottagono, design & architecture
 magazine, 43
Ottinger, Ulrike, 72
Owens, Laura, 53
Paglia, Camille, 257
Paik, Nam June, 277
Palazzo Ducale, Mantua, 9, 27, 29,
 31, 40, 49, 50, 51, 52, 87, 229,
 230–31
Palazzo Remer, Venice, 82, 83
Palazzo Te, Mantua, 31, 32, 33, 34,
 37, 44, 45, 46, 57, 87, 146, 147, 213,
 216, 217

Parkett resp. *Parkett* archive,
- editions, - editors, - space,
8, 12, 38, 41, 43, 48, 49, 70, 71, 72,
74–76, 78, 80, 81, 82, 83, 84, 85, 86,
88, 92, 93, 111, 126, 149, 151, 156–57,
158, 160, 161–63, 168, 171–72, 173,
174, 177–78, 179, 180–81, 184, 200,
201, 204, 213, 215, 224, 226, 228,
240, 254, 272, 276, 289, 307, 323,
335, 346, 347, 376, 393, 394
Pasolini, Pier Paolo, 64, 165
Pavarotti, Luciano, 61
Penone, Giuseppe, 78
Performing Garage, 168
Perron, Wendy, 318
Perucchi, Ursula, 77
Peter Fischli & David Weiss, 72,
 77, 79, 175, 176, 203
Petra, ancient rock city in Jordan,
 104, 107
Petrus Teleonarius ▶ Bishop of
 Nola
Pfeiffer, Walter, 164
Piano, Renzo, 114
Picasso, Pablo, 109, 258, 263
Pieyre de Mandiargues, André,
 258
Piper, Adrian, 114
Piper, nightclub in Rome, 165
Pippi, Giulio aka Giulio
 ▶ Romano, Giulio
Pisanello, Antonio, 49, 147
Platzspitz ▶ Needle–Park, Zurich
Pliny the Elder, 25
Polke, Sigmar, 8, 48, 57, 75, 77, 83,
 96–100, 349, 353, 371, **374–90**
Polke's windows in the Gross-
 münster in Zurich, 8, 96–97, 98,
 99, 100, 101, 225–26, **374–90**
Pope Julius II, 32, 102
Pope Leo X, 46
Poseidippidos, Greek poet, 337
Postmodern dance, 318
Prada, Miuccia, 191
Prince Albert of Sachsen-Coburg
 and Gotha, 141
Prince Consort Bernhard of
 Holland, 390
Prince, Richard, 254
Prix Meret Oppenheim, 126, 201,
 393

Pro Helvetia, 127–28
Prod'Hom, Chantal, 127
Prophet Elijah, 377, 380, 383–84,
 388–89
Proust, Marcel, 89
Pulcinella, 196
Punk, 77, 317
Queen Noor al-Hussein of Jordan,
 104
Queen Victoria, 141
Rabinowitz, Cay Sophie, 163
Raetz, Markus, 57, 151
Raimondi, Marcantonio, 35, 36
Raphael, Raphael Sanzio, 26, 28,
 29, 30, 31, 33, 34, 46, 87, 107, 221
Raussmüller, Urs, 77
Ray, Man, 258, 262, 267
Reed, Lou, 80, 81, 165, 191, 288, 289
Regli, Peter, 57, 60, 61–62
Reinhart, George, 83–84
Reis, Pedro Cabrita, 59, 61
Reitz, Dana, 8, 111, **316–21**
Resnais, Alain, 24
Reust, Hans Rudolf, 127
Richter, Gerhard, 349
Rickenbach, Urs, 100, 375–76
Rist, Pipilotti, 9, 10, 11, 48, 57, 79, 82,
 115, 128–29, 131, 140–42, 144, 166,
 198, 206, **207–11**, 228, 274–77,
 278–83, 394
Romania, 64, 393
Romano, Giulio, 8, 9, 11, 26–28, 29,
 30, 33, 35, 38, 39, 41, 43, 45, 47,
 52, 57, 89, 102, 107, 108, 139,
 146–47, 149, 156, 198, 212–14, 216,
 217, 218, 228, 236 393
Rorschach, Hermann, 116, 119, 381
Rosenkranz, Pamela, 113, 156, 185
Roswitha Haftmann Prize,
 298, 388
Rote Fabrik, Zurich, 73
Rottenberg, Mika, 113
Rouault, Georges, 109
Rubens, Peter Paul, 30
Rubin, Edgar J., 382
Rubinstein, Ida, 48, 307
Ruscha, Edward, 72
Russell, John, 324
Rüthemann, Kilian, 156, 158
Rütimann, Christoph, 97

Ryman, Robert, 78
Said, Edward W., 299
Salviati, Francesco, 205
Salvisberg, Otto, 72
San Lorenzo, church in Venice,
 164–65, 290
San Pietro di Castello, basilica in
 Venice, 69
San Pietro, church in Tuscany,
 64, 69
SANAA, Japanese architecture
 firm, 57, 58, 227
Sanchez-Barriga, Antonio, 68
Sand, George, 381
Sandoz, Basel, 54, 226
Sartre, Jean-Paul, 89
Sauer, Christel, 77
Saus und Braus, exhibition,
 73, 77, 79
Scala, La, Milan, 49, 52, 105
Scalo Publishers, Zurich/
 New York, 84, 172, 394
Scarpa, Carlo, 393
Scarpati, Vittorio, 172
Schelbert, Catherine & Tarcisius,
 9, 11, 206, 218–22, 394
Schelbert, Catherine, 9, 12, 163,
 200, 206, 218–22, 394
Schiaparelli, Elsa, 263
Schiess, Hans Rudolf, 267
Schifferle, Klaudia, 72, 77
Schmid, Daniel, 72
Schmidt, Katharina, 377
Schneider, Gregor, 342
Scholem, Gershom, 22
Schröter, Werner, 72
Schulz, Isabel, 269
Schütte, Thomas, 342, 360
Schutz, Dana, 183–84
Schwarzenbach Initiative, 70
Schwegler, Fritz, 342, 348, 360, 393
Segovia, San Justo, 65, 68
Seiler, Kerim, 57
Sennett, Richard, 47
Serlio, Sebastiano, 30
Serra, Marco, 227
Serra, Richard, 188, 190, 195, 227,
 367, 370, 372, 373
Shah Reza Pahlavi, 293
Shahbazi, Shirana, 113, 156, 158
Shakespeare, William, 30, 195

411

Sheik Ibrahim aka ▶ Burckhardt, Johann Ludwig
Short-toed tree creeper (Certhia brachydactyla), 339
Sidibé, Malick, 169
Sierra, Santiago, 143
Sieverding, Katharina, 164
Sigg, Uli, 54, 181, 182
Signer, Roman, 184
Signorini, Rodolfo, 40
Silber, Alex, 164
Sinar, professional camera, 334
Sinatra, Frank, 89
Singapore, 71
Sirk, Douglas, 72
Sistine Chapel, Rome, 33, 132, 304, 362, 363
Siza, Álvaro, 227
Skaggs, Sarah, 321
Smith, Elliott, 116
Socrates, 89
Sommerakademie im Zentrum Paul Klee (SAK), 7, 101, 112–14, 116, 117, 118, 121–22, 393
Sonetti lussuriosi (Lewd Sonnets) by Pietro Aretino, 35
Söntgen, Beate, 114
Sotheby's Institute, 394
Souto de Moura, Eduardo, 59, 61, 227
Spain, 28, 64, 393
Spotted towhee (Pipilo maculatus), bird, 338
Sprezzatura, term coined by Baldassare Castiglione, 9, 46–47, 49, 70–71, 214, 315
St. Francis, Francis of Assisi, 20, 21, 30, 348
Staffelbach, Franz, 72
Staging Knowledge, term coined by Herbert Lachmayer, 198, 394
Stanford University, 30, 393, 394
Stark, Frances, 114
Staub, Urs, 127
Stefanini, Santino, 191, 192, 193
Stein, Gertrude, 263
Steinberg, Leo, 40
Steiner, Juri, 8, 9, 11, 113, 190, 394
Stockholm, 103, 253, 292
Storr, Robert, 140
Stotzer, Nicole, 12

Strauhof Zürich, 71, 73, 77
Strehler, Giorgio, 195
Streiff, David, 127
Stürm, Isa, 127, 130, 138
Subotnick, Ali, 163
Suicide, resp. Alan Vega, music band, 171
Suter, Vivian, 72, 160
Sutton, Sheryl, 307
Sweden, 78, 211
Szeemann, Harald, 55, 78, 86, 160, 181, 226–28, 376, 394
Tafuri, Manfredo, 38, 41, 89
Tai Chi Chuan, 318
Taipei, 71, 81
Talvacchia, Bette, 35, 37
Tanguy, Yves, 258
Taniguchi, Yoshio, 227
Tasso, Torquato, 30
Tbilisi, 81
Tehran, 293
Tell, Wilhelm, 135, 153
Tharp, Twyla, 318
The Green Henry, novel by Gottfried Keller, 256
Théâtre du Châtelet, Paris, 307
Thema Selection, fashion label, 72
Thoreau, Henry David, 116
Thunberg, Greta, 184–85
Thyssen-Bornemisza, Francesca ▶ Foundation TBA21
Till, Emmett, 183–84
Tinari, Philip, 181
Tiravanija, Rirkrit, 187
Titian, Tiziano Vecellio, 33, 213, 352
Tokalı Kilise, rock church in Göreme, Cappadocia, 63, 66, 67
Toscani, Oliviero, 142–43
Tratteggio technique, 20
Trockel, Rosemarie, 151, 162
Tuazon, Oscar, 116, 117
Turner, J. M. William, 141
Turrell, James, 279
Tweed, Charlie, 117
Twin Towers, New York, 289
Twombly, Cy, 72
UCCA, Ullens Center for Contemporary Art, Beijing, 181
United Nations, 304
University of Bern, 105, 114
University of Connecticut, 35

University of Michigan, Ann Arbor, 318
University of Nigeria, Nsukka, 367
University of Science and Technology, Kumasi, Ghana, 368
University of Zurich, 30, 64, 212, 394
Ürgüp, Turkey, 67
Ursprung, Philip, 127
Utopia Station, 187–88
van Eyck, Jan, 333, 334
van Gogh, Vincent, 53, 328, 339
van Tieghem, David, 168
Vasari, Giorgio, 30–31
Vasella, Daniel, 54–55, 226
Vece, Costa, 81
Venice, 64, 69, 82, 83, 144, 174, 232, 234, 290, 295
Venus genetrix, 27–28, 29
Venus in Furs, novella by Leopold von Sacher-Masoch, 264
Venus pudica, 27
Verne, Jules, 353
Verwoert, Jan, 115
Vierwaldstättersee ▶ Lucerne, Lake Lucerne
Villa Borghese, Rome, 30, 31
Vindonissa, 105
Vischer, Theodora, 127
Visconti, Luchino, 165
Vogt, Günther, 55, 57, 58, 227
von Brentano, Bettina, 272
von Castelberg, Brida, 72
von Fürstenberg, Adelina, 38, 160
von Graffenried, Dieter, 70–71, 74, 80, 82, 224
von Günderrode, Karoline, 272
von Hofmannsthal, Hugo, 109
von Kleist, Heinrich, 96, 342
von Ofen, Michael, 57
von Sacher-Masoch, Leopold, 264
Vonna-Michell, Tris, 113
Vonnegut, Kurt, 89
Waldburger, Ruth, 72
Walker, Peter, 55
Wang-Fô, 390
Warburg, Aby, 221, 348, 393
Warhol, Andy, 72, 159, 164, 349
Warner, Marina, 40, 114, 200

Wasmuth, Corinne, 57
Wassmer, Franz, 82, 83, 239
Waters, John, 72, 172, 200
Watteau, Antoine, 153
Weiner, Lawrence, 78
Weiss, David ▶ Peter Fischli & David Weiss
Welzel, Mark, 163
Wenger, Burkhard, Meret Oppenheim's brother, 256
Wenger, Lisa, Meret Oppenheim's niece, 255
Wenger, Theodor and Lisa, Meret Oppenheim's grandparents, 255
West, Franz, 153, 177, 179
Wetter, Trix, 178, 179
Whitechapel Gallery, 81
Whitney Biennal, 183
Wiemken, Walter Kurt, 267
Williamsburgh Savings Bank, Brooklyn, New York, 363, 364
Williamson Koller, Hanna, 12
Williamson, Sue, 121
Wilson, Robert, 8, 48–49, 50–51, 52, 195, **306–15**, 318, 393
Winckelmann, Johann Joachim, 25, 142, 344
Wirth Schilling, Margarethe "Wirthi," 265
Wittwer, Hans Peter, 265
Wittwer, Steffi, 77
Wolf, Urs, 130
Wooster Group, 168
Wyss, Nikolaus, 84
Wyss, Susan, 72, 73
Young, Arthur, 365
Yourcenar, Marguerite, 390
Yue, Min Jun, 182
Zeng, Fanzhi, 181
Zentrum Paul Klee (ZPK), Bern, 7, 24, 101, 112, 113, 114, 116, 117, 118, 122, 393, 394
Zimmer, Nina, 114
Zöbeli, Sissi, 72, 135
Zolghadr, Tirdad, 113, 115, 121
Zorn, Fritz, 71
Zurkinden, Irène, 257, 258, 267
Züst, Andreas, 15, 72, 74, 84, 106
Zweifel, Stefan, 24, 77, 164, 394

PHOTO CREDITS

David Aebi: p. 113, fig. 95;
p. 117, figs. 96–97; p. 118, fig. 99
Yves André: p. 133, fig. 102;
p. 134, figs. 104–05
Graziano Arici: p. 290, fig. 5
Rita Blum: p. 169, fig. 128
Jacqueline Burckhardt: p. 29, fig. 11;
p. 32, fig. 14; p. 39, fig. 22; p. 45,
fig. 26; p. 51, figs. 34–35; p. 56,
figs. 37–38; p. 73, fig. 57; p. 82,
figs. 67–69; p. 99, fig. 82; p. 106,
fig. 88; p. 108, fig. 92; p. 154,
fig. 110; p. 155, fig. 111; p. 176,
fig. 137; p. 179, fig. 139; p. 190,
fig. 142; p. 307, fig. 1, p. 308, fig. 2,
p. 309, fig. 3; p. 345, fig. 6, p. 358,
fig. 1; p. 363, fig. 7; p. 364,
figs. 8–9; p. 365, figs. 10–11
Bice Curiger: p. 29, fig. 10; p. 42,
fig. 24; p. 73, fig. 56; p. 83,
figs. 70–71; p. 85, fig. 72; p. 94,
fig. 77, p. 95, fig. 78; p. 98, fig. 79;
p. 99, fig. 81; p. 166, fig. 125; p. 170,
fig. 130; p. 176, fig. 136; p. 291,
fig. 6; p. 292, fig. 7
Carmen del Valle Inclan:
p. 68, figs. 52–53
dotgain.info: p. 303, fig. 5
Ivo Faber: p. 180, fig. 140; p. 248–49,
p. 341, fig. 2; p. 346, figs. 8–9;
p. 347, figs. 10–11; p. 351, fig. 16;
p. 353, fig. 19; p. 354, fig. 22;
p. 356, fig. 26; p. 357, figs. 27–29
Kurt W. Forster: p. 37, fig. 21
Katharina Fritsch: p. 247, p. 250,
p. 340, fig. 1
Daniel Gerber: p. 131, fig. 101
Serge Hasenböhler: p. 367, fig. 2;
p. 369, fig. 3; p. 371, fig. 5; p. 373,
fig. 7
Regine Helbling: p. 98, fig. 80
Christof Hirtler: p. 375, fig. 1; p. 377,
figs. 2–4; p. 379, figs. 5–7; p. 380,
figs. 8–9; p. 382, figs. 10–12;
p. 384, figs. 13–15; p. 386,
figs. 16–18; p. 387, figs. 19–21
Maurus Hofer: p. 203, fig. 147
Bill Jacobson: p. 349, fig. 13
Agop Kanledjian: p. 301, fig. 2

Peggy Jarrell Kaplan: p. 319, fig. 3
Julia Kiefer: p. 94, fig. 76
Florian Kleinefenn: p. 302, fig. 3
Marion Lambert: p. 86, fig. 73
Kitmin Lee: p. 305, fig. 6
Christian Leibert: p. 307, fig. 1;
p. 308, fig. 2; p. 309, fig. 3;
p. 312, fig. 4; p. 314, fig. 5
Mancia/Bodmer—FBM studio:
p. 79, fig. 63; p. 169, fig. 129;
p. 179, fig. 138
Ursula Markus Gansser:
p. 80, fig. 64
Parkett archive: p. 49, fig. 30;
p. 80, fig. 65; p. 157, fig. 113; p. 158,
figs. 114–16; p. 161, fig. 117, p. 162,
figs. 118–20; p. 163, figs. 121–23;
p. 173, figs. 132–35
Private archive Matthias Brunner:
p. 73, fig. 58
Private archive Jacqueline
Burckhardt: p. 13, fig. 1; p. 58,
figs. 39–41; p. 65, fig. 46; p. 66,
figs. 47–49; p. 69, figs. 54 a+b;
p. 82, fig. 66; p. 103, figs. 84–85;
p. 104, figs. 86–87; p. 106, fig. 90;
p. 108, fig. 91; p. 110, figs. 93–94;
p. 155, fig. 112; p. 166, fig. 124;
p. 167, figs. 126–27; p. 202,
figs. 145–46; p. 203, fig. 148;
p. 289, figs. 3–4; p. 366, fig. 1;
p. 371, fig. 4; p. 373, fig. 6
Private archive A. Gansser:
p. 106, fig. 89
Peter Regli: p. 60, figs. 44–45
Georg Rehsteiner: p. 305, fig. 7
Travis Rooze: p. 192, fig. 143
David Röthlisberger: p. 101, fig. 83;
p. 118, fig. 98
Thomas Ruff: p. 343, fig. 3; p. 350,
fig. 14; p. 356, fig. 25
Jörg Sasse: p. 349, fig. 12
Daniel Schmid: p. 76, fig. 62
Marco Serra: p. 59, figs. 42–43
Franz Staffelbach: p. 74, fig. 60
Niklaus Stauss: p. 75, fig. 61
Martin Stollenwerk: p. 359, fig. 2
Richard Stoner: p. 346, fig. 7
Isa Stürm Urs Wolf SA: p. 131,
fig. 100; p. 133, fig. 103; p. 136,
figs. 106–07; p. 138, figs. 108–09

Nic Tenwiggenhorn: p. 344, fig. 5;
p. 350, fig. 15; p. 355, fig. 24
Natalia Tsoukala: p. 351, fig. 17
Monique Veillon Cadorin:
p. 67, figs. 50–51
Serafino Volpin: p. 69, fig. 55
Jörg von Bruchhausen: p. 303,
fig. 4
Christoph von Imhoff: p. 18, fig. 3
Rudolf Wakonigg: p. 344, fig. 4
Annik Wetter: p. 53, fig. 36
E. Lee White: p. 317, figs. 1–2
Derrik Widmer: p. 182, fig. 141

COVER CREDITS

Laurie Anderson:
Les Fincher, Frank Micelotta
Jacqueline Burckhardt:
Gächter + Clahsen
Kurt W. Forster:
Elisabetta Terragni
Katharina Fritsch:
Andrei Dureika, Ivo Faber
Herbert Lachmayer:
Philip Mann
Pipilotti Rist:
Jacqueline Burckhardt,
Andrea Panté, Gazeta
Wyborcza, Maciej Zienkiewicz
Juri Steiner:
Anne-Outram Mott

COPYRIGHTS

The image rights are held by the authors or their legal successors.

© El Anatsui, courtesy the artist and OCTOBER GALLERY, London
© Laurie Anderson, courtesy the artist
© Pedro Cabrita Reis, courtesy the artist
© Peter Fischli & David Weiss, courtesy the artists, Galerie Eva Presenhuber
© Sylvie Fleury, courtesy the artist
© The Estate of Kurt W. Forster
© Courtesy the Estate of Dan Graham, Marian Goodman Gallery
© Mona Hatoum, courtesy Beirut Art Center, Bern Academy of the Arts, Galerie Chantal Crousel, Paris, Galerie Max Hetzler, Berlin, MdbK Leipzig and White Cube, London
© Thilo Hoffmann
© Herbert Lachmayer
© Mylène + Jean-Luc Mylayne, courtesy the artist, Gladstone Gallery and Sprüth Magers
© Laura Owens, courtesy the artist, Sadie Coles HQ, London, and Galerie Gisela Capitain, Cologne
© The Estate of Sigmar Polke, Cologne / 2023, ProLitteris Zurich, for the works of Sigmar Polke and Grossmünster Zurich for the windows of Sigmar Polke
© Peter Regli, courtesy the artist
© Dana Reitz, courtesy the artist
© Pipilotti Rist, courtesy the artist, Hauser & Wirth and Luhring Augustine / 2023, ProLitteris, Zurich, for the works of Rist Pipilotti
© Travis Rooze, courtesy Canal Street Communications

© Rosmarie Trockel / 2023, ProLitteris, Zurich, for the works of Trockel Rosemarie
© Oskar Tuazon, courtesy the artist, Galerie Eva Presenhuber
© Robert Wilson, courtesy the artist
© Nachlass: Andreas Züst, courtesy Galerie & Edition Marlene Frei, Zurich

© 2023, ProLitteris, Zurich for the works of:
Ivo Faber
Katharina Fritsch
Serge Hasenböhler
Alex Katz
Alexej Koschkarow
Meret Oppenheim
Thomas Ruff
Jörg Sasse
Niklaus Stauss
Nic Tenwiggenhorn

© Man Ray 2023 Trust / 2023, ProLitteris, Zurich, for the works of Man Ray

Despite best efforts, we have not been able to identify all the holders of copyrights and rights of reproduction. Copyright holders are kindly asked to substantiate their claims, and recompense will be made according to standard practice.

COLOPHON

Jacqueline Burckhardt
My Commedia dell'Arte

Edited by
Theres Abbt and Mirjam Fischer

With contributions by Laurie Anderson, Kurt W. Forster, Katharina Fritsch, Herbert Lachmayer, Pipilotti Rist and Catherine & Tarcisius Schelbert

Authors
Theres Abbt, Laurie Anderson, Jacqueline Burckhardt, Mirjam Fischer, Kurt W. Forster, Herbert Lachmayer, Juri Steiner in conversation with Jacqueline Burckhardt

Translation
Catherine Schelbert, Rupert Hebblethwaite

Copyediting
Theres Abbt, Mirjam Fischer

Proofreading
Michaela Alex-Eibensteiner

Book design
Martina Brassel

Image processing
Marjeta Morinc

Printed by
DZA Druckerei zu Altenburg GmbH

Paper: Munken Lynx, 90 g/m², Munken Lynx, 300 g/m²
Fonts: LL Catalogue, Letter Gothic

Illustration cover
Kai Damian Matthiesen and Herbert Lachmayer,
Hermeneutic Wallpaper, 2021

First edition
Edition Patrick Frey, 2024
1200 copies
ISBN 978-3-907236-71-0

Printed in Germany

©2024 pictures: see photo credits
©2024 texts: the authors
©2024 for this edition:
Edition Patrick Frey

German edition
Jacqueline Burckhardt
La mia commedia dell'arte
Edition Patrick Frey, 2022
ISBN 978-3-907236-30-7

Edition Patrick Frey
Schlossgasse 5
CH–8003 Zurich
www.editionpatrickfrey.com
mail@editionpatrickfrey.ch

All rights reserved. No part of this publication may be reproduced, stored in a retrieval system or transmitted in any form or by any means whatsoever (including electronic, mechanical, microcopying, photocopying, recording or otherwise) without the prior written permission of the publisher.

Special thanks to the private supporters who made this English edition possible.

DISTRIBUTION

Switzerland
AVA Verlagsauslieferung
CH–Affoltern am Albis
ava.ch

Germany, Austria
GVA Gemeinsame
Verlagsauslieferung
DE–Göttingen
gva-verlage.de

France, Luxembourg, Belgium
Les presses du réel
FR–Dijon
lespressesdureel.com

United Kingdom
Antenne Books
GB–London
antennebooks.com

United States
ARTBOOK/D.A.P.
USA–New York
artbook.com

Japan
twelvebooks
JP–Tokyo
twelve-books.com

South Korea
Post Poetics Co. Ltd.
KR–Seoul
postpoetics.kr

Australia, New Zealand
Perimeter Distribution
AU–Melbourne
perimeterdistribution.com

Rest of the world
Edition Patrick Frey
CH–Zurich
editionpatrickfrey.com